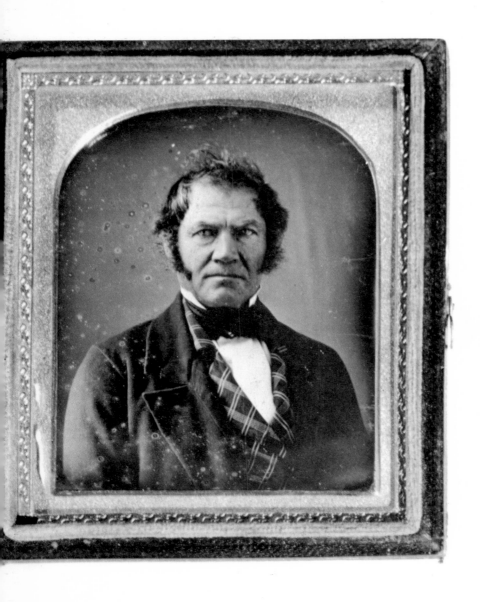

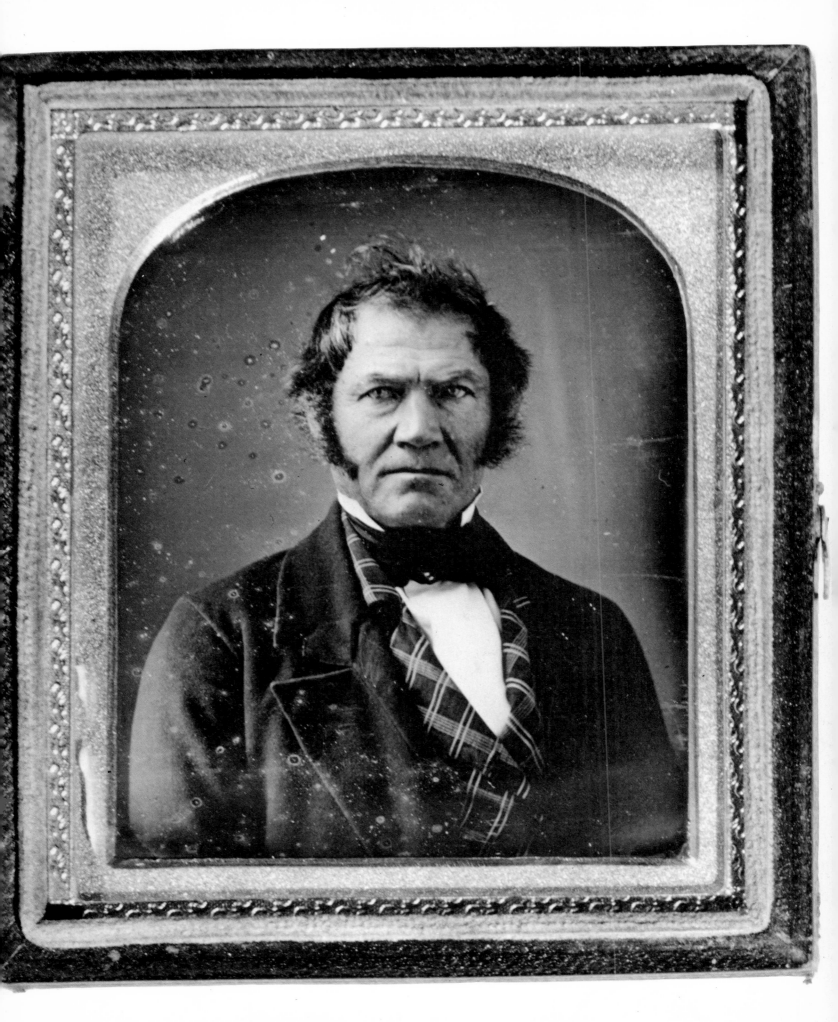

Faces

A Narrative History of the Portrait in Photography
by Ben Maddow

Photographs Compiled and Edited by Constance Sullivan

A Chanticleer Press Edition
Designed and Coordinated by Massimo Vignelli and Gudrun Buettner

New York Graphic Society, Boston

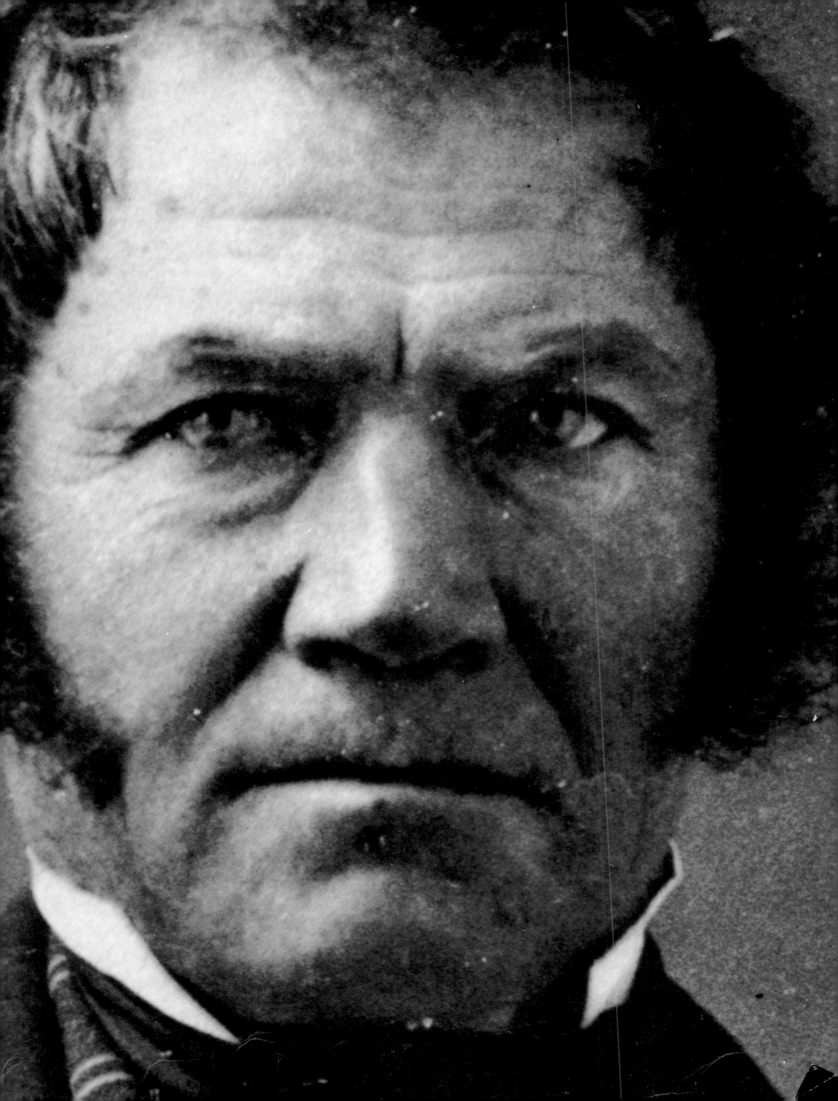

Frontispiece
Photographer unknown
E. Rinehart, no date
American daguerreotype
Rapho/Photo Researchers

International Standard Book Number: 0-8212-0703-2

Library of Congress Catalog Card Number: 76-411-39

First Edition 1977

New York Graphic Society books are published by
Little, Brown and Company.
Published simultaneously in Canada by Little, Brown
and Company (Canada) Limited.

Printed and bound in Japan
Prepared and produced by Chanticleer Press, Inc.

Contents

Foreword

Half the future of photography is in the past. There are not only the uncounted and unseen riches in the vaults and in the stacks or sadly moldering in cardboard boxes in the basement of a city hall or a local historical society; but also the unprinted and often uncatalogued negatives in museums everywhere in the world; the contact sheets in private storage; the reproductions in dead and living or merely somnolent magazines. Just imagine, for example, going through the files of the Library of Congress or the Bibliothèque Nationale or even the National Geographic: each a marvelous lifetime job. So there's another world of the past century and a half of photography which is still unknown, and which might, when examined, hold forgotten vistas of aesthetic pleasure.

Portraits of the past are like gems: each must be weighed individually; they are not wholesale items. More than the artifacts of any other human pursuit, they represent a unique concurrence of the real and the artful, of the momentary and the historical. A single new example might shake all our aesthetic preconceptions; a discovered series might make us rewrite our histories.

These riches being so great, it follows (and, I think, happily) that any such anthology as this is to some degree arbitrary. This book happens to be the crossproduct of several minds; nor has it escaped the restrictions of time, space, availability, and petty revenge: because photographers are almost as human as the rest of us. One can imagine a much more personal and aberrant collection of photographs— one which would be a kind of self-portrait of the anthologist. A complete edition of the portraits done by a single photographer is economically impossible; and such a volume might even be disappointing; for the eye can be fatigued by the mediocre, or even by the not quite successful, just as it is energized and electrified by the superb. So the limited investigation of the past that this volume attempts will no doubt have many curious errors of judgment.

The reader is invited, out of joy or rage at our collection, to make a beautiful and limitless and therefore imaginary one of his own.

It is impossible sufficiently to thank Beaumont Newhall for his thorough and benevolent reading of the manuscript; what errors remain are entirely the author's responsibility. Finally, special gratitude is owed to the patience and labor of the Chanticleer Press staff; to Paul Steiner and Gudrun Buettner, to Milton Rugoff for his comments on the text, and to Helga Lose for her careful attention to the details of production.

. . . since through the eyes the heart is seen in the face . . .
—Michelangelo Buonarroti, 1533

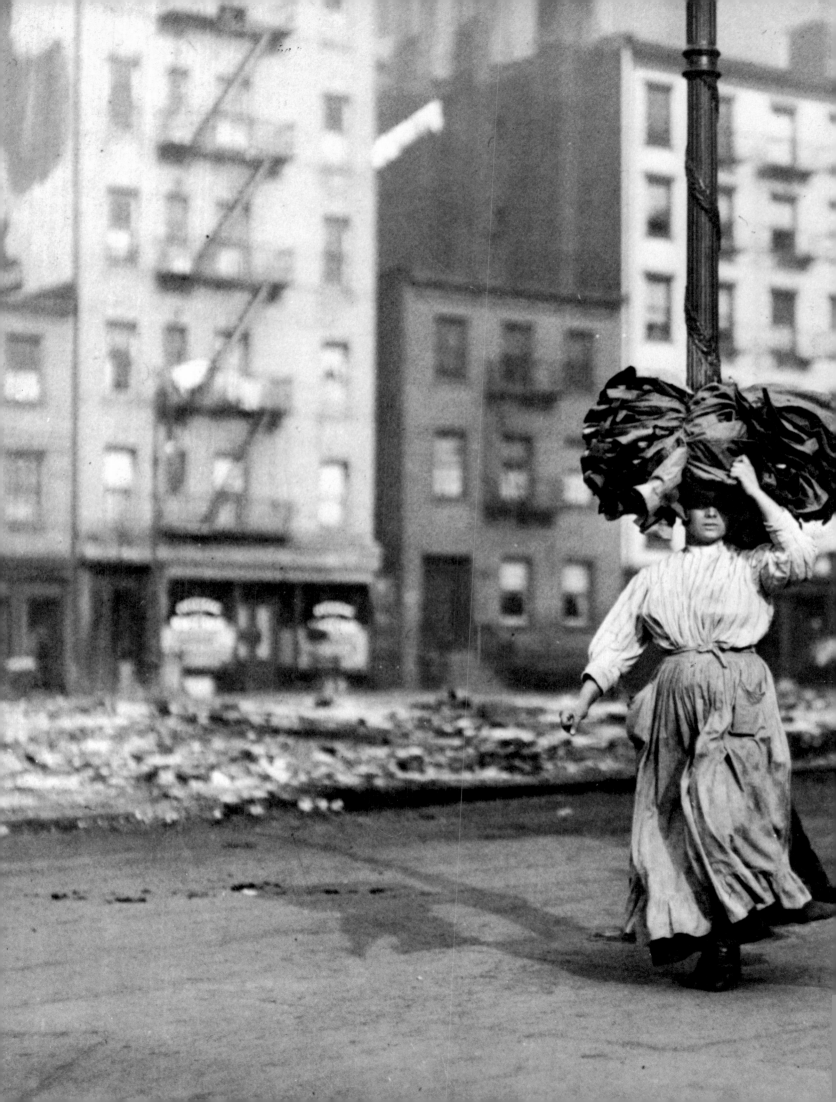

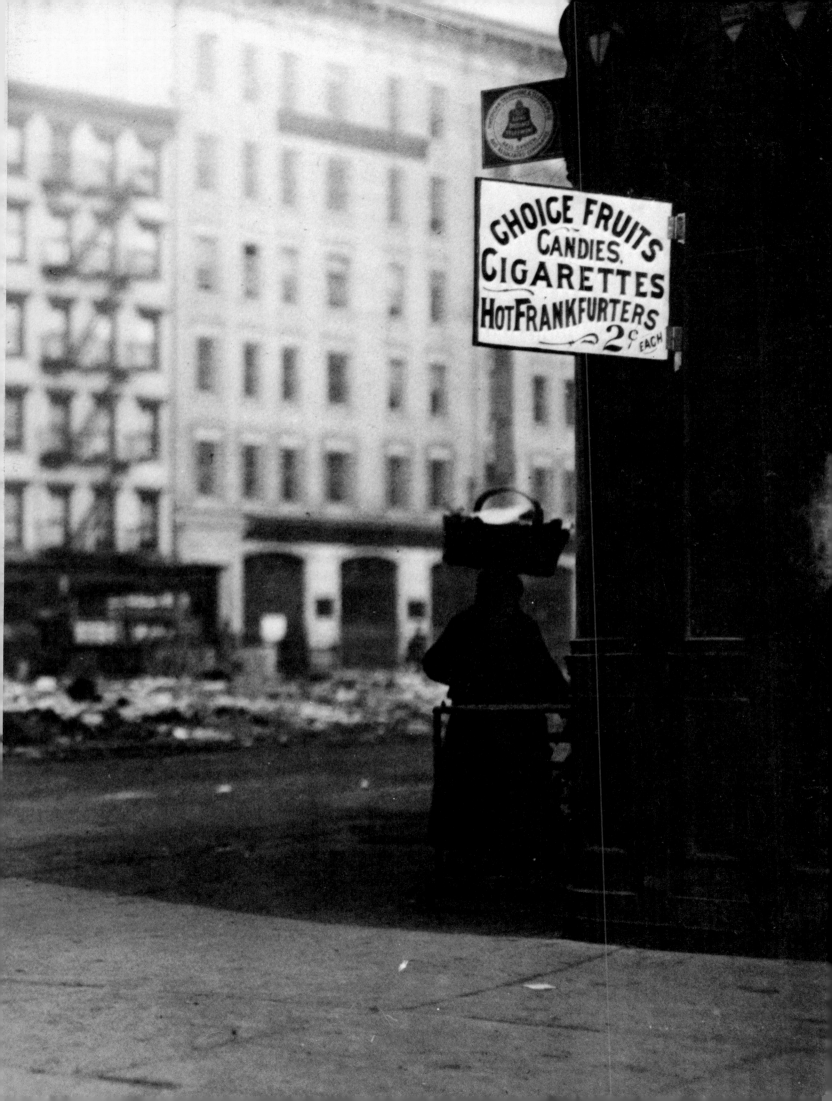

I feel certain that the largest part of all photographs ever taken or being taken or ever to be taken, is, and will continue to be, portraits. This is not only true, it is also necessary. We are not solitary mammals like the fox or the tiger; we are genetically social, like the elephant, the whale, and the ape. What is most profoundly felt between us, even if hidden, will reappear in our portraits of one another.

Because here, in this image, we will see not only our commonality but our singularity, too. Look at two photographic masterpieces, one famous, the other hardly known. Here is a washerwoman carrying her burden on a New York street. The flowing mobility of her clothes, the soft force of her body, the sculptural heroism of work in stride, the momentary isolation of this beautiful, sturdy, ample young immigrant woman: yes, we can separate these particulars, but the whole has an exhilaration that can only be seen and not defined. The photographer was Lewis Hine, and the year was 1909. In 1916, when the young men of Europe were being macerated in the Great War, Paul Strand, one of Hine's pupils, took the second portrait with an angle view finder: again of a woman, again on the street in New York City. She is just as powerful as the laundress, but older, and blind, or so, at least, the sign around her neck declares; the sideward glance of one eye makes you wonder. Still, you never doubt the stony muscles and the bitter tenacity; this is woman, too, and just as monumental. In Strand's blind woman, we do not feel joy this time, but human knowledge: and the sort of knowledge that only art, and the very greatest art, can transmit.

Portraits, luckily, are not pure pleasure. As in painting, music, and literature, one can feel the balancing strain between fact and structure, between reality and desire. The energy of that tension will be found, I think, even in the worst photographs.

This is particularly true of the portrait, because it deals directly with character; and fails when that falters. Sir Joshua Reynolds' portrait of James Boswell—himself a greedy portraitist, who devoured and then spewed forth a verbal painting of his fat friend Samuel Johnson—is a particularly fine example. All we can see in the painting is a rather commonplace and not particularly ugly gentleman of the eighteenth century. There was a lot more to Boswell than that; thumbing the index to the notebook of his Holland journey at age twenty-four, one reads a complexity of traits like this: *Smokes tobacco; fears madness; benevolent; fond of dress: has suit of sea-green and silver, another of scarlet and gold; makes toothpicks; fond of billiards but thinks them blackguard; given to matrimonial schemes; strong feeling of family; vain; likes*

to wash his feet in warm water; likes to sing; has a good ear; can't resist anything laughable; has an excellent memory; is a monarchist; treasures romantic associations; indolent; thinks he was badly educated; kind to servants; plays the flute; honest and good natured; fickle in love; fond of money; likes to sleep with his head high; given to whims of regularity; has great difficulty in rising; a man of strict probity; likes novelty only in matters of the imagination; subject to low spirits; allows himself three hours each evening for amusement; eats too much; gloomy, peevish, splenetic; sits seven hours at cards; happier in vice than virtue; has sad dreams; represses thoughts of whoring; awakes thinking he is dying. . . . Now, just as two points determine a line, three a plane, and four a solid, so with five or more points of character we begin to imagine a human being. It is precisely this zigzag geometry which constitutes the art of the portraitist.

But this implies a kind of ethical obligation: to tell at least a significant portion of the truth. In Boswell, one is given to know some thirty traits of character. Is it possible to make a portrait, by brush, chalk, chisel, or camera, that can cope with this plenitude? No. But the portraitist can depict something else and something more: the resonant, complex harmony of a person, which we can apprehend simply by looking. This is not a small art, and it is as much social and psychological as graphic, therefore a portrait can more easily be flattering than true.

Every photograph, indeed, is a parable. One feels in its presence the agonized punctuation of time. That is specially and poignantly true in the photographic portrait. Unique itself, it projects the unique: the fragile architecture of a human character that has never existed before and will never exist again. A portrait wrestles with the exasperating beauty of this living creature. Its body is limited; most of its muscles are gross, and their movements comparatively slow. The hands are better in this respect: captured by the greatest photographers they can be an expressive twin. On the whole, though, the photographer has relied on the swift geography of the human face.

It is naked, mysterious, commonplace. It haunts our work, our love, and our fantasies. We read a face as we read a clock: to orient ourselves, to see where we are right now, right here, to place ourselves and everyone else in the nervous entanglements of our own society.

Because our first experience is that of a face: gigantic, looming, sensuous, and warm. Current research on the newborn child shows how astonishingly responsive we are just after birth; we look where our mother looks; we watch her voraciously; we learn in the first week of our lives to judge the changes and interpret the signals in that immense maternal face: to smile in response to smiling, to sense fear, and to ward off deeply hidden impatience or even hatred. The power of character and the support of social nexus is strongly concentrated in the face—an organ, one might say, especially made for that purpose.

So one way to see our autobiography is to summon up a disorderly crowd of faces: benevolent or nasty or cold or furious or kind or indifferent or supportive or shut or lost; or open in the communication of, for example, love. If I seem with this statement to mingle art with actuality, it is because I mean to do so; and think, in fact, that this confusion of the world and its image is always fruitful, but especially and most obviously in the photographic portrait. Can we detach ourselves from any Mathew Brady portrait of Lincoln, either young and witty and ambitious, or prematurely old and eroded and plagued with nightmares of his own funeral? Our conception of Lincoln is a tight amalgam of what we know and what we see and what we project. It's fascinating to guess what our conception of, say, George Washington would be if we had his daguerreotype; someone rather different, I would guess. To me, in the Gilbert Stuart paintings, his mouth distorted by false teeth, he simply looks like my mother; but this may be a personal reaction. The photographic portrait implies truth even when it manages to lie; this is a weighty responsibility, and one not really taken in the history of portraiture.

There are no persons painted in the neolithic caves of Lascaux, nor on the low rock ceiling at Santillana del Mar. There are hand prints and occasionally even human beings, but none of these has a particular face. It is not for lack of skill, for the bison and the antelope are marvelous and subtle. No, the reason is, I believe, a psychological one: power springs from the general, not the particular; and these ancient works of man, whether preparatory magic or postprandial celebration, represent the ideal, the platonic before Plato. That there are no portraits does not, I think, say anything about the society from which they might have come. The primitive man who has somehow survived in New Guinea, or along the tributaries of the Amazon, does recognize the force of human personality, but cannot portray it. But this is the true function of portraiture: the celebration, not of humanity, but of a particular person. However, if we look at the historical succession of art, the ease of abstraction invariably precedes the labor of naturalism.

The earliest portraits, in fact, are simply petrifications of the dead. For example, there was an ancient prac-

tice, along New Guinea's Sepik River, of retrieving the skull of the deceased, and then coating and painting the grisly bone back to humanity again. Yet this representation was never a real portrait, for it was meant to be the home and the focus of the spirit; the universal feeling, even among ourselves, is that the dead are somehow powerful and dreadful and angry at being exiled. One wonders whether the mounds and monuments that have celebrated and still celebrate the dead are not, by the power of ritual, at once an honorable home and a monstrous weight that will keep them from rising.

The civilization of the Egyptians was static long enough to develop a practice far more ingenious than the preservation of a skull. They embalmed the whole person; but a mummy wrapped in linen and bitumen is featureless, if morbid; and strangely abstract. So a portrait mask or a portrait statue of painted wood or painted stone was made to identify the invisible corpse. Ceremony and image were combined to transform the fear of dying and the power of the dead into hope and consolation; and the portrait was the very center of this transfer. There is no doubt that the grave is the earliest, the most fundamental, the most persistent, the most universal, reason for human portraiture.

Once again, the first portraits were, if not abstract, at least not particular; the profile of the painted queen was the same as the painted slave. Yet as early as the fifth Egyptian dynasty, some four thousand years ago, one can see a real face for the first time, though on a still beautifully generalized body: the high priest of Memphis is a distinct person, not merely a title. Dynasty by dynasty, these masks and statues became more and more personalized, more individual. We witness the slow encroachment of the human upon the divine. About one thousand years later, we observe the monuments of the heretic King Akhenaten; his face is so pathologically narrow and long that it resembles a camel's; it is carved over and over again with such plain reality that we can see the slightly swollen fold at each side of his regal smile. A portrait of his queen, Nefertiti, is only slightly less particular; it would not move us half as much if it were more divine.

The reader has noticed, I am sure, that peasants and shepherds are not preserved in this way. Portraits were made for the elite; and this would be true for a long, long time; simply and crudely, only the rich and powerful could afford a portrait. Nor were there any self-portraits. The artist was a craftsman, valued but dispensable; he could never afford to waste labor on himself. This does not mean that he didn't use a model less than noble or rich; he would make use of a brother, a mother, a servant, a friend—or an enemy. The arts have their own internal laws, and one of them is the impulse toward the drama of reality. So the artist began to study the unforeseen positions of the human body. This was so among the later Egyptians, and particularly true of the Greeks, who at the height of Periclean culture, about the fifth century B.C., broke out of their own beautiful, stiff, archaic mold to celebrate the freedom of the athletic mind. If we examine closely the "Shield of Aphrodite," a marble relief stolen from the Parthenon and displayed at the British Museum, we see among the combatants a half-baldheaded, mustachioed, frowning, anonymous warrior with Asiatic cheekbones and an axe; he looks, in fact, in this early individual carving, a great deal like V. I. Lenin—whose portrait, made of genuine skin and muscle, lies under glass at the Kremlin. How is that different from the famous death-bed portrait of Victor Hugo, taken by Nadar and his son Paul? The difference is crucial: the three-dimensional reality of the dead poet and novelist, decaying with time, is projected onto an unchanging and two-dimensional surface; the tension between these two modes of understanding, between the world and its replica, is the very engine of portraiture. And this is just as true of the antique as of the modern.

Greece, for example, was a slave state: its poetry and its metaphysics were borne like tattoos on the backs of its servants. Yet slave societies are inherently miscegenous, and those who won their way upward sometimes did so by the force of brain and character. One thinks of Themistocles, son of a Thessalian foreigner and an Athenian nobody, who became powerful and rich by selling his judgments as a magistrate. He preserved Athens against the Persians by burning it down; and went on to defeat them in a great and famous naval battle; and then lived long enough to become a Persian tax collector. Such a man would hardly commission a hieratic portrait, whose power is abstract and divinely procreated; no, his bust is full of particulars: he's a broad-faced, bearded man with wide nostrils and a head thrust forward with crafty intensity—a Ulysses if there ever was one. A new sort of man made a new sort of art.

For when nations decay, rulers begin to look absurd. And when new cultures force their way upward, their doers and shakers require realistic portraits.

Though it is true that the portraitist uses the conventions of his own day—for example, religion—to pay for and enclose his art, he is also engaged in a deeper, scarcely conscious, quest: how to make sense of his world, the world of outer reality and inner emotion,

and give them a personal form. The least motive, or perhaps I should say the lesser, is his professional delight in structure—in rhythm, symmetry in its various disguises, proportion, color sensation and color surprise, which are the fine delights of the abstract. The greater motive of portraiture is the artist's desire to work magic, like the shaman or priest: to have, to hold, to possess, to comprehend the human character by its representation; and then to thrust the image back upon us for our astonishment.

But this mission was generally secret even from the artist: One must never forget his obvious motive: to be paid in that curious abstraction, money. And as money carries the portrait of its guarantor, so the portrait bears the stamp of its payer. And this is not altogether bad. He who pays can hope, at least, for immortality.

It's the special naiveté of the twentieth century to think that the artist alone determines the subject; in examining a succession of photographic portraits one is struck instantly by the will and force of the sitter. Julia Cameron's photograph of Sir John Herschel is a masterpiece not simply by her, but by this great astronomer and chemist and thinker as well. His character, and the fact that science, and therefore scientists, were beginning to dominate the life of the nineteenth century as it swelled to a close—these are to be read in the thoughtful energy of his face.

But the domination of character over craft and aesthetic is a much older tradition than we think. It was the Romans, those military businessmen, who imbued their portraits with their own cruel individuality. Augustus, Agrippina, Caesar: we know their characters from their statues. Each is so markedly himself that he can never be mistaken for merely divine. The museums of Rome are crowded, jowl by jowl, with the portraits of men and women, each one human and unique, and each one marvelous or repellent in a personal way.

There has been an effort, recently, to rehabilitate the claustrophobic centuries that followed the death of the Roman Empire. Certainly there were splendors, in art and in alchemy; the illuminated manuscripts alone would glow in those murky times. But it was not an easy time to live, and therefore it was very hostile to portraiture. The rich, particularly in the Byzantine part of the world, imitated the Egyptians and had their portraits painted on the outer cloth of their mummies; but these grew, under the Christian influence, more and more spiritual and schematic.

In a mosaic of the sixth century, the Empress Theodora is depicted in her jewelled headdress: but it is all splendor and little humanity, and her face is just barely discernible from that of her companion's. This manner is not due merely to the comparative crudity of mosaic as against the hairline of a brush; it is a conscious and deliberate aesthetic.

The love of the humble particular tends to disappear in repressive times. Particularity is a manner of art that requires some measure of social mobility, and a man commissions his portrait when he feels his own force to be greater than society's. Power and status decreed by divine order produce a generalized, one might almost say philosophic portraiture; marvelous it may be, but increasingly rigid. When the eight hundred brutish years of medieval society were ending, there was a rebirth of the portrait into something more than a stony and hieratic icon.

Indeed, there was at that point a mysterious and unreasonable rebirth of all the arts. The Christian Crusades, though each more mad than the preceding, did, in fact, break open the gothic cave of Europe. The East became tangible, visible, and profitable. Italy, by which I mean the city states, particularly Venice and Florence, were the crossroads to Paris, London, Nuremberg; they grew rich with the acquisition of spices, metals, cloth, and Arabian science.

Imagine, in one century, two events as huge in their consequences as the invention of printing and the discovery of America! What magnificent talent lived on the jingling profits of kings and popes and dukes and middlemen! One thinks immediately of Michelangelo, Leonardo and his friend Botticelli, Dante, Boccaccio, Raphael, Machiavelli, Uccello, Brunelleschi, Piero della Francesca, and the glorious Titian. It is beyond our knowledge to comprehend an immense flowering of this kind. For that matter, how can one explain the chorus of marvelous music by Bach, Mozart, Haydn, Beethoven, all in the compass of two centuries and a couple of hundred miles? Or the anti-orthodox Jewish genius of the nineteenth century that produced, all in Central Europe, Marx, Freud, Einstein? Or, all in one generation and on one island: Shakespeare, Ben Jonson, Christopher Marlowe, Francis Bacon, and Philip Sidney? Or the astonishment of Periclean Athens? It's as if a cloud of special air had descended over a culture at particular decades and places, when people of genius breathed more deeply and created more intensely and abundantly.

Portraits are, for me, the signature of a culture; and the faces of the Renaissance reveal more truth than the dates of battles. At the period's uncertain beginning, early in the fourteenth century, Giotto had grown rich depicting the sacred poverty of the saints, but their faces were all alike: frowning and holy. Within a hundred years, the whole style of portraiture

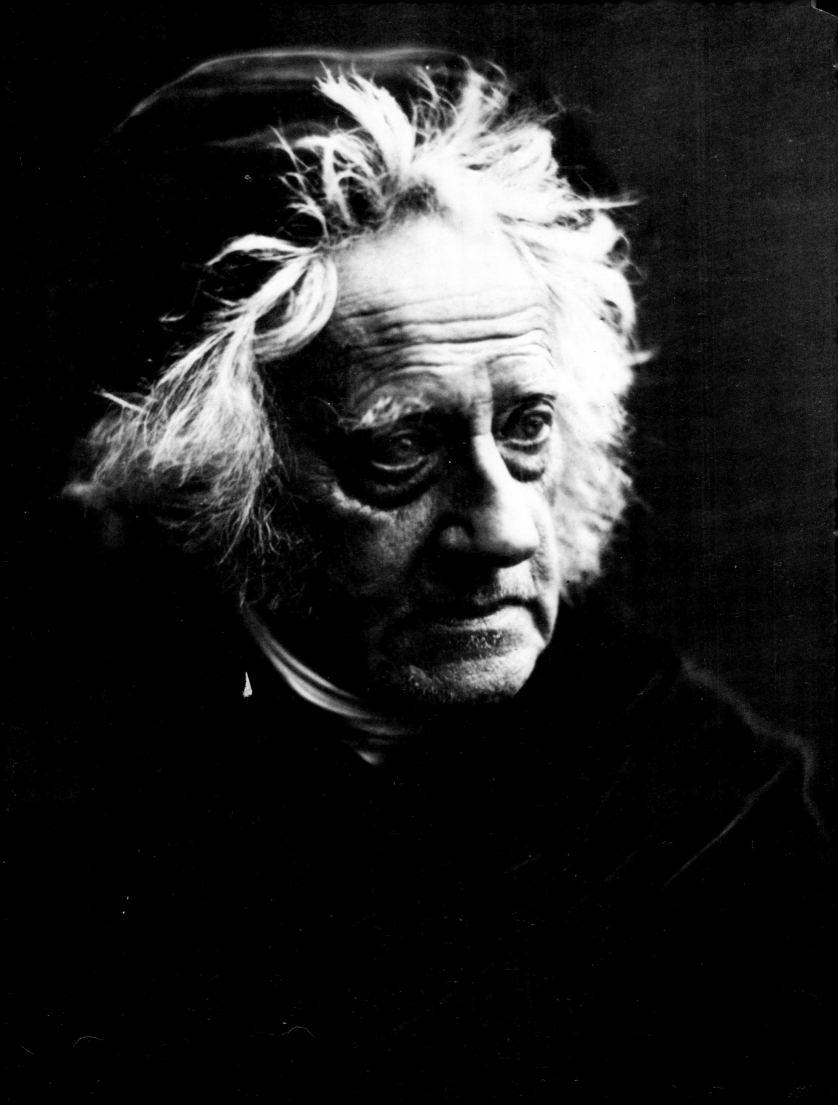

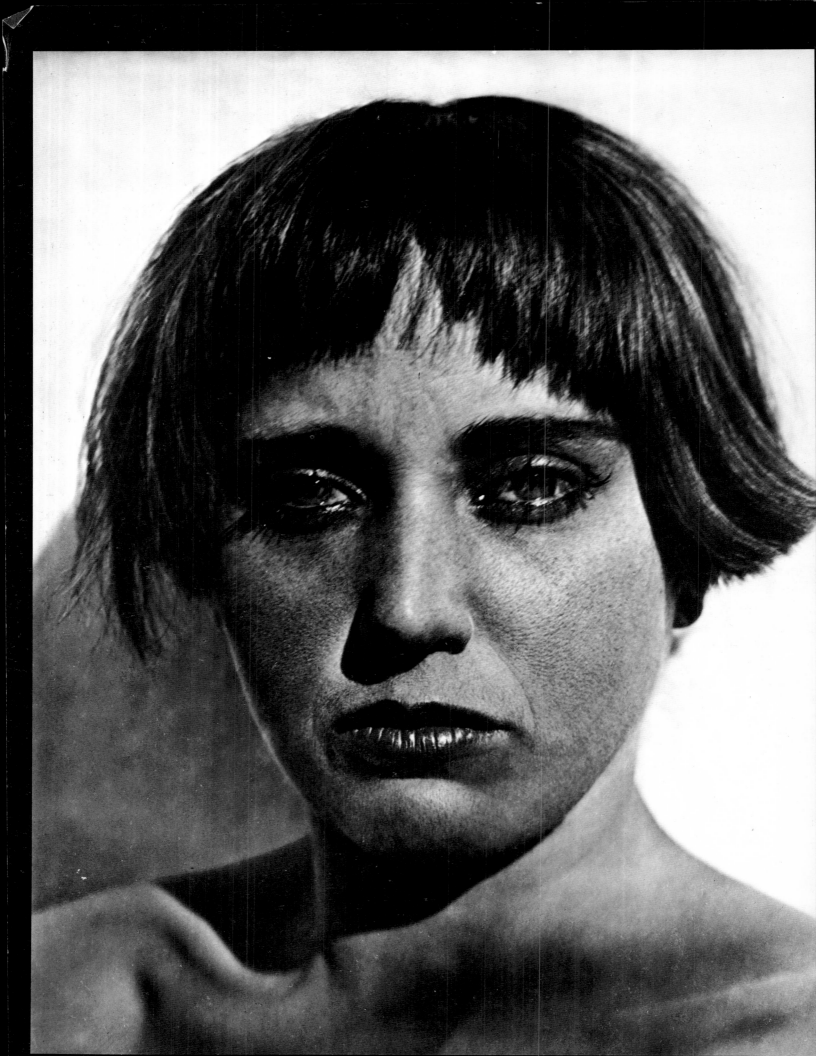

had changed: the portrait of Dante, for example, is marvelously specific: we see a long-nosed, sad, kindly, tolerant man, with a mouth turned down at the edges. But that portrait was done almost a century and a half after his death; such was the hunger, by then—and the fashion, too—for the real instead of the numinous, for the mortal instead of the merely divine.

For some centuries, a typical altarpiece would be a triptych whose central panel was a crucifixion, a descent, a resurrection, or an ascension; but on the side panels, lest they be forgotten in the press of souls toward judgment, were portraits of the man and wife who had paid for the painting. These donors, kneeling in their pride, were given remarkable specificity; here was this man's lip and that wife's chin, that and no other; and what is specially fascinating, their greed, fear, and piety show forth in the very musculature of their faces. They are painted to be seen; and the great collections of the next few centuries, and after that, the endowed museums of our own time, are simple extensions of this motive.

Now, unavoidably, we have come to the crux of portraiture. The spectator inside the pyramidal crypts of Egypt or the Yucatan was only the eyeless deity of time. But now the portrait is hung in public view; in the noble's great dining hall, in the corridors of the rich, and at last, in that nineteenth-century innovation of democracy: the public museum. So there are no longer only two persons involved, the portraitist and the sitter; there is a third: the viewer, intended or unintended. These three are the locus of that indefinable emotion that is embodied in the work. It is a kind of locked, willing antagonism, a love that one weakly resists, a triangle distorted by the usual pressures of time and society, but real and true and powerful nevertheless. Perhaps this trio has always existed; but from the Renaissance forward, all three persons of the triangle become equally important, with this exception: that both artist and sitter generally die within the same century, while the audience is almost, if not quite, immortal. It's also variable, fickle, ill-informed, and uncertain; but it is immersed daily in the real issues of bread and soup and sex and work and survival; so it's a counterbalance to the vanity of the sitter. Who, admiring the portraits of the Duke and Duchess of Urbino, remembers who they are? Or can identify the marvelous bronze nobles of Benin? They are pieces of specificity that have become symbolic.

This dialectic is especially true of photographs. In the early twentieth century, Mexico was molting like a lizard in successive revolutions; her art had a like exuberance and energy; and her artists, generals, and lovers had personalities that exploded into the American Edward Weston's mind, and were transferred thence to his 4 by 5 plates. Who, even knowing her name, would remember Nahui Olin, the subject of one of his most remarkable portraits? She was a minor French poetess who declared herself Indian. We respond to the sensual theatricality of her face and amplify her into a great symbol, and associate her sullen intensity with the learned hetaerae of Greece and the courtesans of early Venice, and even with the huge, smoldering close-ups of Greta Garbo and Pola Negri. The viewer, thus, is an inextricable part of the photograph.

Similarly, Edward Curtis' photograph of Red Cloud is not merely the relationship of a great, sad chief grown old and blind and powerless, and a photographer obsessed with the ruin-romanticism of a vanishing culture. It is also Red Cloud speaking directly to our collective guilt, and to that of the generations after us, as well. We, the viewers, are part of that photograph. Our feelings illuminate it as strongly as the original light, and what we see, as we study and not merely glance at it, is the terrible beauty and power and vulnerability of the human individual.

What we are given in a photograph is a frozen slice—something like a pathologist's view of inner tissue; thin it may always be, but it is nevertheless forever real. For this reason, a photograph, sometimes even the most inept, can exert a hypnotic force. The great photographic portraits are simply stunning; though the very greatest, arguably, are still to be made. Because they are not equal, not yet, to the triumphant procession of portraits in western art from the fifteenth century onward.

The Italians had learned the art of oil and easel painting from the Flemish; and the splendid, sensuous doges of Venice took up the fashion of having their portraits done in robes and jewels—but no longer kneeling. Merchants and shipowners, when they came to afford it, did the same—hired Titian and paid out the gold florins. It was not pure ego; they were moving unaware within the great Renaissance flood of secularization.

Reality, not sanctity, was the new test of art, as it had been in Virgil's day, when real birds would try to eat the painted grapes. The sixteenth-century painter and biographer Giorgio Vasari wrote: "Titian . . . did a portrait of a gentleman of the Barberigo family, who was a friend of his, the coloring most true, the texture of the satin doublet very natural, and the hair so distinctly painted that each one could be counted."

I don't mean to imply that a photographic portrait must now be measured by this sixteenth-century ideal. The shock and play of form is still a deep necessity of

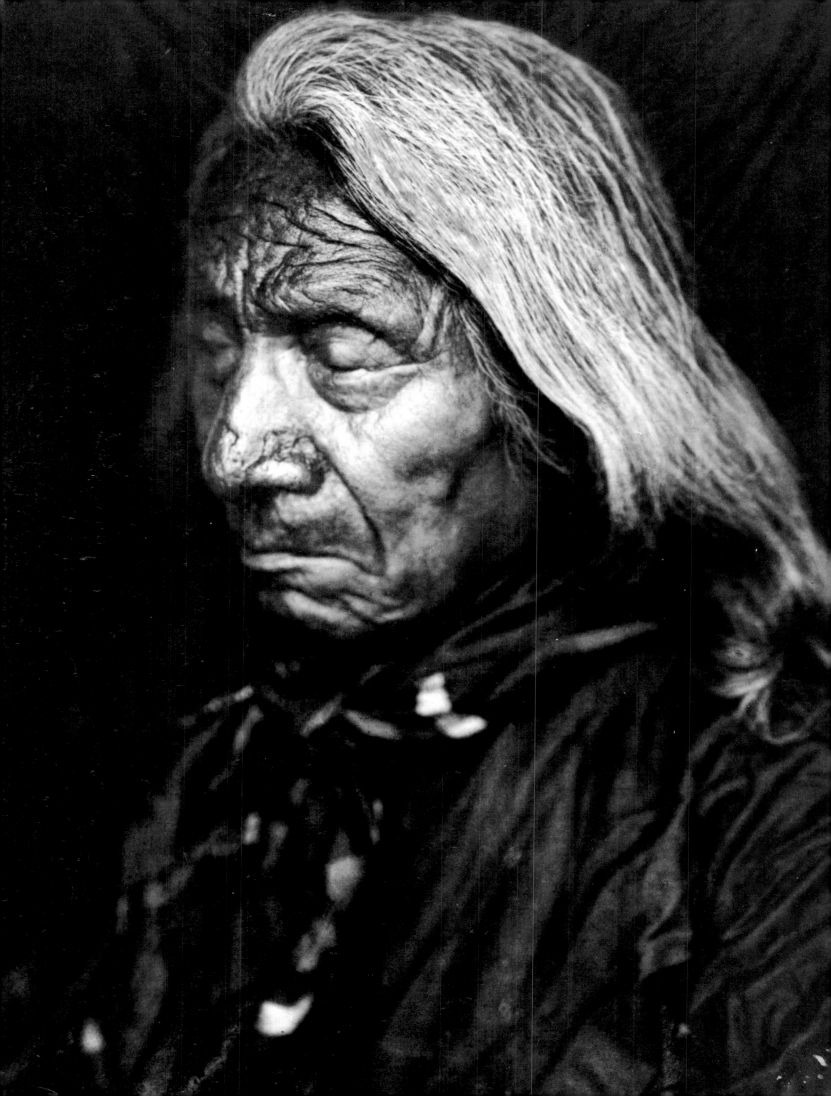

every art; the really great photographs are an unpredictable marriage of the abstract and the real: and this union has always been fertile. What the portrait demands, in addition, is a grasp of character; and this insight is not given easily or painlessly.

The last painting in the Sistine Chapel is a fresco of the Judgment; in one corner of the crowded scene, a man—or rather, the flabby, flayed skin of a man—is being dragged up to the throne of judgment by his hair; the face, for all its distortion, is recognizable: it is the alloy of form, function, outer truth, and inward self-misery of a man's last years. It is Michelangelo by Michelangelo. He wrote, in that same decade: *There is the shit of giants in my doorway . . . A spider spins his home in my left ear . . . I am broken up, ruptured, cracked by my lifelong labors . . . The art for which I was held famous has pulled me down to this: Old, poor, under another's rule . . .*

All this, and more, can be read in the painted portrait. The artist has leaped out of the wings and onto the stage, where he has since remained—for all the world to stand and twist their neck to see. By now, by the sixteenth century, the artist regards himself as the secret owner of everything he does. No subsequent sale will change this certainty. The artist speaks through his flat rectangles; he reckons himself as important as a count or even a goldsmith; and he makes many and sumptuous self-portraits. Dürer, with his conception of himself as the young Christ, faces the viewer straight on. Indeed it is rare before this time to have the gaze straight forward, so that the eyes follow you wherever you walk: a form of visual immortality.

Cranach and Holbein and Titian grew famous, if not particularly rich, on the craze for oil portraits that excited the elite of Europe for the two centuries following. Life was rich, fat, warm with imported Turkish carpets, and especially good for the merchant, as well as for the nobility, who were now really no more than a branch of this new class; and their joy in the facts of wealth and character informs the luxurious texture of their portraits. Yet the artist, a skilled hypocrite from the beginning, has more subversive aims. The famous photograph of John Pierpont Morgan by Steichen depicts the financier with ferocious moustache and eyebrows and with a knife in one fist —except that it's not a knife, only the edge of light on the arm of his chair. Steichen said the effect was adventitious. No doubt it was, but his choice of which negative—out of the two he took of Morgan—is not. The contradictions and complexities of Morgan's character: the intellect, the cunning, the crookedness, the generosity, the excellent taste, the shyness and

grandiosity of the man—these are all neglected in favor of Morgan-as-pirate. Is the portraitist, then, to forget his own caustic opinion of the sitter? He will never succeed, but he can learn to integrate it into a harder and less obvious and perhaps less popular truth than the one in this portrait.

For what is and was the primary drive of the artist? It is, as we've noticed, to get paid; not a small accomplishment in any century; yet there is certainly a finer emotion, hardly to be acknowledged. One of the most striking portraits ever done was painted in the fifteenth century by Hans Memling, the Flemish artist who made the dour, damp Bruges glow with his small paintings. The picture is of a man now unknown; possibly he was one of the numerous Italian traders who lived in the Netherlands. But his face is clarified by a light once reserved for saints; his sweetness and melancholy common sense is thus made visible in all its plain, minute detail. The artist is now the judge; he communicates to the viewer his inner and his outer vision, both; and a nameless man, thus recreated, will sit forever in that square of oiled and varnished canvas; and in turn make me, the viewer, in Emily Dickinson's paradoxical definition of a poem, shiver with a cold that nothing can warm.

No less, finally, should be asked of the photographic portrait. Painting and photography are part of one serpentine tradition: the eye and what is recreated for the eye.

Goya's commissioned portraits, for example, seem, at first, simply commercial: nice, smug figures of Don This or Don That, or the plain idiocy of Charles IV and his family; but sit before these portraits for a few minutes, and you will smell the poisonous acid. For Goya, in his deaf middle-age, humanity was something less than sublime. Even for himself, in the sad portrait painted when he was sixty-nine, there is no compassion and but little tolerance. So there is room for hate as well as love in portraiture.

Rembrandt, however, was the greatest of all these magicians. His portraits have the thickness and the complexity of novels that were yet to be written. In his early fifties, he became unfashionable: his portraits could not compete with the new masks turned out by his talented contemporaries. He went bankrupt, retired to a cold warehouse, let his mistress and his son manage his affairs, and spent his remaining years making portraits of the ghetto people around him: surely the first they had ever had.

And, as he had done since the beginning of his career, he painted himself, obsessively: in a velvet hat, encased in armor; in a great pale turban; or seated, with a sash and a silver cane. In Rembrandt, each step in the triplet of energy I have tried to describe—artist to subject to viewer—is charged with the mysterious tension that electrifies every communication between face and face. These portraits are the most profound works ever brushed onto cloth by western man; we are given such knowledge of one man's essential humanity that we can deduce all the rest, including ourselves. Rembrandt, when he is most exactly himself, begins to look like Everyman.

It must have been difficult to come after him. The decay of the portrait in the late eighteenth and early nineteenth centuries was partly the consequence of its popularity. Joshua Reynolds, Thomas Gainsborough, and George Romney were a dazzling English school, rarely anything more. The rich young bloods of Europe now went on a fashionable Grand Tour, which carried them from university to whorehouse and sometimes back; so they returned to papa with a little knowledge, a flat purse, and a handsome painted portrait from Holland, France, Germany, or Italy. With this welter of portraits came a crowd of painters. In the nineteenth century (a painter complained), one could not kick a doghouse in the dark without rousing an itinerant portraitist. From 1839 on, and increasingly throughout the nineteenth century, portrait photographers would be equally peripatetic.

Obscurely but not suddenly, for there were tremors long before that, an earthquake in the visual arts radiated out of a small town in northern France. The epicenter was not in a studio but in a cluttered laboratory; it shook the new, bursting, crowding, energetic, more and more middle-class world; and the aftershocks are not over yet.

Yet the experience of painting can never be neglected, by those who condemn it or by those who embrace it. It has moral as well as graphic lessons. Photography came at the very height of photographic realism in painting—as if the invention and the art were branches of the same impulse: the investigation and magic of the real.

Yet there is no way to deny a crucial difference, both technical and sociological: the photograph, and in particular the portrait, is a sharply novel phenomenon in human culture. It is not only an art; it is, in my opinion, a new form of human consciousness.

It was equal to the job almost from the beginning. The calotypes of David Octavius Hill and Robert Adamson in the 1840's are unsurpassed and unsurpassable: men they photographed will never exist again. And, early in the twentieth century, the Eugène Atget print of the organ-grinder, dark with age, beside the exultant child-woman singing to the upper stories of a Paris street—that moment, too, will never come

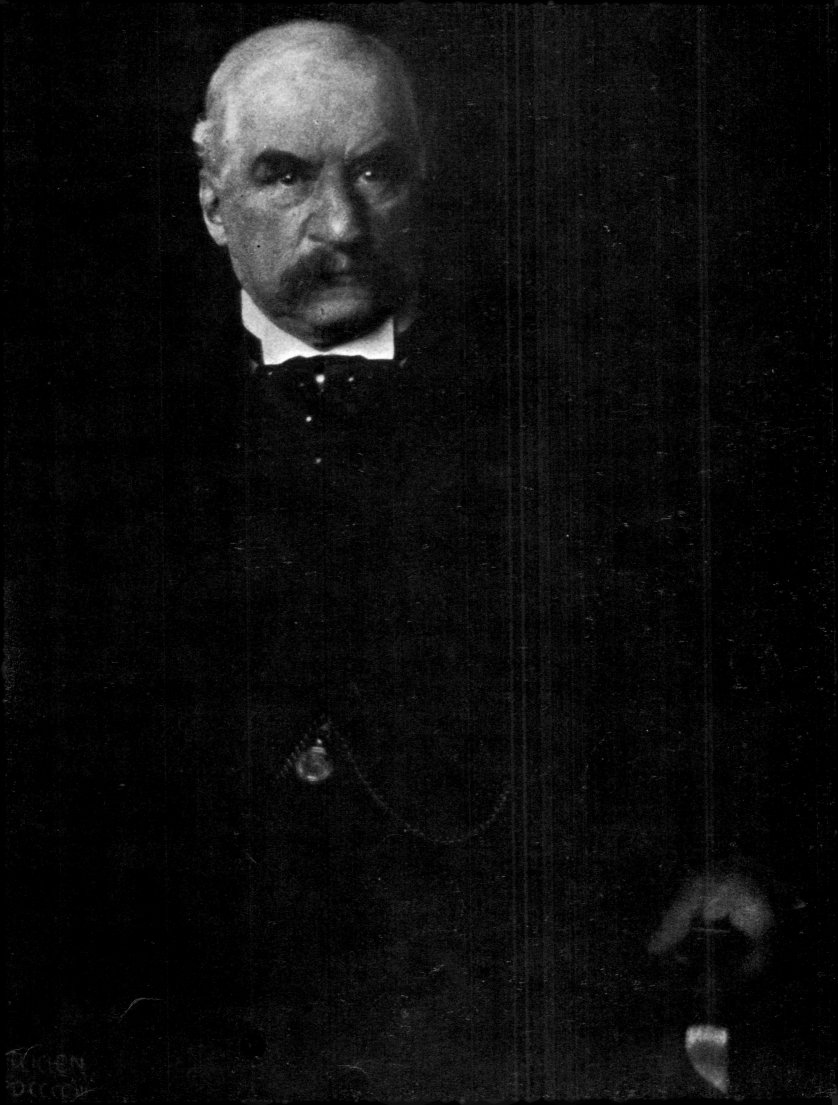

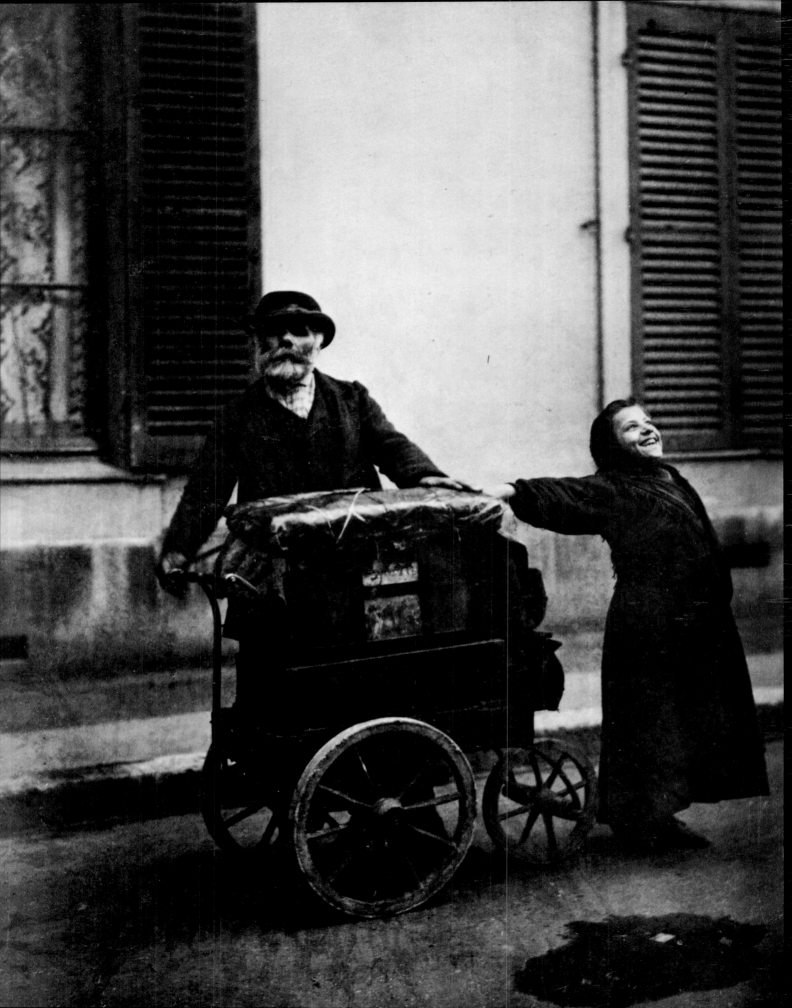

again. The preservation of fragility is the very business of photography. But it has its limitations.

The great thing about the transmission of graphic emotion inside the painter—from eye to brain to spine to hand to brush—is that there is continuous feedback to the eye of the painter again. Customarily, a painter does numerous sketches of the sitter, mostly of his head and hands; but then has him return time after time for lengthy sittings. So by the very processes of work, the artist grows acquainted with his subject, and can learn to see, through the virtual translucency of skin and flesh, the lineaments of age and character; of the general inside the particular, and the particular constructed into the general; of tragedy, dignity, and absurdity, all inextricable.

Is that, in the haste of the photographic portrait, even possible?

More difficult, can it bear the unconscious social function of all art? Can it transmit community magic? Can it be religious on the preliterate level, where the purpose is profound and yet fundamentally impossible: to ward off the anxiety which proceeds from the indifference of the nonhuman that surrounds us, from space illimitably without us in every direction, from infinite time before and after us, and from the peaks and cesspools of our private mind?

Eugène Atget
Street musicians, Paris, no date
The Museum of Modern Art, New York, The
Abbott-Levy Collection, partial gift of Shirley Burden

The immutable truth fixed in a photograph is something the human animal has always desired, from the beginning of portraiture. The means are astonishingly simple. Three things are necessary: light; a focusing device of some sort—a tiny hole will do, and a lens will do even better; and a light-sensitive material.

The first essential, the energy of the visible spectrum, was always there, and because these frequencies bathe and are reflected from every object on earth, there is scarcely any animal that has not developed an eye. At first no more than a dye-stained spot, it became a self-correcting and flexible liquid lens. *"L'occhio, che si dice finestra dell'anima. . . . ,"* wrote Leonardo da Vinci. The eye, which is called the window of the soul, is the principal means by which the central sense can most completely and abundantly appreciate the infinite works of nature.

But neither the eye nor the optical zones of the brain can fix an image for more than a fraction of a second. Painting was one way of separating and observing and fixing the flux of reality; but it was clearly imprecise. Euclid, at the end of the Periclean age, was said to have invented better means. But it is more certain that the Arab mathematician Al-hazen, who lived in the tenth and eleventh centuries, discovered that if you pierced the wall of a darkened room with a tiny hole on the side facing the sun, an image of the sun was projected on the opposite wall. By this means, he wrote, one could observe the changes in the disc of the sun during an eclipse without the danger of burning one's retina. Others, coming after him, found that any brightly lit scene, a city square or the hills of the landscape outside, could also be observed in the shade of that private room.

The spectacle of real animals and persons and clouds moving upside down on a wall was a marvel to the Renaissance man. Leonardo made note of a whole universe of curiosities in his notebooks. Among his drawings is a description of this *camera obscura* (literally, *"darkened room"*): *The images of objects are all diffused through the atmosphere which receives them; . . . [if these] images are admitted to a dark chamber by small holes and thrown upon the plane opposite to these holes, as many images will be produced in the chamber on the plane as the number of the said holes.*

This lonely, self-driven man, slave to his own intellect, obsessed with light and shadow, also drew a device for focusing the light of a candle in a box through a convex lens set into one side; it was, in fact, the obverse of a camera: a projector. Here he made use of the second prerequisite for photography, the lens, which by this time was already a well-known

device, produced by grinding a circular block of clear glass.

Glass, an odd material which is neither crystal nor liquid, was known at least as long ago as the cultivation of crops. Glass objects were particularly numerous in Egypt. With all those complex, rounded forms of goblets and beakers in wealthy houses, certainly someone must have noticed how the image of a face is changed by the circularity of the glass; made small or large or distorted; and with none of the features erased, but turned, generally, left to right and upside down.

This is precisely what happens in the human eye. We see upside down and left to right; but our mad, clever brain reverses these merely optical facts to conform to our other senses. In fact, if we put on reversing lenses, which present the world right side up and the left on the left, it will take us three or four days to adjust to this more correct view of visual reality.

One of man's qualities is that, like the ape, he is tremendously curious, a fact that explains his quick and happy acceptance of photography—as well as his invention of the physical means. In the fifteenth and sixteenth centuries lenses made of glass, first ground by the Chinese sometime before A.D. 1000, were rediscovered by any number of bright Italians. The lens replaced the pinhole in the wall and gave a sharper, brighter image, which painters at once appreciated—to save labor, they said. But there was something much deeper and less rational here.

The brilliance and certainty and infinite detail of the optical image is itself a fascination, and this fascination began to affect the processes of painting. It made the laws of perspective, so patiently described by Dürer, among many others, at once patent and beautiful. And it has been proved, by the shape and measurement of tiles in his paintings, that Vermeer, too, used the camera obscura; and indeed the magical light and shade in his works are plainly the reflection in his mind of the beauty of real rooms, real women, and the real world of Delft.

So the light was ready, the lens and the "camera" perfected; it only remained to discover how, beyond painting, to make the image permanent. Early in the eighteenth century, the unpaid amateur scientist puttered about in his smelly laboratory, examining substance after substance, mostly out of curiosity. So the action of light on silver nitrate was discovered—but without optics, it had no consequence. An Englishman, Thomas Wedgwood, at the very end of the eighteenth century did try to combine the camera obscura with this effect of light on silver nitrate. He failed, but told his failure to the famous chemist Sir Humphry Davy, who failed, too: images could be got by placing objects directly in contact with the sensitized leather or paper, but, as he reported in 1802, they darkened quickly; for Davy knew no way to wash off the unreduced silver salts.

Necessity is not the mother of invention, but more like the godmother—benevolent but erratic. No one "needed" a photograph; the world got on, badly perhaps, but without it. Yet there was always the longing that Everyman felt: the preservation of his human consciousness against the assaults of decay and oblivion. Nobles and merchant princes and gods had their portraits done, but no one else, as yet, could afford it. So, in a culture increasingly middle class, the inventor turned his mind to mass art, mass communication, mass convenience, mass pleasure.

A pair of brothers in a small provincial town near Lyons, in central France, were two such inventors. One of them, Joseph Nicéphore Niépce, was interested in methods of mass reproduction, particularly lithography. His object was to make photo-etchings of drawings, especially portraits, by means of chemicals known to be sensitive to light. So he built a camera: a simple box with a lens; as early as 1816 he exposed a paper, soaked in silver chloride and then dried, to the reversed image of the view from a second-story window. He got, of course, an opaque negative; but even this could not be fixed with the materials he knew.

He tried again with tar, which he spread evenly on a sheet of glass. The bitumen he used does not darken in the light, but merely hardens. Now he could manage to dissolve away the soft, least exposed portions; and so, about 1826, he got a positive instead of a negative image. It was taken from the same window and of the same courtyard. The exposure was eight hours.

He called the process heliography, and mentioned it in a letter to his nephew on May 26, 1826. "My work on heliography is in full swing. I have made some wonderful plates . . . from nature, because with the benefit of reflecting light, the image seems much more distinct." So there is no doubt, if precedence means anything, that Joseph Niépce was the inventor of photography; he also ordered made, at his lensmaker, a zinc iris diaphragm, one of the earliest, if not the first, of this universal design.

In 1826, a cousin of the Messrs. Niépce visited Paris and ordered a lens at the shop of the Chevalier brothers; and, in the course of his business, he showed them a portrait on a pewter plate done by his cousin. It was not a photograph, but a photographic print, made by placing it directly against an etching of a young girl

Photographer unknown
Untitled, no date
French daguerreotype
George Eastman House, Rochester, New York
Page 37
Photographer unknown
Untitled, c. 1846
Belgian daguerreotype
Het Sterckshof Provincial Museum, Antwerp

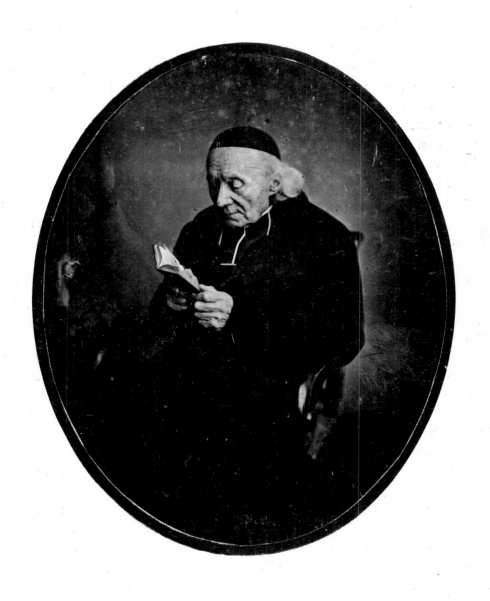

winding flax. The Chevaliers had another customer, the painter Louis-Jacques Mandé Daguerre, who made a living by painting and exhibiting what he called a diorama—landscapes painted on both sides of translucent linen and lit so as to give an illusion of actuality. Daguerre had used a camera obscura in preparing these scenes and was trying to find a way to preserve the magical, sun-created images. So it was natural that when the Chevaliers told Daguerre about this magical pewter print, Daguerre wrote to Niépce —several times, in fact—but the answers were not too informative: "For some time [Niépce wrote] I, too, have been seeking the impossible . . ."

Daguerre himself knew little or nothing of chemistry, but he immediately set up a little laboratory and began to experiment. The two men then politely exchanged products: but neither gift was a photograph; both were etchings, so neither man took the other's bait. In 1827 Niépce was in Paris and, propelled by fear or curiosity, paid several visits to Daguerre. What is natural—and extraordinary—is that Daguerre was trying, with various phosphorescent chemicals, to produce color photographs, for colored images, of course, are what one sees with the camera obscura. Niépce and his wife now proceeded to London; it was a sad visit, for his brother was ill and their joint invention of that shibboleth of all amateurs, the perpetual-motion machine, had ground to a halt. So he now tried to get the Royal Society interested in his heliographic method, and wrote a *Memoir on Heliography: Drawings & Etched Plates. An Account of Some Results Obtained Spontaneously by the Action of Light.* This brief memoir was written December 8, 1827, but was rejected by the British Royal Society; and rightly, perhaps, for it gives little precise chemical information, and is more of a prospectus than a procedure.

Niépce returned to his laboratory in Chalon-sur-Saône and began to experiment with silvered copper plates treated with iodine in order to darken the exposed silver. He sent Daguerre another of his views from his laboratory window, and in turn Daguerre offered him a partnership, promising "a large profit." Niépce, then sixty-four, short of money and depressed by his brother's death, accepted the offer. The two men set up a company in 1829 and wrote a vague contract in which Daguerre promised to improve the camera and lens while Niépce worked out the essential chemistry. Niépce began to use glass plates, but in these too, black was transparent and light was densely coated. These were respectable negatives, but useless, because there was no known way to turn the reversal back to the original.

In 1833, Niépce died, but Daguerre continued to experiment—particularly with iodine in gaseous form. But he got nothing better than had Niépce: the exposure was still eight hours, the photograph was still a negative, and there was no way to reproduce it in multiple positives. This indeed was the goal so constantly sought by Niépce, the former lithographer, who had made etchings to be sold to the middle class by the hundreds. Daguerre had no such background in the manufacture of multiple copies; his dioramas were unique, one-copy paintings; one paid not for a reproduction but for the privilege of entering and seeing them; and this habit of thought freed him to range far wider in his obsessive experiments.

Niépce was a technician of medium talent; Daguerre was an indifferent but meticulous artist, who had to learn chemistry while he ran his show. He got his information, like thousands of other early-nineteenth-century amateurs, from a huge and popular treatise by the Swedish chemist Jöns Jakob Berzelius. Then he got around to using mercury salts and had a tiny measure of success: the contrast was deepened and extended. He went on and heated pure mercury now to get its vapor. Behold! there was a marvelous positive image on the metal plate. But this image, too, slowly disappeared when viewed with enough light to see it. At last, eight years after Niépce had conveyed to him his insufficient secrets, Daguerre found a way of removing the unreduced silver chloride from the plate: he dissolved it away in ordinary salt water.

The miraculous child of a new age was born, thus, in May, 1837. Daguerre was essentially a showman, and the process of exploitation then began; nor has it yet run its course.

Daguerre wanted two hundred thousand francs for his invention; he concocted rumors that the Russian or the American governments were about to purchase it. He showed his work to the influential astronomer François Arago, who got the French government—it took a vote of both houses of the French Parliament —to buy the process. The details of the invention were announced, with considerable éclat, in August, 1839, in the presence of envoys from the principal capitals of Europe.

During the course of the next few weeks, every faddist in the western world rushed to the optical houses to have cameras made, and to the apothecaries to get iodine and mercury. The apparatus marketed by the eager Daguerre was rather bulky: 110 pounds for camera and sensitizing box. But once the patent was public, amateurs rushed in where savants feared to tread.

Still, this mass enthusiasm produced no portraits for

some time. To get proper exposure, the sitter had to remain absolutely still in full sunshine for a quarter of an hour: the result apparently was a population of grimacing idiots. Often, to reflect more light, the sitter's face was powdered like a clown's—a custom that persisted even through the era of silent movies. Daguerre himself made only daguerreotypes of white plaster casts and marble public monuments, both of which were capable of blanched and unblinking patience. The problem was solved by redesigning the lens to increase the speed; and by using only a portion of the plate (sometimes as little as one eighth), a method which permitted accurate focusing at the rather short focal length. Six months after Daguerre's public announcement, equipment could be bought that weighed only eight pounds and permitted exposures as short as one minute in the sun and two or three minutes in bright but diffused light.

The daguerreotype had its craft limitations, as well. The plate itself would oxidize into a blur of discolored purple as time went on, and the tiny droplets of mercury that amalgamated to the silver to form the image were easily erased by the pressure of a careless finger or the brush of a sleeve; so a very finely ground glass had to be put over the print to preserve it, and even then it decayed slowly at the margins. But the worst defect of daguerreotypy was the very demand it had created: there was no way to get duplicates. Every print was unique, and if one had family and friends, one had to pay again for each sitting. Yet a photo was made not to keep but to give.

The hunger of the swarming new middle class for portraits of themselves and of one another, for the fixative that would preserve forever their pride of family, prosperity, and person, was insatiable. All of urban Europe wanted their picture taken. An improved portrait lens designed by the Austrian mathematician Petzval as early as 1840 sold over eight thousand in the next ten years. England and France, Germany and Belgium, particularly, succumbed to the pleasant fever of daguerreomania. The American experimentalist and painter Samuel F. B. Morse happened to be in Paris in 1839, introducing his invention of the electric telegraph to weekly audiences. He wrote to F. O. J. Smith, his partner: "I am told every hour, that the two great wonders of Paris are Daguerre's wonderful results in fixing permanently the image of a camera obscura and Morse's Electro-Magnetic Telegraph." He exchanged visits with Daguerre; would that we had a tape of the dialogue between these two crafty entrepreneurs; Daguerre's book of instructions was first published in Paris in August of 1839 but appeared almost at once in an English trans-

lation, and it reached America on September twentieth of that year. Morse made an experimental daguerreotype of the Unitarian Church near Washington Square in New York City; the exposure was fifteen minutes. By mid-century, New York alone had as many as seventy-seven portrait studios. America was, as it still is, a country of inspired mechanics; what anyone else could do they could do better. The first known self-portrait in the world was taken by a Philadelphia lampmaker named Robert Cornelius, who set up the camera in his backyard, rushed to sit in front of it, sat immobile for five minutes, and then rushed away to develop the plate.

We are looking, in every group of daguerreotypes, at the portraits of persons dead more than a century ago. But how ruddy and vigorous they look: more so sometimes than we who are still alive. That man with the cravat and waistcoat from Belgium, photographed by an anonymous artist—what energy in his frowning, creased face, energy that flows down into his clenched hands! Life has marked him severely; yet he is still certain of himself, wrong or right; his anxiety strains only to determine how best to convey his will. And how beautiful, almost to the point of sadness, are the textures of silk, wool, skin, and hair; yes, this is something that only the amalgam of mercury with silver—on a plate so polished, like a mirror in fact, that one has to turn it in the hand in order to see anything but one's own reflection—does, at last, so perfectly render. Even the most naive daguerreotypes—although in twenty years of collecting, I have seen only five or six poor or negligible ones—have these particular virtues.

In the practice of fine cameramen like Carl F. Stelzner and Hermann Biow (both from Hamburg) the daguerreotype became more than a magical astonishment. Stelzner was a painter who had long supported himself by making miniature portraits in ivory; when he turned to daguerreotypy, he colored the image to resemble his earlier hand-painted work. While Biow's business was to make more formal portraits of plump, serious, forgotten celebrities like the King of Prussia, Stelzner's business was with ordinary middle-class folk; he often photographed whole families, or the country excursions of the local Art Club, where every sitter is a masterpiece of self-created character. But both men were intensely interested in the individual. In this respect, the attitude of all the early daguerreotypists resembles the novelists of the mid-century: their work, reflecting in turn the interests of a greatly increased, prosperous, and leisurely audience, was obsessed, like the Flemish merchants of two centuries before, with the concrete details of life.

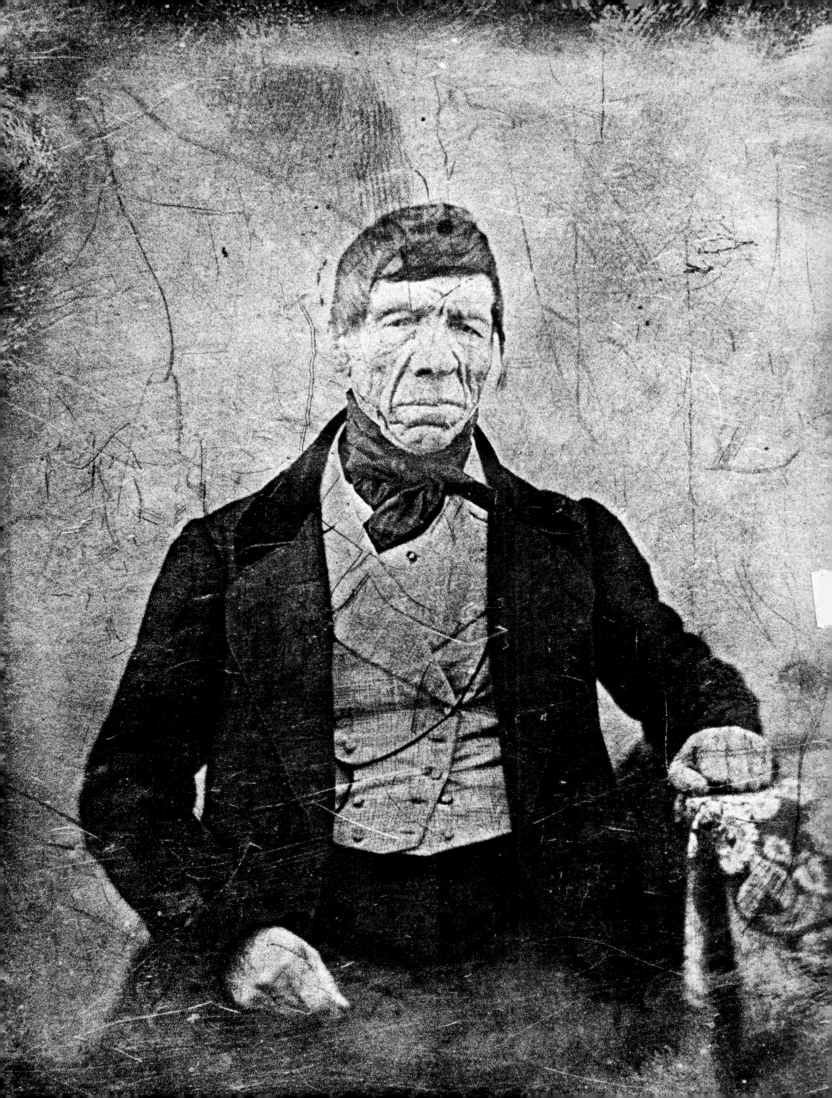

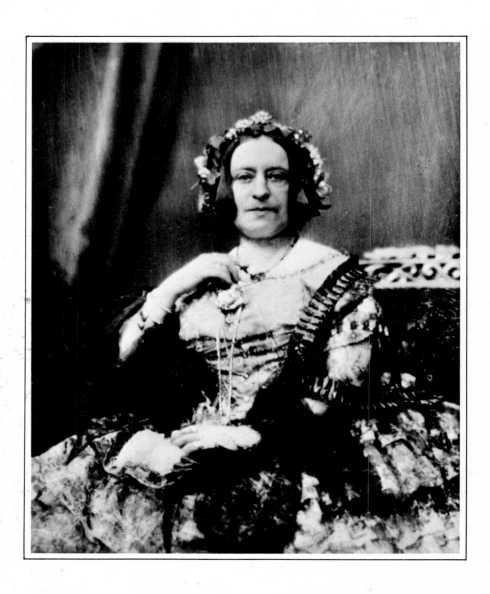

William Telfer
Woman in mauve bonnet, daguerreotype, c. 1848
Gernsheim Collection, Humanities Research Center,
The University of Texas, Austin

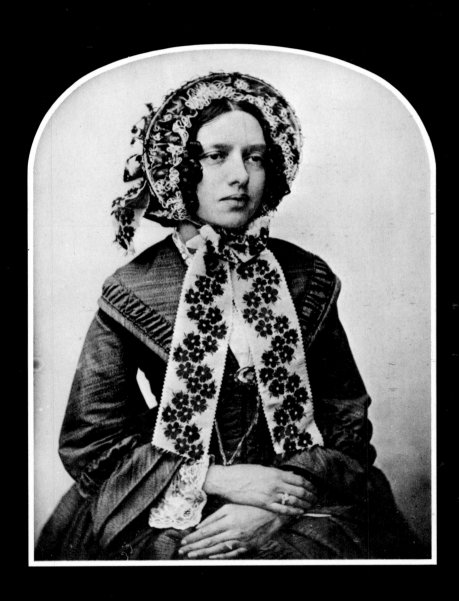

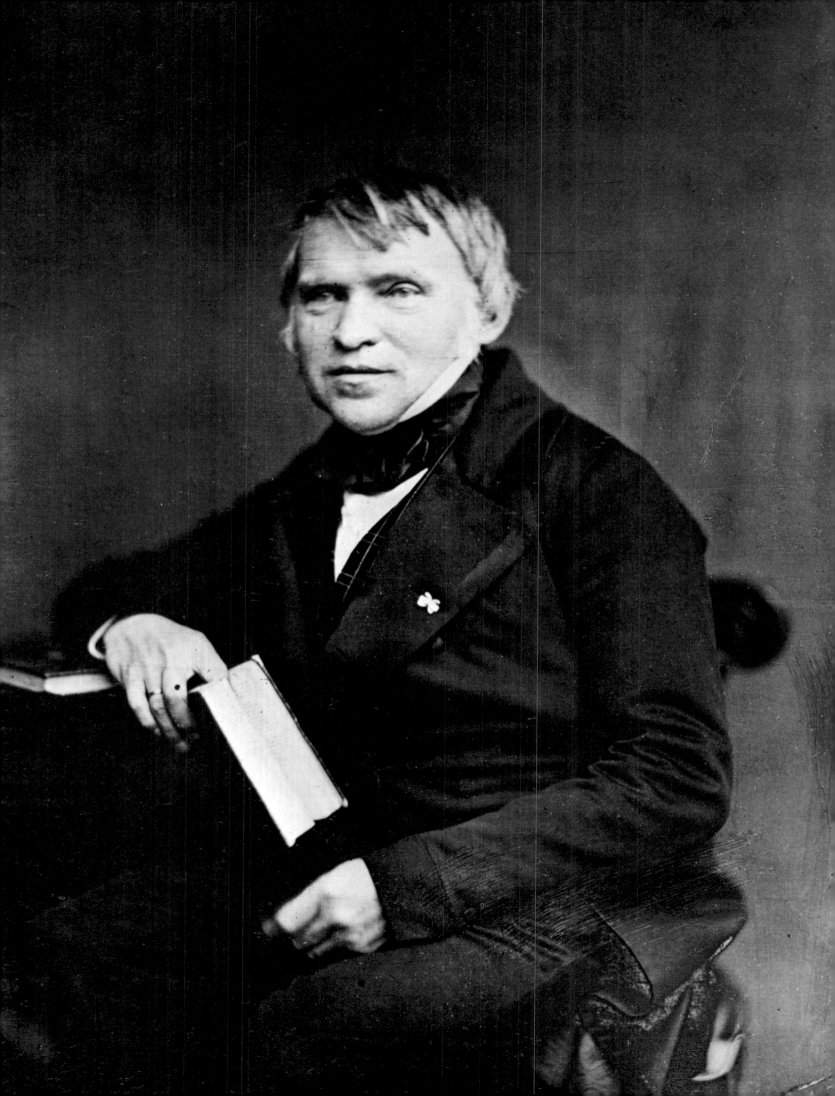

Hermann Biow
Christian Gottfried Ehrenberg, chemist, Berlin, 1847

Hermann Biow
King Frederich Wilhelm IV of Prussia, 1847
Both, Staatliche Landesbildstelle, Hamburg

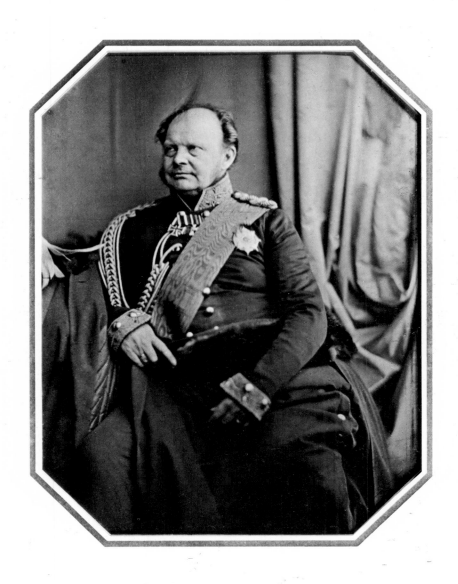

Carl Ferdinand Stelzner
Daguerreotype of his wife, c. 1848
Staatliche Landesbildstelle, Hamburg

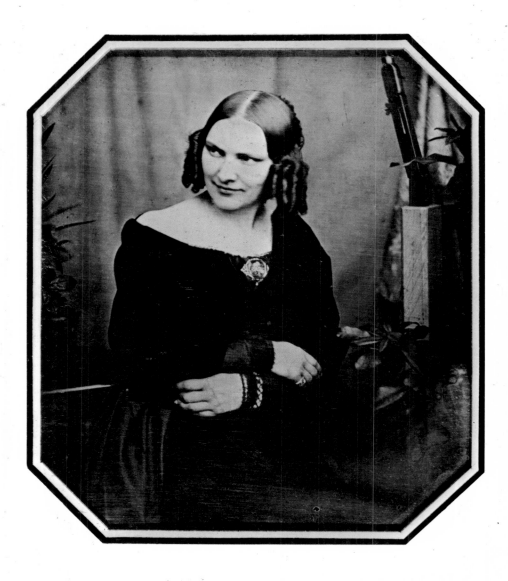

Carl Ferdinand Stelzner
Daguerreotype of unidentified family group, no date
Staatliche Landesbildstelle, Hamburg

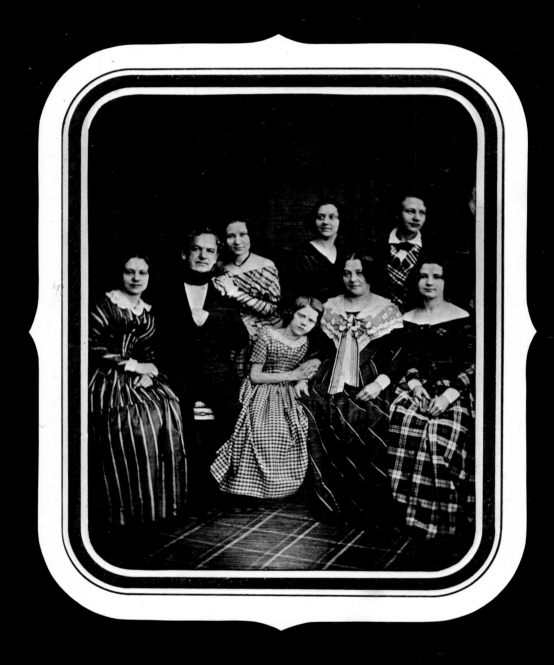

Richard Beard
Daguerreotype of a lady, 1842
Gernsheim Collection, Humanities Research Center,
The University of Texas, Austin

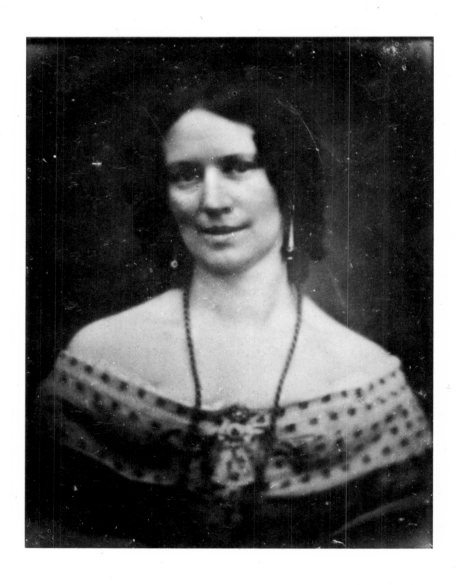

Antoine Claudet, a Frenchman living in London, had been a dealer in expensive cut glass; he sailed back to France, learned the mechanics of photography from Daguerre himself, and by 1840 had improved the chemistry so that, in full sunlight, he could take portraits in as little as twenty seconds. Telfer, Cortelyou, Nivet: one could list a hundred talents from everywhere in the western world; and their names are known only because of the curious accidents of preservation.

So there were anonymous photographers and anonymous sitters; this nomenclature should have no mystical shadow about it. Nobody is anonymous by intention. The truth is that most of the daguerreotypists were a combination of craftsmen and tradesmen: they opened a shop and made money out of their new skill. This was as true of the Englishman Richard Beard, who had a chain of portrait studios in London, as it was of the great Bostonians Albert Southworth and Josiah Hawes. Common exposures were three minutes, and the photograph was ready for sale within hours. The price in America (reports that immensely learned and sympathetic photographic historian Beaumont Newhall) was two dollars, complete with case, and the cases themselves were paper colored to imitate leather, or composite materials to the same end; but they were hot-pressed into low relief, fanciful with the scallops, cherubs, flowers, and curly vines that were supposed to signify Art. So the same taste that made the silver truth of the photograph supplied the unctuous sentiment that has always been the other facet of the popular mind.

Yet the early daguerreotype craftsmen fully appreciated the velvet infinities of detail, the interweaving of form and character, that one can see in these portraits. Certainly there is, in any age, an elite of artists; but it tends to be self-defined and self-enclosed. Genius continues rare; but the riches of talent are everywhere, and in some degree in every person, even you and me. The cultural history of the arts can be viewed as a succession of double waves: first, toward a set of conventions, eventually exhausted and petrifying; then, a wave of vulgarization, of refreshment, from the coarse, real, dirty, unexpectedly beautiful and multifarious world. Photography was, is, such a second wave.

It is an art continually renewed by its roots in the rich compost of reality; and even the most manipulated prints cannot wholly sterilize this living essence. The daguerreotype, by its almost infinity of texture, glories in the pungency of the actual.

For example, if we look very steadily at a portrait like the one of Stelzner's wife, we see beyond the black, gray, white plane of the mirror surface and into a reincarnated world: the new, mid-nineteenth-century middle class of northern Germany. For this seductive woman is the obverse, as were the Flemish portraits of the seventeenth century, of the abstract figure of greed: the real, if inconstant, pleasures of the skin, the tongue, the stomach, the nose, the sex, and the eye. We respond, as viewers, to her shoulder half revealed, to her oiled curls and sidelong look, to her half-smile of secret promises.

So what is small, human, and trivial is, by this very quality, universal. And this paradox is the very heart of the photographic portrait.

Photographer unknown
Untitled, no date, American daguerreotype
Rapho/Photo Researchers

Photographer unknown
Untitled, c. 1847, American daguerreotype
Gernsheim Collection, Humanities Research Center,
The University of Texas, Austin

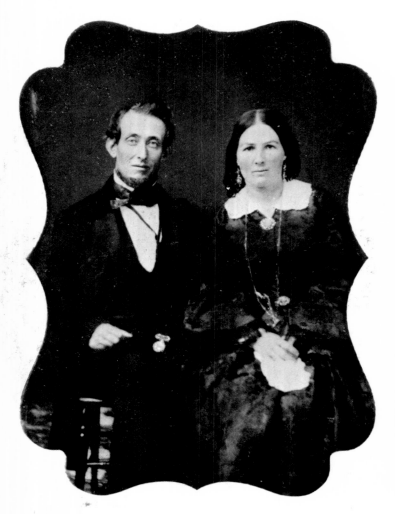

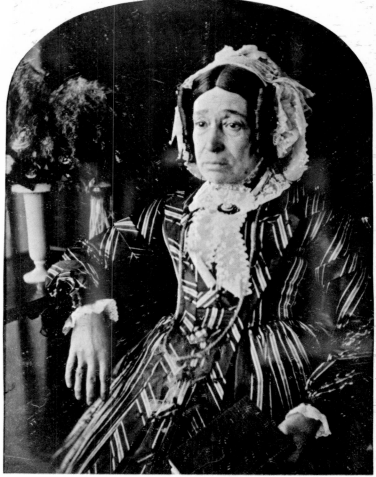

Photographer unknown
Untitled, c. 1850, American daguerreotype
George Eastman House, Rochester, New York

Photographer unknown
Untitled, no date, American daguerreotype
George Eastman House, Rochester, New York

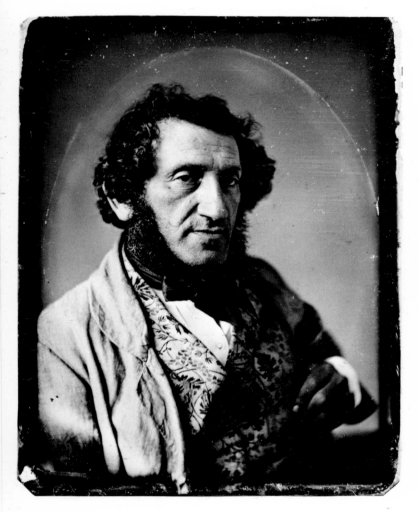

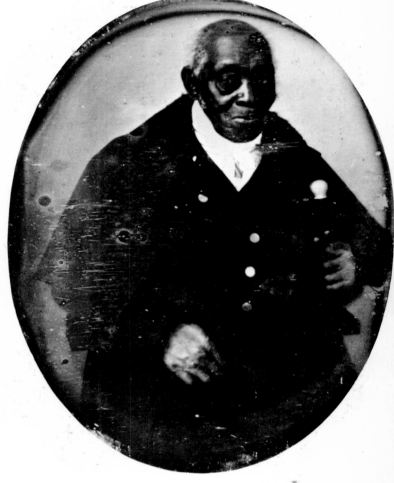

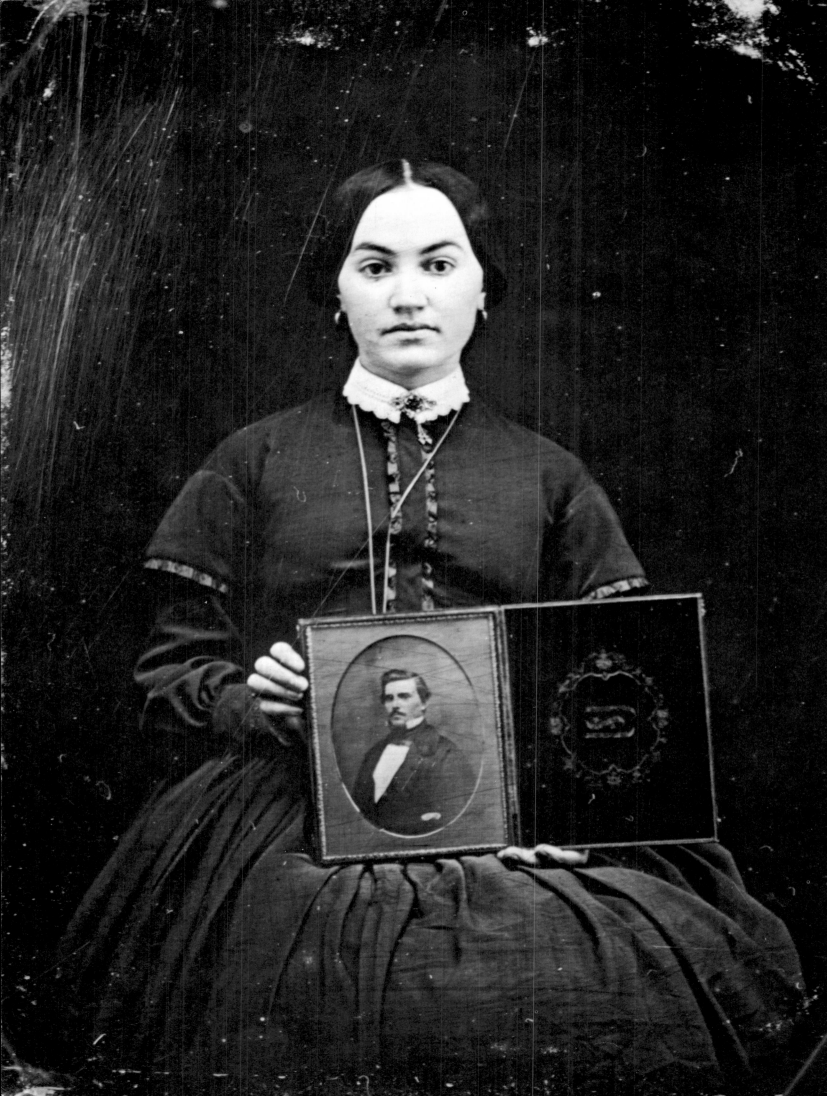

Photographer unknown
The family daguerreotype, c. 1850
George Eastman House, Rochester, New York

Photographer unknown
Untitled, c. 1850, American daguerreotype
Northampton Historical Society, Massachusetts
Page 50
Photographer unknown
Untitled, c. 1850, American daguerreotype
George Eastman House, Rochester, New York

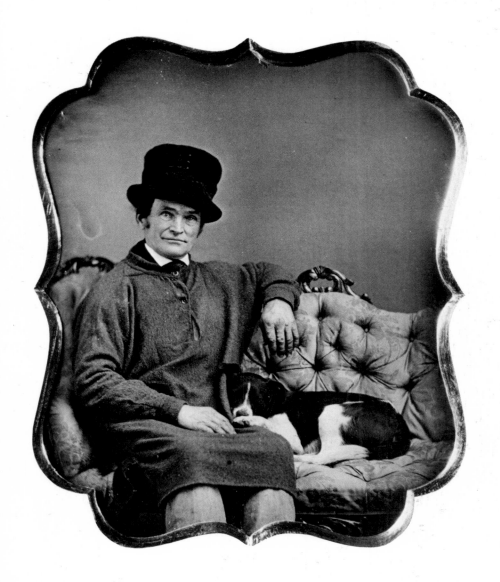

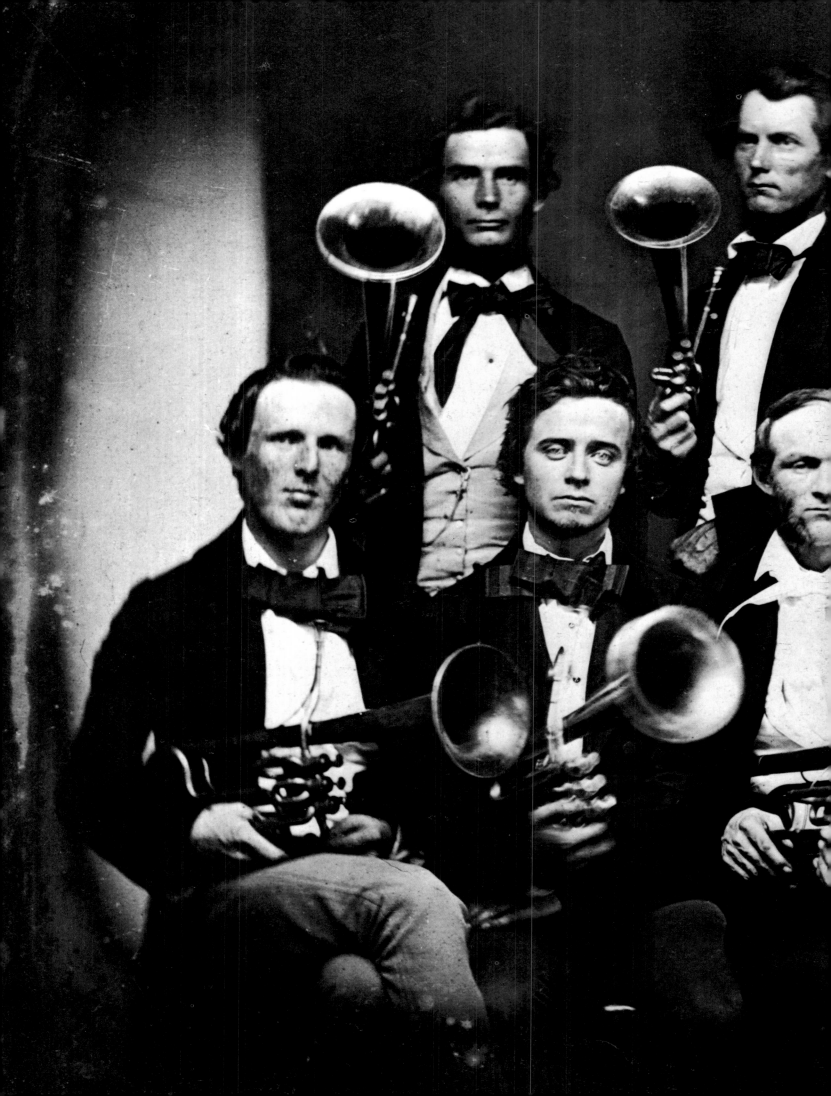

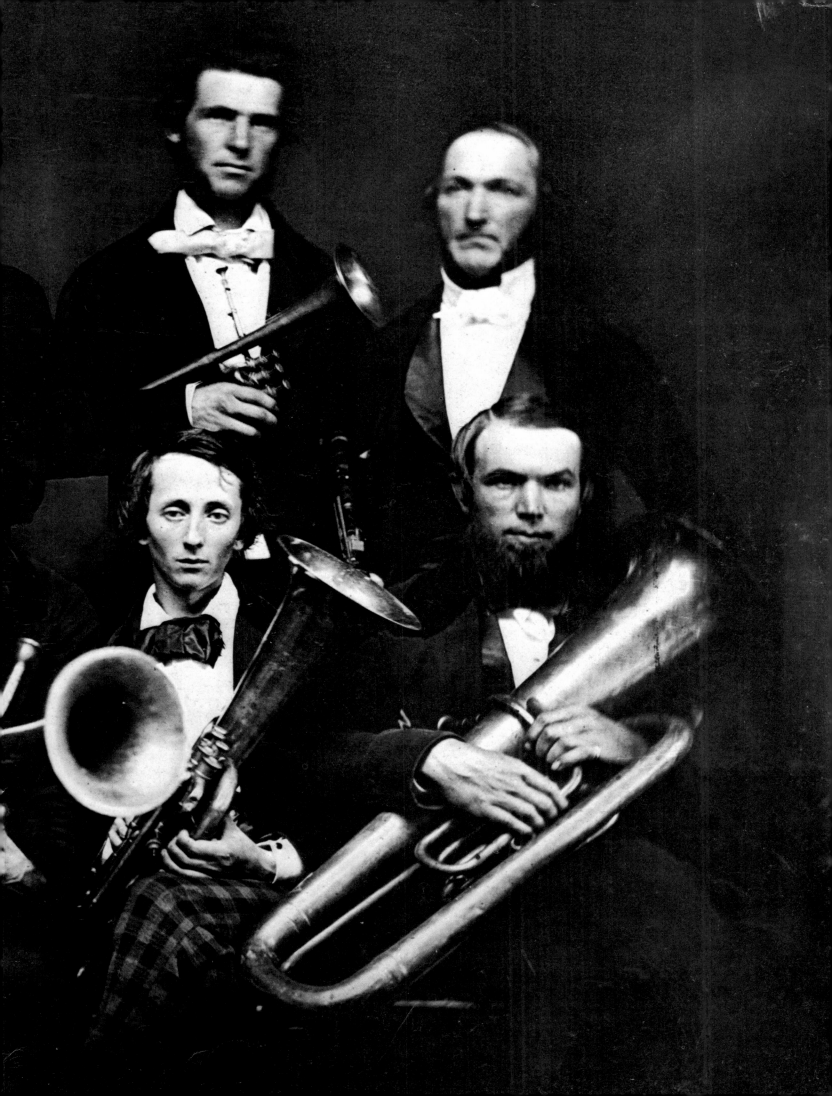

The Sun as Artist: Calotype and Daguerreotype

In the method invented by Niépce and improved by Daguerre, no copies could be made of a photograph; each, like a painting, was unique. This was an insufferable state of affairs, which clever men at once studied to remedy. In 1833, W. H. Fox Talbot, an English amateur mathematician and scientist, visited Italy. Enchanted by Lake Como, he tried, like many an educated man of his time, to sketch these romantic landscapes with a conventional aid: the camera lucida. He wrote: *I came to the conclusion that the instrument required a previous knowledge of drawing which unfortunately I did not possess. I then thought of trying again a method which I had tried many years before. The method was to take a camera obscura and to throw the image of the objects on a piece of paper in its focus—fairy pictures, creations of a moment, and destined as rapidly to fade away. It was during these thoughts that the idea occurred to me, how charming it would be if it were possible to cause these natural images to imprint themselves durably, and remain fixed upon the paper!*

Talbot remembered that silver chloride was light sensitive, so he dipped the paper in this solution, dried it, and tried two sorts of experiments. At first he simply placed leaves, butterfly wings, and similar flat objects against the treated paper and then exposed the arrangement to the sun. He got elegant negative patterns: a discovery rediscovered by every generation of darkroom enthusiasts. But he also tried placing small cameras of various designs at different positions inside and outside his house; his wife complained that they reminded her of "little mousetraps." These cameras had a small viewing hole which could be opened at intervals to see how the image was developing.

Talbot's first negative was the bright, divided window of his study, angled outward to the sky, to the dark trees and chimney pots outside his home. Again, he got negative images on paper, and he fixed them with a solution of common salt, followed by silver nitrate. But the exposures were thirty minutes or longer, quite impossible for portraiture; also, they faded rather quickly.

Fox Talbot solved both problems by sensitizing the paper negative with a combination of gallic acid and silver nitrate; it could then be taken from the camera in less than five minutes; the "latent image" (the term is Talbot's) is developed out with the same solution. Next, the excess silver salts were dissolved with sodium hyposulfite—"hypo"—a chemical step suggested by Talbot's friend the astronomer and chemist Sir John Herschel. The negative image could then be transformed into a positive by simply placing another

sensitized sheet of paper in contact with the negative, exposing it to the sun, and developing and fixing it in turn. This process reduced the exposure from close to an hour down to several minutes: so portraits were now possible. Once more, one is astonished at the persistence and ingenuity of the scientific amateur of that age.

So far, the process was known only to Talbot's circle of friends. But when he heard, in 1839, of Daguerre's rival discovery, he rushed to get his own process announced and firmly patented. Competition, the life-blood of trade, thus revealed to the world what might otherwise have remained a plaything.

The success of Fox Talbot's method was by no means immediate: for one thing, it was true that his *calotypes*—a word he coined, meaning "beautiful pictures"—were coarser in detail, less finely scaled between black and white than daguerreotypes. That alone should make them less beautiful, the photographic purists might say. But no rules, particularly the universal ones, should ever be strictly enforced. The early calotype of Talbot's breakfast table is mysteriously tender and lovely; the famous "Broom" is the precursor of a hundred thousand doors, doorways, and barns, and as good as any of them. His book of photographs, *The Pencil of Nature,* was published in 1844; the very name indicates his understanding of that mysterious connection between reality and the photographic image which continues to astonish and puzzle us: *The little work now presented to the Public is the first attempt to publish a series of plates or pictures wholly executed by the new art of Photogenic Drawing, without any aid whatever from the artist's pencil. The term "Photography" is now so well known, that an explanation of it is perhaps superfluous; yet, as some persons may still be unacquainted with the art, even by name, its discovery being still of very recent date, a few words may be looked for of general explanation.*

It may suffice, then, to say, that the plates of this work have been obtained by the mere action of Light upon sensitive paper. They have been formed or depicted by optical and chemical means alone, and without the aid of any one acquainted with the art of drawing. It is needless, therefore, to say that they differ in all respects, and as widely as possible, in their origin, from plates of the ordinary kind, which owe their existence to the united skill of the Artist and the Engraver.

They are impressed by Nature's hand; and what they want as yet of delicacy and finish of execution arises chiefly from our want of sufficient knowledge of her laws. When we have learnt more, by experience, re-specting the formation of such pictures, they will doubtless be brought much nearer to perfection; and though we may not be able to conjecture with any certainty what rank they may hereafter attain to as pictorial productions, they will surely find their own sphere of utility, both for completeness of detail and correctness of perspective.

Talbot had patented his process three years before, and demanded royalties for its practice. Only in 1852 did he relent and conform to the pressure of his own group and allow amateurs, scientists, and artists to follow his process free of charge; professional portraitists were still obliged to pay. Had he been a member of England's upper classes, whether titled or not, any contact with business would have been abhorrent. But although he lived on an inherited income, the social situation now was such that money honestly earned was no longer tainted. He set up his own business, in Reading, as early as 1845. He took numbers of portraits, and exhibited great sensitivity to posture and body language, as in his well-known studies of chess players. He combined—as we can read in his very early (1842) portraits of himself, his camera, and his subject—both business and pleasure.

How astonishing, yet how logical, that photography, in spite of its great and successful use by professionals who declare themselves sole proprietors of taste and intelligence, was born, and developed, and has substantially remained, in the clever, cheerful, persistent, blundering hands of the eternal amateur. This is a huge fact which is rooted in its very technique. Nor can it be erased by all the critics who would prefer dealing with a well-ordered succession of geniuses. Still, it is useful to remember that amateur photographers, in every period, have to have money as well as talent. Fox Talbot had a fair amount of both. The life at Lacock Abbey was spacious and leisurely; the servants outnumbered the family two to one, and he made portraits of his coachman as well as his family and friends. The poet Thomas Moore, in self-exile from Ireland (a habit he shared with so many other Irish writers) lived within walking distance of Talbot. He wrote in his diary for August 18, 1841: . . . *I started for Lacock Abbey this morning on my way to town. The day beautiful, and I found grouped upon the grass before the house Kit Talbot, Lady E. Fielding, Lady Charlotte and Mrs. Talbot for the purpose of being photogenized by Henry Talbot who was busy preparing his apparatus. Walked alone for a while, about the gardens, and then rejoined the party to see the result of the operation. But the portraits had not turned out satisfactorily, nor (oddly enough) were they at all like, whereas a dead likeness is, in*

Henry Fox Talbot
A portrait being taken at Lacock Abbey, c. 1842
Calotype
Science Museum, London, Fox Talbot Collection

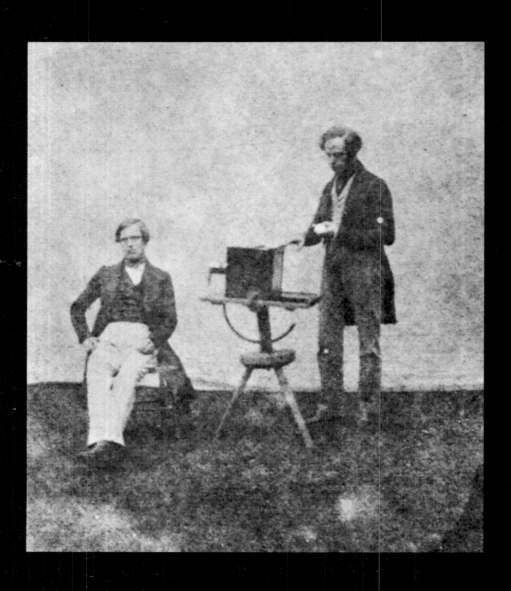

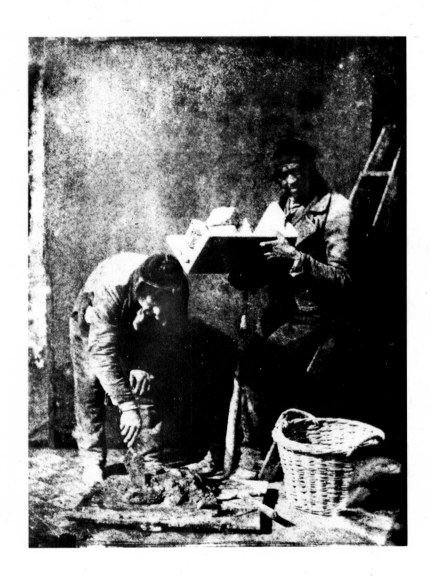

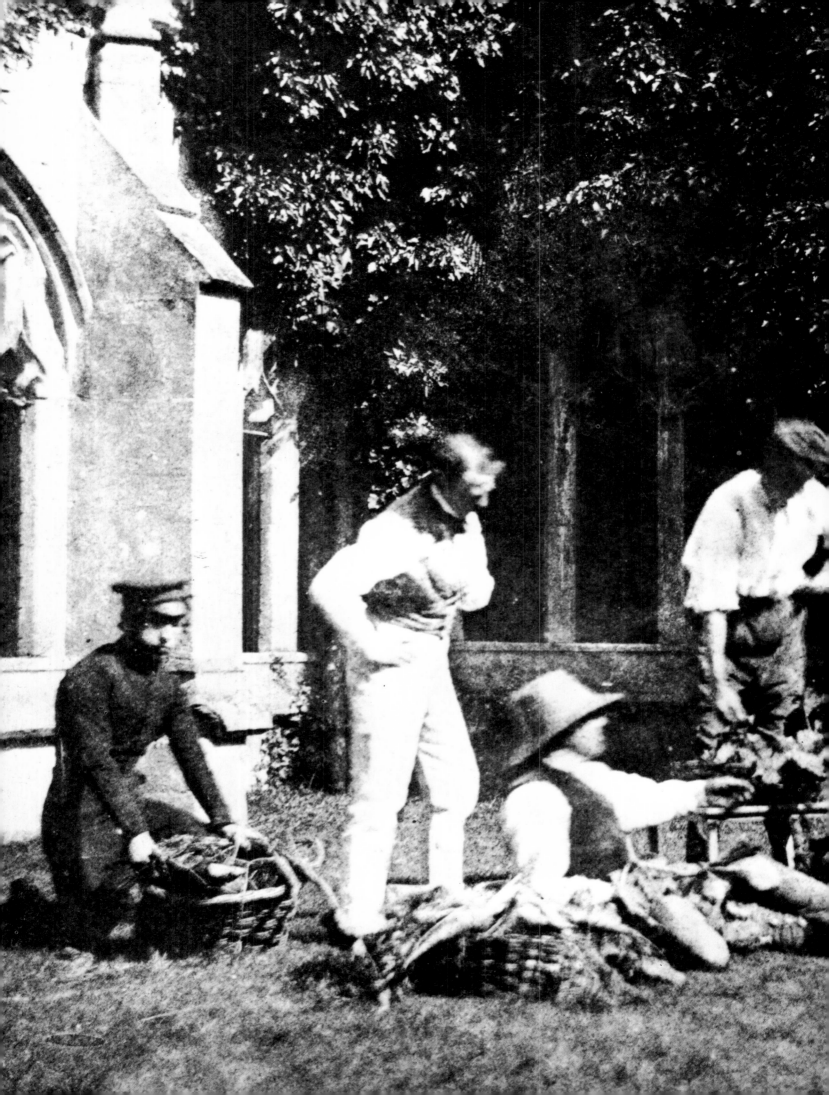

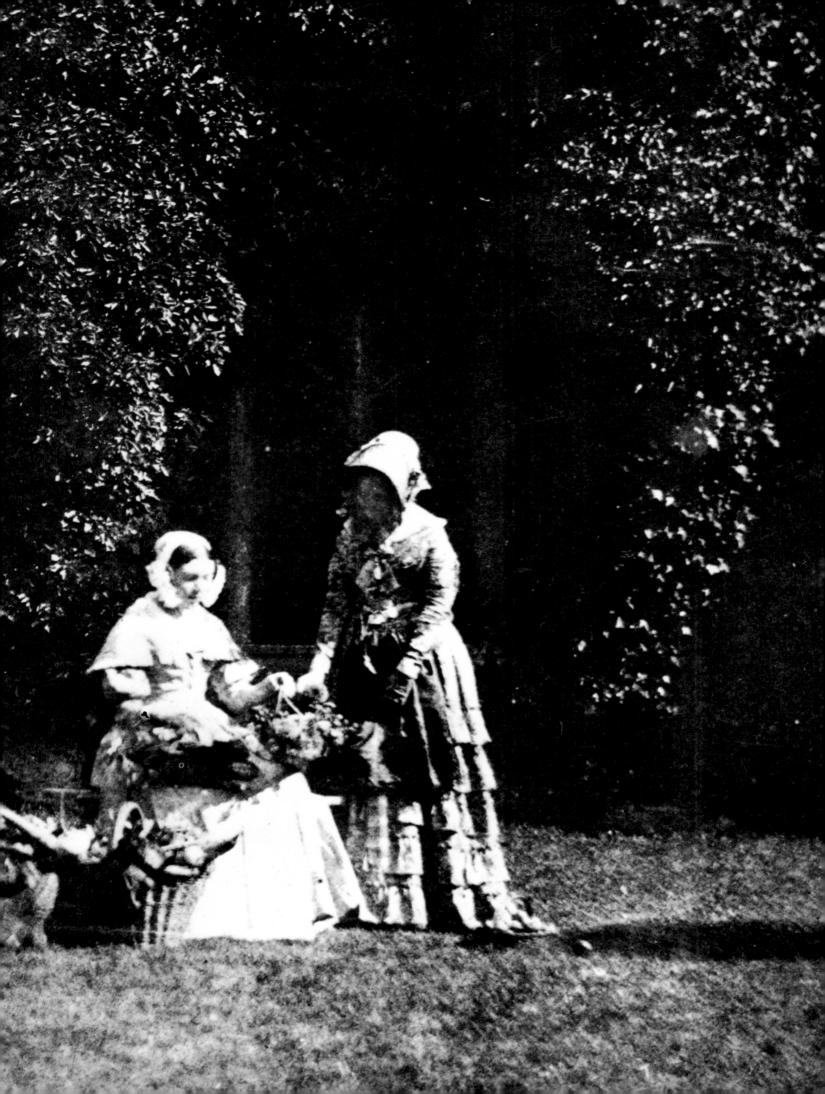

general, the sure, though frightful result of Daguerre's process.

It is possible that Moore never saw the final positive, which, in practice, was often boldly retouched with pencil or pen. This could not be done to the daguerreotype, but the calotype was, after all, simply paper; and the very texture of the paper contributed to the soft effect. An English reviewer, seeing calotypes in 1842, wrote: "The portraits, those at least we have seen, are very satisfactory. There is a rough air of truth about them, which reminds one of the first, and sometimes the best, sketches of the artist . . . full of broad effects and vigor."

The truth was, however, that Talbot, though an intelligent craftsman in the long English tradition of the gentleman scientist, was hardly an ideal portraitist. He lacked the uncanny faculty of getting inside the sitter's skin, of knowing him better than he knows himself, of combining the portraitist's character with that of the subject, of blending this spiritual mix so that the two, taker and taken, can scarcely be analyzed apart. Fox Talbot was, I think, too happy a man to seek the addictions and entanglements of the born artist. The really great calotypes (or talbotypes) were made by two intense and serious Scotsmen.

A close friend and correspondent of Fox Talbot's was Sir David Brewster, principal at the University of St. Andrews in Edinburgh. He showed Talbot's photographs, including two portraits, to members of his faculty. He then wrote to inquire how to produce them, and following Talbot's instructions, one of the college teachers, the chemist Dr. John Adamson, was able to make passable prints. In 1842, Talbot inquired of Brewster whether there was anybody in Scotland who could be persuaded to make calotypes his profession. Sir David suggested Dr. Adamson's young brother Robert. In less than a year, Robert Adamson had a flourishing portrait business.

Now another coincidence: the first general assembly of a dissident religious group called the Free Protesting Church of Scotland met in the spring of 1843. David O. Hill, a painter, decided he would like to do a group portrait of this assembly. The project seemed a bit overwhelming, for there were upward of five hundred ministers visiting Edinburgh. By July they were ready to go home to their parishes, and still only a small number of the necessary sketches were done. There was a possible solution, though; Brewster wrote Talbot: *I got hold of the artist—showed him your calotype and the eminent advantage he might desire from it in getting likenesses of all the principal characters before they dispersed to their respective homes. He was at first incredulous, but went*

to Mr. Adamson, and arranged with him the preliminaries for getting all the necessary Portraits. They have succeeded beyond their most sanguine expectations . . . They have taken, on a small scale, groups of twenty-five persons in the same picture all placed in attitudes which the painter desired, and very large pictures besides have been taken of each individual to assist the painter in the completion of his picture. Mr. D. O. Hill the painter is in the act of entering into partnership with Mr. Adamson and proposes to apply the calotype to many other general purposes of a very popular kind. David Octavius Hill was the son of a bookseller and had been trained at Edinburgh as a painter and lithographer, with a particular interest in landscapes and historic contemporary events; the assembly was a natural assignment.

In the first group of well over five hundred photographs taken for this purpose, there are certainly fifty of the most beautiful photographic portraits ever made. The ministers were photographed individually and in groups; and the latter must have given a fair amount of trouble, for although they were photographed outdoors, each man's head was immobilized by a steel support made of rods and thumb screws. One group has a very young preacher reading a manifesto about a yard long, while seven other young firebrands listen with frowning intensity. One would think that their apparent emotion was born of religious ardor. Not so: the Adamson-Hill portraits of engineers, sculptors, and judges complete with monocle had the same knitted brows and searing gaze. These men—there are no weak-minded among them —bear the awful weight of their conscience at a point just back of the center of their forehead. So, in fact, does the beautiful portrait of Hill.

There is no doubt that this inner recalcitrance, as of a man walking steadily forward in a stony world, strongly affects the face and posture of his sitters. But even this conclusion is not simple: because Hill was certainly expressing the self-conception of the Scottish middle-class man: firm, intense, honest, the victim of tyranny but eventually the victor. There are no smiles in these marvelous portraits; the eyes are rarely forward; they are fixed on the tragic burdens which they assumed were inseparable from life. That potent triad, the two hands and the face, are always present, sometimes close, but mostly separate: three vortices of personal force.

Hill, who posed these sitters, had quite a different attitude toward women. Here he reflects the early Victorian ideal—or more precisely the ideal as projected by the educated upper middle class of Scots society. The women are serious, true; again none of

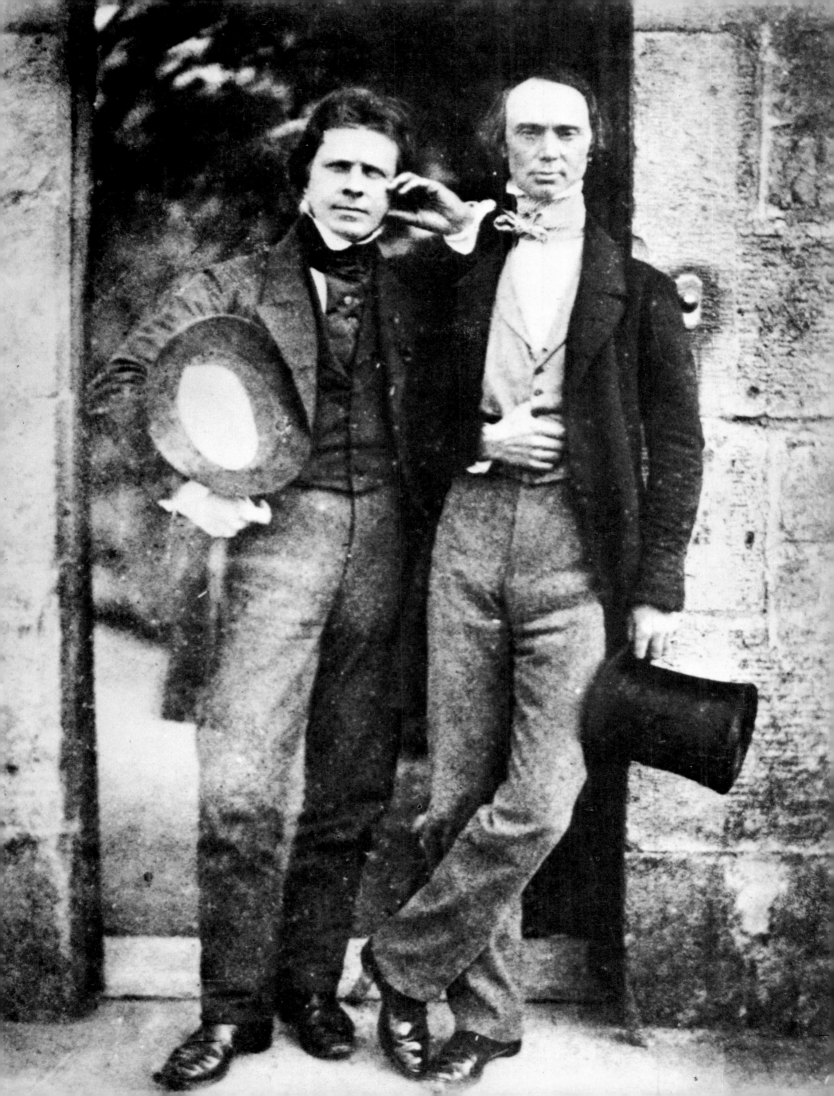

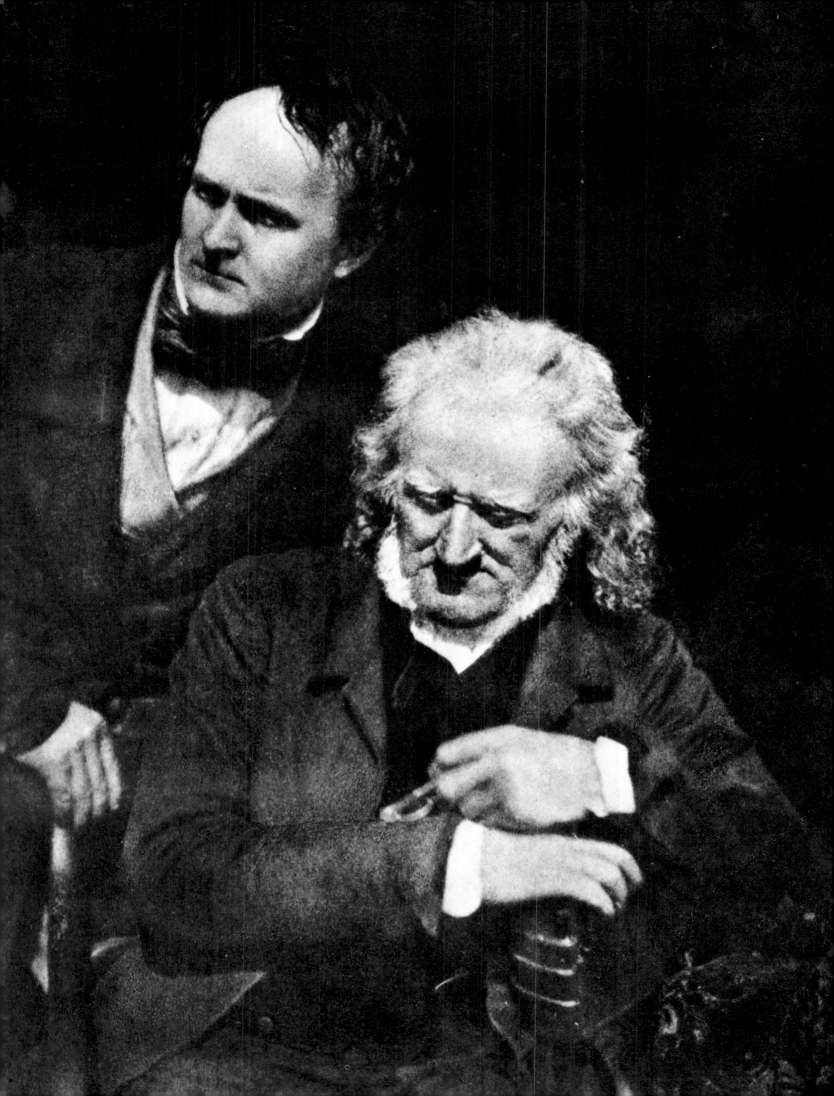

David Octavius Hill and Robert Adamson
Alexander Handyside Ritchie and John Henning,
from negative made 1846–48
Calotype
The Metropolitan Museum of Art, New York,
The Alfred Stieglitz Collection

David Octavius Hill and Robert Adamson
Unidentified man leaning on chair, no date
Calotype
George Eastman House, Rochester, New York

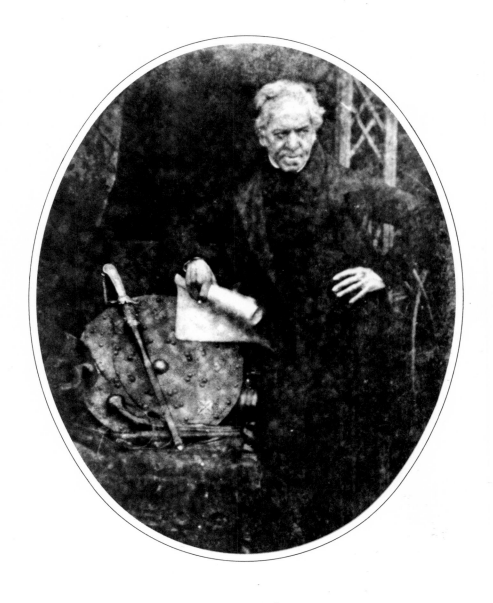

them smile; and they never directly confront us eye to eye. Whereas the male sitter stares at some invisible event, generally to the right of the frame—and sometimes so strongly (I am thinking here of the famous double portrait of Thomas Duncan and his brother) that one is forced to imagine what it is they are so keenly watching and judging. The women look away, too, but down as well; their aspect is serene, melancholy, patient. The hands are open, and displayed as open; the body is relaxed, the weight of the torso shifted lightly to one side.

We come, then, to what is probably a less than startling conclusion—since truth is indifferent to whether it is banal or not—that David Octavius Hill's attitude toward his sitters is a twisted, inextricable combination of his own character and the station and sexual role of the sitter. The pious and irredentist society of Edinburgh of the 1840's and his own particular psyche: these two, twined together, determine the posture and gesture of his portraits. I emphasize the aesthetic of Hill, for the technical work was done entirely by Adamson. Contrary to every photographic cliché, these two functions were actually separate; this can be true, perhaps uniquely, in photography. Hill was a skilled but indifferently talented painter; yet he became a profound observer and extraordinary photographer. He did portraits to the number of fifteen hundred or more, mostly of the dim celebrities of Edinburgh. But also he and Adamson, following the tradition of genre subjects in early-nineteenth-century painting, traveled down to the fishing villages on the coast and took photographs of women and children of the poorer classes. The children have their eyes shut to keep them from fidgeting about; but the women are at ease and quiet.

The stereotype of the bawling fishmonger doesn't appear in these photographs. These are no burly, cursing, hard-handed, fleshy wives. They have the sad, quiet dignity, the smooth, centrally parted hair of any gentle lady. And they, too, look down and away, as if in the recollection of a dream or a memory. But also they wear the strongly striped skirts and striped kerchiefs fashionable at the time; and these stripes are in beautiful counterpoint to the wicker stripes of their sunlit baskets; so here, maybe, the abstract side of Hill the painter has become more obvious and more striking.

Our current taste has veered once more toward the pattern and away from the character. Maybe, in our particular decades, humanity has become slightly unbearable. It is possible that Hill and Adamson's time was, in one sense, more serene. Europe had finally done with the mad Napoleonic Wars; the new "Ten

David Octavius Hill and Robert Adamson
The gown and the casket, no date,
Calotype
Gernsheim Collection, Humanities Research Center,
The University of Texas, Austin

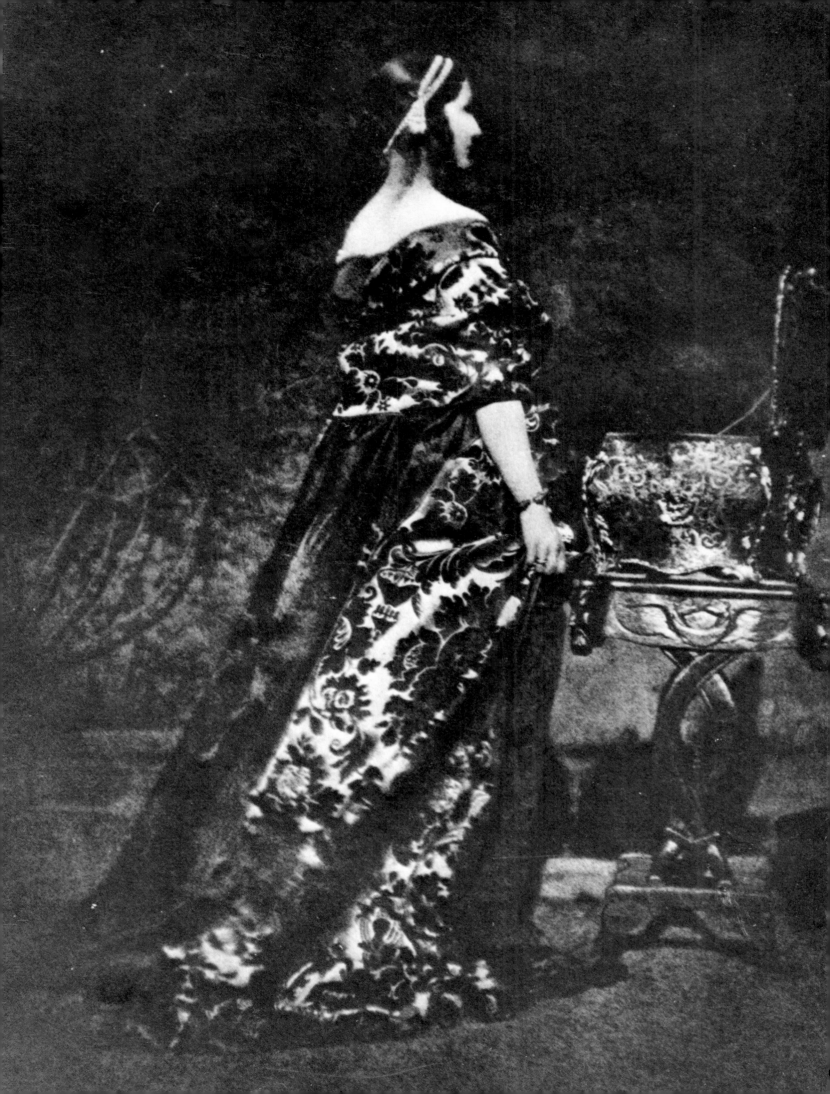

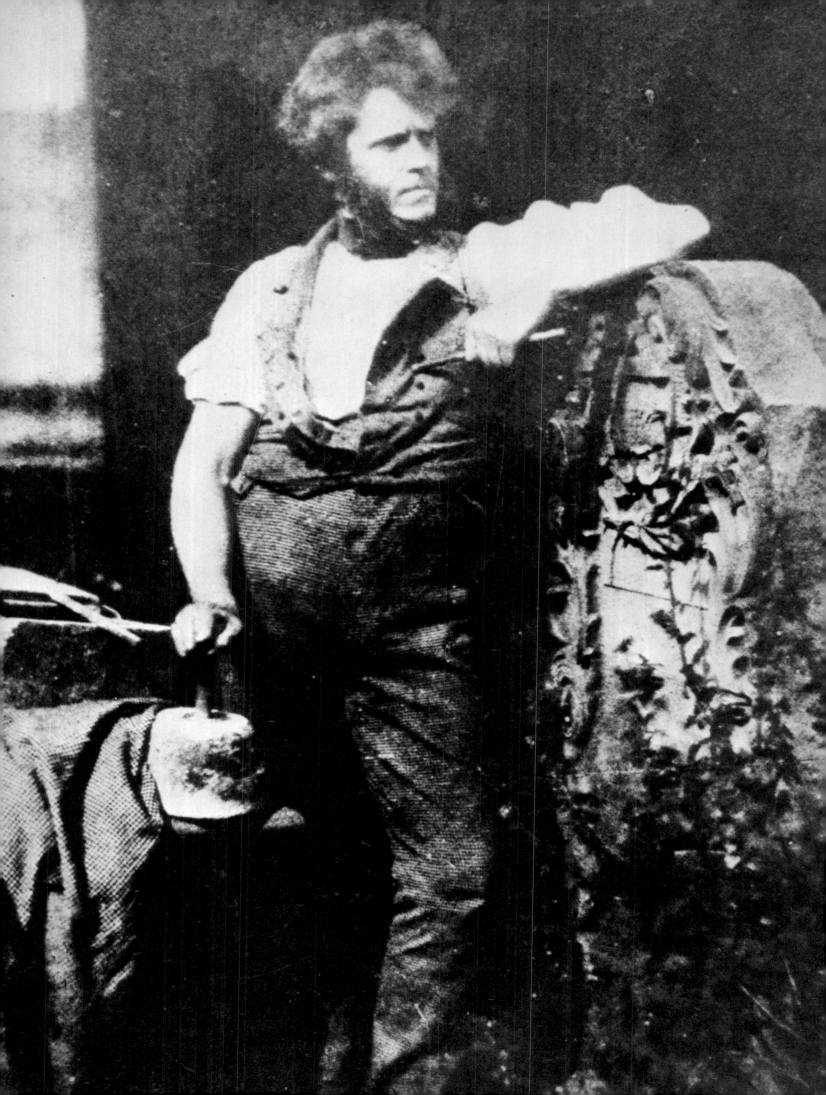

David Octavius Hill and Robert Adamson
Hugh Miller, no date, calotype
Gernsheim Collection, Humanities Research Center,
The University of Texas, Austin

David Octavius Hill and Robert Adamson
Newhaven fishwives, c. 1845, calotype
The Metropolitan Museum of Art, New York,
Harris Brisbane Dick Fund

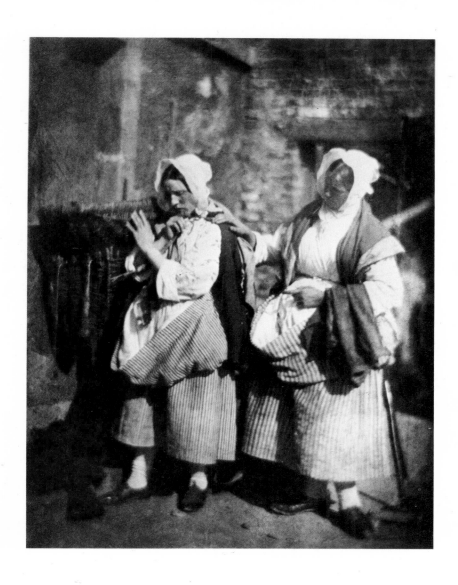

David Octavius Hill and Robert Adamson
Messrs. Balfour, Douglas, and Captain Martin,
1843–48
Modern print by F. C. Inglis from negative by Adamson
Page 68
David Octavius Hill and Robert Adamson
The Chalmers family
From negative made 1843–46, calotype
Both, The Metropolitan Museum of Art, New York

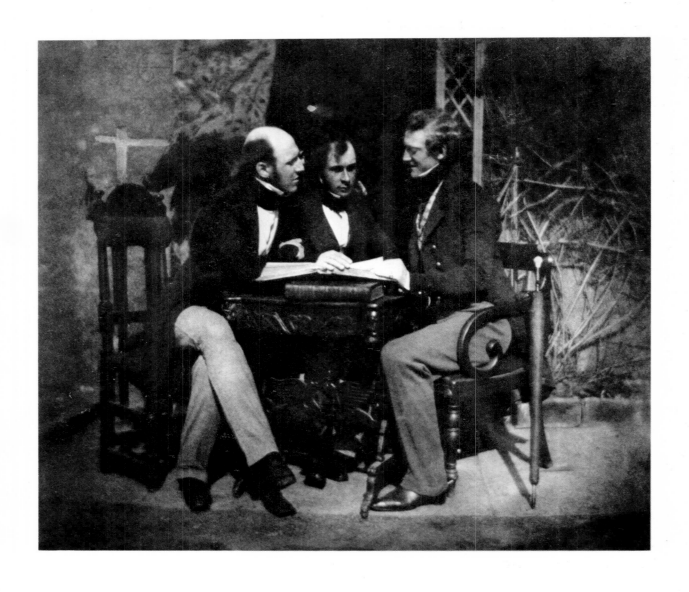

Pound" electoral law of the late 1830's (one had only to prove that his place of residence was, or could be, rented for at least ten pounds yearly) had enfranchised the middle class, roughly doubling the electorate. Industry and commerce and empire were all doing extremely well—for their owners. Yet there was an unease, a melancholy, under the surface. Illness was poorly treated, and death was close, frequent, and early. Is that what these men confront, and the women merely endure? Maybe not: but there is some deep universal communication here—between ourselves and these Scotsmen, plus something special and local: a blend of fire and common sense, of oatmeal laced with whiskey.

In 1848, aged twenty-seven, Robert Adamson died of tuberculosis; and Hill gave up photography at once to return to his second-rate painting. The monstrous composite portrait of the assembly of ministers, on a canvas 11 feet by 5 feet, was never quite finished. Only the magnificent legacy of Hill and Adamson paper negatives remained—again by chance—till rediscovered and printed fifty years later.

Famous in their own provincial decade, the Hill-Adamson portraits were too fine, too close to the edgy subtleties of human life to resist the changing currents of public taste. Hill himself wrote in 1848: "The rough surface and unequal texture throughout of the paper is the main cause of the calotype failing in details before the daguerreotype . . . and this is the very life of it. They look like the imperfect work of a man . . . and not the perfect work of God . . ." Indeed they were grainy, contrasty, somber, while the daguerreotype was bright, sharp, biting in its reality. A hunger for stronger stuff is the one driving constant of popularity; but there were no copies to give to one's extended family and friends. What was wanted now, by the middle of the 1850's, was the magical shock of the daguerreotype, along with a process for cheap and easy reproduction. A new, a third process, was sought and found; and intentionally or not, it would be beautiful in its own right.

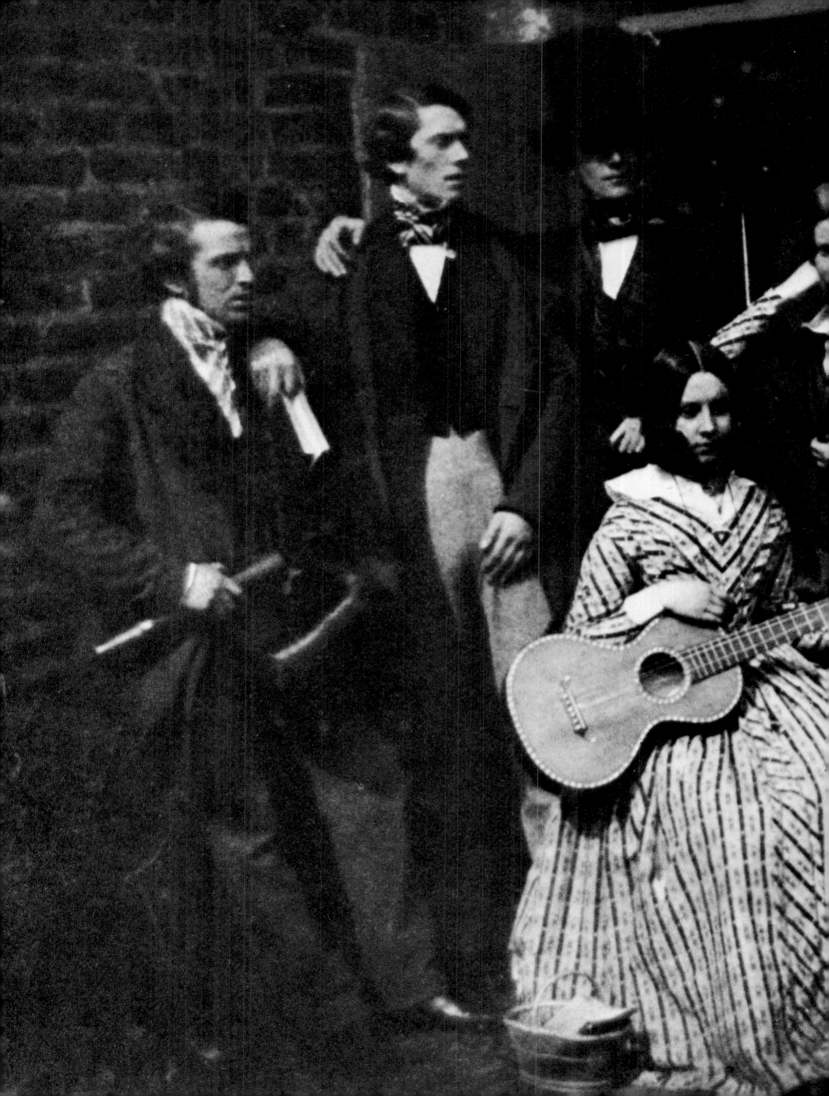

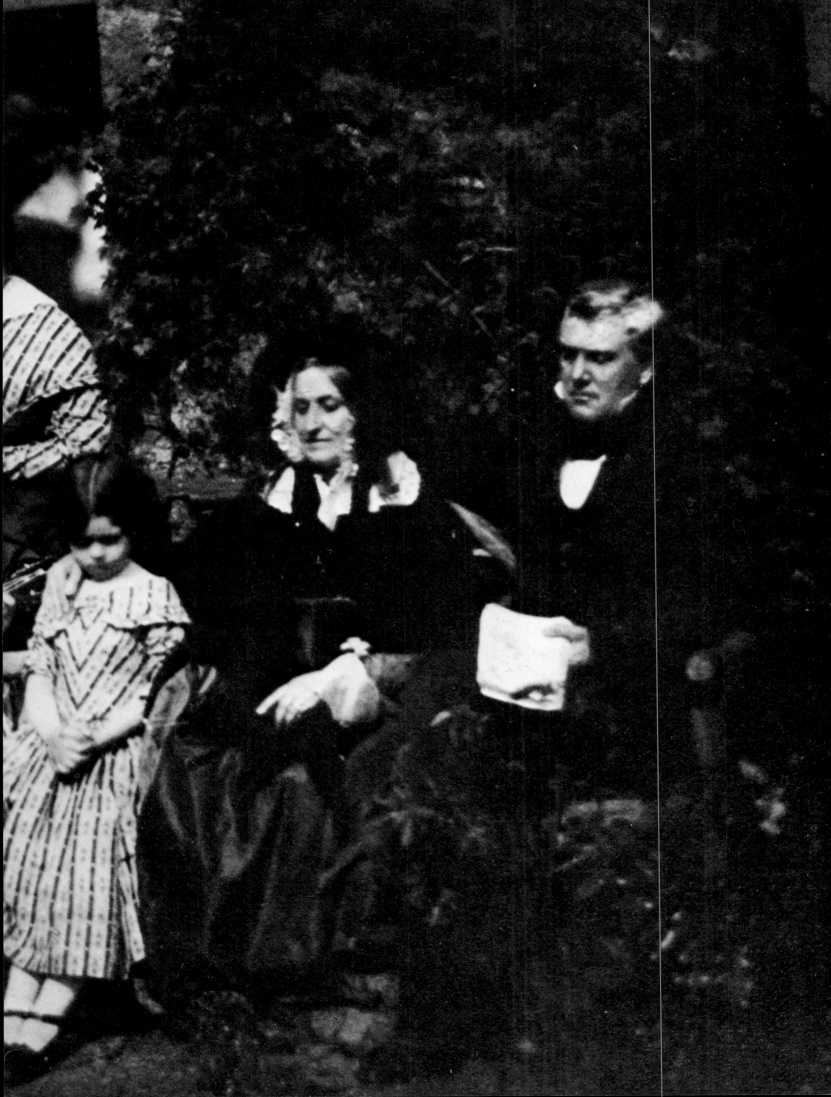

A Democracy of Portraits: America in the Nineteenth Century

One of Ralph Waldo Emerson's more surrealist aphorisms pictured a world of customers beating a path through the Adirondack woods to reach the rough-hewn cabin of a man who had, with Yankee ingenuity, built a superior mousetrap. Yet that's essentially the story of the daguerreotype in the United States. A few months after Daguerre's ceremonial announcement in Paris, his pupil François Gourard sailed to New York City, where he set up as a salesman and demonstrator of daguerrean apparatus. A small-town druggist, Albert S. Southworth, heard him lecture in Boston in the spring of 1840.

That same year, Southworth opened a portrait studio in partnership with his school-chum Pennell, an assistant to Professor Samuel Morse, who introduced Southworth to the eminent man. The partners moved to Boston in 1841; but Pennell left three years later. Southworth found another partner fairly soon: Josiah Hawes was a carpenter and a part-time painter of portraits, who had also seen Gourard's demonstration, and in fact had begun to make daguerreotypes himself. Their business was marvelously successful and so agreeable to both men that Hawes joined the family by marrying the studio assistant, who was Southworth's sister.

They charged five dollars a sitting, a great sum at that time. They usually exposed the entire plate, exactly 6½ by 8½ inches. These large portraits were remarkably beautiful in detail and strong, even rugged, in composition; but more important, the photographers were acutely sensitive to character, and concerned that the portrait must convey the energy of this character to the viewer. The portrait of Massachusetts' Chief Justice Lemuel Shaw is deliberately lit by sunlight from above and to the right to throw into contrast the deep, baggy hollows of his sad and formidable face. Nor was Southworth an unconscious artist: *What is to be done is obliged to be done quickly. The whole character of the sitter is to be read at first sight; the whole likeness, as it shall appear when finished, is to be seen at first, in each and all its details, and in their unity and combinations. Natural and accidental defects are to be separated from natural and possible perfections; these latter to obliterate or hide the former. Nature is not at all to be represented as it is, but as it ought to be, and might possibly have been; and it is required of and should be the aim of the artist-photographer to produce in the likeness the best possible character and finest expression of which that particular face or figure could ever have been capable. But in the result there is to be no departure from truth in the delineation and representation of beauty, and expression, and character.*

Stricken with the gold fever of 1849, Southworth left Boston for two years; came back ill and poor. He left the partnership in the first year of the Civil War, so the bulk of the portraits taken in the studio were subsequently done by Hawes, who worked almost till his death at the age of ninety-three. There are thousands of Southworth and Hawes daguerreotypes in American museums; but it would be difficult, especially among the famous early ones, to distinguish Southworth's contribution from Hawes's, the eye of the part-time painter from the hand of the former apothecary. In a trade like photography, it would be, perhaps, useless to separate artist from chemist. We are grateful for the legacy of their work, which was so far above and beyond the call of business.

One of the most compelling attractions of their portraits, in fact of many, if not most, nineteenth-century portraits, is the way they grow as you peruse them. Not only that as you watch his face it expands into life-size, but it grows by implication as well. Somehow, in the set of the cheek and forehead, you deduce the size and posture of the belly and the legs and even the feet; and then, as if by a sudden movement of a cloud from the sun, you sense with great clarity the whole station and character of the person, and beyond him, his community, his era, and their collective values and judgments. It is as though the four straight confines of the portrait were the edges of a window through which you can see another world just as real, conflictual, and yet consistent, as your own.

Of course, you see through this magic rectangle, dotted with microscopic silver, from the vista of your own place and time. But photographs hold their own; though physically fragile, they turn out to be the most stubborn objects of art ever known. They resist; they insist on telling you what they are.

It is interesting, then, to compare two American portraits, taken within a generation of one another. One is Southworth and Hawes's daguerreotype of Daniel Webster; the other is L. A. Huffman's 1879 photograph of Red-Armed Panther. First of all, they are each very beautiful, powerfully constructed men, with the mouth curved decisively down and the cheekbones cast out of dark iron; their sense of personal worth is really intense. Red-Armed Panther was a Cheyenne scout attached to Fort Keogh, Montana Territory; nothing more is known of him; he was certainly not a famous shaman or a chief. Senator (and later, Secretary of State) Daniel Webster was a famous public speaker, but he never achieved genuine historical importance. So these are lesser figures, compared to Lincoln or Sitting Bull: but how certain they are, or appear to be, of their own values. Trivial, perhaps, but

in each portrait the right hand is clenched, the left open and relaxed, while the face rests on a pedestal of white: a cravat for Webster, a bone necklace for Red-Armed Panther. They are like father and son; from opposing cultures, yet with a like sense of self. But I am nagged by a similarity that is deeper, something that their unshakable dignity implies and defines.

Manual ingenuity was valued by both races, and a joking contempt for pain was the common mark of manhood. The resonant orations of Senator Webster were acts of historical theatre. And every Indian tribe, without exception, had men who were honored because they were noble and poetic speakers: again, a highly individual gift. In pioneer and Indian society both, there was a deep belief in the reality of words. Prayer and vision were powerful and credible. Man spoke to God, and God to man: person to person. One has only to look at their portraits, putting General Grant at Antietam next to Red Cloud in Washington, or match Custer with Little Big Man, to see how each society, white or red, was flamboyant with strong, deeply marked individuals. It was a glorious century for the portrait photographer. What riches of character came to their studios and their light-proof tents and wagons, to be rendered temporarily immortal!—and it was easy; the traits of the individual were close to the surface of his face and posture.

At work at the same time as Southworth and Hawes, and equally famous, was Mathew Brady of New York. His success, in a country where industry and self-improvement were virtues surpassing mere talent, was natural; celebrities of every sort went to Brady as customarily as they bought a hat. He was a byword, as for example in Bret Harte's verses about the up-and-still-coming middle class:

Well, yes—if you saw us out driving
Each day in the Park, four-in-hand—
If you saw poor dear mamma contriving
To look supernaturally grand,—
If you saw papa's picture, as taken
By Brady, and tinted at that,—
You'd never suspect he sold bacon
And flour at Poverty Flat.

And this, from Philadelphia's *Photographic Art Journal,* 1851:

Stanzas Suggested by a Visit to Brady's Portrait Gallery

Soul-lit shadows now around me. . . .
Houston, San Jacinto's hero;
Fremont, from the Golden shore;

71

Laton Alton Huffman
Red-Armed Panther (sometimes called Red Sleeve),
a Cheyenne scout, Fort Keogh, Montana, 1879
The Huffman Pictures, Miles City, Montana

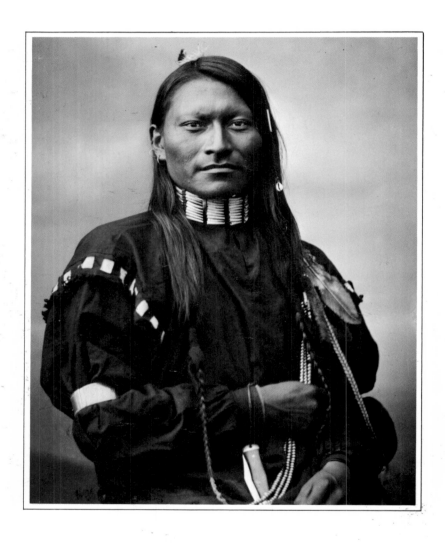

Albert Sands Southworth and Josiah Johnson Hawes
Daniel Webster, 1850, daguerreotype
The Metropolitan Museum of Art, New York,
gift of I. N. Phelps Stokes, Edward S. Hawes,
Alice Mary Hawes, Marion Augusta Hawes, 1937

Albert Sands Southworth and Josiah Johnson Hawes
Lemuel Shaw, Chief Justice of the Massachusetts
Supreme Court, 1851, daguerreotype
George Eastman House, Rochester, New York

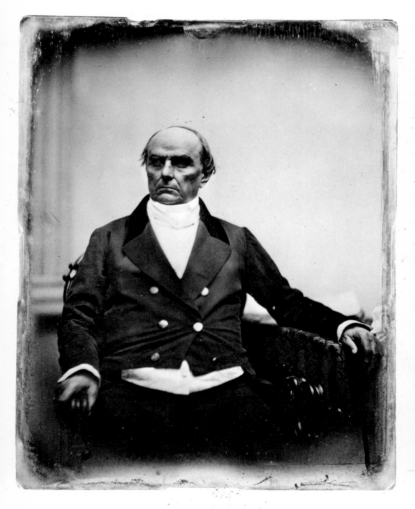

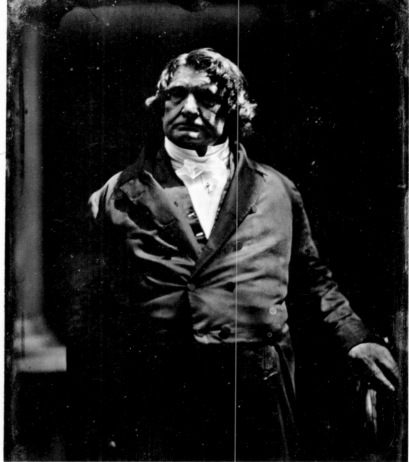

Albert Sands Southworth and Josiah Johnson Hawes
Portrait of an unidentified woman, c. 1850
The Metropolitan Museum of Art, New York

Albert Sands Southworth and Josiah Johnson Hawes
Rollin Heber Neal, pastor of the First Baptist
Church, Boston, c. 1850, daguerreotype
George Eastman House, Rochester, New York
Page 76
Albert Sands Southworth and Josiah Johnson Hawes
Lola Montez, actress, c. 1851, daguerreotype
The Metropolitan Museum of Art, New York

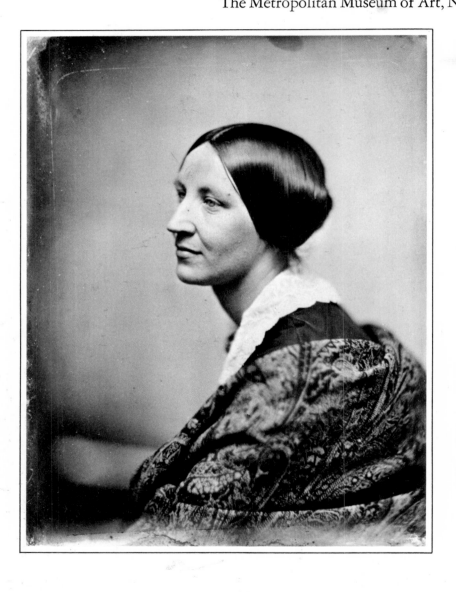

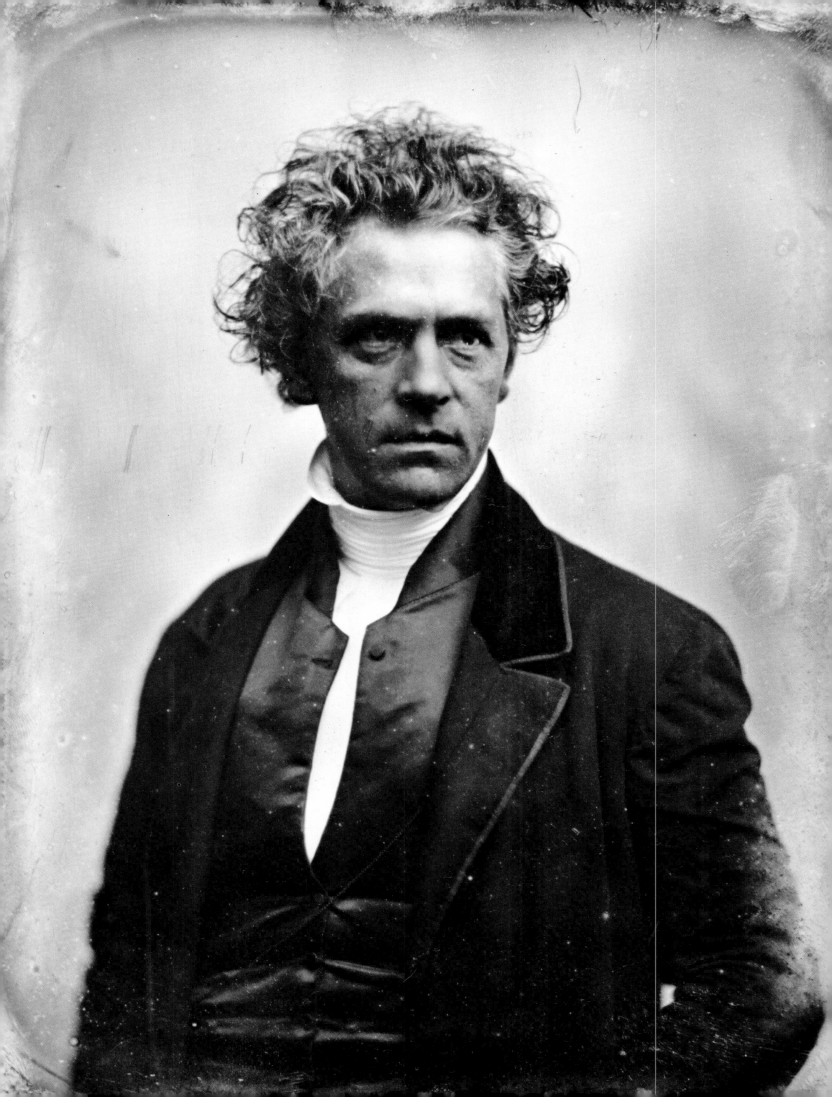

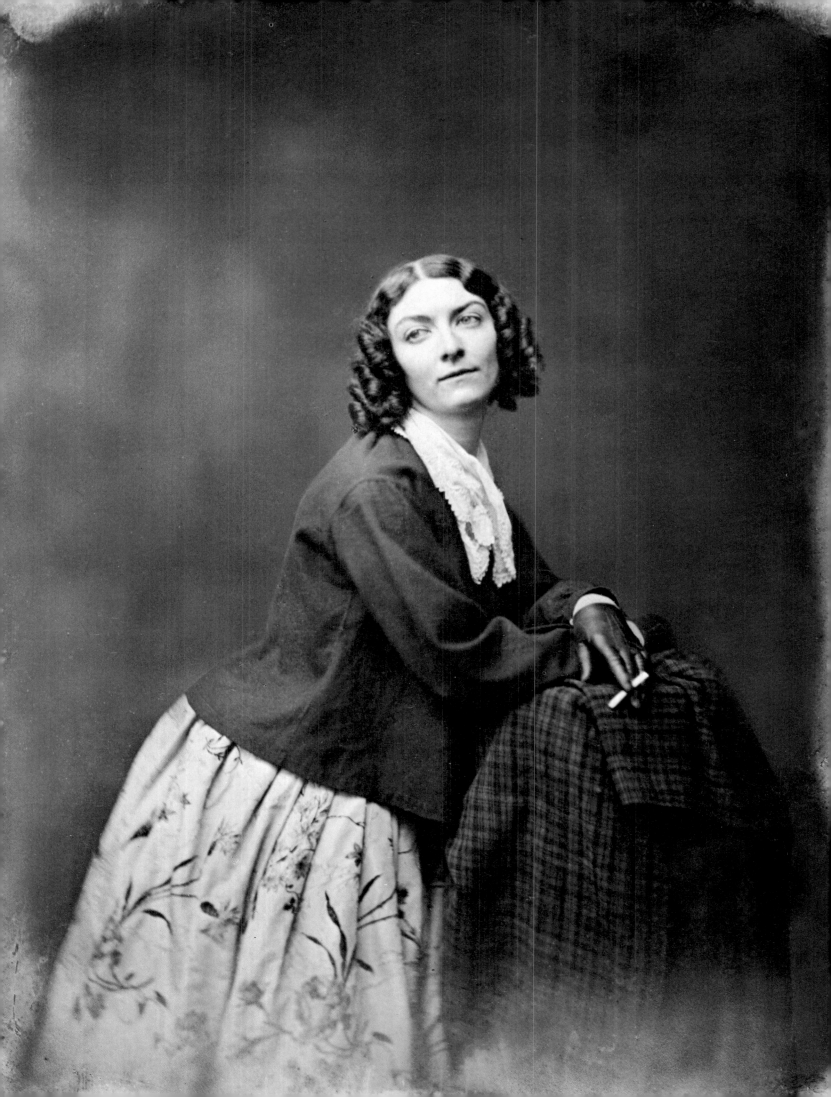

Jackson, as a lion, fearless; . . .
Webster, with a brow Titanic;
Calhoun's eagle look of old . . .
Audubon, from out the forest;
Prescott, from historic page;
Bryant, pilgrim of our poets;
Forrest, vet'ran of the stage . . .
Colt, of our mechanic peers;
Emerson, of Yankee notions . . .
Soldier, statesman, poet, painter,
Priest and Rabbi, side by side . . .
And I ask what great magician
Conjured forms like these afar?
Echo answers, 'tis the sunshine,
By its alchymist Daguerre.
—CALEB LYON, *of Lyondale*
Broadway, December 12th, 1850

Brady's work took prizes at the London World's Fair of 1851: "On examining the daguerreotypes contributed by the United States, every observer must be struck by their beauty of execution, the broad and well-toned masses of light and shade, and the total absence of all glare, which render them so superior to many works of this class." But two facts threatened Brady's business, and this at the height of his fame. The daguerreotype was a dying art—ironically, because it was so popular, even though there was no way to supply copies. The second threat was a personal one: Brady's eyesight was, by 1851, failing so badly that he no longer worked behind the camera. He hired many assistants, of whom the most gifted was a Scots immigrant; a jeweler, journalist, and Utopian thinker, Alexander Gardner. He came to the States in 1856, when Brady paid his fare to get an expert on his staff who knew the collodion process.

As early as 1847, Claude Niépce de Saint-Victor, a nephew of the famous Niépce, used egg white to fix silver salt to glass. The Englishman Frederick Archer, in 1851, used a better but tricky procedure. First, the photographer had to dip a glass plate into a thick solution of guncotton, to which was added a halide like potassium iodide. The plates were not necessarily small, either; he had to hold them by one corner, between thumb and forefinger, and deftly manipulate them so the viscous stuff spread evenly over the whole surface. He then let it partly dry, making a brave attempt to breathe at the same time, and while the coating was half dry but still sticky, dipped it into a bath of silver chloride for several minutes. Then he pulled it out, and while it was wet, slipped it into a plate holder which was, he hoped, impervious to light.

Now he went to his big camera and got the sitter posed, either indoors or outdoors, and covered his head with a dark cloth as he studied the upside-down image on the ground glass. Then he covered the lens, pulled out the ground glass, inserted the moist slide, removed the cover of the slide case, studied his sitter again, removed the lens cap, counted the requisite number of seconds, and put the lens cap back on once more.

Was he ready, then, to develop the negative at leisure? By no means: he had to put back the slide cover and remove the wet plate to his darkroom at once. There, he poured the developer over the surface of the plate; and then, by his little red light, watched a negative image develop out. When he judged it sufficiently dark, he rinsed the plate in water and fixed the image in still another solution, to wash away the unreduced silver salts. Back to pure water again, to remove the excess hypo; finally, he lit a small spirit lamp and dried the plate slowly and carefully.

The method was hard on the nerves, as an American amateur, the Reverend H. J. Morton, wrote in an article for one of the numerous photographic journals of the mid-century: *But cows are not the only pedestrians that disturb plates. A beautiful negative has been obtained after much toil, and the plate is set up endwise to dry. While at work with other plates, a speculative spider mounts the slanting glass, crawls carefully over all its surface, as if to test the tenuity of the film. . . . The perils of the photographer rival the plagues of Egypt. . . . It is a hot day—very hot. The inside of the tent is like the inside of an oven. We bend over a carefully prepared plate with all a parent's fondness for his promising progeny. Stop! What is that? A large drop of perspiration from our heated brow courses slowly down our guiding nose, and splashes on the glass! The plate is ruined, and we must recommence our labours. . . . On the other hand it is not hot but cold. A sharp October air is sparkling and making everything crisp. Our outlines are beautifully distinct. The negative is absolutely perfect. We stand the plate in the open air. The frost follows where the bugs were fond of promenading. The film is frozen, peels off, and our labour is in vain. . . . Few people realize, in looking on a fine photograph, through what perils it has passed, ere it reached its destination in the artist's portfolio or the admirer's parlour.* Nor were such petty disasters compensated by the ease of making copies. There were, after a while, only two methods: you could make a positive by exposing sensitized paper against the plate, thus reversing negative into positive. Or you could fit the glass plate against a dark sheet of

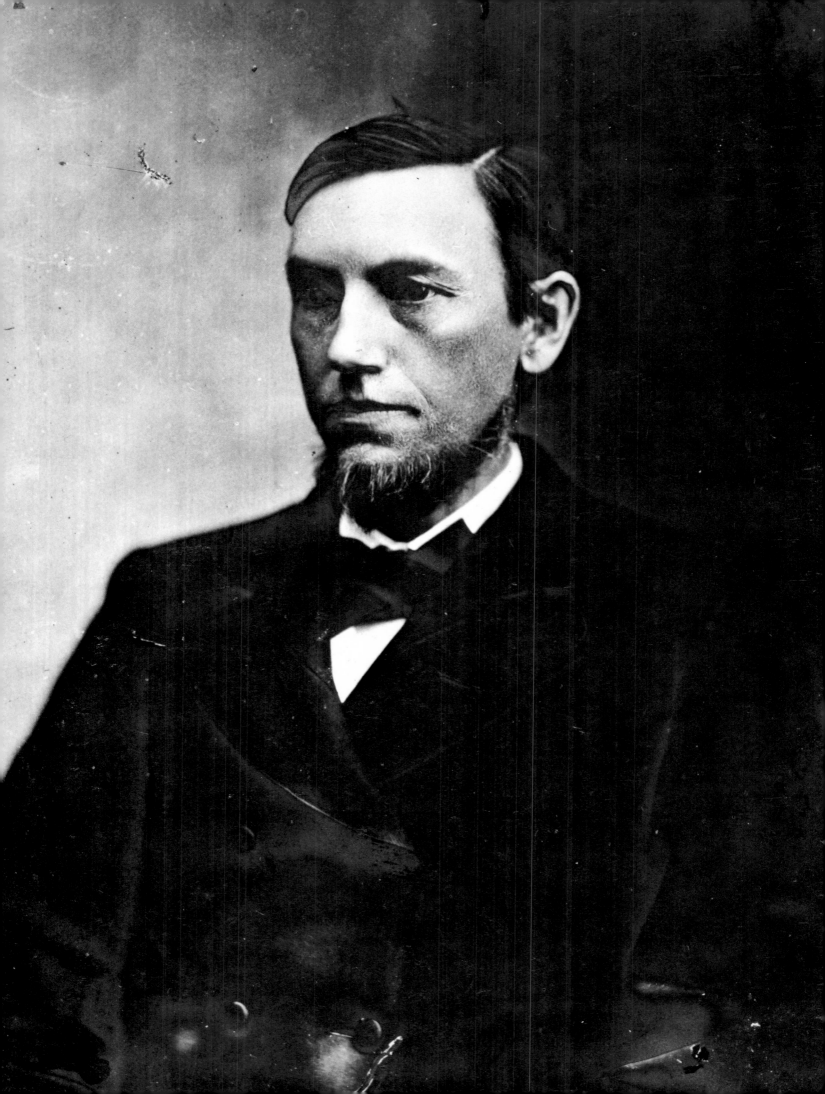

Mathew Brady
J. A. Bentley, Commissioner of Pensions, no date, daguerreotype

Mathew Brady
Henry Clay, 1849, daguerreotype
Both, The Library of Congress

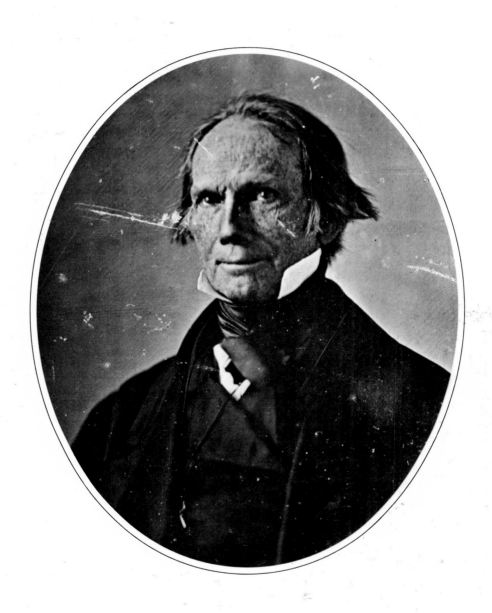

Mathew Brady
Edgar Allan Poe, no date, daguerreotype

Mathew Brady
Ella Jackson, actress, no date, daguerreotype
Both, The Library of Congress

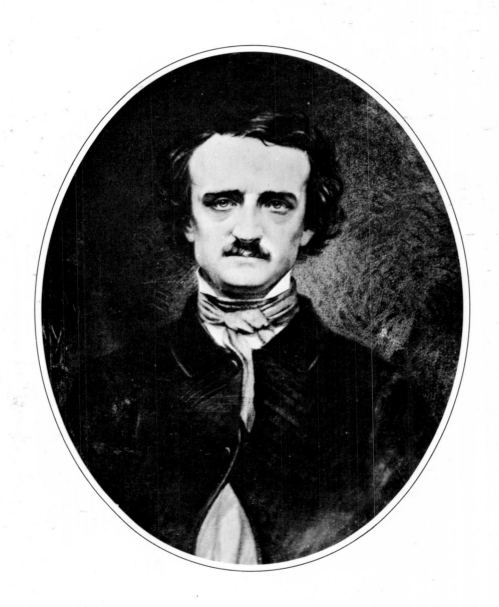

any sort, either metal or glass, whereupon the negative showed up as a positive by contrast; this was called an ambrotype. Thus, a small handbill circulated in March, 1858, announced:

DAVIS & CO.'s
ORIGINAL 25 CENT
AMBROTYPE ROOMS,
Cor. Winter & Washington St.
BOSTON

Davis & Co. are now executing from
three to four hundred Pictures per day, and
giving better satisfaction than any
Establishment in NEW ENGLAND.
Particular attention paid to copying,
and satisfaction warranted.

In the same decade, it was found that the sensitized collodion could be put on a darkened sheet of metal instead of glass, so multiple exposures could be made on a large plate; these were then snipped apart with a metal shears, so the customer could enclose this small, light, thin, unbreakable "tintype" in his letters home.

Because nearly everyone in America was on the move. Every personal mischance or failure, or the general misery of recurrent panic and loss of employment or business every ten years or so, was a goad to get them legging and hoofing and wheeling it from wherever they were to somewhere else. Lucky or unlucky, the rootless wanted photos to send home, themselves with pick and pan, or a sarcastic slogan on their wagons: "Boston or Bust." They also, boasting, bought pictures of some of the "hostiles" they met at the trading post or on the blistering trail. And they wanted not just one souvenir, but dozens, because their friends and family, too, were scattered over the inexhaustible space of an America whose limits were two oceans, a flexible latitude to the north, and a dubious river to the Mexican south. Carpenters, wheelwrights, tinsmiths, blacksmiths, were all in instant demand; and photography was simply another business. Good, clean, sharp, cheap, informative, accurate copies were the demand of the transient, but the strange thing was that the technology for providing for this need was curiously delicate and touchy.

By 1871 the dry plate had been invented by Dr. R. L. Maddox, an English physician; he used gelatin instead of guncotton, for the smell of ether sickened him; thus the delicacy of this man's feelings caused a complete revolution in photographic technique. Dry gelatin on glass, sensitized in advance, and developed at leisure, was sixty times as fast as previous plates,

and so displaced every other photographic method: the daguerreotype, the calotype, the collodion wet-plate, the ambrotype, the tintype—each of them having flourished only an amazing decade or so.

Up to 1880, the itinerant photographer, in pursuit of the wandering farmer, miner, cowhand, or shopkeeper, had to be equipped with a great box on wheels: a buggy converted into a darkroom. In the new towns, some of which were little more than a street of bars, hotels, and livery stables—much like American freeway towns that are all motels and gas stations—the peripatetic photographer would set up shop, settle down behind the wooden false front, and record for us, not always unconsciously, the marvelous rough tide of American faces.

The relatively few portraits—say 100,000 or so—that escaped the destruction that each generation visits upon the preceding, do indeed fascinate us. There were superb artists among these obscure craftsmen. For example, there were the Melander brothers, Silas and Lewis. Silas Melander had been brought from Sweden at the age of one. At thirteen, he became an assistant to the famous Chicago daguerreotypist Alexander Hessler, who had photographed Longfellow and other native celebrities. Melander, too, set up a portrait studio, but he and his brother traveled thousands of miles to get material for their popular stereo views; and this was, by intent or chance, the habit of all these photographic salesmen-artists, notably Adam Henry Olbert, Joseph E. Smith, E. E. Henry, Harrison Putney, the great William Hunt Jackson, and the two Stevensons. They were all professionals; but amateurs also traversed the flat, rich lands of the Midwest, newly stolen from the Sioux, and photographed the pride of the defeated and the humility of the victors: workworn, plain, socially cheerful, and deeply anxious. One Lorenzo Lorain, a second lieutenant and a graduate of West Point, documented the pioneer towns of Oregon City and Williamette Falls; but then his duties took him further back into the wilderness, and here he photographed both his soldiers and the frowning, dignified leaders of the Klamath and Modoc. The photographers' names alone indicate the Anglo character of the first two thirds of the century; they are the accidental, surviving names and plates of a great crowd of craftsmen and dabblers.

A better than average photographer was the Swedish immigrant John Anderson, who set up a studio in Nebraska, just as an interesting sideline to his main job as a trader at the Rosebud Indian agency; here he took upward of four hundred fascinating glass negatives of the Brulé—a minor band of the Sioux

Silas and Lewis Milander
Chicago, 1876, stereoscopic card illustration
Collection of David R. Phillips, Chicago

Will Soule
Indian squaw, no date
History Division, Natural History Museum
of Los Angeles County

nation. William S. Soule was an even more sensitive and skillful artist. He was a Maine boy who learned his trade in Chambersburg, Pennsylvania, and then moved again to Fort Dodge in Kansas, where he was a clerk in the army store and only hoisted his fifty-pound camera to supplement his income. After that he set up shop in Fort Sill, Oklahoma, which also happened to be an Indian agency. It was there that he took most of his extraordinary Indian portraits.

The traditional gravity of the Indian, whether photographed outdoors, or indoors by diffused skylight, is lightened by a kind of sweetness. They are Comanche, Kiowa, and Apache, as well as Cheyenne, so it is no tribal friendship for the whites that we feel. It is sympathy, an ease, a kindness that flows from Will Soule to the sitter and back again through the lens to the collodion. There are women among these portraits, too; and it is fascinating to think of them side by side with the Hill-Adamson women; to see how much more ready and eager and certain about life are these half-nude squaws—except for one, the beautiful, mournful daughter of the Kiowa Chief Satanta, who hanged himself during his second imprisonment by the U. S. Army.

There was to be a second, and far more romantic revival of photographic interest in the noble Indian, late in the century, indeed almost too late; but first, in the 1860's, there was a terrible slaughter of whites by whites that was to drag on, one ghastly campaign after another. For one thing, military tactics are generally one war behind the awful advance of military hardware. The American Civil War was fought like an eighteenth-century game, with marches and countermarches and huge companies of men attacking in strict parade order. But by 1861, and increasingly during the next four years, the rapidity, power, number, and caliber of ordnance became truly enormous. The air was saturated with metal, yet cover and squad attack were disdained on both sides; gallantry was the deadly standard. Consequently, battle casualties of fifty per cent were not uncommon. A man with a wound in his leg was lucky to lose it on the table of a field surgeon's tent; if he did not, it would kill him, three weeks later, by means of gangrene, for which there would be no remedy for some eighty years.

It is hard to imagine photographing this hideous conflict with wet, sticky plates, 8 by 10 inches or even larger, and dragging along a darkened box on a wagon. But the tremendously successful Brady, by now with studios in both New York and Washington, saw the chance of historic profits, and applied directly to two powerful men whom he knew and had photographed before: one was Abraham Lincoln, and

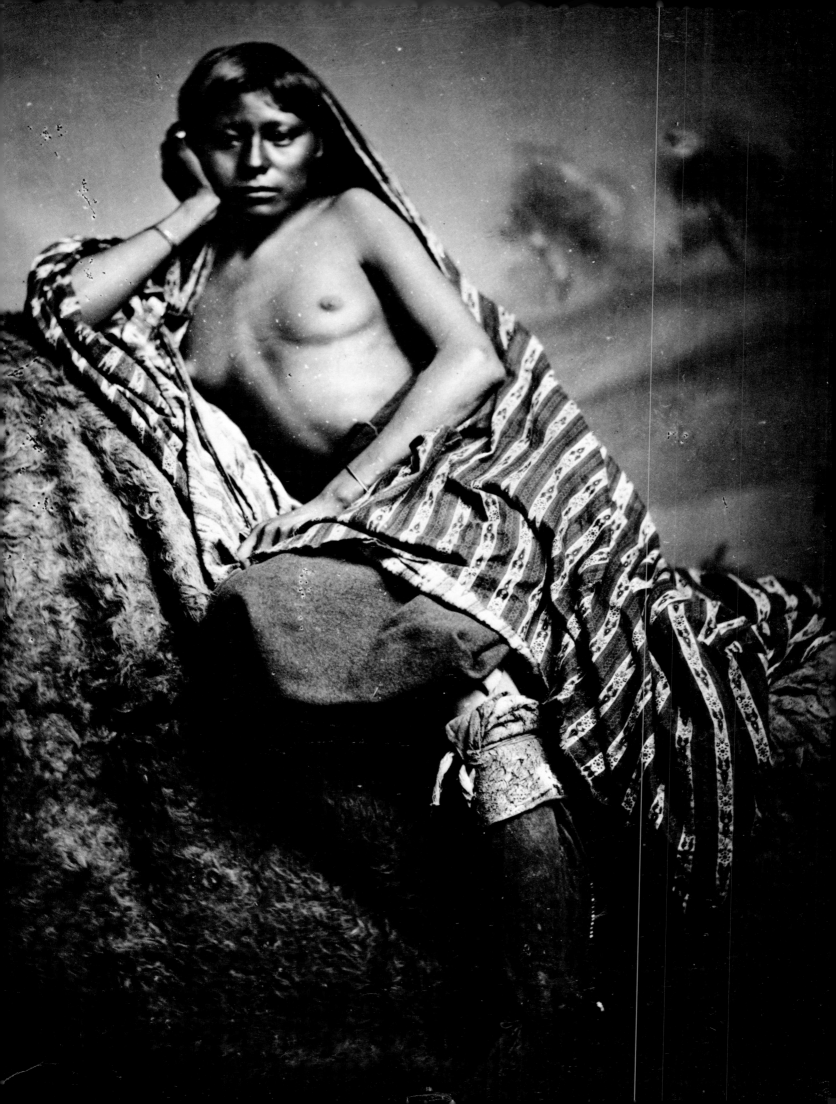

Will Soule
Sitting-in-the-Saddle, Lone Wolf's son, no date
History Division, Natural History Museum
of Los Angeles County

William Henry Jackson
Long Dog, Pawnee, 1869
Amon Carter Museum, Fort Worth, Texas

Edward Curtis
Untitled, no date
The Library of Congress

Adam Clarke Vroman
Hopi maiden with squash blossom hairdress, 1901
History Division, Natural History Museum
of Los Angeles County

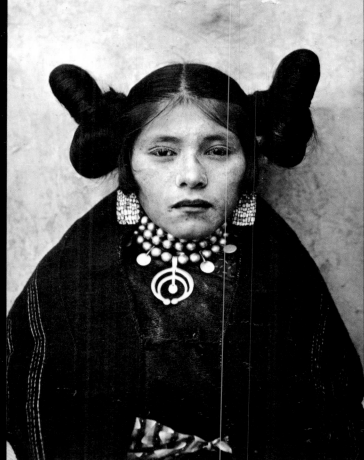

the other was Allan Pinkerton, whose operatives were responsible for wartime security. Pinkerton thought Brady was trustworthy, and Lincoln, reassured that no government expense was involved, inscribed a bit of paper: "Pass Brady."

Brady was with the first campaign, designed to end the war in six weeks, and he retreated with General Irvin McDowell from the first disaster at Bull Run. There was no doubt that Brady exhibited considerable courage in pursuit of his trade. A reporter from the magazine *Humphrey's Journal* wrote: *The plucky photographer was forced along with the rest; and as night fell he lost his way in the thick woods which were not far from the little stream that gave the battle its name. He was clad in the linen duster which was a familiar sight to those who saw him taking his pictures during that campaign, and was by no means prepared for a night in the open. He was unarmed as well . . . until one of the famous company of "Fire" zouaves, of the Union forces, gave him succor in the shape of a broadsword. This he strapped about his waist, and it was still there when he finally made his way to Washington three days later. . . .*

Still, one must erase any romantic impression that Brady, in his peculiar hat and white duster, was the solitary artist exposing plates in a rain of grapeshot. He invested more than $100,000, and had portable darkrooms rolling down at every camp and front. Manning these photo-wagons, besides Alexander Gardner and his brother, were at least a dozen others, including the remarkable Timothy H. O'Sullivan. Of the hundreds of thousands of portraits taken in the field by the Brady establishment, of generals, lieutenants, or plain troops, either alive or in the arched rigor of sudden death, we know for certain the photographer of only a scant couple of hundred.

Again, what a roll call of faces the Brady outfits recorded!—Secretary of War Edwin M. Stanton, with his "granny glasses" and two white streams of hair trickling down into his ample beard; James H. Lane, the fierce, long-faced Kansas guerrilla captain, wrapped in a flowery cape like an actor; General William T. Sherman, his right hand thrust Napoleonically into his general's tunic, and his gaze turned sideways frowning victory; Major General George A. Custer, with great drooping moustaches and long curly hair; officers' wives in their many-layered silk dresses; a Union private, name and serial number unknown, with an innocent face under a broad hat; and a Zouave (so named after their flamboyant costume) with long bayonet and regulation baggy pants, frank, sad, but still at ease; four soldiers clowning with sabers; and a nameless Confederate soldier, too, his

Mathew Brady
Major General William T. Sherman, 1864
The Library of Congress

Mathew Brady
Major General George Armstrong Custer, c. 1865
George Eastman House, Rochester, New York

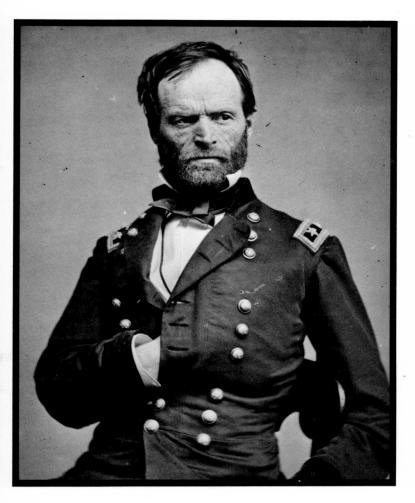

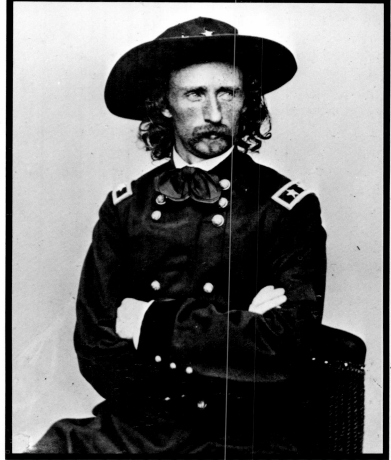

face turned open-mouthed to one side, his rifle as long as his body, and very young and freshly dead.

It was an unimaginably bloody and courteous war. Northern photographers, on a slack day, would drive their photo-wagons (soldiers on both sides called them the "What-is-it?") across the intervening stream or ridge or broken fence and set up shop in the opposite camp: so Johnny Reb could have his picture took to send to his family back in Georgia or Alabama, where, no doubt, it was shown round to his family slaves, as well. Equal privileges were extended to Confederate photographers, of whom there were a great many, though mostly unidentified.

By far the best of these Rebel photographers, George Cook of Charleston, was a friend of Brady's, and even managed Brady's gallery when the latter went abroad in 1851. Cook, with his Northern connections, got supplies from New York in the midst of the war. He photographed the whole echelon of Confederate generals, of which the most striking I have seen is that of General Braxton Bragg, whose single thick eyebrow above his alarmed eyes gives his bearded face a haunted, dark anxiety.

One of the strangest Civil War portraits is a photograph of the Vice President of the Confederacy, Alexander Stephens, whose pale skin is stretched over his skull till he looks like an immensely aged child; and this photograph was (one should no longer be astonished) by Brady—"or his assistant." For Brady knew, and had photographed, most of the Confederate hierarchy; before the war, they had come to his studio like any other American who could afford the modest fee. In this way, Brady had become a personal friend of General Robert E. Lee, and could urge him, against his inclination, to pose on the back porch of Lee's home in Richmond, on the nineteenth of April, 1865, only a week and a half after his surrender that ended the war at Appomattox. It is a full-length portrait; it sags with its own weight, and though we can read the weariness in the face and posture, there is no bitterness and no tension; he is a man who feels he's done his honorable duty. He was, in fact, a kindly and remarkable general, who spent all his personal force in defense of a cruel and indefensible society. Brady shows no awareness of this moral gulf; why should he? The artist is our necessary hypocrite. Lincoln, it may be noted, was dead only four days when this photograph was taken.

Brady had made many photographs of Lincoln, the earliest one probably taken during Lincoln's campaign for the presidency in 1860, when he had come to New York to speak at Cooper Union. The photograph was copied by artists and published by

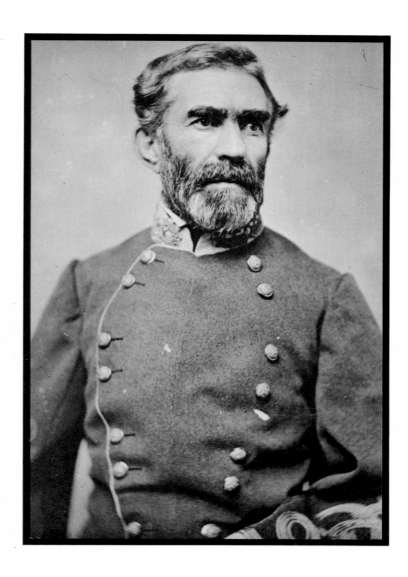

Mathew Brady
Alexander H. Stevens, Vice President of
the Confederacy, no date

Mathew Brady
General Robert E. Lee, 1865
Both, The Library of Congress

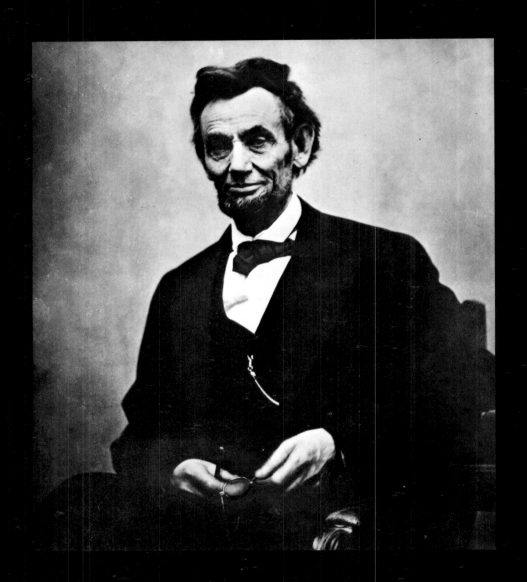

Alexander Gardner
Abraham Lincoln, 1865
The Library of Congress

many journals. Lincoln said, "Brady and the Cooper Union Institute made me President." How calm, young, relaxed, and, one is tempted to say, unfanatic, he looked! When Fort Sumter was captured and the Confederacy emerged, Lincoln asked Congress for authorization to raise 75,000 troops. More than a million would eventually sicken, be wounded, or die. His last photograph, also by Brady, taken on April 10, 1865, has all the weariness of Lee's, but with the cruel marks of nightmare and sorrow as well. Five days later, he lay bleeding to death in an upstairs bedroom of a boarding house across from the Ford Theatre.

The victorious North reacted to the assassination with hysteria: everyone suspected a widespread and powerful conspiracy. The truth was too odd for belief. John Wilkes Booth, brother of the famous Edwin Booth, and a fairly well-known actor himself (for prints of his portrait hung in thousands of American parlors) was one more in the long line of assassins who are obsessed with their victim; so strongly that one suspects a deeply censored homosexual attachment.

Booth's plan was to kidnap Lincoln and exchange him for some 70,000 Confederate prisoners of war. The first assault was on Lincoln's carriage: but it held only a young cavalry major. In the second assault, Booth sent Lewis Payne, one of his most ardent fans, to kill Secretary of State William H. Seward. Payne, as he called himself, had deserted from the Confederate cavalry.

Armed with pistol and knife and a fake parcel, he got into Secretary Seward's house, put his gun out of commission in a struggle with the Secretary's son, and ran upstairs into the bedroom to cut Seward's throat; luckily, the Secretary had broken his jaw in a carriage accident and the knife was baffled by the steel braces around the injury. This poor, huge, dim-witted assassin was captured in the woods a week later, kept hooded and manacled, and hanged along with three others on July 7, 1865. Alexander Gardner photographed each of them in addition to Mary Surratt, who was later convicted and hanged.

The Brady firm had long been aware of the profit to be made from a public which (exactly like our own) was hungry for the physical look of its heroes and villains. The psychic distance of industrial culture is precisely what makes us eager to look at photographs: two-dimensional analogues of flesh and blood. How extraordinary, then, especially for us today, when all the principals are dead, to look at the faces of a Confederate spy and her daughter; Mrs. Rose O'Neal Greenhow, we know, lived in Washington and sent cypher messages to the Confederate General P. G. T.

Beauregard till she was captured by Pinkerton himself. And here she is, wearing a lovely ruffled dress with voile sleeves, and a fine kid glove holding a huge white magnolia—posed in the yard of the Old Capitol Prison. The full-length photograph of Lewis Payne in prison shows us a rather blank face: there is little fear and certainly no fury. If one covers the handcuffs, it is a portrait of a man newly roused from sleep, uncombed, dazed perhaps, obedient, co-operative, neither eager to have his picture projected into history, nor particularly fearful of it, either.

A fascinating photograph, but maybe not the full truth; for there are things impenetrable even to art. One that is plain, though, is the selfish, stubborn energy of the nineteenth-century American character. It strikes you with every photograph, whether taken in the raw field before the new-raised house, or standing on the bearskin, before the painted drop in Brady's studio. This sociable egotism, which every American now takes for granted, is first of all the product of a great sieve. After all, those earliest Scots and English nonconformists, those Irish who fled the potato blight, those Germans who left after the broken revolts of 1848, were the most energetic, the most optimistic of their class and time. Others, unwilling to break the network of home and family, stayed in old Europe with all its festering nations. America was the seedland of the bold—though not necessarily the brightest or the best.

Drawn between the tension of the decaying past and the apparently inexhaustible future, the American had two contradictory ideas in his head. He was often by nature and selection a utopian, though he did little about it. Emerson, who elaborated in public orations the inner proverbs of the age, noted and approved of this idealism. He wrote a vast essay on *Self-Reliance* and said that, "Not a reading man but has a draft of a new community in his pocket." There were, however, no more than a few thousand who ever undertook to put these notions into practice; some utopias, indeed, insisted on chastity, and were thus programmed to self-destruct. Idealism is by nature a bit vague, and the border between madness and reform, never too clear, shifts from decade to decade. The fanatics who shouted for abolition of slavery and suffrage for women were to have their ideas written at last into the deliberate sanity of the American Constitution.

On the whole, though, the American kept his doctrines for the campfire or the saloon. His daily actions were governed by the certainty, no matter how many times disappointed, that he had only to go another thousand miles to find his fortune, and the best

Alexander Gardner
Samuel Arnold, conspirator in the Lincoln
assassination plot, Washington Navy Yard, 1865

Alexander Gardner
Lewis Payne, conspirator in the Lincoln
assassination plot, Washington Navy Yard, 1865
Both, The Library of Congress

Alexander Gardner
Samuel Arnold, conspirator in the Lincoln
assassination plot, Washington Navy Yard, 1865

Mathew Brady
Rose O'Neal Greenhow with her daughter in the
courtyard of the Old Capitol prison,
Washington, D.C., 1865
The Library of Congress

Timothy H. O'Sullivan
Confederate women in front of the house in which
Brigadier General Charles S. Winder died, 1862
The Library of Congress

way to get it was to grab it by the tail. "To make a killing": here the satisfactions of money and aggression were combined. Along with this went a truly remarkable gullibility regarding others who were trying to make it the easy way: table-knocking, spiritism, the deduction of one's destiny and character from the bumps on one's head; Joseph Smith and P. T. Barnum were the true prophets of the nineteenth century, and Mary Baker Eddy and Lydia Pinkham were its healers. Confidence men abounded. As Lincoln's law partner William H. Herndon once wrote: *These men could shave a horse's mane and tail, paint, disfigure and offer him for sale to the owner in the very act of enquiring for his own horse. They could hoop up in a hog's head a drunken man, they being themselves drunk, put in and nailed down the head and rolled the man down New Salem Hill a hundred feet or more. They could run down a lean, hungry wild pig, catch it, heat a ten-plate stove furnace hot, and putting in the pig, could cook it, they dancing the while a merry jig.*

By the last one third of the century though, the folk heroes were no longer snake-oil salesmen or statesmen or poets—but inventors. Thomas Edison, inventor of the movie, the phonograph, the electric light bulb, and the talking doll, would appear to be the archetype every American had in mind. "I never once made a discovery," he said. That was true, for he simply applied certain basic ideas to the sort of thing he thought people wanted. After all, that is exactly how photography was invented, too. Edison was a brilliant amateur, and at the same time, a typical American businessman of the nineteenth century: self-taught, clever, impatient. Yet when we really look at his photograph, and not merely glance, we discern something else: something boyish, abstracted, a bit odd; a shrewd, naive, cock-eyed genius. Here is an entry in his journal: *Awakened at 5:15 AM. My eyes were embarrassed by the sunbeams—turned my back to them and tried to take another dip into oblivion—succeeded—awakened at 7 AM. Thought of Mina Daisy and Mamma G—— put off 3 in my mental kaleidoscope to obtain a new combination a la Galton. Took Mina as a basis, tried to improve her beauty by discarding and adding certain features borrowed from Daisy and Mamma G. a sort of Raphaelized beauty, got into it too deep, mind flew away and I went to sleep again. Awakened at 8:15 AM. Powerful itching of my head, lots of white dry dandruff—what is this d——mnable material. Perhaps it's the dust from the dry literary matter I've crowded into my noddle lately. It's nomadic, gets all over my coat, must read about it in the Encyclopedia. Smoking too much makes me nervous—must lasso my natural tendency to acquire such habits—holding heavy cigar constantly in my mouth has deformed my upper lip, it has a sort of Havanna curl. Arose at 9 o'clock came down stairs expecting twas too late for breakfast—twasn't. Couldn't eat much, nerves of stomach too nicotinny. The roots of tobacco plants must go clear through to hell. Satan's principal agent Dyspepsia . . .*

That was a Sunday between wars: July 12, 1885. It has a perky innocence that was already tarnishing. The somber flame of American blast furnaces colored the sky by night and day, and the steel plants poured out iron by the millions of ingots. The clear eastern rivers ran varicolored with dyes from the textile mills, and the factories were famished for labor: not the labor of the craftsman who could quit any Wednesday to go fishing, but the daily, twelve-hour, seven-day labor of sturdy Slavs, Italians, Jews. There was a storm of strangers in America. The impact of their unfamiliar faces, walking in the earliest morning to mine or blast furnace, gave a new face to America; the soot and throb and slag heaps were changing the air and the landscape. A new century was coming, and the iconography of American life—dominated by the photograph—was about to take another turn.

Photographer unknown
Thomas Edison, 1887
Gernsheim Collection, Humanities Research
Center, The University of Texas, Austin

103

Trailing Clouds of Glory: Victorian England

Photography is not the favorite muse of most critics of art; some have even managed the delicate feat of not mentioning it at all. There is a degree of truth in Alfred Stieglitz's remark that photography had become a fad, like bicycling. The trouble is simply that this fine silver image can serve any number of purposes, some of them very odd indeed. This was particularly true of Victorian England and its photographers. They followed the compulsive illusions of their own time, although sometimes confused as to what they were.

Of course, no culture is homogeneous. Sepik River or Chelsea Hotel, our values and our practices are borrowed as easily as born; still, most societies manage to get by with, at worst, a bit of moral schizophrenia. The nineteenth-century English, though, enjoyed excruciating pain from the chasm between reality and religion. The advance of science in the preceding century, with its neat reduction of the moving heavens and the earth to a paradox of motion by the sum of infinitesimals, seemed to destroy all the angels in one flashing equation. Blake accused Newton of Satanic mathematics: Jerusalem could never be rebuilt on such lean curves. He was morally right, philosophically wrong.

Concurrently, in nineteenth-century England, there was a new dilemma. Darwin's pious wife left him notes on the kitchen mantle, protesting that his ideas would destroy God, not to speak of Bishop James Ussher, who had proved beyond all Christian doubt that the world was created in the six days that began at exactly 4004 B.C. So Darwin, at least partly persuaded, did not publish his views for more than twenty years.

Meantime, photography, discovered by chemists and opticians, was one more triumph of scientific magic. The dichotomy between what life on this earth ought to be and what it really was tore at the conscience of every English artist, and of the photographers especially—for they struck reality like a naked toe against a chair.

For many decades, the painters concealed this gap between fact and fancy by doing genre pictures: anecdotes of country inns, of foul weather assailing the good shepherd and his flock, of dainty lace makers and their clumsy suitors; of sweetly melancholy scenes like the young couple leaving England forever, in the rain, naturally, with their newborn child wrapped in its mother's cape. Didactic sentimentality colored them all, even those done with skill and talent. But under the meticulous surface there was an abyss of feeling, and monsters rose out of this concealed chasm between a straight morality and a bent practice, between

middle-class comforts of a place in the country and the crowded horrors of Liverpool and London.

There was a group of writers and painters, oftentimes both, which included the Rossetti brothers and the painters W. H. Hunt and John Millais, who genuinely hated the grime and misery of expanding industrial and imperial England, yet did not attack it as Blake had done:

I wander thro' each chartered street,
Near where the chartered Thames does flow,
And mark in every face I meet
Marks of weakness, marks of woe.

In every cry of every Man
In every Infant's cry of fear,
In every voice, in every ban,
The mind-forged manacles I hear.

How the chimney-sweepers cry
Every black'ning Church appalls;
And the hapless Soldier's sigh
Runs in blood down Palace walls.

But most thro' midnight streets I hear
How the youthful Harlot's curse
Blasts the new born Infant's tear,
And blights with plagues the Marriage hearse.

Though they cried for truth in painting, the group did not sully their art with lower-class misery; they chose to turn their backs on contemporary England and to depict, as in Millais's "Ophelia," only romantic and upper-class tragedy. They called themselves the Pre-Raphaelite Brotherhood, because only in the painters of the earliest Italian Renaissance did they find the simplicity of manner and the innocence of faith that they admired. Dante Gabriel Rossetti wrote:

The blessed damozel leaned out
From the gold bar of Heaven . . .
She had three lilies in her hand,
And stars in her hair were seven.

The lady was, in a sugary and somnolent way, pornographic:

Her robe, ungirt from clasp to hem . . .
Her hair that lay along her back
Was yellow, like ripe corn.

She was beautiful, and of course, dead: a combination irresistible to the current taste for religious necrophilia; it required, as had Poe in America, that purity and sexuality be mixed until the former cancelled the latter. The title of a poem by the Rossettis' sister Christina, who contributed to the Brotherhood magazine, *The Germ,* is "When I Am Dead, My Dearest." The paintings by the group are sufficiently characterized by their titles: "Christ in the Carpenter's Shop," "The Light of the World," "Triumph of the Innocents," "Isabella and the Pot of Basil"—the pot being where, one hesitates to recall, she kept her dead lover's head.

John Ruskin, whose prose was studded with jewels but whose taste was somewhat uneven, admired daguerreotypes as early as 1840, because he considered them preliminary sketches for genuine artists, himself among them: "I must regret that Artists in general do not think it worth their while to perpetuate some of the beautiful effects which the daguerreotype alone can seize." He was a close friend of the Brotherhood, and of the Utopian thinker William Morris. Purity and corruption were Ruskin's early themes, a consequence, maybe, of the fact that both his parents were crusading preachers. His critical writings were enormously influential: he was morally certain that Gothic was pure and that the Venetian Moorish arches and palaces were corrupt. It proved a popular notion.

There is an early photograph of Ruskin leaning on Rossetti's arm. It is somehow a very poignant contrast: the plump and darkly Italianate poet and painter, with his consciously sleepy eyes, dark felt hat, and careless handkerchief; and the egotistical frown, the bamboo cane, and the posture, half-belligerent and half-dependent, of the critic who browbeat English art for two generations. Both their personal lives were feverish. Ruskin married, but the union was annulled after six years because he was, in the event, impotent; he suffered from recurrent insanity, which disabled him for the last decade of his life. Rossetti married his first model, but like a true Pre-Raphaelite, she died two years later, and he buried a whole sheaf of manuscript poems with her body—which he later disinterred; after that he fell desperately, and it is presumed, uselessly, in love with William Morris' wife, Jane.

The scores of photographs posed by Rossetti of Mrs. Morris, ostensibly to use as studies for his paintings, are remarkable for the mutual intensity of the sitter and portraitist. She was a perfect embodiment of the Brotherhood's eroticism: luscious but forever distant. The rich, dark folds of her dress, so stiff and simple that it resembles a drape rather than a garment, was perhaps supplied by Rossetti. The curves of her long neck, both nape and throat, her large, open, languid hands, her wildly curly mass of hair above a strong

London Stereoscopic Company
John Ruskin and D. G. Rossetti, c. 1865
Gernsheim Collection, Humanities Research
Center, The University of Texas, Austin

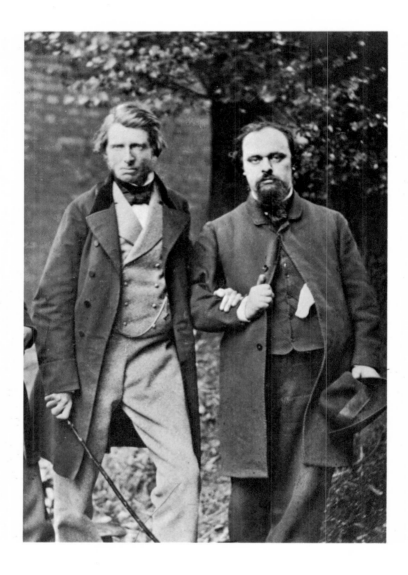

Jane Morris posed by D. G. Rossetti
in front of tent in his Chelsea garden, 1865
Victoria and Albert Museum, London

Jane Morris posed by D. G. Rossetti, c. 1865
Victoria and Albert Museum, London

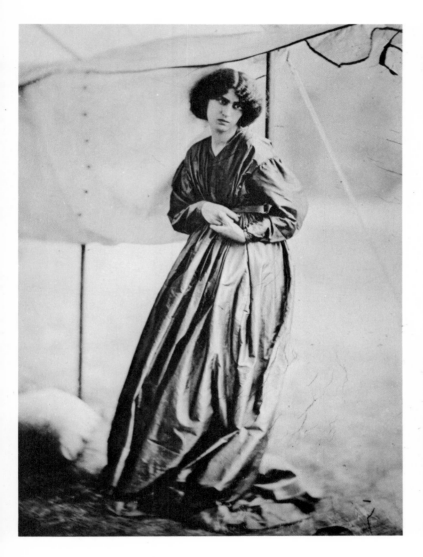

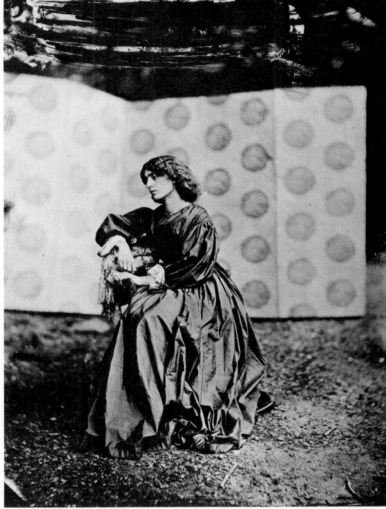

triangular face, with large dark eyes and heavy lips —all have a Mediterranean sexuality that Rossetti equated with Dante's equally hopeless love: Beatrice. And there is something more: though this series of photographs was taken when he was past forty, they seem the bemused, painfully stirring spirit of an adolescent; in some sense, indeed, the whole Pre-Raphaelite Brotherhood was an extended adolescence of nineteenth-century British intellectuals.

Once again, good art can embody almost any sort of illusion, however odd; and these photographs of Mrs. Morris and other Rossetti models, who all look like sisters, and are exposed under the softly bright diffusion of a translucent tent in the open air, with postures directed by the enamored artist, have the peculiar intensity of impossible love, of throbbing dreams and fantasies.

More literal, far less talented, and therefore a lot funnier, is the work of photographers like Henry Peach Robinson and Oscar Rejlander. The latter was a Swedish professional photographer who had settled in London and who took portraits to sell to contemporary painters: for example, "The Milkmaid," complete with cat and costume. A curiosity of his work are thirty photographs of human emotions (staged, of course), as displayed by the contortions of the face; these were commissioned by Darwin for his *Expressions of the Emotions in Man and Animals.* Rejlander's private ambition was to outdo the painters of his time by composing, sometimes out of masked negatives, great sugary tableaux like "The Two Ways of Life." This allegory, like its predecessors in paintings and its successors in cinema, pretended to point a moral which, luckily, was scarcely visible among the crowd of nicely naked ladies. Another of his photographs, "Hard Times" (1860), manages to convey economic distress by giving the worrier two faces on one head—the left a woman's, the right a bearded man's. Another photograph, called "The Dream," often reproduced as early surrealism, depicts a sleeping man clothed, but in a plainly and, I am sure, intentionally onanistic pose; he's dreaming of the skeletal frame of a woman's skirt, which swarms with tiny climbing mannequin figures, of the sort used by sculptors. One of these figures, ascending the volcanic slope of Woman (a concept immortalized in ten thousand amateur movies) manages to plunge headfirst into the very cone.

I would hesitate to describe these photographs as erotic rather than merely ridiculous if it weren't for the fact that the professional Rejlander, for commercial purposes, took a great many nude photographs (under coy titles like "Mother's Clothes") of pre-

Oscar Gustav Rejlander
The Juggler, c. 1855–61
The University of New Mexico Art Museum, Albuquerque, New Mexico

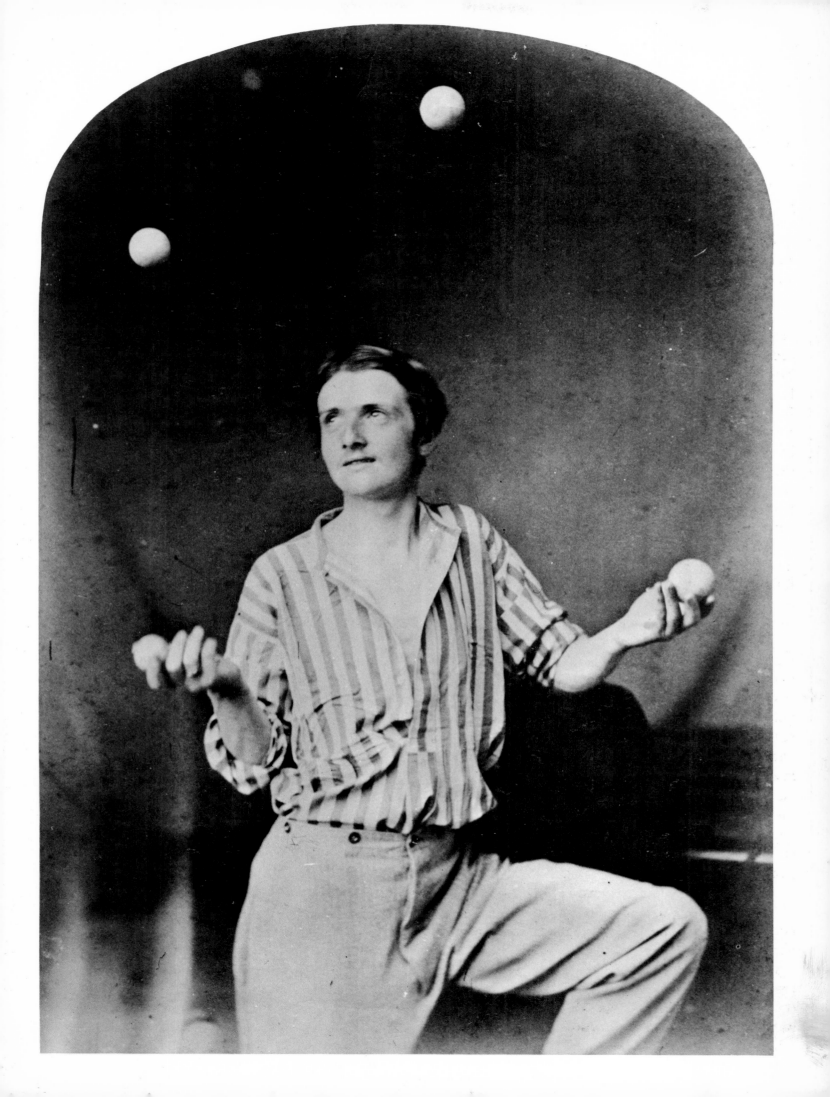

Oscar Gustav Rejlander
Hard Times, spiritistical photo, 1860
George Eastman House, Rochester, New York

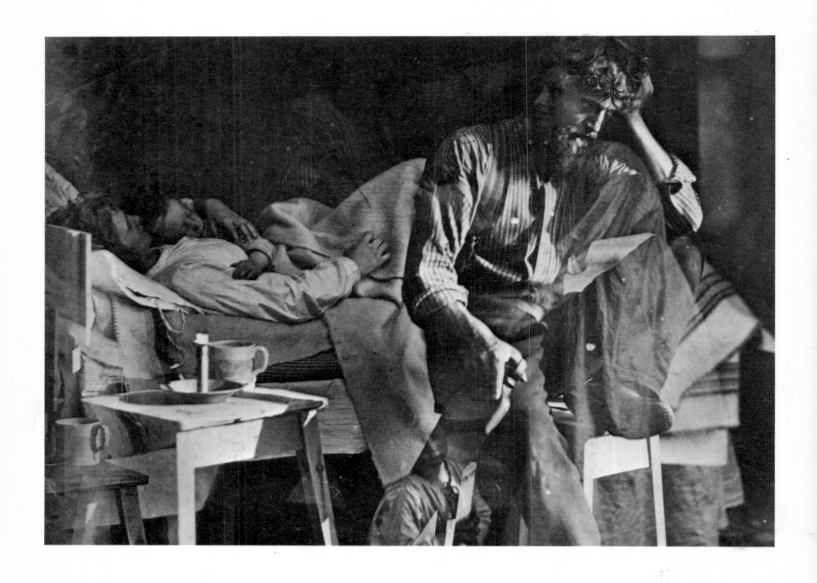

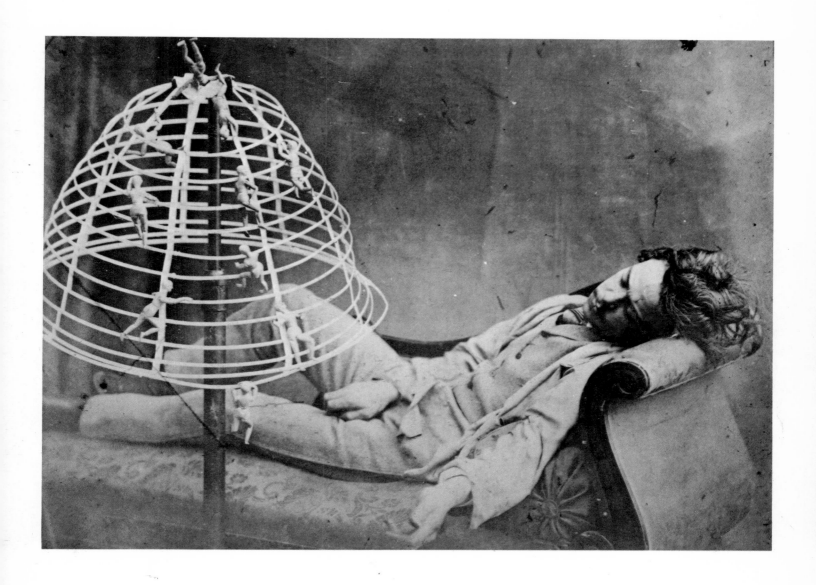

pubescent little girls; and indeed, for many decades, albums of naked children, often posed in pornographic attitudes, were an article of private commerce not only on the Continent, but in England.

Nude photographs of English children were taken by a far greater artist, Lewis Carroll, the pseudonym of Charles L. Dodgson. One of a long tradition of English gentleman photographers, he frequently visited Rejlander's London studio; they were friends, and photographed one another, but I doubt the popular opinion that Rejlander had a strong influence on Carroll's work, for the Englishman was a stubbornly self-taught and self-protected man.

In 1855, when Carroll was twenty-three, his uncle taught him how to do the, by then, old-fashioned calotypes, and it is possible that the aesthetic of chiaroscuro, the dramatic opposition of light and shadow that was one of the great virtues of the calotype, had an effect on Carroll's style. Shortly afterward, he bought a camera and developing boxes for the collodion process, and made himself a glasshouse studio on the roof near his rooms at Oxford. That year, for the first time, he photographed the children of the dean, one of these, aged four, was Alice Liddell, who became the model for that masterpiece of perverse logic, *Alice's Adventures in Wonderland.*

From that time onward to the end of his life, children were his lucky obsession; for his photographs of Victorian celebrities—Tennyson, Millais, Michael Faraday, Rossetti and even Rossetti's model—are competent but prosaic. There are exceptions: for example, a fine and affectionate portrait of his aunts, with its cleverly divided blocks of light and shade; and they look, in fact, rather like large and slightly aged children. The poetry in Dodgson's head, so bad when expressed in his numerous verses, expands and glows in his photographs of little girls; they are the products of hidden passion, of a complicated and conflicted mind.

Dodgson's father was a minister, and Charles was one of eleven children who grew up in an isolated parsonage. His nephew's memoir, published in 1898, the year of his uncle's death, is naive, adoring, and cruelly revealing; it summarizes these first boyhood years: *. . . Indeed he seems at this time to have actually lived in that charming land which he afterwards described so vividly; but for all that he was a thorough boy . . . At twelve, he was sent—a little late in life, by middle-class custom—to a boys' boarding school. He wrote home: They made me sit down . . . and told me to say 'Go To Work' which I said, and they immediately began kicking me and knocking me on all sides . . .* Hazing, that delightful male rite of passage, was his introduction to the real world. The memoir adds: *Public school life then was not what it is now; the atrocious system then in vogue of setting hundreds of lines for the most trifling offences made every day a weariness and a hopeless waste of time, while the bad discipline which was maintained in the dormitories made even the nights intolerable—especially for the small boys, whose beds in winter were denuded of blankets that the bigger ones might not feel cold.* Still, he was an excellent pupil, got admitted to Christ Church College at Oxford (where his father had done quite brilliantly), and after graduation he was given the curious post of student and mathematical lecturer. He took Orders, but only as a deacon. He would indeed have become a full minister, like his father, except for his passion for the theatre; his bishop, the powerful Samuel Wilberforce, said: "The resolution to attend theatres or operas is an absolute disqualification for Holy Orders." His first published volume was *An Elementary Treatise on Determinants.*

He was then twenty-eight years old, stammered badly, and had begun to acquire a whole set of eccentricities: *He hardly ever wore an overcoat, and always wore a tall hat . . . Great were his preparations before going on a journey; each separate article used to be carefully wrapped in a piece of paper all to itself so that his trunks contained nearly as much paper as of the more useful things . . . He had a strong objection to staring colours in dress . . . One little girl who came to stay with him was absolutely forbidden to wear a red frock while in his company.* He set himself mental tasks, as though he were his own schoolboy, and physical ones as well, often walking as many as eighteen to twenty therapeutic miles a day.

One of Dodgson's numerous self-portraits (all one had to do in those leisurely days was get somebody to take off and put on the lens cap) depicts him as a gentle, good-looking young man, leaning his melancholy head on one hand. His later portraits had the same sweet sadness. His nephew wrote: ". . . The shadow of some disappointment lay over Lewis Carroll's life." The remarkable fact is that he was deeply in love with Alice, and when she was sufficiently grown, asked for her hand in marriage; but (as Helmut Gernsheim reports in the preface to the 1969 edition of *Lewis Carroll, Photographer*) was rebuffed by "Dean and Mrs. Liddell, who considered the middle-aged and somewhat eccentric mathematics lecturer of modest means a far from desirable suitor."

It was a rude clash between fancy and fact; the world won, as it usually does. The sadness of these inevitable defeats began the day he was sent to school from the play-world of his father's parsonage. There is a sense

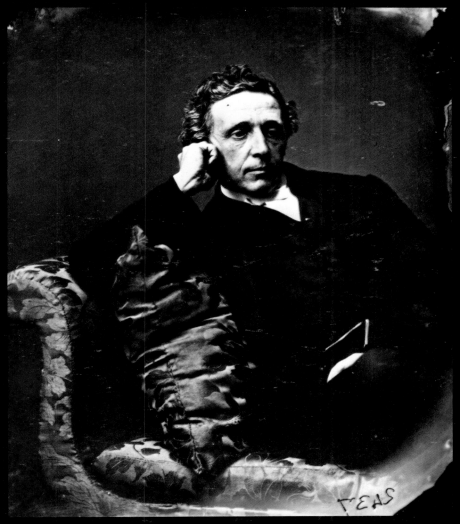

Lewis Carroll
Alice Liddell as a beggar maid, no date
Morris L. Parrish Collection of Victorian Novelists,
Princeton University Library

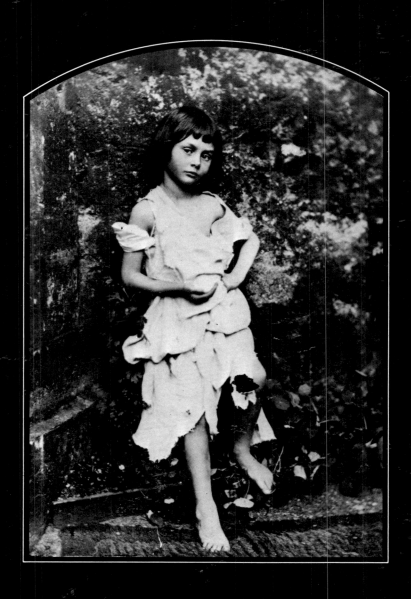

in which *Alice In Wonderland* and its sequel and the little-girl subjects of his camera are each examples of his gentle revenge on the grown-up world.

He was devoted to the theatre, indeed had written plays when a child. In many of his photographs, Carroll dressed up the little subjects in Chinese or Japanese costumes, or in a mixture of both. On one of his visits to the London theatre, when he saw *The Winter's Tale,* he wrote: "I especially admired the acting of the little Mamillius, Ellen Terry, a beautiful little creature, who played with remarkable ease and spirit." The actress, who was eventually to be the object of Bernard Shaw's platonic passion, too, was then eight years old. Her beauty at that age, and those of a hundred other little girls he knew and photographed, had, to his mind, something more angelic than human. It was a quality they might approach, though never reach: ". . . because no living child is perfect in form: many causes have lowered the race from what God made it." When he was forty-seven and Ellen and the other Terry children were quite grown, he dreamt that he visited Ellen's sister, Polly, "looking about ten or eleven years old," and offered to take her to the theatre—"to see the grown up Polly act!" He wrote: . . . *Nine out of ten, I think, of my child-friendships get shipwrecked at the critical point, "where the stream and river meet," and the child-friends once so affectionate, become uninteresting acquaintances, whom I have no wish to set eyes on again.* His nephew details the strategy of these friendships: . . . *A chance meeting on the seashore, in the street, at some friend's house, led to conversation; then followed a call on the parents, and after that all sorts of kindnesses on Lewis Carroll's part, presents of books, invitations to stay with him at Oxford, or at Eastbourne* [the seaside resort where he vacationed], *visits with him to the theatre. For the amusement of his little guests he kept a large assortment of musical-boxes, and an organette which had to be fed with paper tunes. . . . In addition to these attractions there were clock-work bears, mice, and frogs, and games and puzzles in infinite variety.* The obsession was obvious enough to puzzle even his reverent nephew, but he solved the problem thus: "If I were asked for one comprehensive word wide enough to explain this tendency of his nature, I would answer unhesitatingly —Love." I think, for all its naiveté, that this insight is essentially true. Self-banished from ordinary sexual relations, which his nature declared beastly and sordid, he retreated into his own boyhood, when, as any reader can testify, sexual desires are as powerful in their impulse as they are powerless in their execution. Love is not too strong a word for this baffling emotion in

childhood; and love is what we feel in the mutual joy, the patience (on both sides, for the little girl had to sit perfectly still for anywhere up to seven minutes, depending on the weather), the sense of affectionate play, the obvious tenderness of all his child portraits. His love of material textures, of the compositional balance of black and white, are not simply the method of all fine photography; they are intimately connected to the human result.

But the sexual drive behind them must not be overlooked. At Eastbourne he was famous among the children for persuading their mothers that it was quite proper for one to take off one's gloves when bathing; and he also carried a pocketful of pins to hoist up their pinafores if they chose to wade. Even the original "Alice"—Alice Lidell—he photographed as a "beggar child," with her dress provocatively torn off one small shoulder. His photographs of nude little girls were not few; he concealed them, though, and never pasted them up in the numbered and indexed volumes of his portraits; but many have survived. He even wrote to one of his illustrators: "Naked children are so perfectly pure and lovely; but Mrs. Grundy would be furious—it would never do." And, for his diary: *I had warned Mrs.——— that I thought the children so nervous I would not even ask for "bare feet." I was agreeably surprised to find they were ready for any amount of undress, and seemed delighted at being allowed to run about naked. It was a great privilege to have such a model as ——— to take: a very pretty face, and a good figure. She was worth any number of my model of yesterday.* This was neither the first nor the last time that the camera has served as an erotic tool.

Did his obsession go any further? It is doubtful; I rather suspect that the long walks were meant to diminish temptation into "the solitary vice"—it has remained a popular prescription even into our enlightened century. Yet London swarmed with many thousands of prostitutes, who practiced their trade in "houses of accommodation"—or against the alley wall, depending on price. Among these were hundreds of child prostitutes; or stranger yet, ordinary prostitutes dressed up as children. The streets were a kind of (what was extremely popular) dress-up charade; for even the most miserable wore clothes that were ragged caricatures of the gentility.

Poetry and the novel—those sprawling giants of the Victorian centuries—were affected by, and in turn, did effect some small amelioration of the age. Poems like Tennyson's *In Memoriam,* written in the months of despair at the death of his close friend Hallam, dealt with voluntary man trapped in an involuntary

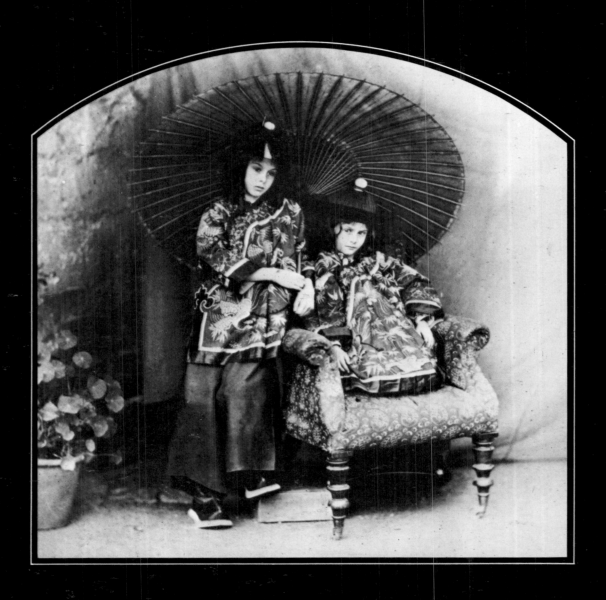

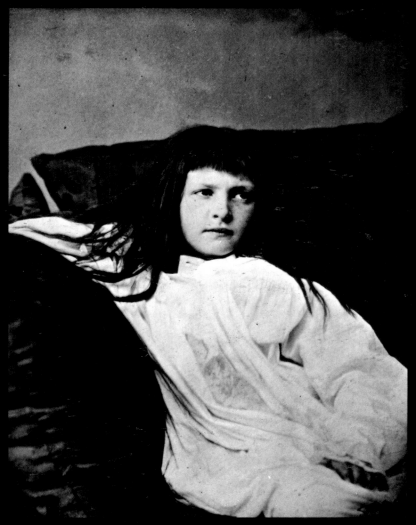

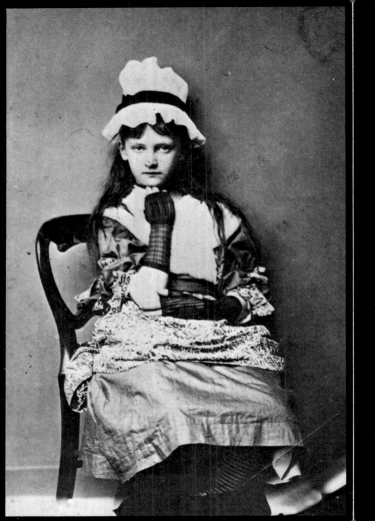
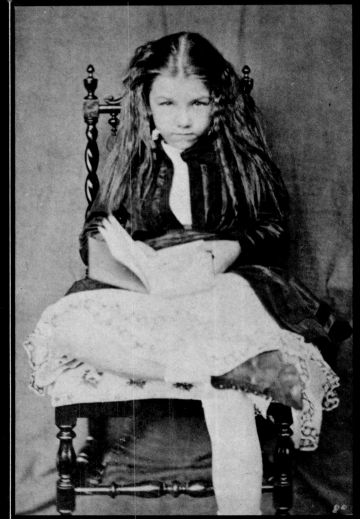

Lewis Carroll
Xie Kitchin in garden chair with Japanese sunshade,
no date
Gernsheim Collection, Humanities Research
Center, The University of Texas, Austin

universe: "Nature, red in tooth and claw, with ravine, shriek'd against his creed . . ." And such a novel as Dickens' last, unfinished *Mystery of Edwin Drood* begins with its churchly protagonist paying his weekly visit to an opium den: an allegory—one hopes, for it is not a particularly good novel—of the universal hypocrisy of his time. Could Victorian photography have had a similar moral function? Certainly it tried.

But without real success; when photography intends the universal, it achieves the maudlin. It is inherently specific, stubborn, and infinite. Which doesn't mean that a photograph of a particular individual has no generality; but that it rarely permits a purely intellectual statement; at most, it projects in us, the viewers, an emotional enlargement of itself. We meet a photograph with an immense file of experience already inside us; so we see a photographed face within the context of all the faces we have already seen in the four dimensions of our lives. Of course, precisely the same is true of the photographer who takes a portrait. The artist's equipment is not just the camera, nor even the human eye; these are only a small part of the apparatus; the greatest part lies coiled behind the vision: in the weighty machinery of experience and the emotion that is geared into it. So that is precisely how the society of any particular time produces its effect on the sensitized plate.

It happens that in mid-Victorian England, as in mid-nineteenth-century America, great social value was placed on the idiosyncrasy of the strong individual. Carlyle, in his heroic concept of history, was only expressing a common judgment. Every eccentricity was, if not liked, at least tolerated and often extravagantly admired. Naturally, one conformed to the manners proper to one's station: "If one gives up dressing for dinner," said a nineteenth-century upper-class father, "one will soon find oneself sleeping with one's cook." In fact, the nineteenth-century gentleman, as often as not, did both.

Was the woman in a Victorian family given equal privileges? If she was, it was only at the cost of deeper hypocrisies. The middle- and upper-class woman was expected to be the angelic comforter and nurse, in both senses, of her family. When her surviving children were grown and sent away to school before they were ten, she was often left with an aging husband, a large house, and a bureaucracy of servants on whom she was entirely dependent, and vice versa.

One of these was Lady Clementina Hawarden, whose photographs were seen by Lewis Carroll at a London exhibit in 1864. He bought some of her work the following day, and included it in an album of photographs he admired. They met and approved of one another's work; and indeed there is the same erotic melancholy in many of their photographs. Their friendship was brief, for she died the next year, at forty-two—an age when her contemporary, Julia Cameron, did not yet even possess a camera.

It took a woman with an especially powerful and energetic personality to burst out of her needlework frame; one of them, Julia Margaret Cameron, became, by the very force of her eccentricity, a great artist and a classic portraitist.

To be an amateur photographer was not quite the same in the nineteenth century as it is today. The skill necessary was not trivial, for wet glass plates were easily scratched or broken. So it was not a Sunday hobby, but more like an obsession; not yet an occupation, but rather a preoccupation: in which one invested all of one's best energies. Mrs. Cameron was by no means the only woman in this field. Lady Elizabeth Eastlake wrote in 1857: *Tens of thousands are now practising a new pleasure, speaking a new language, and bound together by a new sympathy . . . When before did any motive short of the stimulus of chance or the greed of gain unite in one uncertain and laborious quest the nobleman, the tradesman, the prince of royal blood, the innkeeper, the artist, the manservant, the general officer, the private soldier, the hard-worked member of every learned profession, the gentleman of leisure, the Cambridge wrangler, the man who bears some of the weightiest responsibilities of this country on his shoulder, and, though last, not least, the fair woman whom nothing but her own choice obliges to be more than the fine lady? . . . The very talk of these photographic members is unlike that of any other men, either of business or pleasure. Their style is made of the driest facts, the longest words, and the most high-flown rhapsodies. Slight improvements in processes, and slight variations in conclusions, are discussed as if they involved the welfare of mankind. They seek each other's sympathy, and they resent each other's interference, with an ardour of expression at variance with all the sobrieties of business, and the habits of reserves.*

Among the thousands of surviving prints, made and discussed and exchanged by the amateurs of that long, peaceful three fourths of an English century after the fright and carnage of Napoleon, there are some thirty large portraits by Mrs. Cameron that stand out like Stonehenge on its windy plain. One of the most penetrating and yet compassionate studies is that of Charles Darwin. He was photographed by Cameron in 1869, ten years after the moral explosion of *The Origin Of Species*. All that one knows of Darwin is

Viscountess Clementina Hawarden
Untitled, no date
Victoria and Albert Museum, London
Page 123
Julia Margaret Cameron
Charles Darwin, 1869
Gernsheim Collection, Humanities Research
Center, The University of Texas, Austin

compressed in this beautiful, somber profile: his shy inwardness; the eyes drawn back, almost as if by an effort of the will, under the great bony walls of his forehead; the worry of a psychosomatic illness that forced him to lie down in exhaustion every afternoon; the persistence of that frowning look, and the terrible sobriety of someone who assumed the obligation of looking at the truth of our human position: Christian souls evolving blindly out of warm ancestral marshes. Darwin had come to the Isle of Wight, where Cameron now lived, to recover from an illness that struck him while writing *The Descent of Man.* Cameron seized him by moral force, as she did so many of her famous and near-famous visitors, and posed him over and over until she had got what she liked. He wrote on the back of those she gave him that he liked them "much better than any other which has been taken of me."

But Cameron was equally perceptive of nonentities; though then, as in her lyric portrait of another neighbor, Eleanor Locker, her romanticism is perhaps plainer than her psychological insight. Hair, to which Cameron was particularly sensitive (she made the astronomer Sir William Herschel wash his hair before the sitting, so it would fly out into a halo of light), flows down around the beauty's face and cascades over her shoulders. What one feels in all the best of her photographs is not only spiritual truth but something more: a kind of warm and benevolent greed: a novel emotion, new to the world, which any photographer has, if he is honest, felt as he pressed the release: the peculiar thrill of *photo-possession.* You have "taken" the subject; it is yours, and forever, beyond any vagary except the decay of the paper itself.

Cameron was that sort of genius that rises to eminence on the corpses of their earlier selves. Virginia Woolf, who was her niece, wrote a marvelous essay about her; which is particularly charming because a good many of its facts are merely fancies. The truth is really odd enough. Cameron was raised in India, where her father was high in the civil service: rich positions where Englishmen lived like maharajahs. She had six sisters, all said to be great beauties; whereas she herself, as we may judge from a photograph taken by Lewis Carroll, was rather pleasantly plain, with a long thick nose and a sad, wide mouth. She married another servant of the empire at twenty-three and for years was the great hostess of Anglo-Indian society, until they returned from this fabulous exile to cold, damp England, laden with shawls, ivory, jewels, and peculiarities.

Julia Cameron was generous to the point of oddity, and spoke and wrote with great, and, it was reported, "ardent" warmth. She loved everyone overwhelmingly: her family (which included five sons and a daughter), her servants, her visitors; but insisted on equal passion—platonic, of course—in return. To Sir Henry Taylor, a somewhat less than minor playwright and poet and a very sweet and passive man with a fine soft beard, she wrote every day for years—long letters with long postscripts (she was working on a huge Anglo-Indian novel which, Taylor reported, he dreaded the day she would finish and he would have to read it). Of course, all middle-class Victorians wrote incessantly; they had a *horror vacui* at least equal to that said to be felt by God.

She and her husband eventually moved to the Isle of Wight where they inhabited several small houses at once. They were within walking distance of Alfred Tennyson, and it is suspected that Tennyson was the reason for her removal to the island. She cultivated him fiercely, and of course for his own good. As Virginia Woolf reports: "She chased Tennyson into his tower vociferating 'Coward! Coward!' and thus forced him to be vaccinated." When she was forty-eight, and her children were all adult, her husband left on a business mission to India which would last several months. To assuage her melancholy, which was often as deep as her enthusiasm, her daughter Julia gave her a wet-plate apparatus to fill up her hours. Cameron set furiously to work. Her glass plates were very large and cumbersome, but their very size and awkwardness seemed to challenge her impetuous personality. She refused to retouch: scratches, dust spots, defects of development were all left to preserve their history on the print. While Carroll's negatives were rarely bigger than 4 by 5 inches, hers were at least 8 by 10 and often 12 by 15. "I began with no knowledge of the art. I did not know where to place my dark box, how to focus my sitter, and my first picture I effaced to my consternation by rubbing my hand over the filmy side of the glass." By her own account, she learned to focus sharply and then defocus till she found the precise and instinctive balance she wanted.

These great faces, sometimes life-size, are the product of the old triangle: the intensity of the relation between Cameron and the sitter she admired, combined with the effect upon us, who see and respond to these noble, serious, frowning Victorians. Where the central relation, between sitter and photographer, was weak or superficial, we sense it immediately, and the third angle of the triangle narrows down to inconsequentiality. What could be sillier, because trivial in personal emotion, than the series that Tennyson per-

Julia Margaret Cameron
Mrs. Herbert Duckworth, no date
The Witkin Gallery, New York

Julia Margaret Cameron
Eleanor Locker (later Mrs. Lionel Tennyson), 1869
Gernsheim Collection, Humanities Research Center,
The University of Texas, Austin

Julia Margaret Cameron
Alfred Tennyson with sons Lionel and Hallam, c. 1864
Gernsheim Collection, Humanities Research Center,
The University of Texas, Austin

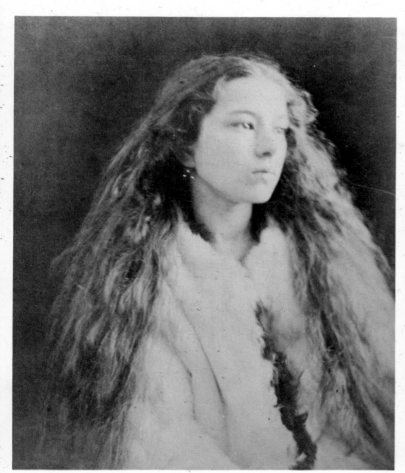 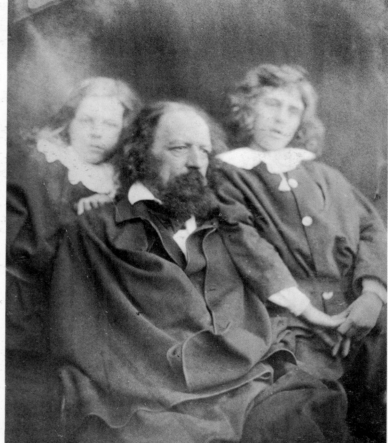

Julia Margaret Cameron
Thomas Carlyle, 1867

Julia Margaret Cameron
Henry Wadsworth Longfellow, 1868
Both, George Eastman House, Rochester, New York

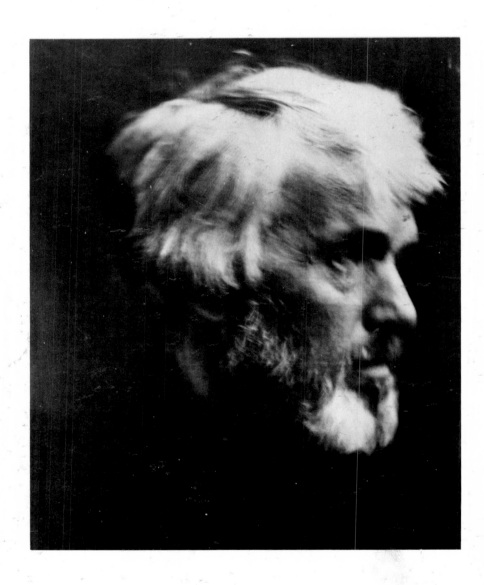

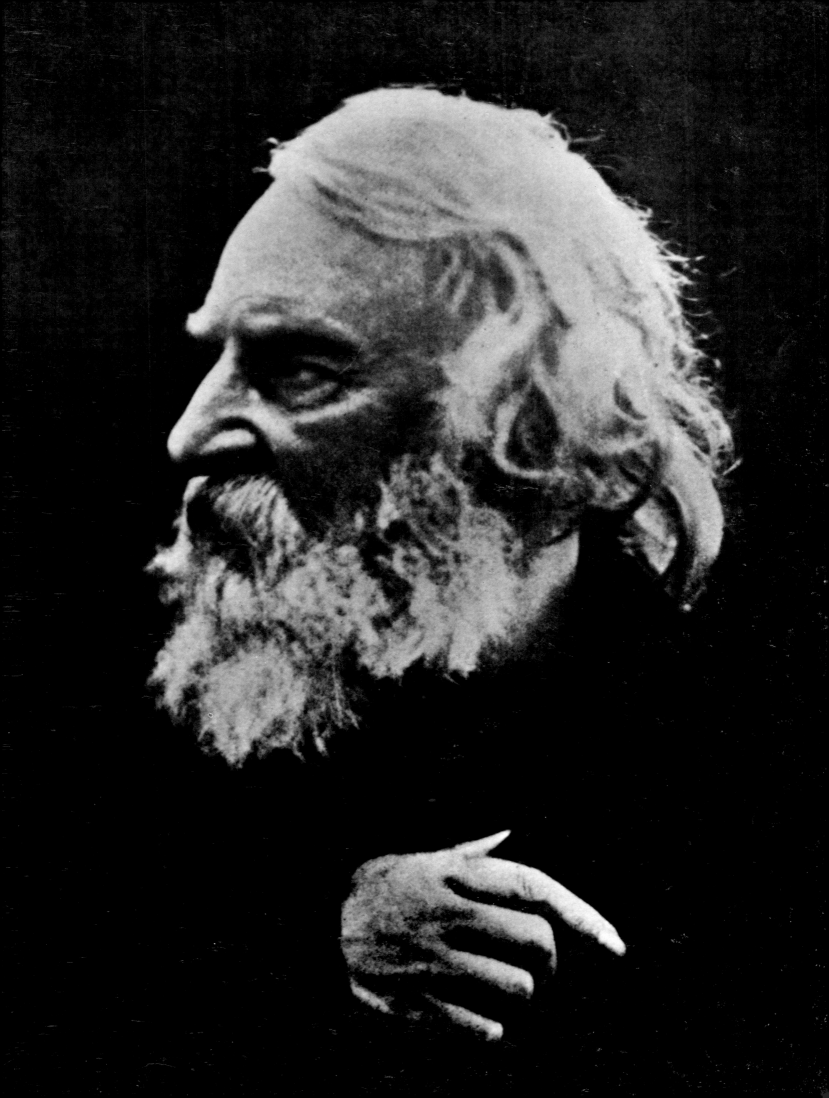

suaded her to do: these were "Tableaux Vivants," posed illustrations for his poem *Idylls of the King*, than which nothing could be less alive. Some of this suet pudding sentimentality creeps into the edges of her best photographs: one notices that Tennyson's and Browning's shoulders are draped in the same monkish blanket, which she kept in the chicken house she had converted to a studio; not Darwin, though; I could bet he refused any costume but his own.

Her direct, brutal, passionate insight was practiced on children, too. One feels that they resist, but that very resistance enters the photograph. The portrait of Alice Liddell is very fine. There is no sugar there; it is woman looking at woman; and this truth is very beautiful. So, of course, are Carroll's portraits of the same Alice, his first child-love; only we feel in his work the anguish of their relationship more than its verity; the flirtatious, grown-up child posing for the enchanted, childlike man.

English society has had a closed structure for many centuries; it was as strong in Victorian times as the castes of India; but one interesting result was that the intellectuals of any decade all knew one another. So not only did Dodgson/Carroll photograph many of the same celebrities as Cameron, which included the Pre-Raphaelites, but also most of their children. These two great amateurs were therefore destined to meet and, of course, photograph one another. Their opinions of each other were not always kind. I quote from Dodgson/Carroll's diary, the entry of June 23, 1864: *Went to the Photographic Exhibition, which was very scanty and poor. I did not admire Mrs. Cameron's large heads, taken out of focus . . .* But a month later, July 28, 1864: *Called on Mrs. Cameron, who begged I would bring over my pictures in the evening. Went over to Mrs. Cameron about nine, and found her, two sons and a Mr. Lindsay Neale. Mr. Cameron was unwell. She showed me her pictures, some very beautiful.* He wrote, August 3, 1864, a more considered opinion to his sister:

My Dear Louisa,

. . . In the evening Mrs. Cameron and I had a mutual exhibition of photographs. Hers are all taken purposely out of focus—some are very picturesque—some merely hideous—however, she talks of them as if they were triumphs in art. She wished she could have had some of my subjects to do out of focus—and I expressed an analogous wish with regard to some of her subjects. The next 2 or 3 days were very enjoyable, tho' very uneventful. I called on Mrs. Cameron on Monday and told her I felt rather tempted to have my camera sent down here, there are so many pretty children about . . .

These two splendid, complex people, the shy, sweet, secretive Carroll and the bold, warm-hearted Cameron, were, in spite of their contrast, very typical of the English intellectual of their time. One, the product of exoticism of the empire, returned to Ceylon to live the rest of her life, photographing local types and potentates; dying at last, in her curtained bed, upon the whispered word: "Beautiful!"; the other, the closeted don, who gave up photography for the last long years of his life, grew slightly and whimsically mad, and fell victim to a curious hallucination of "moving fortifications" before his death in 1898: the end of a prodigious age.

Julia Margaret Cameron
Florence Fisher, 1872

Julia Margaret Cameron
Alice Liddell (daughter of Henry George Liddell,
Dean of Christ Church, Oxford) , no date
Both, Gernsheim Collection, Humanities Research
Center, The University of Texas, Austin

Intellectual Barricades: The Nineteenth Century in France

In 1869, the extraordinary French diarists, Jules and Edmond de Goncourt, made a couple of ironic entries on the mutually boring and irritating relationship of art and government:

Wednesday, April 28th
At the Princess's. As a touching surprise for the Emperor, who was coming tomorrow, she has ordered the court improvisor to read aloud a piece of prose written by the prisoner of Ham [this was Napoleon III, who was Napoleon's nephew, and who had, after committing the crime of failure at a *coup d'état*, been sentenced to life in the fortress of Ham in western France] *on the return of his uncle's ashes—a rather substantial piece of prose. In the course of the day, Gautier hastily wrested ninety lines from his muse.* O platitudo!

April 29th
We arrive at 11:30. The Imperial ceremony is over. As we sadly shake hands with Gautier, who missed out in the Academy election today, he says: "Oh, I am quite consoled. My thing went over very well. We saw the Emperor weep!"
Poor naive fellow, who was led to compromise himself publicly by such obvious flattery, and whom the august mouths scarcely thanked, the Emperor having spent the rest of the evening talking about the cultivation of pineapples, and the Empress talking for a whole hour with Dumas fils *about his repentant prostitutes.*

This domestic scene was the mirror and the consequence of the new French middle-class prosperity. Napoleon III was a little man, not so much stupid as small-minded. He had come to supreme power in France by a series of historical stumbles. For after the defeat and exile of the grandiose and bloody Napoleon I, the frightened kings of Europe imposed a king on France: he was the brother of Louis XVI, and an aging nonentity who had lived in England since the Revolution. Managing to offend all classes except the extreme right, he was overthrown when republican forces marched on Paris in 1830. He was succeeded by one of his own officials, Louis-Philippe, who was made, after the English fashion, a constitutional monarch.

Simultaneously, very much as in England, there began an extraordinarily swift development of industry, based as usual on a twelve-hour day, seven-day work week. Early riots were put down with sabers and cannon; but by 1848, when Nadar and his friend Honoré Daumier were drawing cartoons for the greatly popular and bitterly antigovernment weeklies, workmen from the suburbs of Paris rose in revolt and defended their narrow, cobblestoned streets with

barricades. Louis-Philippe resigned, and there was a brief republican government, crushed a year later in the invasion of Paris—by the French army. A little monster of a man, a nephew of Bonaparte himself, with waxed moustaches grown to a point of fanaticism, was elected president. Three years later, he abolished the Assembly, and concocted the only brilliant notion he had ever had in his life: he held a popular plebiscite to approve of the fact that he was to make himself emperor.

These bloody and contemptuous shufflings enraged the intellectuals of Paris, but the official censor, the police and the military, now enforced Napoleon III's idea of public art. It is a curious fact that both the extreme left and the extreme right share the common belief that art is powerful; it is a flattering illusion that has cost artists their freedom and even their lives.

Writers and painters in mid-nineteenth-century France were, through the Academy, closely connected to the government. Because they relied upon it for jobs, pensions, commissions, and—for no profession except the military is as vain as the artist—for medals, ribbons, and sashes. The graphic arts were especially conscious of this servility. Its practitioners even gave themselves a name—*"le juste milieu"*—whose work combined naturalism with narrative; in practice, their work glorified French history so that even the illiterate might read it. Théophile Gautier, the sad poet laureate of Napoleon III, had once proclaimed a thundering future for this movement: *We should like to see organized great camps and armies of painters, working at speed but immaculately, producing the vast works which will decorate the buildings of the Republic—the buildings we dream of, designed for the gigantic life of the future. . . . No doubt individualism would suffer, and a few would lose their little originality, their mastery of details; but the great works of art are almost all collective.*

Napoleon III had the acquisitive habits common to the French bourgeois; his political brain was neatly separated from the financial. To the painter Courbet, a radical and unregenerate republican and socialist, he made (in 1851) a generous offer to buy Courbet's self-portrait, but was refused; when, two years later he saw Courbet's "The Bather" ("This heap of matter," said a critic, "cynically turning its back on the beholder"), Napoleon III struck the painting with his whip—a somewhat ambiguous gesture. Like any well-to-do Frenchman, he kept a mistress; he combined his political interest in Italian nationalism with an affair with the pretty Italian Countess de Castiglione, whom the photographer Adolphe Braun made enticing and immortal by masking her with an empty portrait frame.

Braun, who first worked as a designer for a fabric house, had become famous for his still lifes, views of architecture, and Swiss alpine landscapes. But he also took ordinary street scenes in Paris, and became a fashionable photo-portraitist, working with lenses stopped way down, and consequently with rather stiff poses of up to half an hour. He was one of the few photographers in government favor, and made a curiously gloomy triptych of "The Court of Napoleon III at Fontainebleau on June 24th, 1860." Napoleon III, instead of being posed, robed or uniformed on a central throne, is depicted in a little rowboat at the lower right. The three-part portrait might just as well have been called "A Sad Picnic," and perhaps this was Adolphe Braun's little joke on the postures of banality.

Another favorite of the court was Charles Nègre, who from 1850 on had begun to photograph architecture, but purely as studies for his paintings. But after seeing—and photographing—the common spectacle of a horse falling dead between the shafts of a wagon outside his studio, he extended his work to street scenes as well. In 1859, the Empress Eugénie commissioned him to photograph scenes in a convalescent hospital for injured workmen, and these revealed the painter's eye for the glowing texture of glass and porcelain and metal, where the patients were no more than white uniformed props.

The freshness of the medium tempted practitioners of various origins. One remarkable photographer was Felicien Bertall, the pseudonym of the Vicomte d'Arnoux, a pupil of and assistant to the pioneer daguerreotypist Hippolyte Bayard; and there were sculptors like Antoine Samuel Adam-Salomon, who only devoted a couple of hours a day to portrait photography: he draped his sitters in thick folds of velvet, set them on a revolving stage to catch the right angle of light, and retouched his negatives (a practice as early as 1855, says the photo-historian Helmut Gernsheim) with a painter's brush.

Melandri, a somewhat later and entirely professional portraitist of the 1860's and '70's, was the most popular of them all—and the least known. In 1876 he photographed Sarah Bernhardt, in a pose suggested by herself, wearing a pants suit and leaning toward a portrait bust done by herself. The softness of focus reminds one of the later Photo-Secessionists' work; and the effect is, like theirs, very "painterly." If the work of all these men was markedly different, it was really because they were imitating different kinds of painting.

Mayer et Pierson
Napoleon III, c. 1860
George Eastman House, Rochester, New York

Adolphe Braun
The Prince Imperial with his father Napoleon III,
no date
The Metropolitan Museum of Art, New York,
McAlpin Fund

Adolphe Braun
Countess Castiglione, seated, no date

Adolphe Braun
Countess Castiglione, holding oval picture
frame up to her eye, no date
Both, The Metropolitan Museum of Art, New York,
gift of George Davies

Felicien Bertall
Paul de Kock
From *Galerie Contemporaine,* Paris, 1877
George Eastman House, Rochester, New York

Antoine Samuel Adam-Salomon
Jules Armand Stanislas Dujaure
From *Galerie Contemporaine,* Paris, 1878
George Eastman House, Rochester, New York

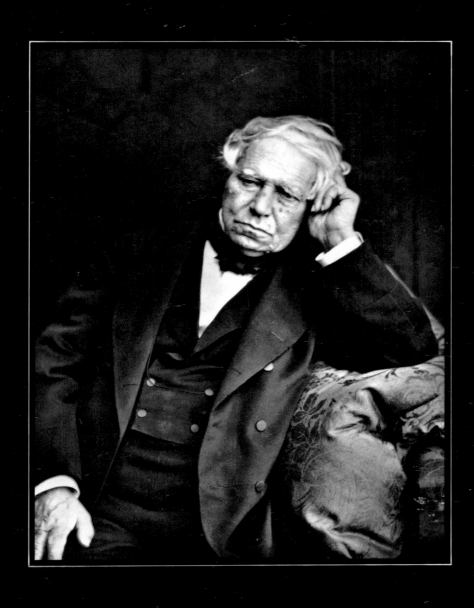

Melandri
Sarah Bernhardt in *"Ruy Blas"*
The Theatre, No. 11, new series (woodburytype)
The Art Institute of Chicago

Melandri
Sarah Bernhardt with her self-portrait bust, c. 1876
Gernsheim Collection, Humanities Research
Center, The University of Texas, Austin

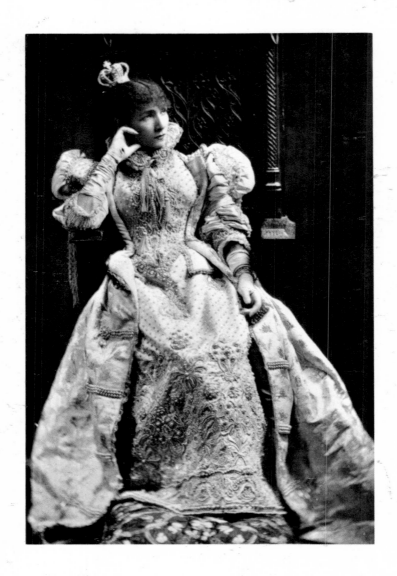

Nadar
Portrait of an old woman, 1855
Caisse Nationale des Monuments Historiques
et des Sites, Paris

143

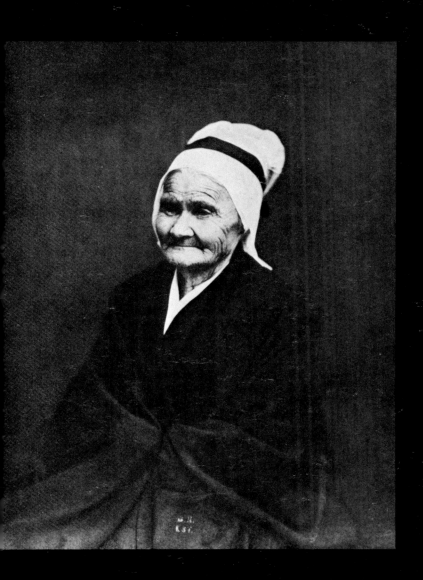

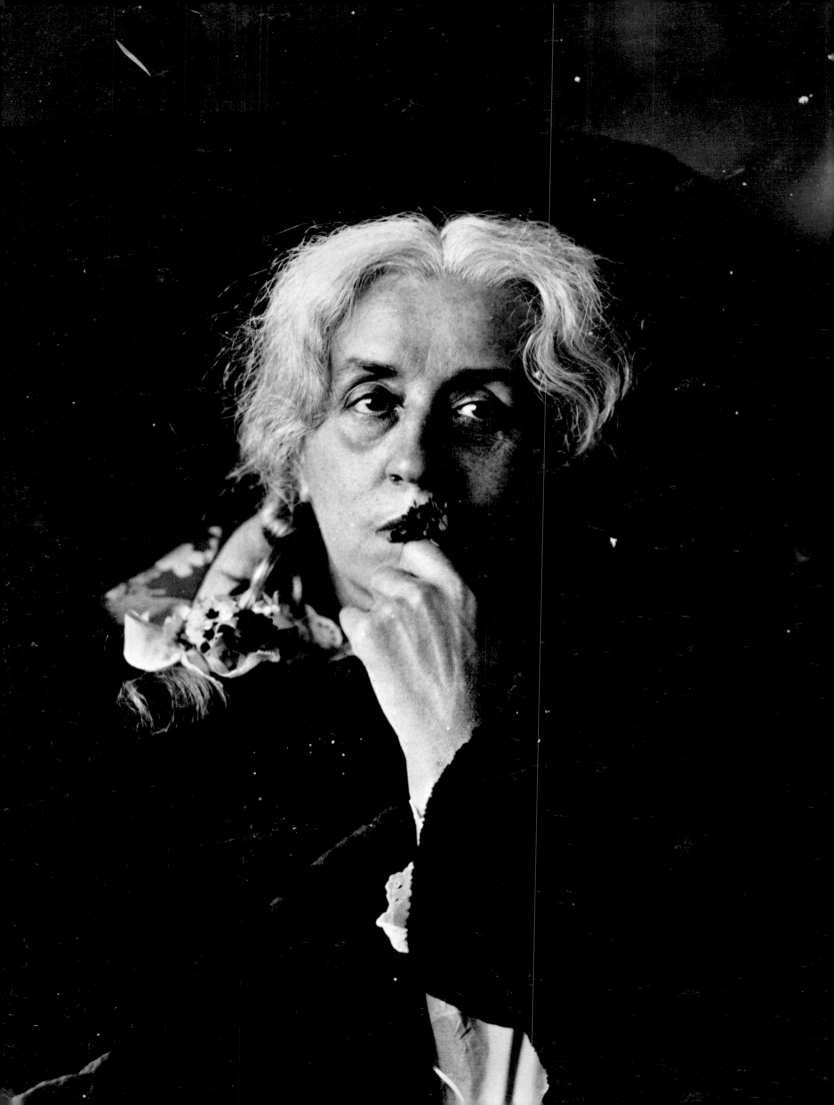

photographs in the next two years which were made with no other aim than pure affection.

One of them is that of his mother. She had been Nadar's father's mistress for a number of years, and only married him when her son was eight years old and there was already a younger brother, Adrien. His mother, white-haired by now (1854), bourgeoise certainly, but with the sensibility, the sidelong look of a beautiful woman who is face to face with the evidence of her age; she holds a tiny bunch of violets to her lips, and wavelets of dark, velvety cloth frame her hand and her head. Another old lady, whose name has been lost, resolute, cheerful, toothless, and wearing a peasant's white cap, is draped, again, in the same dark folds; the marvel here is Nadar's instinct for the photographic tension between flaxen white and woolen dark. These two photographs were plainly not taken for monetary reasons; and that is just as true of the ones for which he was paid. People were one of his obsessions, and Paris was full of the most extraordinary figures.

In 1854 he published, after nearly a year's work, an immense lithograph which he called the Panthéon Nadar. There is no evidence that he did photographic studies for any more than a small percentage of the 270 celebrities drawn (one is tempted to add: and quartered) thereon. Most are sadly unknown today. But we do recognize Balzac, Victor Hugo, the two Dumases, Doré, Delacroix, Proudhon, Alexander Humboldt, the brothers Goncourt, Baudelaire, and Berlioz. He drew them in the current satiric style: very large heads on exact, but shrunken bodies; the only exceptions are the drawings of ten bodyless women borne on a tray. This procession of the great and the merely famous coils down toward a bust of the goddess George Sand; this homage is not satiric—he admired her as much as he admired Balzac.

This immense drawing also depicts a plank nailed to a post, on which is inscribed the following characteristic legend: *To the gentleman whom I regret assuredly in advance not to have known and who, on the 24th day of the 3rd month of the year 3607, will race to the auctions like a lost dog, trying to purchase at a fabulous price* [à prix d'or] *this work, which had become unobtainable and yet indispensable to him, in order to complete his great work on the historic figures of the 19th century.* The wry tone of this inscription reflects more than Nadar's character. He had time for a work of this size and ambition because other sources of income had become downright dangerous. A whole series of bloody convulsions shook French society, and especially the life of Paris. France, by the 1850's, became a dangerous place for a caricaturist

Nadar
Therese Tournachon Maillet, his mother, 1854
Caisse Nationale des Monuments Historiques et des Sites, Paris

to work. Barricades and cannonades had polarized the intellectuals. Napoleon III who had, in prison, written a vaguely socialist tract, now sat firmly fixed on the narrow pinnacle of the extreme right.

It was in this stifling atmosphere that Nadar, broke and about to marry a girl from a respectable middle-class family, turned to photography as a way of life. The immense lithograph he had drawn made him famous in Paris, but it did not support him. Thus the photographic portrait studio, which he had rented merely as one facet of his multifarious life, now became the chief source of his livelihood. In 1856 he was working, unsuccessfully, on a device he called the "acoustic daguerreotype"—a mad concept that Edison was to make only too real. By 1857, he had managed to indulge a new obsession, and build and launch an expensive balloon.

The camera and the contemporary collodion wet-plate method were as congenial to Nadar the lithographer as a similar combination was to the lithographer Niépce. He began by photographing his friends. They were the elite of Paris and therefore, in their opinions, of Europe. It is interesting to parade them in our own pantheon, for each of them was remarkable in appearance and character.

Mikhail Aleksandrovich Bakunin is a figure out of Turgenev or Gogol: a careless, heavy, bearded, eastern-lidded man, holding in his bulbous fingers a cane covered with dreadful knobs. Richard Wagner described his meeting with him in 1844: "Everything about him was colossal. His bulk gave the impression of primitive force . . ." He was, in fact, born a Russian aristocrat, but he supported the German revolts of 1848 and got sent to Siberia. He escaped, and elaborated his doctrine of romantic violence and voluntary collectives as a replacement for government. These ideas were in direct conflict with the centralist, statist opinions of Marx; Bakunin lost the intellectual debate, and was actually expelled from the First Communist International—an outcome he himself must have regarded as utterly logical. From a contemporary journalist at the time of his expulsion: "Laughing, he rated the scale of human happiness thus: first,—the supreme felicity,—to die fighting for liberty; second, love and friendship; third, science and art; fourth, smoking; fifth, drinking; sixth, eating; and seventh, sleeping."

Here we have a complete and consistent character: a Falstaffian anarchist (indeed Falstaff had much the same sentiments—in reverse); and what is amazing is that we can read nearly the identical traits in Nadar's photograph taken when Bakunin was at the height of his influence.

Charles Baudelaire knew both Nadar and Bakunin; but for Baudelaire, refined intellectual though he was, ideas such as Bakunin's, or Pëtr Kropotkin's—all of them photographed by Nadar—simply stuck in the mind, hardly understood, far less digested, and merely served as points of inflammation for Baudelaire's opinions. He and Nadar were of almost equal age, and had been friends from their earliest days in Paris. Here is part of a begging letter from Baudelaire, dated Sunday, September 18, 1853, a time when Nadar had just begun to take up his new profession:

MY DEAR NADAR,

Try, try *to meet me tomorrow, when I intend to come and find you in your new life and talk to you about my miserable troubles. The truth is that if you were able, not to help me fundamentally—I don't think you could do that—but in a small way—you would perform a brilliant deed. Ah!* Profoundly *would be too beautiful* . . . It is a shock, of course, to realize that even the poets of wickedness and vice do occasionally need money.

Nadar photographed his friend at least five times. The first was probably in 1854, when Baudelaire was thirty-three; he wears a great coat with the collar up, and with one hand thrust Napoleonically between its buttons. He has dark hair, the too-high forehead of the partly bald, a set, almost grim mouth, and the look of an intense ego determined to have its own way. In all of his photographs we have the strange impression that this poet, probably the greatest of his time and language, is also a petulant child. A year later, Baudelaire was photographed in a somewhat more relaxed mood; he appears almost to be dreaming; this reminds one that he was already heavily committed to opium. We must remember that it was not, especially in the form of laudanum, a forbidden drug.

In 1857 Baudelaire published the only volume of his verse ever to appear, *Les Fleurs du Mal;* it provoked a national scandal, for in that curious era, people actually read and understood poetry. Yet the worst that Baudelaire can be accused of is that he confounded (like his idol, Poe) beauty with death, a harmless intellectual perversion common to all of western culture in the first part of the nineteenth century. Its source, I believe, was in reality: the prevalence of tuberculosis ("Fading Away") among the young and therefore attractive.

In 1859 Baudelaire and Nadar were still close friends:

MY GOOD NADAR:

I am like a soul in torture . . . I let my mother go on a little trip without asking her for money and I am alone . . . without a penny. Would you have the

147

Nadar
Charles Baudelaire, 1854

Nadar
Charles Baudelaire, 1860
Both, Caisse Nationale des Monuments Historiques
et des Sites, Paris
Page 151
Nadar
Eugene Delacroix, 1858
George Eastman House, Rochester, New York

charity to send me (right away, alas!) a money order for twenty francs, which I will pay back on the first of the month, if you promise not to laugh too much at this pledge . . . It was well known, and certainly to Nadar, how desperately attached, beyond the merely filial, Baudelaire was to his mother. The poet continues: There is a coffee house that, extraordinary thing, gets your journal, [Le Journal Pour Rire] so that I am happy to see parading before my eyes the folly, the injustice, the almost imbecile caresses, and finally all the bizarre stuff that I associate with the exceptional character of Nadar . . .

In 1860, when the poet was forty-nine and Nadar a year younger, he took the most famous of these Baudelaire portraits. Seen somewhat closer than was usual, the stern mouth pouts a bit, but the thin, blanched intensity of the look has little changed since 1854. Baudelaire's battles with the censor have made him famous—and infamous.

Nadar went to London in 1863, provided with letters from Baudelaire to Swinburne and to James McNeill Whistler, not to photograph them but to make arrangements so he could lecture on his aeronautical adventures. He brought with him a model for a steam-powered helicopter with two horizontal propellers, but got no support for this somewhat alarming device. That same year, in a new balloon called "The Giant," Nadar flew triumphantly across half of Europe, until the airship was wrecked outside of Bremen. Fantastically enough, it was a flight on which Baudelaire himself had been persuaded to fly, but he was off-loaded at the last moment, to save weight. What a strange companionship—the alcoholic, turned-on, brilliant, syphilitic Baudelaire, and the cheerful, handy, spry, merely intelligent Nadar!

What was it that all these extraordinary men— Delacroix, Manet, the brothers Goncourt, even the intense and solitary Cézanne—had in common with a balloon-mad photographer? The charm of an energetic personality, as ever; but perhaps something more. His lithographs were skillful though not inspired, but his photographs, from the very beginning, were marvels. Further than that, they were in gear with a new movement, a rising, powerful if vague aesthetic, in fiction as well as in painting, that had begun to dominate the intellectual life of mid-century France. It is possible that the bloody paving stones of 1848 and '49 destroyed forever the optimistic and symbolic neoclassicism and romanticism of the first one third of the century. Courbet's autobiography— he tells it in the third person—describes how his friends took him to see the work of Delacroix and Ingres at the Musée de Luxembourg: They placed him in front of the Delacroix and asked him what he thought of them. His audacious reply is quoted: "I could paint pictures like that tomorrow if I dared to." As for Monsieur Ingres, he did not understand his work at all to begin with, but later he realised that all these painters were significant and that they were all searching for a means to establish art in France. Seeing all these efforts, he said to himself: "The only thing to do is go off like a bomb across all the sub-divisions."

What was to remain after the explosion was more simply stated by Corot, in a dialogue recorded by a certain Madame Aviat: I pray to God every day that He will change me into a child, that is, that He will make me see nature and paint it like a child . . . One always wins by copying nature. And when I don't succeed in following her for as short a distance as a centimeter, I make every effort to go out and find her again . . . Nature before all.

It was an idea that animated the younger artists all their lives, but it was genuinely hated by the older generation. Delacroix, for example, who painted big, active canvases, such as "The Capture of Constantinople by the Crusaders," wrote in his famous journal, on April 15, 1853: . . . I went to see Courbet's paintings. I was amazed by the vigor and three-dimensional quality of his main picture ["The Bathers"], but what a picture! What a subject! The vulgarity of the forms wouldn't matter; it is the vulgarity and futility of the thought that are abominable . . . What do these two figures mean? A fat bourgeoise seen from the rear, entirely naked except for a carelessly painted scrap of rag covering the lower part of her buttocks, is stepping out of a little area of water that doesn't seem deep enough even for a foot bath. She is making a gesture that expresses nothing, while another woman, whom one supposes to be her servant, is sitting on the ground taking off her shoes. We see the stockings she has just taken off; one of them, I believe, is only half off. Between the figures there is an exchange of thoughts which we cannot understand . . .

The extraordinary thing about this comment is that the painting is actually as romantic as Delacroix, while Delacroix criticizes it from an almost realist point of view. Much the same bad opinion was expressed by the poet Gautier and by the elder Dumas, which, considering the work they did, was only natural.

But it was also held by Nadar's friend Baudelaire. He was a constant and prolific critic of painting, and wrote diatribes against realism as late as 1859— though he refrained from attacking Courbet himself. The two men were complete opposites and great friends; Baudelaire actually lived in Courbet's home for a considerable time. Yet in 1846, in the course

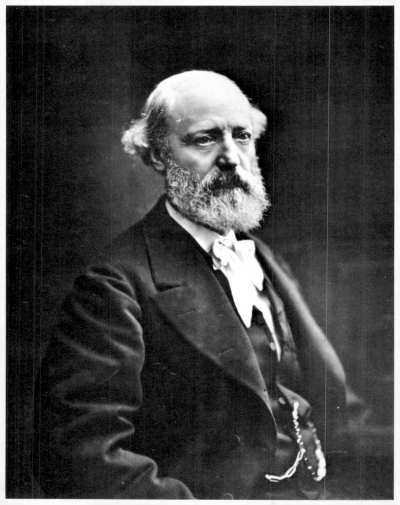

of an article on the official Salon of that year (he managed to do one almost every year on the current official exhibition), Baudelaire wrote: *Have you ever felt the same joy as myself upon seeing a guardian of the public repose—a constable, the true army—beating a Republican with the butt of his musket? And have you, like me, said in your heart: Hit him, hit him harder, go on hitting him, policeman of my heart?*

This passage can only be understood, if at all, if one realizes that the aesthetic doctrine of realism was closely associated with a conscience about the political and social crises of the time. Nor was Baudelaire completely contemptuous of dramatic events of the mid-century. In the great and violent demonstrations of 1848, he marched with the workmen pouring out of their suburbs, and he shouted, "Mort au Général Hupick!"—perhaps because the poor, forgotten General was guilty of marrying Baudelaire's widowed mother. Delacroix, by 1855, had honestly changed his mind, especially about Courbet's very large painting, "L'Atelier," which had been rejected by the Salon of that year, as usual: *I discovered a masterpiece in his rejected picture. I could not tear myself away from it. In rejecting this picture they have rejected one of the most striking works of our day. But he is not the sort of fellow to be discouraged by so little.* Incidentally, this painting has, among all the other figures, a nude model watching Courbet at the canvas; and this nude is derived from a photograph which Courbet borrowed from the collection of his earliest patron, the millionaire Alfred Bruyas.

All of these friends—the lean, aristocratic Delacroix; and the easy intellectual Corot; both Dumases, the father fat, frizzy and jolly, and the son slouching and morose; the dark, opinionated Courbet; and the fat, sloppy Gautier—were seized and photographed one by one through the lens of the endlessly video-greedy Nadar. It was a century, in France as in England and the United States, when the middle classes were pushing furiously toward the top. One of the most interesting consequences of this social change was the amused adoration that both men and women had for strong-willed, eccentric, boldly colored personality. No wonder it was a golden age for portraiture; and especially photo-portraiture, where less is disguised and more is revealed—to ourselves, certainly, viewing them more than a century later—than either the photographer or the sitter can possibly have intended, or even, perhaps, really knew.

Most, if not all, photographs have a realistic aesthetic; but it is modified or even distorted by quite other conceptions: for example, in Nadar, by a satiric and yet affectionate romanticism. Nadar's bent was formed by his earliest intellectual impressions, which were those of the bohemian artist of the early 1840's in Paris. Café life of the time was dominated by the personality of a man named Henri Murger, author of *Scènes de la Vie de Bohème;* it had a point of view that became amazingly persistent: the self-indulgent, antibourgeois, fiercely independent pose (except for monthly tribute from their families) of the young artist and poet.

We can see the clash between the realist and the bohemian views of the world beautifully synthesized by Nadar in his numerous photographs of George Sand. To what degree do they represent the "real" woman, born Amandine Aurore Lucie Dupin, Baronne Dudevant? How can we separate her true character from Nadar's idea of her character? And how would these photographs speak to us if we did not know that Nadar was sixteen years younger than her, and adored her? Certainly there are details which are characteristic of George Sand and not of Nadar. For example, she did really—in the photograph in which she wears that curious, loose, two-piece, narrowly striped dress and man's fancy cravat—choose to dress exactly that way. Yet in another photograph, Nadar draped over her shoulders a velvet studio prop. Also, he has impressed his own view by having her turn her face, sweet with a certain kind of successful middle age, so as to reveal her conventionally sleepy eyes and sensuous half-smile and the torrent of curly, dark, Mediterranean hair. So Nadar's admiration, out of a real person, has made a "real" selection. It is truthful, but it may not be the whole truth. For Baudelaire had a different view: *No need to believe that the devil tempts only clever men. Without doubt he scorns imbeciles, but he doesn't scorn their cooperation. On the contrary, he puts his greatest hope in such as these.*

Look at George Sand. She is above all, and more than anything else, a great fool, but she's possessed. And the devil has persuaded her to rely upon her good heart and her ordinary mind, so as to persuade all the other great fools to trust in their good hearts and ordinary minds.

I cannot think of this stupid woman without a shiver of horror. If I meet her, I cannot abstain from hurling upon her head a tubful of holy water.

George Sand is one of those old ingenues who don't want to leave the stage.

Finally, I have read a preface in which she pretends to be a true Christian who nevertheless cannot believe in Hell.

She's got good reason to want to suppress Hell.

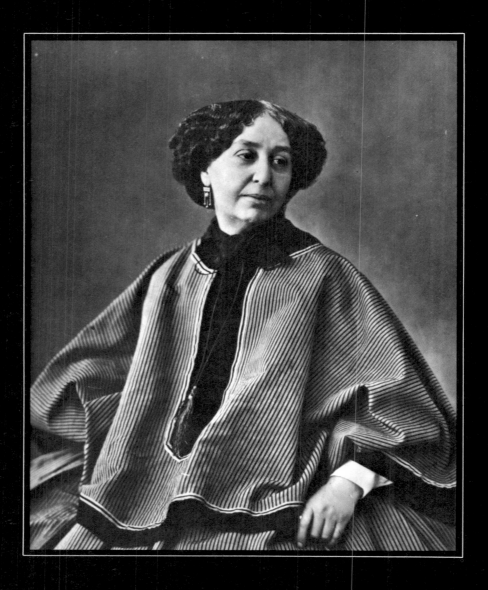

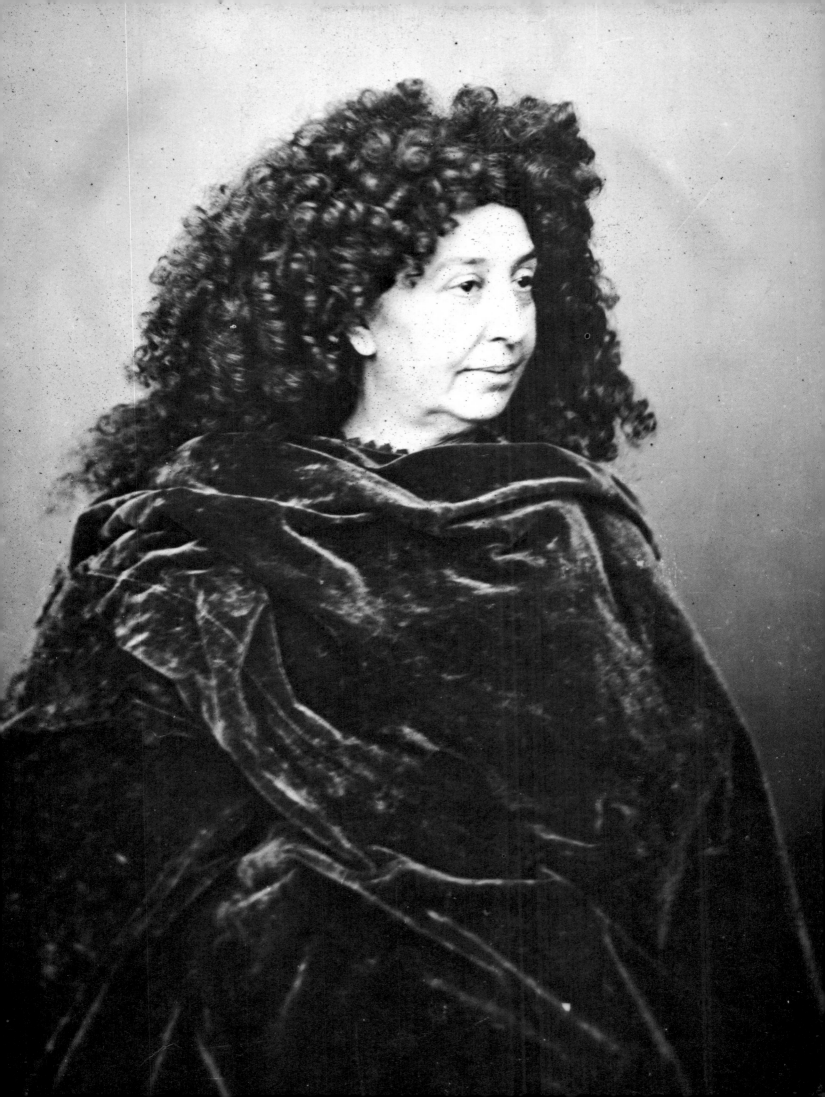

Nadar, as we know, was a discreet man of the left; he once undertook a secret mission for the Polish national cause. And there is no doubt that Nadar's veneration for George Sand was based on their common social conscience—"She had a pen like a sword," and a number of her eighty or so popular novels depicted the lives of the poor peasants in the district where she was born. She wrote: *If Communism means a violent conspiracy to impose a dictatorship, then I am in no way a Communist. But if Communism means the desire and the wish, using all the lawful and acknowledged methods to arouse the public conscience, that the revolting inequalities of the very rich and the very poor should come to an end today and give place to the principal of true equality; then, yes, I am a Communist.* What was possibly of equal importance to Nadar was the lack of hypocrisy in her personal life: for her affairs with the famous, including the self-exiled Chopin, who had been introduced to her by Liszt, had intersections with Nadar's circle.

Sand, like everyone else he knew, from the amiable Kropotkin to the increasingly mad Baudelaire, admired Nadar a good deal. She wrote: *Among the initiates, the ardent vulgarisers and martyrs who demean truth to the status of a demonstration, Nadar was neither a scientist nor a dreamer, but a great natural man, with a firm will who brought his word and the fruit of his reflections into a time of confusion . . .*

All this was probably true, but it seems a little one-sided. Nadar, after all, was a wit, a balloonist, an inventor, an eccentric who had a passion, unusual at that time, for the color red.

While Nadar was to some degree a flamboyant creation of himself, there was a second man, who was as great, or even greater, a photo-portraitist working quietly and modestly at the same time. All intellectual worlds are small, and the two men knew one another; Nadar, in his account of his photographic life, praises Etienne Carjat. The latter, of his long life (1828–1906) spent only twenty years at photography, and then only when he had an interesting subject, for he was not dependent on his studio for a living. He wrote, late in his career, a bit of doggerel on the profession:

Lament of a Photographer

*If for a lucrative business
You want to give up painting,*

*Don't choose the lens:
It's an instrument of torture!*

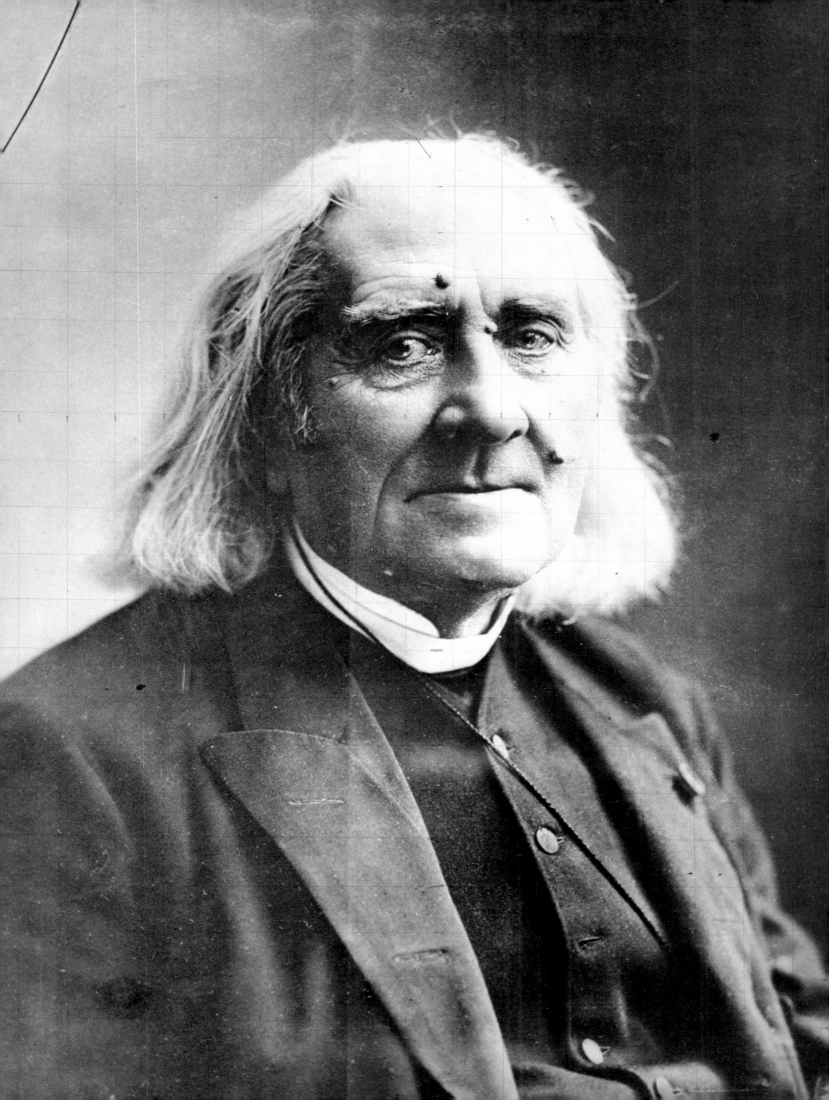

It's two crystal discs
Enclosed in a long copper tube
Point straight to the hospital,
and I try hard not to follow.

Rather make yourself a police spy, a deputy sheriff,
Bear-trainer, wrestler, acrobat—
If you don't want to finish your days
In a garret a long way from the Bank.

Make yourself a Quaker, a Mormon,
Or even a buonapartisan
But never a photographer. Oh no!
The lot of the convict is less sad. . . .

Carjat was an actor and playwright, and a caricaturist like Nadar and Bertall; he was a close friend of the great Gavarni, and the editor of a satirical magazine for a couple of years. Though he specialized in theatre, the circle of his friends was quite as wide as Nadar's, and indeed in many instances identical. Courbet wrote him:

MY DEAR CARJAT—
As you know, I wish you well, you are my confidante in matters of love, my photographer, my biographer, my friend.
The lady from Saintes ardently desires the photograph you took of me . . .

His portraits of Courbet are, in fact, reciprocally affectionate. Nevertheless, Carjat was quite capable of vivisection. Where Nadar was often content with a brilliant and powerful image, Carjat cut a lot deeper. His portrait of Henri Monnier, a minor writer and artist who illustrated the classic Fables of La Fontaine, reveals Monnier as a bloated, snuff-eating clown. The truly imposing Rossini (Nadar photographed him, too) does indeed impress upon the plate his massive good nature, but Carjat does not spare us the scars of Rossini's career: the swollen jaw and the indrawn mouth. Here is proof, once more, of the obvious: that the personality of the photographer himself alters one side of our familiar triangle of sitter, portraitist, and viewer.

Carjat's portraits of Emile Zola reveal the fierce and erratic and yet obsessive quality of this genius of naturalism; and his photograph of Alexandre Dumas shows us the smug and romantic pen-pusher. So the contrast between Carjat and Nadar is not in photographic technique but entirely in the characters of the photographers.

That is particularly evident when we look at Nadar's photograph of the great, erratic ("the divine") Sarah Bernhardt. This very pretty and very determined young lady managed to overcome even her early mediocrity; she dared to play Hamlet in *Hamlet;* and when she was crowding seventy, sick, vain, with an amputated foot, she carried her coffin with her as one might a wardrobe trunk and toured Europe and America in final triumph. But Nadar's portrait of her, taken when she was twenty-one and hardly known, sees her as simply beautiful, naive, and sensuous. It is Nadar's stubbornly romantic view of women; he has draped her body, below a frank revelation of white shoulder, with the tasseled cloth of a curtain pulled down from the studio window.

Similarly, Nadar's veneration for Victor Hugo produced a series of photographs that are a good deal less acerbic than the contemporary view, by the revolutionary Michelet, who pictured Hugo "not as a titan, but as Vulcan, a gnome . . . a creator and lover of monsters. . . . Hugo has strength, great strength, whipped up and overwrought, the strength of a man constantly walking in the wind and taking two sea baths a day."

Nadar's view of Hugo came from a long association. He had first gone, in 1853, to Hugo's home on the island of Jersey; he went to make not a photograph but a pencil sketch in preparation for the first Pantheon Nadar. The first photograph he took of Hugo was on the occasion of a great banquet in Brussels, in 1862, to celebrate the publication of *Les Misérables.* Hugo was then sixty-two; always a simple, broadly human man, he now has, in this photograph, the quiet ease of the man whom public acclaim has finally convinced that he is a genius; he approaches the last decades of his long life with a kind of calm, sad patience.

Nadar photographed him again in 1883, and got the following note of appreciation:
Tuesday
I have received your splendid print. Thanks and bravo. You've succeeded in everything, even with an old pumpkin-head like mine . . .

Nadar no longer focuses with the icy sharpness that was his almost invariable custom. It could not have been merely to conceal from the viewer the ravages of Hugo's age; for in Nadar's photograph of Liszt, he does not spare us the famous wens on the face of one who was the romantic fantasy of every middle-class woman in Europe, the very image of four-handed love at the piano. No, the softness of light and focus in his portrait of Hugo must certainly have been intentional: an attitude expressed by technical means; a sign once more of Nadar's remarkable sensitivity to his sitters.

One day in 1886, Nadar got a letter by messenger from Hugo's housekeeper: "Thursday, 1:30 AM.

Etienne Carjat
Henri Monnier
From *Galerie Contemporaine*, Paris, 1878

Etienne Carjat
Gioacchino Antonio Rossini, c. 1868
Both, George Eastman House, Rochester, New York

Etienne Carjat
Pierre Dupont
From *Galerie Contemporaine,* Paris, 1878

Etienne Carjat
Gustave Courbet
From *Galerie Contemporaine,* Paris, 1878
Both, George Eastman House, Rochester, New York

Etienne Carjat
Alexander Dumas
From *Galerie Contemporaine,* Paris, 1878

Etienne Carjat
Emile Zola, no date
Both, George Eastman House, Rochester, New York
Page 166
Nadar
Victor Hugo, c. 1883
Caisse Nationale des Monuments Historiques
et des Sites, Paris

Come at once." Nadar immediately packed his camera and the necessary boxes of chemicals and went with his son Paul to Hugo's house. In the slanting early morning light from the bedroom window, he photographed the dead man—in profile, his beard totally white at last, and wearing the thin, clean, white shirt in which he would be buried.

Nadar's era had already died: in giving birth to another. In painting, the Impressionists were now fashionably hated. It is an interesting problem to determine what influence this vogue of photography had on avant-garde artists. It is often said that the Impressionists gained from photography their interest in every nuance of light, shade, and weather. If there was such influence, it was subtle and unconscious. Nadar sympathized with the Impressionists because he admired their revolt and was excited by the obloquy with which they were greeted. In 1874, he loaned them his studio building (painted red!) to mount a historic exhibition.

But Nadar's time was destroyed by the harsh events of social history. The marching, shouting crowds of social unrest in the 1830's; and in 1848, the stone streets used as battlegrounds, echoing the blast of cannonfire directed against tenements; all culminated in 1870 with the overthrow of Napoleon III. He had just been defeated in his war against the Prussians, and the revolution was driven as much by injured national pride as by the frightful lives of the poor. The subsequent republic was almost immediately invaded by the Germans, who besieged and strangled Paris early in 1871. A second revolution, from below, threw the middle classes out of power; and in March of that year, the mingled and often contradictory ideas of the Frenchman Proudhon, the Russians Kropotkin and Bakunin, and the German Marx were put into practice. The French army, severely beaten by the Prussians, had a much easier time with the poorly armed Communards of Paris; that innovative government fell in late May. A conservative government was restored, and its position secured by the army with summary executions. I quote from the journal of the Goncourts, kept now by the surviving brother, Edmond: *I go by carriage into the Champs Elysées. In the distance legs and more legs running in the direction of the broad avenue. I lean out of the door. The whole avenue is filled by a confused crowd between two lines of horsemen. I get out and join the running people. The attraction is the prisoners who have just been taken at the Buttes Chaumont marching in fives, with an occasional woman among them. "There are six thousand of them," one of the escorting cavalrymen tells me. "Five hundred were shot at once." At the*

head of this haggard multitude marches a nonagenarian on trembling legs.

In spite of the horror you feel toward these men, the sight of the lugubrious procession is painful; among them you see soldiers, deserters, wearing their tunics inside out with grey canvas pockets bulging around them. They seem already half undressed for execution. . . .

I go back to Le Chatelet by the quay. Suddenly I see the crowd head over heels in flight like a mob being charged on a day of riot. Horsemen appear, threatening, swords in hand, rearing up their horses and forcing the promenaders from the street to the sidewalks. In their midst advances a group of men at whose head is an individual with a black beard, his forehead bound with a handkerchief. I see another whom his two neighbors hold up under the arms as if he did not have the strength to walk. These men have a special pallor and a vague look which remains in my memory. I hear a woman shout as she takes herself off: "How sorry I am I came this far!" Next to me a placid bourgeois is counting: "One, two, three. . . ." There are twenty-six of them.

The escort makes the men march on the double to the Lobau Barracks, where the gate closes after them with strange violence and precipitation. I still do not understand, but I feel an indefinable anxiety. My bourgeois companion, who had just been counting them, then says to a neighbor:

"It won't be long, you'll soon hear the first volley."

"What volley?"

"Why, they're going to shoot them!"

Almost at that instant there is an explosion like a violent sound enclosed behind doors and walls, a fusillade having something of the mechanical regularity of a machine gun. There is a first, a second, a third, a fourth, a fifth murderous rrarra—then a long interval—and then a sixth, and still two more volleys, one right after the other. This noise seems never to end. Finally it stops. Everybody feels relieved and is beginning to breathe when there is a shattering sound which makes the sprung door of the barracks move on its hinges; then another; then finally the last. These are the coups de grace given by a policeman to those who are not yet dead. . . .

At that moment, like a band of drunken men, the execution squad come out of the door with blood on the ends of some of their bayonets. And while two closed vans go into the courtyard a priest slips out, and for a long time you see his thin back, his umbrella, his legs walking unsteadily along the outer wall of the barracks. The new time, like any other child, was being breeched in blood.

Nadar had escaped being shot in the confusion, but, tied as he was to the conventions of studio portraits, never recorded any of the events he must have seen. He left studio work more and more to his assistants, and indeed had quit photographing altogether by 1890. The whole tone of his life had changed; he was no exception: every great historic experience, especially the hemorrhagic ones, alters the set of people's minds, and particularly that of its artists. Once again, from the Goncourt journal of March 28, 1880, nine years later, and a whole epoch different in tone!

Today Daudet, Zola, Charpentier, and I set out to dine and spend the night at Flaubert's in Croisset.

Zola is as gay as an auctioneer's clerk going off to take an inventory, Daudet as a man escaping his home to go on a spree, Charpentier as a student who looks forward to a series of beers from bar to bar, and I, I am very happy at the prospect of embracing Flaubert.

Zola's happiness is marred by a serious preoccupation; he wonders whether on this fast train he will be able to piss in Paris, at Mantes, and at Vernon. The number of times the author of Nana *pisses or at least tries to piss surpasses the imagination.*

Daudet, a little tipsy from the port drunk at lunch, begins to talk about "Chien Vert," about his amours with that crazy, wild, erratic woman whom he inherited from Nadar—a wild love affair, steeped in absinthe and occasionally made dramatic by knife stabs, a scar from which he shows us on one of his hands. He mockingly describes to us his dreary life with that woman, whom he lacked the courage to break away from and to whom he felt somewhat bound out of pity for her vanished beauty and for the front tooth that she broke eating hard candy. When he got married and had to cut loose from her, he tells us that, on the pretext of giving her a dinner in the country, he took her to the middle of the Meudon woods because he dreaded her outcries where other people might hear her. There among the leafless trees, when he had told her it was all over, the woman rolled at his feet in the snow and mud, bellowing like a young bull and pleading: "I won't be bad any more; I'll be your servant." Then, after that, supper, at which she ate like a bricklayer, in a state of stupefaction. He breaks off this account to tell us about a love episode with a young and charming creature named Rosa, with whom he had a night of passion in a room at Orsay, a room shared with seven or eight people who the next morning somewhat cooled the transports and poetry of their love as each one pissed at length in his chamber pot, farting loudly. A love episode a bit frightening by its perniciousness and coarseness.

Gustave Flaubert had published the realist novel *Madame Bovary* in 1857, but the sinister, luxurious, erotic *Temptation of Saint Anthony* in 1874. A few years later, there would be Mallarmé and Rimbaud and Toulouse-Lautrec and the intellectuals' obsession with foreign places like Egypt and the circus, the dance hall and the brothel. The narrow streets in the working men's quarters of Paris would be widened to provide splendid vistas and make it impossible to erect barricades; and in the parks, in the mornings, would ride the equestrian demimondaines of La Belle Epoque; and the last decades of the century would see the publication in 1884 of Huysmans' (who had once worshipped Balzac and Zola) novel *A Rebours*, with its living, jewelled tortoises and its gourmandise by enema; and photography, dying of triviality in France, would be reborn, beauties and misconceptions and all, in America.

Nadar
Alphonse Daudet, no date
The Art Institute of Chicago
Page 170
Nadar
Charles Garnier, 1865
Caisse Nationale des Monuments Historiques
et des Sites, Paris

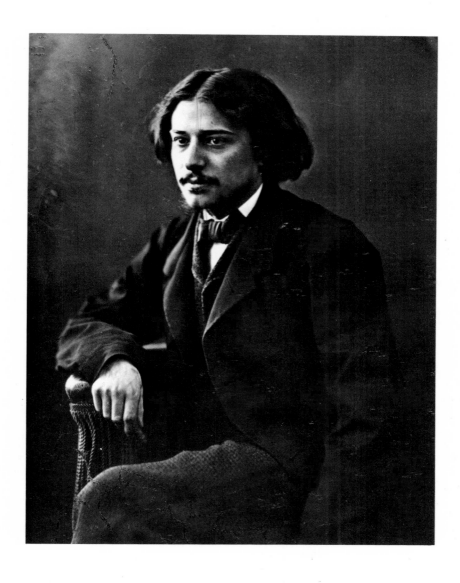

Nature Improved I: Pictorialism in Europe

One of the recurrent and irritating issues in photography, argued endlessly by the Pictorialists of England and America as the century turned its quiet corner, was whether photography is an art in the same sense as painting or fiction. The question really arose out of class snobbery, because from the 1820's to the 1890's, photographs were made either by amateurs or tradesmen. But the answer to the question is not simply an angry Yes; photography is, as I've said, a new human experience: a renewal of contact with the gross, forceful complexities of truth.

But how much truth can we endure? The fine and subtle American photographer Walker Evans was once asked whether the camera ever lied. He hedged by saying "Always"—maybe because he was trying to correct a common delusion.

Because what the eye sees is filtered by the head; and not just the head of the photographer, but the head of each viewer down the years; and neither is immune to the poisons and distortions of his own society—and his own personal character, whether secret or acknowledged. Face stares at face, and history at history; and between them there is often a stubborn obfuscation. Is the camera, invented by an industrial society, really able to look at the cruel, wasteful, energetic culture that bore it?

The Europeans had already faced this special dilemma. Maeterlinck, the Belgian Nobel prize winner for literature, persuaded perhaps by his portrait taken by the American Edward Steichen, who hung it in his one-man exhibit in Paris in 1901, wrote in praise of photography: *I believe that here are observable the first steps, still somewhat hesitating but already significant, toward an important evolution. Art has held itself aloof from the great movement, which for half a century has engrossed all forms of human activity in profitably exploiting the natural forces that fill heaven and earth. Instead of calling to his aid the enormous forces ever ready to serve the wants of the world, as an assistance in those mechanical and unnecessarily fatiguing portions of his labor, the artist has remained true to processes which are primitive, traditional, narrow, small, egotistical and overscrupulous, and thus has lost the better part of his time and energy. . . . Man, today, is on the point of realizing that everything around him begs to be allowed to come to his assistance and is ever ready to work with him and for him, if he will but make his wishes understood . . . It is already many years since the sun revealed to us its power to portray objects and beings more quickly and more accurately than can pencil or crayon. It seemed to work only its own way and at its own pleasure. At first man was restricted to making perma-*

nent that which the impersonal and unsympathetic light had registered. He had not yet been permitted to imbue it with thought. But today it seems that thought has found a fissure through which to penetrate the mystery of this anonymous force, invade it, subjugate it, animate it, and compel it to say such things as have not yet been said in all the realm of chiaroscuro, of grace, of beauty and of truth.

Fascinating about this prose poem to Reason and the Machine is that it was written, in 1903, by a man whose whole philosophy was irrational and mystic; he shared this view with the American Ralph Waldo Emerson, who managed to extol Progress and Enterprise as somehow equivalent to the transcendental Buddha. This contradiction, this embrace of the bustling, noisy, industrial society simultaneous—sometimes in the same print!—with a flight from its dirt and its horrors, is a nearly universal trait of photography in the last decades of the nineteenth century; the trait persists well into the work of the twentieth. Huysmans, whom I cited as the chief, but certainly not unique stylist of a finicky sense of decay, wrote (in *A Rebours*): *Does there exist in this world of ours a being, conceived in the joys of fornication and brought to birth amid the pangs of motherhood, the model, the type of which is more dazzlingly, more superbly beautiful than that of the two locomotives lately adopted for service on the Northern Railroad of France?*

Yet, to my knowledge, there were no French portraits of machinery, nor indeed were there, by the last quarter of the nineteenth century, any French photographers of real merit. Yet professional photographers, their studios crowded with customers and furnished with the conventional props of drape, chair, rug, and classic pillar, were more successful than at any other time in the nineteenth century. They produced hundreds of thousands of mediocre portraits, many of them using the four-lens, eight- exposure camera invented by Adolph Disdéri in 1857.

Disdéri is an excellent example of how to lie with a portrait camera: not by telling a plain falsehood, but by refusing to go any deeper than the skin, by stopping at that easy threshold, the objective surface of the sitter. Personal knowledge of the sitter, to these craftsmen, was an unwanted complexity; Disdéri, in fact, was really a clever businessman who disguised himself in extravagant costume; he postured and shouted, and his assistants did the work.

Clothes are never negligible. In Carjat or Nadar, what a man or a woman wears constitutes a second and more elaborate skin, more telling sometimes than the original, since its choice is characteristic of the sitter. Disdéri-esque portraits, the *cartes de visites*, were

souvenirs, given away to be mounted in rococo albums; here the clothing served to conceal the man.

The invention of the dry plate in 1870, the increasing speed of the film, and the decreasing size of the camera, made the event of the photograph more and more trivial. By the end of the century, photography had become the sandbox of the mediocre. For example, a minor artist, but famous in his time, was Robert Demachy, whose nude female portraits, mostly of children, were not simply genteel pornography, but a conscious imitation of charcoal drawing or etching, and copied the vague edge and the Pointillism of the Postimpressionists. He wrote, in 1907: *A straight print may be beautiful, and it may prove superabundantly that its author is an artist; but it cannot be a work of art . . . Pictorial photography owes its birth to the universal dissatisfaction of artist photographers in front of the photographic errors of the straight print. Its false values, its lack of accents, its equal delineation of things important and useless, were universally recognized and deplored by a host of malcontents. There was a general cry toward liberty of treatment and liberty of correction. Glycerine-developed platinotype and gum bichromate were soon after hailed with enthusiasm as liberators; today the oil process opens outer and inner doors to personal treatment.* Yet, even in this painterly tradition, he sometimes produced a print like "L'Effort," which was a work-a-day scene of nine boys beaching a heavy boat. But on the whole, the photographer's reaction to his own culture, to the stifling mixture of smoke and money on the contemporary European landscape, was to ignore it.

In England, by the 1890's, there was a change in the intellectual weather. The dilemma of the artist as photographer, imprisoned in an industrial world for whose visual aspect there was no real precedent: this intellectual agony was acknowledged by the English, even if nothing was done about it. On the one hand, there was the timid decadence of Aubrey Beardsley and the lush swoons of Swinburne; on the other hand, there was the clever surgeon, Oscar Wilde, who, out of distaste for the finicky, hated Beardsley and was appalled by the famous literary periodical *The Yellow Book;* and who neatly skewered the great, ungainly, mid-Victorian household hero Charles Dickens by challenging the reader to carefully peruse a scene like the pathetic death of Little Nell, ". . . and refrain from bursting into laughter." And then there was that supreme, sexless, and vegetarian intelligence, that visitor from a superior planet, disguised in a rough tweed suit: George Bernard Shaw. His estimate of current photographic

Robert Demachy
Untitled, no date

Robert Demachy
Untitled, no date
Both, from *Robert Demachy Photographs & Essays*,
Academy Editions, London/St. Martin's Press, N.Y.
Page 176
Robert Demachy
Portrait of Mademoiselle D.
From *Camera Work*, No. 16, October, 1906
George Eastman House, Rochester, New York

methods is at once kind and acerbic: *The camera can imitate the most flagrant makeshifts of the draughtsman, and in so doing get all the advantage of that curiosity which mere processes rouse: the same curiosity that makes people with no ear for music crowd eagerly round a pianoforte to see Paderewski play. When a photographer prints from his negative through a hatching, and so makes the resultant picture look like an engraving or etching of some kind, his work immediately becomes what bric-a-brac dealers call a curio; and as a photograph had better be curious than merely null, the trick is not so unmeaning as it seems. Then there are the pigment processes, in which the most amusing games can be played with a kettle of hot water. The photographer gains control of his process, and can, if he likes, become a forger of painter's work.*

The critics, being professional connoisseurs of the shiftiest of old makeshifts, proclaim that photography has become an art; and all the old phrases that were composed when Mr. Whistler was president of the British Artists, and the New English Art Club was perceptibly newer than the New River Water Company, are scissored out of the old articles and pasted into the new ones, with substituted names, such as Steichen for Whistler, Käsebier for Wilson Steer, Demachy for Degas or Sickert, and any lucky underexposer for Peppercorn or Muhrman. Now this is all very well; but who would not rather produce a silver print which could be fitted to an old description of a picture by Van Eyck or Memling, or a platinotype portrait that would rival a good impression of a mezzotint by Raphael Smith, than imitate with gum or pigment plasters the object lessons of the anti-academic propaganda of twenty years ago. Shaw was mad about photography, and made numerous self-portraits, which his friend, the excellent photographer Frederick Evans, was kind enough to print, and was the cheerful center of a scandal when Evans not only photographed him in the nude but exhibited the print on a chaste London wall. *I grant that some propaganda is still needed; that the old guard of photography used to tolerate, and even rewarded by medals, such monstrous faking as no gummist has yet been guilty of; that the plucky negative with microscopic definition, plenty of detail in the shadows (and everything else), and a range from complete opacity to clear glass was made just as much an end in itself as the simulation of the makeshifts of painting and draughtsmanship now threatens to become; and that Philistinism was as rampant in the Royal Photographic Society as in the Royal Academy. But none of the Impressionists was so wanting in respect for his art as to pretend that the pictures in which he preached tone and atmosphere, or open-air light, were not paintings but photographs. Besides, he aimed at representing these things as he saw them, sometimes with very defective sight, it is true, but still honestly at first hand. Now some of our photographers who have been corrupted by beginning as draughtsmen and painters are wanting in self-respect; for they openly try to make their photographs simulate drawings, and even engravings; and they aim, not at representing nature to the utmost of the camera's power, but at reproducing the Impressionists' version of nature, with all the characteristic shortcomings and drawbacks of the makeshift methods of Impressionism. This modeling of new works of art on old ones, instead of on nature and the artist's own feeling, is no novelty: it is Academicism pure and simple . . .*

What right has photography to these allowances? None whatever, it seems to me. The difficulties which justified the Impressionist in asking for them do not exist for the camera. The photographer has his own difficulties and receives his own allowances for them; and the minimization of these is quite enough to keep him busy. If he deliberately sets to work to make his photograph imitate the shortcomings and forge the technique of the Impressionists, he must not be surprised if he finds that those who were most tolerant of both when they were the inevitable price of originality will be the most resolute not to stand them for a moment when they are a gratuitous academic affectation.

On the other hand, here is the opinion of an English photographer, Henry P. Robinson, whose fame rested on portraits like the already cited "Fading Away," as well as photographic illustrations of "Little Red Riding Hood": *It must be confessed that it takes considerable skill to produce the best kind of lies. It is in the hands of first-class photographers only—and perhaps the indifferent ones—that photography can lie. With the first, possibly, graciously; with the latter, brutally. The photographers of only average attainments, and such as we should get turned out in quantities by an art-less Institute, seldom get beyond the plain, naked, uninteresting truth . . .*

What Robinson defended was not retouching—that was a technique used from Talbot upward and downward—but the gross manipulation of the print. The gum bichromate process, for example, subjected the developing print to a bleaching mixture of bichromate in a thickening of gum arabic. Was this justifiable? The Pictorialists, reacting to the commercial deluge of portraiture, said Yes; they would even use the etcher's burr or a fine sable brush to "pictorialize"

and alter the print. To other Englishmen, this method was deeply offensive.

And so this chronic question, which has persisted into our own time, filled the pages of English photographic journals and was the eternal subject of their monthly photographic clubs. Still, we must remember that both the purists and the Pictorialists had the same deep revulsion against the materialism of the English middle classes, of whom they were mostly the sons and heirs. Both sides hated and refused to photograph the "uglification," to use a Carrollian word, of England's villages by factories, and of hedgerows by the slag heaps of the mines.

One remarkable English portraitist solved this problem by embracing both points of view. Peter Emerson, born in 1856, was in vigorous middle age when in the 1890's, he sided with the young Pictorialists of the Linked Ring, a British photo-secession society. In an address to the Camera Club Conference of March 1889, he made a sharp distinction between the views of science and art: *The raison d'être of a work of art ends with itself; there should be no ulterior motive beyond the giving of aesthetic pleasure to the most cultivated and sensitively refined natures. The first thing, then, we must do is to sit in judgment of our model. [For] it is utterly impossible to record all the facts about him with our material, and we soon find it is undesirable to do so—nay, pernicious. We cannot model those hundreds of fine wrinkles, those thousands of hairs, those myriads of pores in the skin that we see before us. What, then, must we do? We obviously select some—the most salient, if we are wise—and leave out the rest.* This opinion leads him to condemn optical sharpness: *It is constantly advocated that every detail of a picture should be impartially rendered with a biting accuracy, and this in all cases. This biting sharpness being, as landscape painters say, "Quite fatal from the artistic standpoint" . . . It is curious and interesting to observe that such work always requires a name. It is a photograph of Mr. Jones, of Mont Blanc, or of the Houses of Parliament. On the other hand, a work of Art really requires no name—it speaks for itself. It has no burning desire to be named, for its aim is to give the beholder aesthetic pleasure, and not to add to his knowledge or the Science of places, i.e., topography.* Ten years later, the Pictorialists had won the intellectual battle; their prints got the prize at every exhibit in London, Vienna, Paris, Chicago. Emerson wrote: "The opticians were right from the mathematical standpoint, and I was right from the physiological and psychological standpoints, and so it was evident there were two truths to nature—the perspective or mathematical truth and the psychological or visual truth."

Nevertheless, it is astonishing that Peter Emerson's portraits of rural characters are the equivalent of Millet's paintings of half a century before: they are evidently and exquisitely realist in conception and execution. Why? The fact is, an artist's work is determined more deeply by what he feels than by what he declares in public; the latter belongs to the dialectic of his group, *i.e.,* his doctrinaire fellow photographers; the former is determined more profoundly by his personal experience and by his consequent view of life; and this, for Emerson, meant his fascination with the sad society of labor, working or standing in an open space—in the still unblemished, misty, and subtle English countryside.

Visual or psychological truth, when they do not quite coincide: may one alter the negative to make them congruent? This was the central technical question of photography in the last quarter of nineteenth century and the first quarter of the twentieth. This curious problem—to retouch or not to retouch—was at first unique to photography; but it remains concealed like a minefield in all the later developments of documentary film. It can never be resolved, I think, in general, but each case must be considered separately; for if our thesis holds, that the viewer is part of the portrait triangle, then his judgment, as to pleasure or truth, understandably confused, will determine what happens when the photographer is alone, excited or miserable with his negative, in the obsessive silence of the darkroom.

The problem: how, if at all, to alter the sun's edict, finds a different solution with every personality. A good example is the work of the Englishman Frank Meadow Sutcliffe (1853–1941), a realist photographer by instinct and training. Borrowing a trick from the English pioneer Francis Frith, he used tissue paper to hold back portions of the negative, particularly the background. This is equivalent to the present technique of "dodging," the use of the hand or a tool to modify the light on portions of the negative. But Sutcliffe was not above using a lead pencil, or, indeed, scraping away an entire figure with the edge of a pocket knife; or introducing clouds from another negative. As his biographer, Michael Hiley, notes, he felt he was "adding natural effects which his plates had, unnaturally, failed to register."

The distinction is difficult but important. When one photographs a person, there is, from the beginning, no possibility of presenting the whole truth of character; for one thing, nobody knows what the truth is, perhaps least of all the sitter. But one can and must

Peter Henry Emerson
A Fisherman at Home
From *Idylls of the Norfolk Broads,* 1888
The Library of Congress

Peter Henry Emerson
The Poacher—A Hare in View
From *Pictures of East Anglian Life,* 1888

Peter Henry Emerson
Haymaker with rake
From *Pictures of East Anglian Life,* 1888
Both, The Art Institute of Chicago

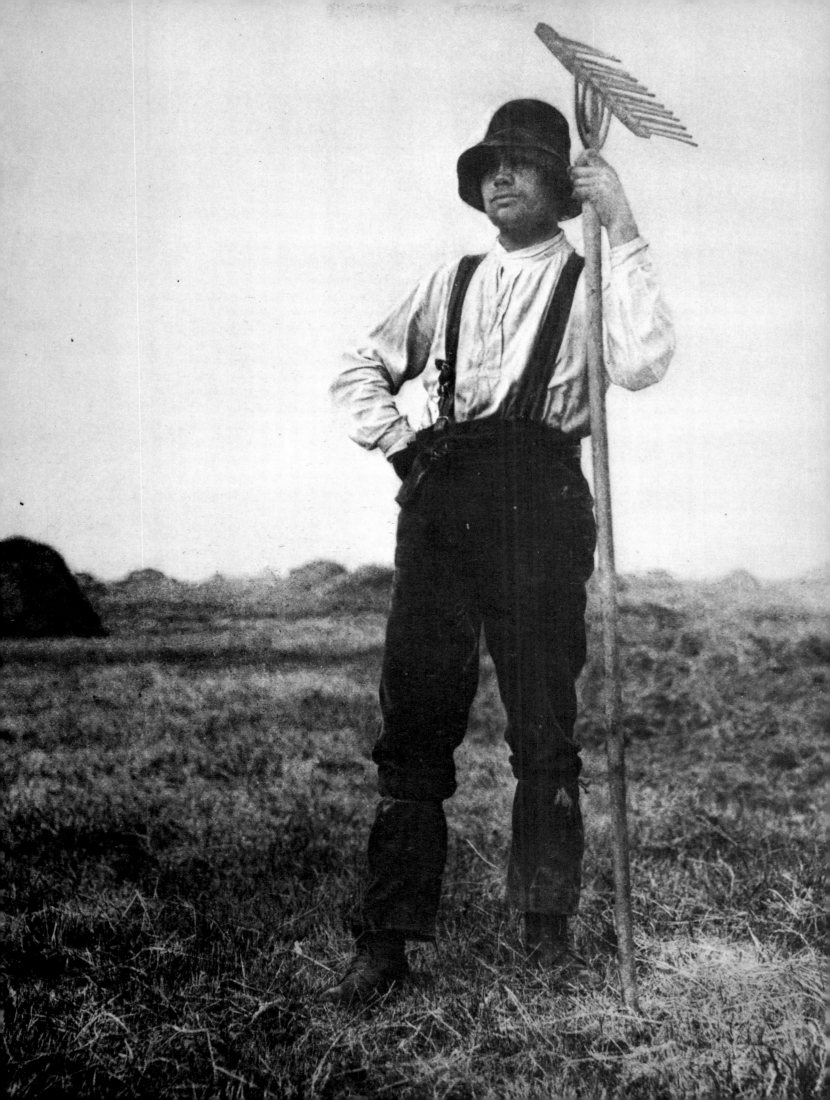

Frank Meadow Sutcliffe
A Bit of News, c. 1884, Tommy Baxter Street,
Robin Hood's Bay, Whitby, England
Page 184
Frank Meadow Sutcliffe
Limpets, two barefoot Whitby girls, c. 1876–80
Both, The Sutcliffe Gallery, Whitby, England

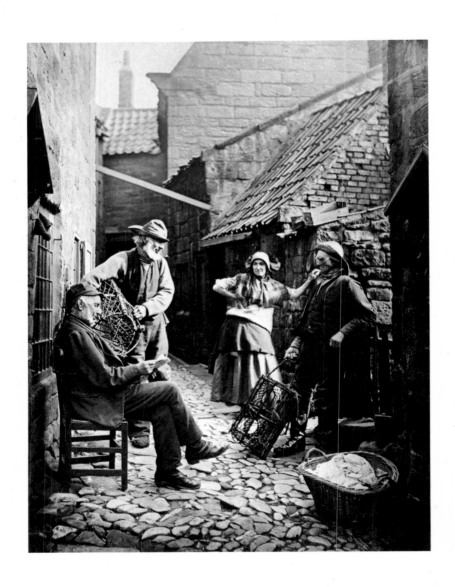

make the distinction between choosing, or even bending nature; and inventing or destroying nature. Photography, we realize, is an extremely verbal art, and Sutcliffe, like many photographers before and since, wrote extensively about his life and art. His view on our crucial question is fairly simple: "The student . . . may do whatever he likes, but he must not be found out."

Sutcliffe, like many of his peers, thought himself not a philosopher, not even an artist, but simply a clever craftsman making a living at his trade. He wrote, "My father once said to me, 'How can the reflection of a guttapercha world in a brass door handle be a picture?'" We still, in spite of all our lengthy denials, ask ourselves the same odd and fundamental question. Sutcliffe was certainly a tradesman, like a maker of boats or houses; his pride was his work, but he never blushed at the fact that he photographed what could be sold. His specialty was genre: the depiction of scenes from ordinary life—a powerful tradition in all of art, since Brueghel at least. The titles of many of his photographs had the easy jocularity of such art: "Stern Reality" (a photograph of the backs of a dozen boys looking over a parapet); "Dinnertime" (the plowman looking at his watch); and the sensation of British photography in the 1880's: "Water Rats" (naked boys at play in the harbor). One feels that photography in this era was a thoroughly domesticated art.

Sutcliffe was the oldest child of eight, and his father was a quite respectable painter and etcher who had a long interest in photography, although the family never owned a camera. Ruskin said of one of his drawings, "The furze [a plant that abounds on the English moors] . . . is admirable, and the whole thing got straight from Nature."

Young Sutcliffe, when he was nineteen, journeyed to see Ruskin and take his portrait, seated before a picturesque stone wall. Sutcliffe's first camera was "three feet long, when extended, and was fitted with a 24-inch lens of brass shutter stops; there were no meters in those days, and exposures had to be guessed."

He was a country boy by choice and by nurture, and after failing at his trade in a fashionable town, settled in Whitby, a tourist and fishing village. The tourists he took into his studio, but he photographed the fisher-folk outdoors, against sea and sky and—his favorite—mist. He thought that the stinging chemical fog that came up the valley from the industrial chimneys of Leeds was very beautiful; like others of his time, he accepted industrialization as beneficent, even if it choked you.

We see much more in his photography than he would have admitted: the sweetness and ease of "Limpets"; the grim labor behind the smiles of "A Bit of News." They were all people he knew by name and by character: not a bad platform for any photographer. An admirably sensible man, he was one of the founders of that rebel group, the Linked Ring; but he refused any sort of dogmatism: *It seems to me that the long and short of natural photography is that, as everyone sees differently, so some like to make their photographs sharp everywhere, others just the opposite. Living in this age of freedom, I do not consider myself bound by any rules. . . . Some people . . . can see nothing and care for nothing in a photograph but the detail. . . . They take out a pocket microscope, and, placing the eye to one end and the photograph at the other, . . . exclaim either "How beautifully sharp!" or "What a funny photograph! Why, it isn't sharp at all!" Such people do not think it right to take photographs except when the air is clear, and look upon the photographer as a fool if he sets up his camera when nature is veiled with fog, or blurred with rain, or almost lost in the shades of evening. P.S. Of course, when I am taking . . . soldiers in their war paint, and ladies in their best dresses . . . I do not give people the opportunity of saying that my eyesight is getting dimmed by intemperance or by old age.*

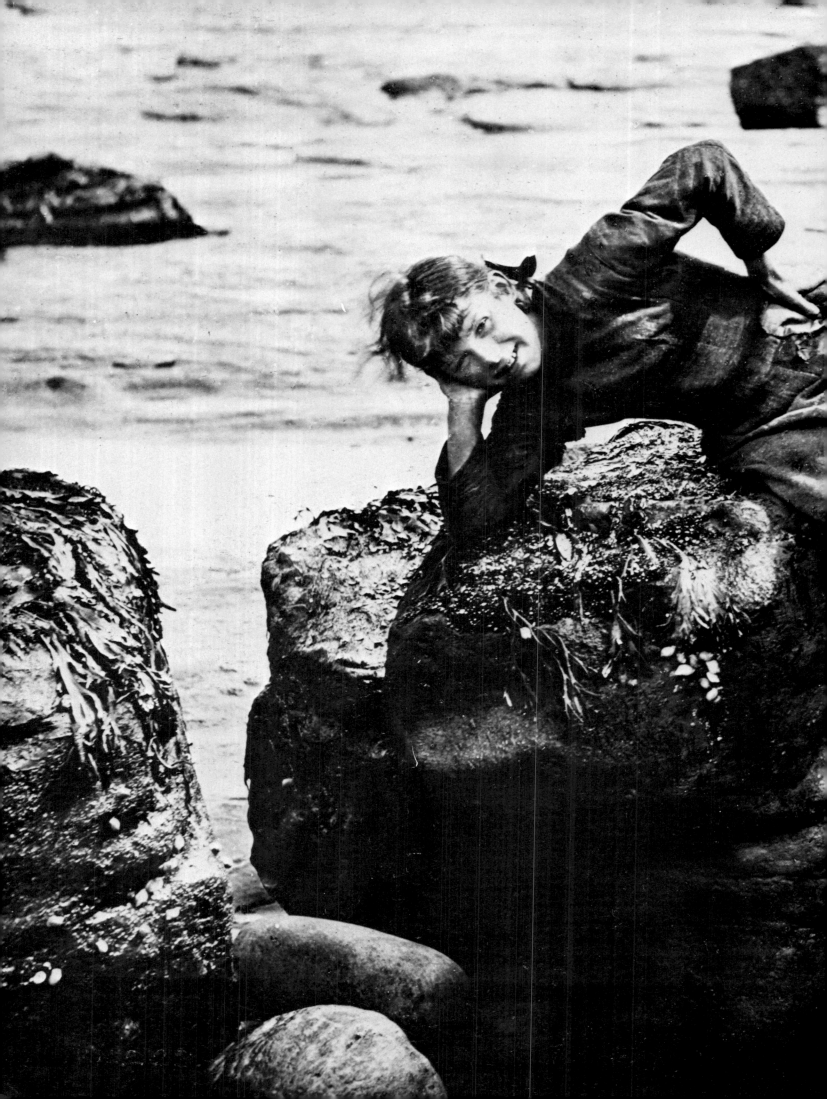

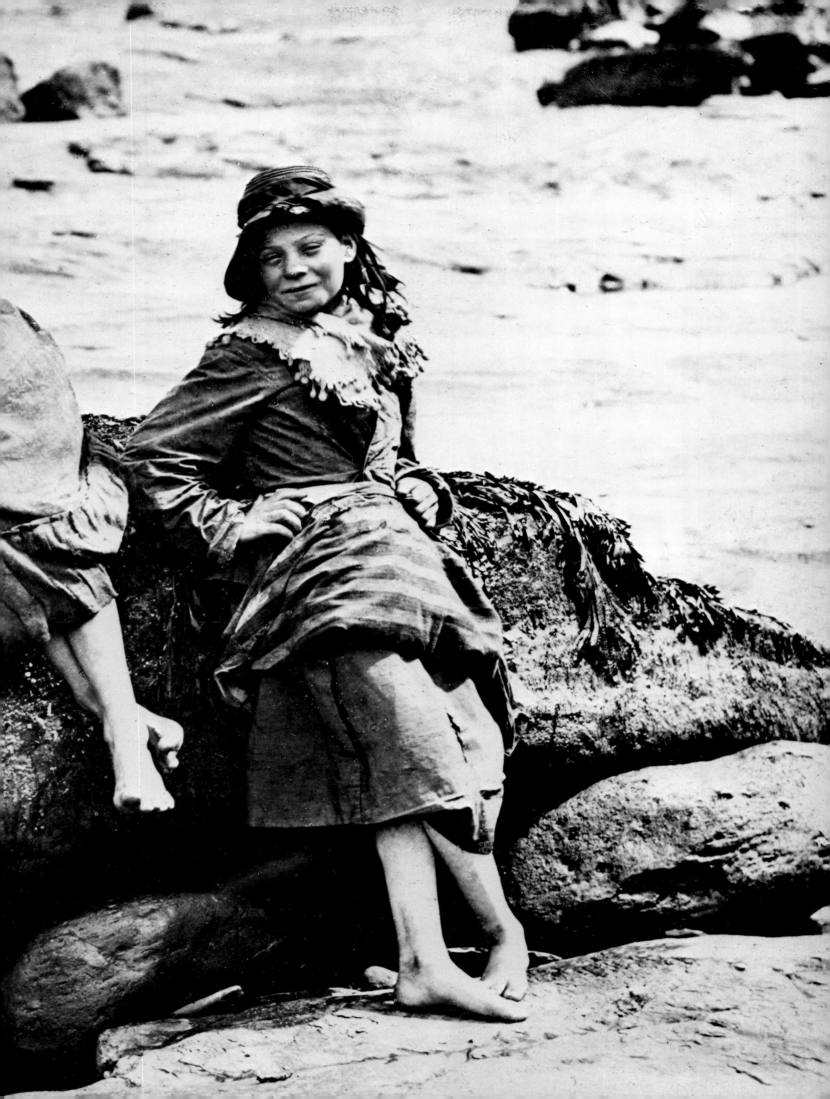

In the extended adolescence of the American spirit between 1865 and World War I, Europe had a resented but still maternal influence. This was particularly evident among American upper-class young people who went abroad to complete their education. One of them was an American who went to Europe at the age of eighteen, enrolled first at a technical high school in Karlsruhe, Germany, and then attended the Berlin Technische Hochschule, a technical university. He began with mechanical engineering, but Germany was then the center of another intellectual explosion: that of discoveries in organic and inorganic chemistry. The young man—he was Alfred Stieglitz—became fascinated by photochemistry, so he had a sound reason to do what everyone else did: he got himself a camera. By the time he was twenty-two, he had sent prints to the various competitive photographic shows; and his first acceptance was by the same Peter Emerson who had managed to fix himself on that thorny boundary between "straight" and "pictorialist" prints.

There can be no doubt that the young engineering student was aware of this controversy and, in fact, he was never to quite resolve it in his own work; nor did he need to do so. He saw, and I strongly believe he was right, that what counts in a photograph, as in any other art, is not method but result. He was always, therefore, an eclectic; his work ranges in no particular order from his self-portrait as a lean, confident, vain young man sprawled on a set of steps in Venice, to his small hieroglyphic "Equivalents," which were little photographs of a bit of cloudy sky. There is a fairly general misconception that he somehow invented Pictorialism and began the movement of Photo-Secession. But, as we have seen, both ideas were widely known in Europe, and especially potent during the eight years that he was there.

The vague term Pictorialism ought to be defined. It is simply the use of technical methods of any sort—soft-focus lenses or alteration of the negative by over- or under-development or by manipulating or toning the final print, or the choice of textured papers, or even the use of a brush or a pencil; or some or all of these—to produce the softening effects associated with the handmade art of the time. It must be remembered that the source of this photographic aesthetic was not only painting but graphics: the prints of Whistler and Seurat, for example. The reason is simple: although color photography was just possible by 1890, it was complicated and unsatisfactory; the vast body of photographs were not merely black and white (though some were softly toned with gold) but a particular kind of black and white. Plates,

formerly almost insensitive to frequencies in the red, orange, and yellow half of the visual spectrum, had been improved to the point where all but a full red would be registered. So in this "advanced" ortho-chromatic film, red lips, the rosy edges of eyelids, the reddish shadow inside the nostrils, were all rendered black. It gave almost any portrait a certain dramatic intensity, which the earliest movies, already being made before the twentieth century, exploited with white pancake makeup and scarlet eye shadow.

In short, the technical nature of the film did, in this instance, have an effect on the way that photographers looked at their art. Thus the partly arbitrary black-and-whiteness of the photographic portrait did allow it to resemble, and so be classified, as graphic art. This resemblance was, or was felt to be, a necessary step toward the elevation of photography above mere genteel amusement, above craftsmanship and business, to the glory and idiosyncrasy of an art. Stieglitz felt this need very strongly; and devoted much of his life to its satisfaction.

I must point out that he could afford it. He was supported, in the main, by family income; indeed, his family, descendants of an earlier German immigration, had become rich in America. And like many another beneficiary, he hated the very milieu that gave him the leisure to do what he chose. One of his most famous—and to my mind, most puerile—photo-graphs is that of the underquarters of a dray horse: castrated, naturally; with the title "Spiritual America"; though this kind of satire is still one of the silly temptations of the photographer, it was, happily, the only one of its kind in the magnificent catalogue of his work.

Still, it was true enough that the America to which Stieglitz returned in 1890 was crass, mediocre, violent, energetic, and mad about the getting and spending of money: all common characteristics of an expanding economy. This Gilded Age, as it moved toward its climax and its close, absorbed two major events with-out altering its values in any way. The first was the military action against the Spanish colonies in 1898: not a war, really, rather a series of marauding ex-peditions to enlarge the holdings of empire. Photo-graphs of this war are little known, I think, for moral reasons; with certain exceptions, you will not find among them the realism of bold or weary soldiers, or the landscapes of the swollen dead, which were the work of the Civil War photographers; instead there are studies of "picturesque natives." Or else the stagy photos of Pennsylvania's best lining up their rifles against the Philippine rebels, who, by the curious twist of primitive logic, didn't want the Spaniards

either. So these photographs only echo the hypocrisy of that war.

The second, and far greater event, was the tidal wave of immigration from 1880 to the First World War. It came, not out of the blond regions of Scandinavia, England, and Germany, but out of the eastern and southern regions of Europe: the Slavs in their variety, the Jews of Poland and Russia, the Italians of Naples and Sicily. Alfred Stieglitz, going back to Europe in 1907, . . . *hated the atmosphere of the first class on that ship. One couldn't escape the nouveaux riches . . . On the third day out I finally couldn't stand it any longer. I had to get away from that company. I went as far forward on deck as I could . . . There were men and women and children on the lower deck of the steerage. There was a narrow stairway leading up to the upper deck of the steerage, a small deck right at the bow of the steamer.*

To the left was an inclining funnel and from the up-per steerage deck there was fastened a gangway bridge which was glistening in its freshly painted state. It was rather long, white, and during the trip remained untouched by anyone.

On the upper deck, looking over the railing, there was a young man with a straw hat. The shape of the hat was round. He was watching the men and women and children on the lower steerage deck. Only men were on the upper deck. The whole scene fascinated me. I longed to escape from my surroundings and join these people.

A round straw hat, the funnel leaning left, the stair-way leaning right, the white draw-bridge with its railings made of circular chains—white suspenders crossing on the back of a man in the steerage below, round shapes of iron machinery, a mast cutting into the sky, making a triangular shape. I stood spell-bound for a while, looking and looking. Could I photograph what I felt, looking and looking and still looking? I saw shapes related to each other. I saw a picture of shapes and underlying that the feeling I had about life. And as I was deciding, should I try to put down this seemingly new vision that held me—people, the common people, the feeling of ship and ocean and sky and the feeling of release that I was away from the mob called the rich—Rembrandt came into my mind and I wondered would he have felt as I was feeling.

He ran and got his Graflex out of the first-class cabin: *I had but one plate holder with one unexposed plate. Would I get what I saw, what I felt? Finally I re-leased the shutter. My heart thumping. I had never heard my heart thump before. Had I gotten my pic-ture? I knew if I had, another milestone in photog-*

raphy would have been reached, related to the mile-stone of my "Car Horses" made in 1892, and my "Hand of Man" made in 1902, which had opened up a new era of photography, of seeing. In a sense it would go beyond them, for here would be a picture based on related shapes and on the deepest human feeling, a step in my own evolution, a spontaneous discovery.

This self-glorification is quite characteristic of the man; perhaps of most remarkable men, who have the lucky ability to see around them, whatever the environs, only the grand landscapes of themselves—not without, naturally, an occasional visitor; while beyond that horizon of the ego all is wasteland and grinding chaos. Stieglitz's central importance to the development of American art has never been equaled; but the changing scene of art, let it be admitted, didn't in its turn alter the course of American history in any real way. On the contrary, the contradictions of American life affected, corrupted, strained, and cheapened—in every sense—the art of photography. Stieglitz wrote, in 1897: *Photography as a fad is well-nigh on its last legs, thanks principally to the bicycle craze. Those seriously interested in its advancement do not look upon this state of affairs as a misfortune, but as a disguised blessing, inasmuch as photography had been classed as a sport by nearly all of those who deserted its ranks and fled to the present idol, the bicycle. The only persons who seem to look upon this turn of affairs as entirely unwelcome are those engaged in manufacturing and selling photographic goods. It was, undoubtedly, due to the hand camera that photography became so generally popular a few years ago. Every Tom, Dick and Harry could without trouble, learn how to get something or other on a sensitive plate, and this is what the public wanted—no work and lots of fun. Thanks to the efforts of these persons hand camera and bad work became synonymous. The climax was reached when an enterprising firm flooded the market with a very ingenious hand camera and the announcement, "You press the button, and we do the rest." This was the beginning of the "photographing-by-the-yard" era, and the ranks of enthusiastic Button Pressers were enlarged to enormous dimensions. The hand camera ruled supreme.*

In 1897, Stieglitz founded and edited the publication *Camera Notes*, the organ of the New York Camera Club. He resigned five years later, in 1902, in violent disagreement with their exhibition policies. He then founded the Photo-Secession with a group of similarly dissatisfied photographers; the name, as he himself said, simply copied the various secessions of European painters. Three years later, in 1905, he opened a gallery at 291 Fifth Avenue in New York City. The rooms were painted in neutral colors, and there was, for a time, a curious skirt or pleated curtain that came part way up the wall. All this, quite different from the gilded settings of other galleries, was aimed to set off and separate the prints, to distinguish them from mere furniture, to display them as individual and respected works of art.

The photographs of Stieglitz and of his early group were pictorialist in approach—and thoroughly remarkable. Among them were scenes of industrial America: but colored by a misty romanticism: steaming horses, gleaming rails, gas lamps reflected in wet streets, and the curving, baroque effects of a fallen snow. The treatment of the dull or hideous or mechanical or terrifying in American life in the mode of romantic realism was not invented by Stieglitz; it was a national habit that lasted till the 1920's; and persists in the popular arts.

It was particularly true of our view of the Indian. Sioux, Cheyenne and Blackfoot were endlessly photographed; and the majority of these plates show them in their finest holiday clothing, noble in posture, defiant, strong, silent and mysterious: an American form of that persistent western myth: the noble savage. "Close to nature"—this was half of the American myth about the Indian, though not much credited in the western towns, where the hard-bitten speculator and the honest sod-buster, armed with rifle and Bible, held an opposite and equally mistaken view: that the Indian was filthy, lazy, sneaky, and brutal. Actually, the two opposing views were the same, in that each held the Indian to be something other than human.

The humanity of the subject would seem to be implicit in the very fact of the photograph. Certainly the most realistic portraits of the Indian were taken by that traveling salesman, the frontier photographer. Many visited the camps and reservations of the tribes, and were accorded a dignified hospitality; still, it is rare to find any photograph where an Indian is simply and characteristically at ease. One would think that the Indians—who were of a hundred different cultures and languages—had one universal rule: never smile. Even the Sioux, who were notable for their humor and cheerfulness and practical jokes, were never photographed with anything but grim cheeks and defiant chins. One reason is very simple: there are no photographs of Indians by Indians.

Because across that first leg of the triangle I have described: the relationship of photographer to sitter —there was always the psychic barrier of old blood on the ground. Equally, there was the expectation of

Page 189
Alfred Stieglitz
Paula, Berlin, 1889
The Museum of Modern Art, New York,
given anonymously.

Edward Curtis
Little Daylight, 1905
The Pierpont Morgan Library, New York

the nineteenth-century viewer, the white who looked at a portrait of an Indian with ingrained prejudice, either good or bad, and fed his distortion back to the cameraman. Today, of course, we look at, for example, the gifted amateur Adam Clark Vroman's or the professional William H. Jackson's work with our own late-twentieth-century eyes, and perhaps these are a bit askew, also. I think we distort these fine portraits, seeing them not as human beings, each with his own individuality, but as the noble witnesses of our guilt. We are rarely aware of the complexity of Indian life; for instance, the Indian appreciation of strongly marked character was different for different cultures: for a Plains huntsman like the Cheyenne, the powerful much-married maverick was a valued hero; for the housed and agricultural Hopi, anyone exceptional was considered a joke.

This lack of distinction is very clear even in the gentle and perceptive work of Edward Curtis. There is little final difference in Curtis' attitude between his photograph of a man from a high pueblo of Walpi and his woman of the northern coastal Salish. Both are serious, noble, beautiful, and somewhat melancholy. It was his vision of the dying splendor of a race—which, in the event, did not die out at all, but survived to become decultured and miserable. But after all, Curtis did not begin his monument of work—some forty thousand photographs—until 1896, which was only six years after the last humiliation at Wounded Knee. In 1906, Curtis obtained the financial support of J. Pierpont Morgan: it came, finally, to a million and a half dollars. Curtis went every year for several months, as far north as the Arctic Circle and as far south as Tierra del Fuego, nor was his work done until late in 1930. It is little realized that the splendor of Indian clothing and religion had long decayed; so Curtis had to borrow props from museums and from his friend, the Indian scholar George Grinnell, and costume his subjects to look like he imagined they should. So it's no surprise, looking at the hundreds of gravures that were made from his negatives, that this image is melancholy and romantic. He wrote: "It is thus near to nature that much of the life of the Indian still is . . ." The troubling fact is that a cattleman or a wheat farmer is just as dependent on nature as any Indian; but, indeed—so is the metallurgist and the nuclear physicist.

Still, just because the persistent idea of the noble, mystic, doomed Indian—*The Last of the Mohicans* was published in 1826!—is not quite real, it does not automatically mean that portraits made with this idea are therefore false and bad. Illusions are the very bread of art; and the Photo-Secessionists, who looked to Whistler as their God and Stieglitz as their talking chief, should have included Curtis as their own: one has only to examine his portrait of "Little Daylight," with its balance of white and dark dividing the face, with the dramatic lines of the bone chestplate, to realize how different Curtis' portrait is from the burning clarity of a daguerreotype by Southworth and Hawes some sixty years before; and how similar a Curtis portrait is to, say, the portrait of "Landon Rives," 1904, by his contemporary, Alvin Langdon Coburn. Nevertheless, in each there is the same human quality, the same mixture, in white woman and Indian, of pride and shyness, and yet a very moving self-possession. So we have once again the special power of the photographic portrait: its aesthetic may be naive or sophisticated, but the reality of the person somehow shines through the exact mirror and the moody chiaroscuro.

Alvin Langdon Coburn was not one of the original founders of the Photo-Secession. He was a young painter and a cousin and lover to the photographer F. Holland Day, who was famous for his re-enacted scenes from a saccharine version of the life of Christ, in which he played the Saviour—though Day, in his less ambitious portraits, was equally capable of a lovely and persuasive lyricism. Coburn's first photographic work, with Day's encouragement, was exhibited in Boston when he was fifteen, and in London in 1900, when he was eighteen.

He had, at twenty-four, his first one-man show. George Bernard Shaw, who had himself taken a portrait of Coburn, wrote a generous preface to his friend's catalogue: *Mr. Alvin Langdon Coburn is one of the most accomplished and sensitive artist-photographers now living. This seems impossible at his age; but as he began at eight, he has fifteen years' technical experience behind him. Hence, no doubt, his remarkable command of the one really difficult technical process in photography—printing. Technically good negatives are more often the result of the survival of the fittest than of special creation: the photographer is like the cod which produces a million eggs in order that one may reach maturity . . . [Coburn] is free of that clumsy tool—the human hand, which will always go its own single way and no other. And he takes full advantage of his freedom instead of contenting himself, like most photographers, with a formula that becomes almost as tiresome and mechanical as manual work with a brush or crayon.*

Coburn traveled with his widowed mother and, fortunately descended from some six generations of affluent Americans, he could spend his life in pursuit of his personal goals. His life was typical of a good

one-half of the Photo-Secessionists; they were oriented toward Europe and despised the materialistic culture of America without understanding it; they were really outsiders, safe within the values and politics of their own group. Coburn, though he photographed industrial landscapes, saw them in a veiled and romantic light. In middle age he retired permanently to Wales, gave up photography for years, and entered the entrancing world of the mystic. His own aesthetic had a peculiar, if useful, lack of logic: *Real beauty is fundamental, unchanging and eternal. It is not a beauty of this or that; the earth, and the fruits thereof know it not save as a reflection from very far away. We can photograph abstract beauty but not ultimate beauty. The mind can reach out for it and in silent hope at the uttermost confines of its domains— aspire. . . .*

Photography born of this age of steel seems to have naturally adapted itself to the necessarily unusual requirements of an art that must live in skyscrapers, and it is because it has become so much at home in these gigantic structures that the Americans undoubtedly are the recognized leaders in the world movement of pictorial photography. . . .

Just think of the combination of knowledge and sureness of vision that was required to make possible Stieglitz's "Winter on Fifth Avenue." If you call it a "glorified snapshot" you must remember that life has much of this same quality. We are comets across the sky of eternity. . . . I find that my vision of New York has gradually taken upon itself a still narrower range, for it is only at twilight that the city reveals itself to me in the fullness of its beauty, when the arc lights on the Avenue click into being. . . . Probably there is a man at a switchboard somewhere, but the effect is like destiny, and regularly each night, like the stars, we have this lighting up of the Avenue. . . .

Nevertheless, he spent most of his life in Europe, where he took portraits of Henry James, G. K. Chesterton, Max Beerbohm, Yeats, Mark Twain (who was on tour), as well as those of Foch, Clemenceau, and David Lloyd George.

It is worth repeating: in photographic as in all portraits, what counts is the human triangle, and not the current technical fashion. So Coburn's portraits may be shallow in focus, but they are deep in their grasp of these complex personalities, managing to retain the mask that fame has given them, but cutting below it, dissecting with light, as it were, to the weary, anxious character underneath.

There is a fascinating portrait of Coburn and his mother, which has a psychological history implicit in its pose. Young Coburn, bearded and thoughtful at

F. Holland Day
Portrait of Zaida Ben Yusuf, c. 1890
The Metropolitan Museum of Art, New York
Gift of Alfred Stieglitz

193

Alvin Langdon Coburn
Henry James, 1906

Alvin Langdon Coburn
Max Beerbohm, 1908
Both, George Eastman House, Rochester, New York

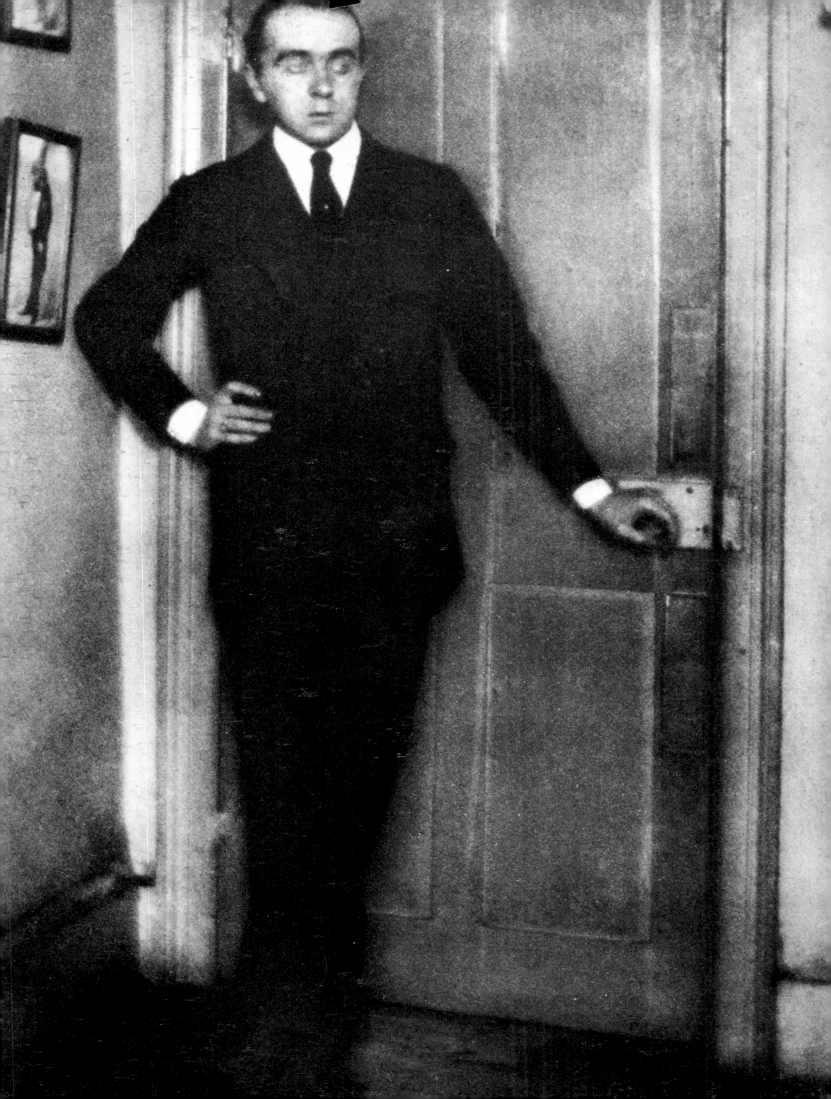

Alvin Langdon Coburn
G. K. Chesterton, 1904
George Eastman House, Rochester, New York

Alvin Langdon Coburn
Landon Rives, 1904
The Metropolitan Museum of Art, New York
Gift of Alfred Stieglitz

Clarence H. White
A. L. Coburn and his mother, 1909
George Eastman House, Rochester, New York

twenty-seven, is clasping a portfolio of prints; but he is in the background, while very large in the foreground is his indulgent gentle mother, crowned by a hat with fabric roses that easily dominates the whole composition. This acute portrait was made in 1909 by another, and a founding member, of the Photo-Secessionists: Clarence White. He is one of the regular astonishments of photography: a very great talent that springs up apparently out of nowhere. White was a small-town, twenty-three-year-old grocery clerk in Newark, Ohio, who had never had professional training of any kind—except what he could get from Stieglitz's beautiful periodical, *Camera Work*. And what White saw in this magazine was generally exquisite and special, for the gravures were sometimes better than the prints, and they were pressed onto extra heavy Japanese rice paper, hand-tipped and matted, which implied a real respect for the photograph as an object of art.

White's earlier work, first shown in Ohio in 1896, has what is comparatively rare: a great affection for the women of his town. They are all quite young; their youth, you recognize, is not just an accident of birth, but a genuine virtue, bearer of poetic vigor and freshness, which overflows from the face and saturates the composition.

White did not abandon his job in Newark simply because he was published in *Camera Work;* he chose to stay in Ohio, and rose to the exalted position of head bookkeeper at the grocery. Only in 1907 did he leave this good, steady job and come to New York City to teach. His hometown roots were cut, and he went through the ordeal of most exiles: his work became uncentered, lifeless, and commercial—except for one very beautiful, side-lighted nude, which was the product of one of the curiosities of photographic history: the picture is credited equally to White and to Stieglitz, a collaboration between a country bookkeeper and a tyrannical genius.

For a long time Stieglitz kept his membership in the Linked Ring, the British counterpart of the Photo-Secessionists; and its members were regularly printed in *Camera Work*. Notable among them were the gravures made by the Scotsman J. Craig Annan from the negatives of Hill and Adamson, which he had rediscovered in Edinburgh. Another influential contributor from abroad was Frederick H. Evans. He'd been a London bookseller for years; but then, at the age of forty-six, had turned to professional photography. His fine photograph of Aubrey Beardsley is one of a whole series he made of his close friends among the artists and writers of his time. They are by no means uniform in style; each is marked by long

and special observation. He turned toward architecture in his later years, and photographed churches both in England and France; but, unable to obtain platinum paper after World War I, he gave up photography entirely. There is a strange discontinuity in the life and work of many photographers. Where most composers and painters work continually, whether their reputation goes up or down, photographers tend to burn out after a few years, and take up other pursuits for a decade or longer, from which they may or may not return with renewed force.

One of the most interesting things about Photo-Secession is that of the 105 photographers who were members, at least twenty were women. It reflects a like proportion among photographers in general, but why? There are interesting differences, reported in the scientific literature, between men and women in the way they perceive an imagined space. But before leaping unfashionably to a genetic conclusion, one would have to carefully consider the psycho-social position of women in our culture. Graphic talent, it's true, is seen rather early; still, it requires years of development and training. A woman in nineteenth-century and early-twentieth-century western society is drawn back, in the second or third decade of her life, into the arduous pleasures of home and children. When the children are grown, the mother is characteristically forty or older—too late for the necessary years of drawing and painting. The camera can then become her draftsman; so she can make immediate use of her eyes and judgment and taste, and her experience with close and heated personal relationships; so she becomes attracted to portraiture. Men deal every day with hard-edged abstractions like work or money; but their wives deal with people. These female artists were scarcely reproduced in *Camera Work,* with the exception of Annie Brigman, who, to judge by "The Cleft in the Rock"—a pale nymphet posed between grim cliffs—seems to me of minor interest. A far greater artist, published indeed in *Camera Work* No.1 and whose reputation is still growing, fed by our new appreciation for the pictorialists, is Gertrude Käsebier.

She was born Gertrude Stanton, in Des Moines, Iowa, in 1852, but the family joined the silver rush to the pioneer boom town of Leadville, Colorado. She was educated at the Moravian Seminary for Girls, the parochial school of a sect that originated in Germany; its adherents emphasized conduct rather than doctrine and, without much modesty, called themselves "a company of saints." Their piety remained with her all her life. When she was twenty-one, she married Edward Käsebier, a German immigrant salesman; but

Clarence White
Girl with a rose, 1908
From *Camera Work,* No. 23, July, 1908

Clarence White
Portrait of Miss Mary Everett, 1908
From *Camera Work,* No. 23, July, 1908

Clarence White
Lady in black with Statuette, 1908
From *Camera Work,* No. 23, July, 1908
All, George Eastman House, Rochester, New York

Frederick Evans
Ethel Wheeler, no date
Philadelphia Museum of Art, purchased with
funds given by Dorothy Norman

Frederick Evans
Aubrey Beardsley, c. 1894
George Eastman House, Rochester, New York

205

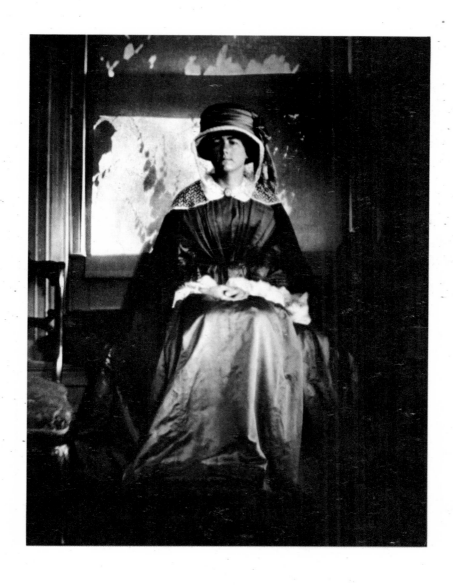

Gertrude Käsebier
Little girl in hat, no date

Gertrude Käsebier
Woman in hat, no date
Both, The Art Institute of Chicago

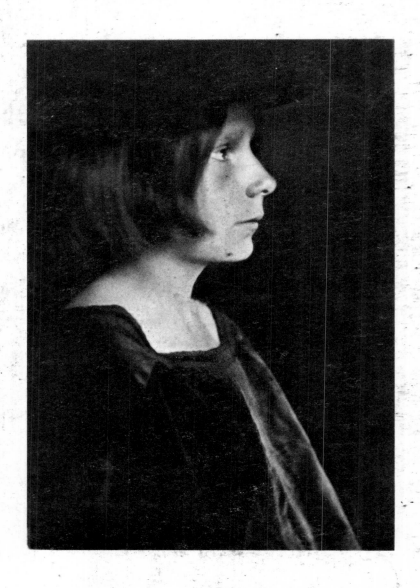

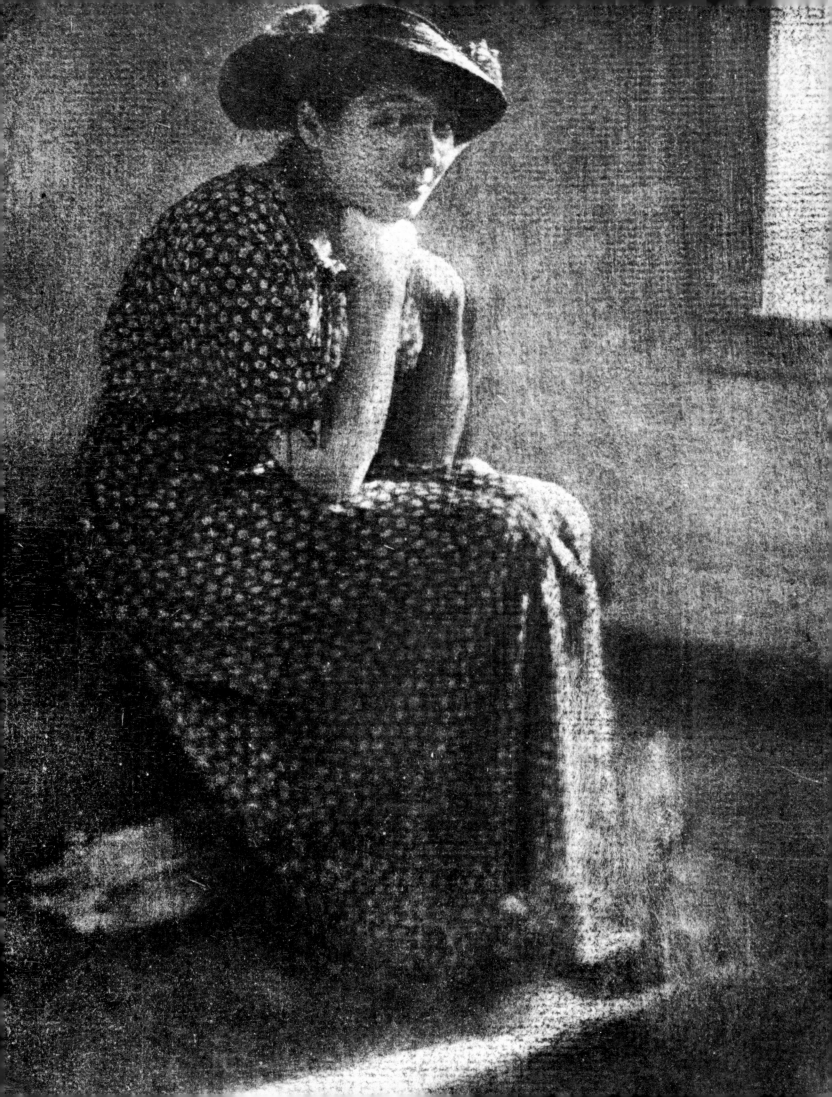

how largely the possession of Camera Work *has helped me in my work as a teacher, and what an incentive it has always been to my pupils toward a higher standard. It does that for the man with a camera what the Bible has, more or less vainly, for centuries, tried to do for the man with a conscience.*

It is a curious confession, for Frank Eugene Smith was not primarily a photographer; his early reputation was based on his connection with *Jugendstil,* the word used in Austria and Germany that corresponds to Art Nouveau: a curled and whiplike line, an eroticism, only slightly depraved. But his preconceptions disappear in most of his photographic work; his camera, in spite of the obvious reworking of his negatives, remains marvelously stubborn. In fact, it is a quality of the camera, almost universally true, that it is transparent. It gives us the luscious reality, for example, in his two portraits of "Miss Cushing"—one clothed and one nude. Like Goya's two portraits of Maja, they are two aspects of the same person.

Now let us examine those twin giants of the Pictorialist movement, those admirable, contradictory, and almost indigestible characters, Edward Steichen and Alfred Stieglitz. They were lifelong friends, but I have not found any marked influence of one upon the other. Out of Steichen's work, pursued through many years and many difficulties, one could easily pick a hundred striking portraits. But after they have struck us, we have inner doubts and unsatisfied hungers. Steichen photographed numerous actors and dancers; and of these one of the most beautiful and true was the tragic innovator Isadora Duncan. She, certainly, deserved to be photographed as if on stage; her life was lived very much that way. But Steichen puts everyone on stage, even the nonactors. In the Introduction I have discussed the most famous American portrait of all, that of the industrialist J. P. Morgan, done in 1903; here, however, the actor was rich and powerful. Steichen relates that he took the photograph as a study for a painting to be done by his friend Fedor Enke: "Morgan arrived, took off his large hat, laid a foot-long cigar on the edge of a table, and took his habitual portrait pose." The sitting lasted only three minutes. Morgan said, "I like you, young man. I think we'll get along first rate together." And before getting on the elevator, Morgan gave Enke five one-hundred-dollar bills for Steichen.

Steichen had taken only two exposures; he retouched the nose on one, but on the other he also removed all "the spots that were repulsive." Steichen showed Morgan a proof of both negatives, and the millionaire ordered a dozen of the first—and tore up the second proof into bits. "That stung very deep," writes

Frank Eugene
Portrait of Miss Cushing, no date

Frank Eugene
Sitting Nude, no date
Both, The Metropolitan Museum of Art, New York,
The Alfred Stieglitz Collection

Steichen, and he enlarged the negative and worked assiduously on it until he could express—rare, indeed, in photographic portraiture—his hatred of the old pirate.

Steichen went to Europe to study painting, but returned to his New York garret at Gallery 291, and split his time between these two arts. He became, in time, an extremely successful portrait and fashion photographer, occupations which between the Great Wars were as highly paid as any junior business executive. The drama of his portraiture is obviously popular, and directly and powerfully conceived. But is there anything more?

There are, I sometimes imagine, only two kinds of photographs: one sort requires a long look and repeated visits; it is subtle, its strength is hidden, its effects are slow and deep. The other sort hits you in the face like a cold shower, chilling and stimulating; but when the effect has dried off, there is not that much left to see. It is necessary to forget the photograph, let time go by, and then return suddenly to experience the same delightful and dramatic shock. Probably one needs both kinds of photographs; in any case both are being actively made, whether one chooses to look at them or not.

Stieglitz, though, is altogether outside any such categories. A tremendous amount has been written about him, and as usual in photographic history, it is largely worshipful. He was an intense, even overbearing, and highly vocal man. He loved to discover unknown and neglected talent; but if they became successful, he often began to dislike and distrust them; possibly he was right. He was sharp, obsessed, and merciless. He took hundreds of portraits of the painter Georgia O'Keeffe, who became his wife; nor did he neglect her sensual qualities; but that was true of all of his work. He had a voracious ego, and never separated his work from himself. In 1910, when the Photo-Secession was running out of steam, he wrote to one of his friends: "Get Busy. . . . The reputation, not only of the Photo-Secession, but of photography is at stake and I intend to muster all the forces available to win out for us."

The great photographer Edward Weston, who when he was thirty-six and about to break the restraints on his style of life as well as work, went to visit him in 1922. He made a verbal portrait of himself and Stieglitz: *"A maximum of detail with a maximum of simplification"—with these words as a basis for his attitude towards photography—Alfred Stieglitz—talked with Jo and me for four hours. . . . His attitude towards life presented no revolutionary premise to distress me—though it was all fascinating conversation—but*

my work he instantly laid open to attack—And I am happy! I saw print after print go into the discard—prints I loved—yet I am happy! for I have gained a new foothold—a new strength—a new vision—I knew when I went there something would happen to me—I was already changing—yes changed—I had lugged these pictures of mine around New York and been showered with praise—all the time knowing them to be part of my past—indeed not hardly enthusiastic enough to put on an exhibit—I seemed to sense just what Stieglitz would say about each print— So instead of destroying or disillusioning me—he has given me more confidence and sureness and finer aesthetic understanding medium—Stieglitz is absolutely uncompromising in his idealism—and that I feel has been my weakness—Quick as a flash he pounced upon the mother's hands in "Mother & Daughter" (Tina) on irrelevant detail in the pillows of "Ramiel in his Attic"—bad texture in the neck "Sibyl" and the unrelated background in "Japanese fencing-mask"—"Why did you not consider this pipe in 'Pipe and Stacks'—it's just as important as those stacks—nothing must be unconsidered—there must be a complete release"—And all this to one who has believed in and been praised for his rendering of textures! On the other hand I feel that I was well received by Stieglitz—it was obvious that he was interested and the praise interjected was sufficient to please me—for I know his reputation as an egoist and his rightfully intolerant attitude towards most photographic salons—"You feel—I can see that—you have the beginning—will you go on—I do not know! You are going in your own direction but it is good— go ahead. . . ."

In my enthusiasm—I do not accept Stieglitz absolutely—as an infallible master for as he remarked —"friends made me out a God—when all I asked was to be treated as a human being—then turned on me when I couldn't be all they asked—and '291' went down. . . . I have nothing left—no home [word illegible in faint xerox] . . . ted by friends and wife and child—and yet in no period of my life have I been so enthusiastic and interested in photography—and anxious to work—yes—Miss O'Keefe [sic] has painted and I have photographed—and I will show you"—then he did show us a few of his photographs—most of them being in storage—I turn alternately hot and cold as I recall some of them— the hands sewing—the pictures based on the mons veneris—the breasts—"ah—you do feel deeply—and that little girl over there—trembles with emotion— you will go away and tell of this meeting and they will say 'Stieglitz has hypnotized you' (and I am sure

Edward Steichen
Portraits—Evening, no date

Edward Steichen
Eleonora Duse, New York, 1903
Both, from *Camera Work,* special Steichen Supplement,
April, 1906
George Eastman House, Rochester, New York
Page 218
Edward Steichen
F. Holland Day, Paris, 1901

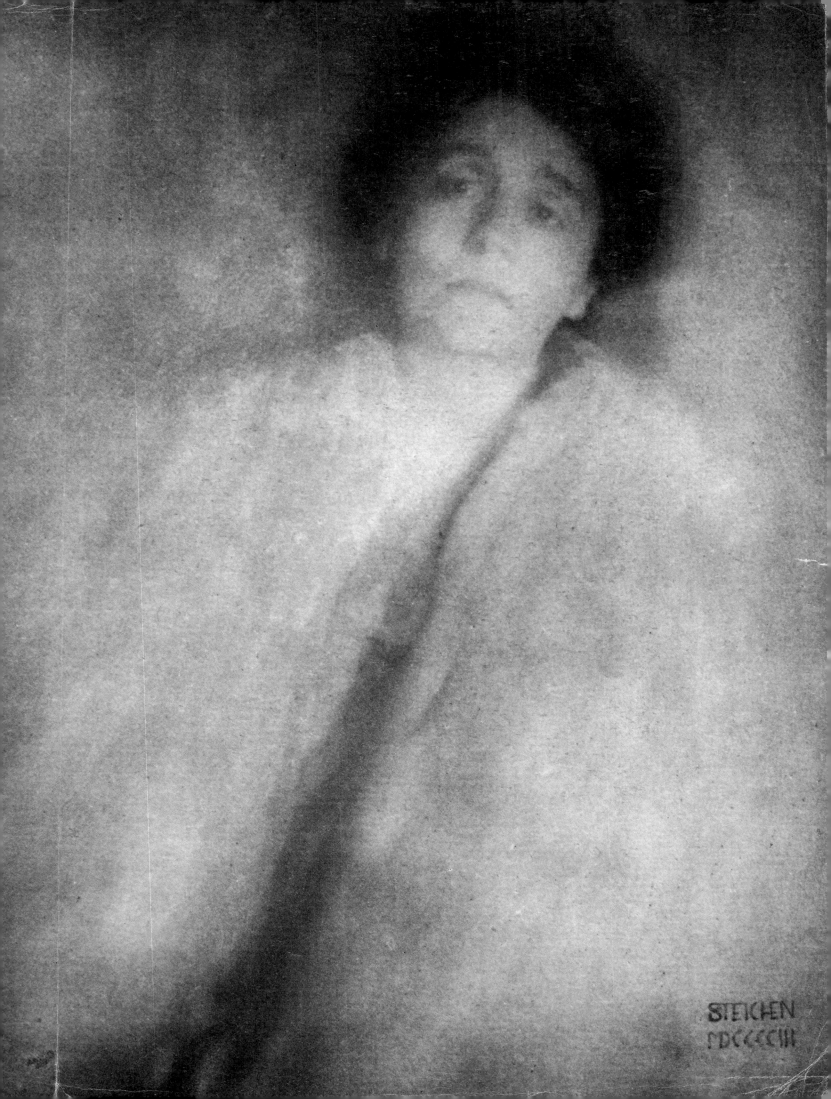

he did!) *but I have simply bared to the world a woman's life. After all we only know what we feel —if you had come to me a few years ago I would not have been ripe to give you what I do now"—nor I ripe to receive it—I have been unafraid to say what I feel—you see that in my work—I have broken every photographic law—optics included—I have put my lens a foot from a woman's face because I thought to myself—when one talks intimately one doesn't stand ten feet away—and knowing that it takes time to get deep into the very essence of matter I have stopped down and given exposures of three or four minutes—you see my prints—the eye is able to wander all over them—finding satisfaction in every portion—the ear is given as much consideration as the nose—but it is a task this desire to obtain detail plus simplification—*

Here, too, one must remember that the image of a person living and therefore changing in real time is constantly distorted by that inner lens, the brain of the observer. The physicist Werner Heisenberg's famous principle, that the observation itself alters the object it observes, operates in photography as surely as it does in the sub-atomic world. Here, for example, is Stieglitz's disciple and biographer Dorothy Norman's view of him: *Someone after a conversation with Stieglitz asks him in wonder who he is. Stieglitz replies: "I am the moment. I am the moment with all of me and anyone is free to be the moment with me. I want nothing from anyone. I have no theory about what the moment should bring. I am not attempting to be in more than one place at a time. I am merely the moment with all of me."*

The view of his contemporary, the gifted critic Waldo Frank, was a little less metaphysical: *The life of Stieglitz had the cruel economy of a poetic drama. . . . The chance visitor to his rooms was at once part of the dramatis personae; if he did not realize this, perhaps innocently asking the price of a picture without knowing the integral relation of the price to his life, to America, to all life, so much the worse for him. If he was an old friend with some inward wound of his own life-dream, coming to seek solace, certainly he did not find it, when he found himself suddenly transformed into the Stieglitzian drama.*

And here is what Stieglitz had to say about himself (in 1921): *I was born in Hoboken. I am an American. Photography is my passion. The search for Truth my obsession. Please note: in the above Statement the following, fast becoming "obsolete," terms do not appear:* ART, SCIENCE, BEAUTY, RELIGION, *every* ISM, ABSTRACTION, FORM, PLASTICITY, OBJECTIV-ITY, SUBJECTIVITY, OLD MASTERS, MODERN ART,

Alfred Stieglitz
Georgia O'Keeffe, 1918
Courtesy of Georgia O'Keeffe for the Estate of
Alfred Stieglitz

Alfred Stieglitz
Georgia O'Keeffe, 1918
Courtesy of Georgia O'Keeffe for the Estate of
Alfred Stieglitz

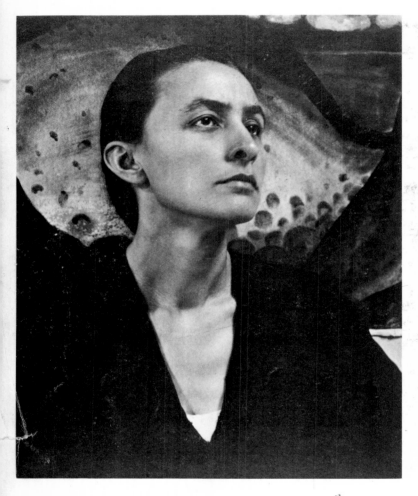

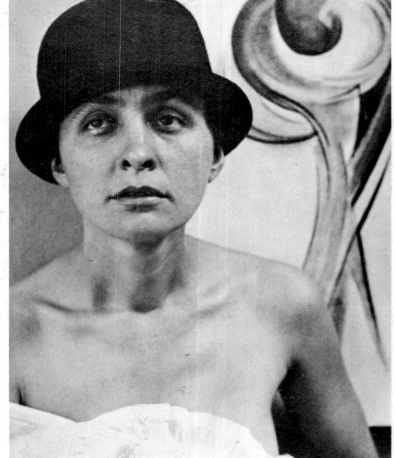

Alfred Stieglitz
Georgia O'Keeffe, 1918
Courtesy of Georgia O'Keeffe for the Estate of
Alfred Stieglitz

Alfred Stieglitz
Georgia O'Keeffe, 1918
Courtesy of Georgia O'Keeffe for the Estate of
Alfred Stieglitz

Alfred Stieglitz
Georgia O'Keeffe, 1918
Courtesy of Georgia O'Keeffe for the Estate of
Alfred Stieglitz

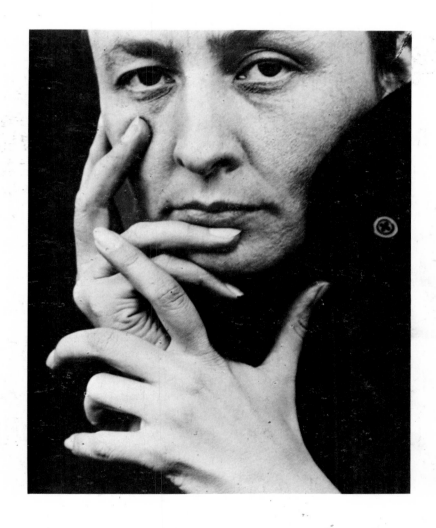

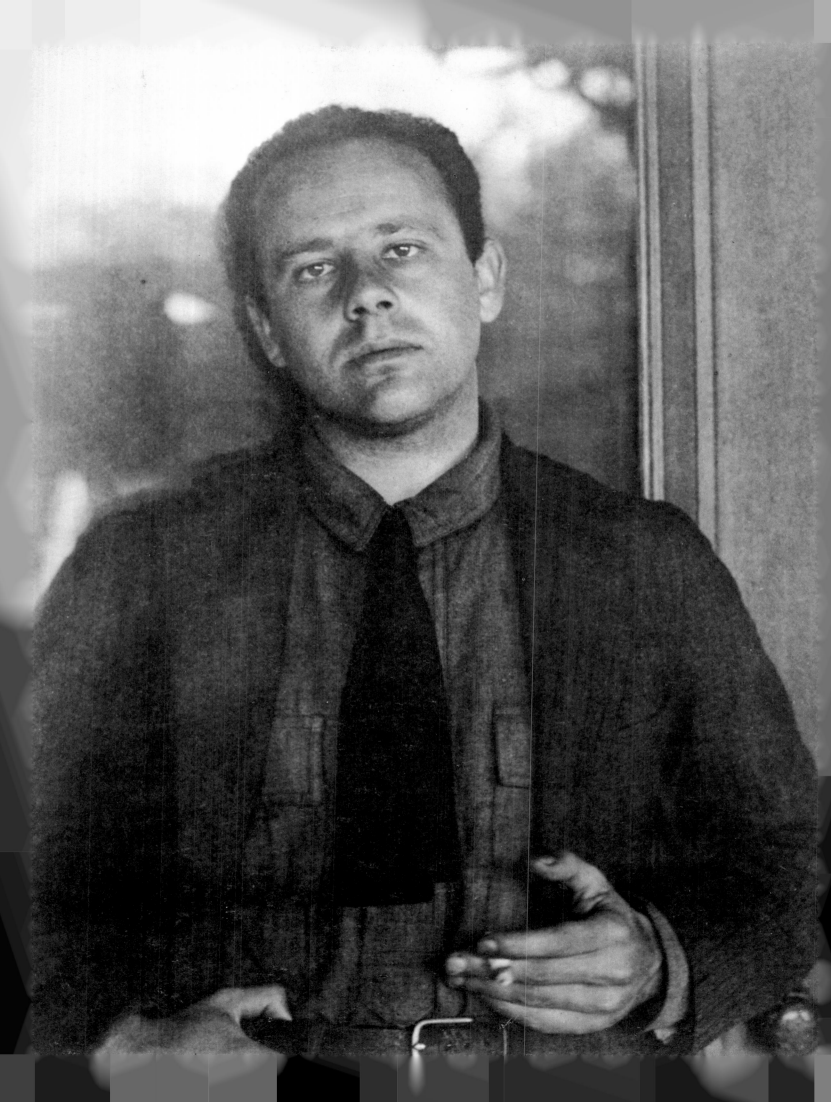

PSYCHOANALYSIS, AESTHETICS, PICTORIAL PHO-
TOGRAPHY, DEMOCRACY, CEZANNE, "291," PRO-
HIBITION. *The term* TRUTH *did creep in but may be
kicked out by anyone.*

Of course, Photo-Secession was nearly dead. Its de-
cay was caused by an old confusion of method with
aim: the aim was to make photography respected and
independent as an art; the method was to imitate an
art already respectable. So the method thinned away
the examples of the art in a gruel of gelatin and gum,
while "straight" photography, which had continued
in the meantime, reared up its fierce and vulgar head.
Stieglitz was a tactless and honest man, and far too
intelligent for self-deception. He printed no photo-
graphs in *Camera Work* for some years, but used it
to acquaint the American public with monsters like
Picasso, Gordon Craig, Marsden Hartley, John Marin,
Matisse, Rodin, and the ritual sculpture of Africa. His
view of the photographic scene was marked by an
atypical public silence, accompanied by a private
despair. The lyric manipulations of the Pictorialists
had degenerated into a fuzzy and sentimental manner-
ism, which (so indestructible is bad taste) can be
found in photographic magazines even today. In
1914, Stieglitz wrote: *I know as a fact that the pho-
tographers of this country are not very eager to see.
And that is why their photographic work is not de-
veloping. They may be improving technically as far
as processes are concerned but they are adding nothing
to their own vision. They have no vision. And where
in the world are those photographers who really be-
lieve in photography?*

And then, one morning in 1915, there came the *coup
de grâce* for Pictorialism. Young Paul Strand, who
had been a frequent visitor to the Gallery and had
sought Stieglitz's advice, brought him a group of pho-
tographs taken on the streets of New York City. This
work so moved Stieglitz that he published two large
numbers of *Camera Work* devoted only to this youth
of twenty-five. Stieglitz wrote: . . . *His work is
rooted in the best traditions of photography. His vi-
sion is potential. His work is pure. It is direct. It does
not rely upon tricks of process. . . . The man has
actually done something from within. The photog-
rapher has added something to what has gone before.
The work is brutally direct. Devoid of flim-flam; de-
void of trickery and of any "ism"; devoid of any at-
tempt to mystify an ignorant public, including the
photographers themselves. These photographs are the
direct expression of today . . .*

Alfred Stieglitz
Paul Strand, 1917
Courtesy of Georgia O'Keeffe for the Estate of
Alfred Stieglitz

Alfred Stieglitz
Margaret Treadwell, 1921

Alfred Stieglitz
John Marin, 1922
Both, courtesy of Georgia O'Keeffe for the Estate of
Alfred Stieglitz

I have in my hand a postcard photograph of the sort immensely popular in Europe in the innocent decade before August, 1914; it's the portrait, taken in Mannheim, Germany, of a gentleman of about thirty; long-lipped, long-chinned, square-jawed, with a nice little patronizing smile; wearing a two-buttoned vest over a belly already plump, and a bow-tie under the two stiff wings of his collar; he has both hands occupied with an open silver cigarette case, and he wears a monocle in the frown around his right eye; he is truly at ease in his time and station. His clothes, gesture, face, and monocle are not revelations, but signs. He is, and firmly desires to remain, not a person but the representative of a group; but of what group? Two sadomasochistic wars have since rendered this question irrelevant. Yet surely there is a suffering, enjoying man under the incunabula of that cavalier smugness and self-confidence. And if one turns the card over, there is, in fact, marks of this individuality: a penciled message (in French!) that reads, translated: "From the semivirgin to the ———, a Souvenir."

If drama is the crystallization and shattering of conflict, then no photograph can be dramatic in itself. Having said so, I can think of a hundred exceptions; but they are only exceptions, after all. We are dealing with a deliberate stillness; but that point of calm may imply a whole era and the laminations of a whole society. So there is an entire class of portraits that has a sociological force, a conflict implied but not stated: the in-group watching the out-group; or the reverse. This is true everywhere, but nowhere more consciously than in England.

Here class position was, and still is, so much a part of English society that the great treasures of English fiction, for example, are inconceivable without it. It is no surprise, then, that this one leg of our triangle, photographer to sitter, should be affected, too; and produce a most fascinating body of work; because there is no way to escape the elastic fabric of society: even bitter opposition to it is governed by the very norms which it may hate. But to work within the conventions of one's own society means a certain ease and abundance. So the periscope raised over the wall separating groups and classes in society represents a very early use of the camera. There are hints of it in Hill and Adamson's fisher-folk and Julia Cameron's servant-maids; but these were accidents of photographic curiosity. The work of John Benjamin Stone and John Thomson had no other obvious motive than to record the faces and mores of the English castes.

John Benjamin Stone was born in 1838, the son of a well-to-do glass manufacturer, and thus middle-class

by definition; and very correct and orderly and decent and sensible in his habits. On occasion he was called upon to lecture his equals on the improvement of their minds (that middle-class nineteenth-century obsession) with travel, good reading, and chess. He conducted the family business, lived in a thirty-room country house, stood for Parliament, and even managed to win. There was no doubt he was also a bit of a kindly ass, if one is to take seriously his advice to the girls of Duddlestone Ward in Birmingham, from which he was standing for office: "Don't have any sweethearts who are thoroughly not good Conservatives!"

He was at first an avid collector of photographs: especially those of peoples and monuments and curiosities in other countries. Only in 1868 did he begin to make his own photographs; for example, he made portraits of every one of his fellow parliamentarians. But it took him more than twenty years to decide that he really meant them to be a great record of his own times and his own society.

But his well-known portrait of the coachman of the lord mayor of London, who was still, in 1906, dressed in brocaded coat, white gloves, buckled shoes, and tri-cornered hat, is something a good deal more than a mere record; in his fat, quince-shaped head we read Stone's amusement. Again, in the old charcoal-burner leaning on his axe, we see, under the deference to the photographer, the tough, dignified, enduring, life-weathered stance of the manual laborer. Stone had a taste for the macabre, too, photographing a certain stiffly proper Mr. Smith in an armchair whose arms are human and whose headrest is a ghastly, stuffed leather face. Thus, peering in the reverse way through the omnivorous lens of Sir Benjamin—if we imagine him focusing on that sad, ridiculous couple of children at church in the Maundy ceremony—we glimpse an eye for the cryptic absurdity of anyone, everyone; which is one trait, anyway, that transcends class and degree.

In curious contrast to this busy amateur, there worked at the same period a professional photographer of almost the same age: John Thomson, a Scotsman who was educated at Edinburgh University and made photography his career. He traveled to China and published four volumes illustrated with his own photographs. These books earned him a position as instructor in photography at the Royal Geographic Society; indeed they contain fine and powerful portraits; the rags and horror of Chinese life are not romanticized. A writer named Adolphe Smith then came to him and proposed that they do a new book on the slum dwellers of London; Thomson agreed—it was

Page 229
Sir Benjamin Stone
The Maundy Ceremony, children of the Royal Almonry, Westminster Abbey, 1898

Sir Benjamin Stone
Coachman of the Lord Mayor of London, 1906
Both, the Benjamin Stone Collection, Birmingham Reference Library, England

Sir Benjamin Stone
Old charcoal burner, Worcestershire, 1896

Sir Benjamin Stone
Mr. Smith in grotesque leather chair, 1905
Both, Benjamin Stone Collection, Birmingham
Reference Library, England

another sort of voyage for him, and quite as alien, at first, as China had been. In the preface to the published work, they say: *We have visited, armed with note-book and camera, those back streets and courts where the struggle for life is none the less bitter and intense, because less observed. . . . [It is] a vivid account of the various means by which our unfortunate fellow-creatures endeavour to earn, beg, or steal their daily bread.*

The last previous work on the subject was the huge reportage done by Henry Mayhew in 1850, and illustrated by woodcuts made after daguerreotypes by Richard Beard. Life among the London poor—which included by far the largest part of its inhabitants—had not changed much in the intervening twenty-seven years. What had changed was the growing power of the new trade unions. The link here was Adolphe Smith: he was a reporter who volunteered to be official interpreter at the series of International Trade Unions Congresses from 1886 to 1905, and by no means an uncritical observer either, for he published (1888) a pamphlet attacking the leadership for lack of contact with the very people they were trying to organize.

What *Street Life in London* does is to bridge this gap: not, of course, to close it. Again, it was not, and could not have been, the workmen or immigrants or small craftsmen who made these photographs. Neither the time nor the equipment nor the attitude was available to them. The Englishman Mayhew—and the Frenchman Doré, who came from Paris to make engravings of London slums—as well as Smith and Thomson, were essentially middle-class intellectuals. In England particularly, habits of speech and dress and comportment instantly marked and separated them, equally from the poor and from the landed gentry. Yet one must not forget that although their book appears to be a realistic record and social outcry, it is an emotional document of individual conscience, as well.

Yet it is something deeper, just as Jacob Riis's and Lewis Hine's work, as I shall come round to consider, was deeper than they knew. Take, for example, the "Public Disinfectors": here are two men drawing a closed cart, and supervised by a gentleman in a top hat. They were sent to remove the bedding and rags in the rooms of a smallpox victim, whether recovered or dead. Smith's original commentary says: *There is something peculiar, not to say sinister, in the little group this formed. To the excited imagination of a convalescent their appearance might evoke a sense of horror. The presence of men who are ever engaged clearing out fever dens, and are constantly handling the bed-clothes belonging to persons who* *have suffered from the most repulsive, contagious, and dangerous complaints, is certainly calculated to produce a painful impression on a debilitated mind: though, to those whose reason is not impaired by sickness or prejudice, these considerations should, on the contrary, enhance their admiration for the devotion and courage so unhesitatingly displayed. Nor is this the disinfectors' only claim to our sympathy; they are men whose honesty is frequently exposed to temptation, and against whom I, at least, have never heard the slightest complaint. They alike disinfect the houses of the poor and the rich; one day destroying the rubbish in a rag merchant's shop, and the next handling the delicate damask and superfine linen which shade and cover the bed in some Belgravian mansion. Once in the sick-room, no prying eyes are allowed to watch the disinfectors at work. They have strict orders to exclude every one from their dangerous presence. Alone and unseen, they remove, one by one, all the clothes, bedding, carpets, curtains, in fact all textile materials they can find in the room, carefully place them in the hand-cart, and drag them off to the disinfecting-oven.*

These grim facts are certainly not contradicted by the photograph; but mere conscience did not set these three men in so powerful a composition, white against black, nor choose an angle so felicitous as to include the black space of a smashed window in line with the limed wheel. And the downward, sideward look of the disinfectors; this is beyond their trade; it is the aim of great portraits—to record character and not characteristics.

But is it sensible to expect this of a tool like a camera? For it is a machine, certainly, of the nearly infinite human mind; but it is an instantaneous machine, not a tool like a brush or a chisel or a burin, which provides feedback to the brain over a long and laborious time. Does the camera really stop at the skin, unable to go deeper? Yes, that is its limit, but it is not a defect, only one more proof that photography is a unique art—profound only if the artist is equal to the subject.

So if we, as viewers, examine his photographs with the same kindly intensity as did Thomson himself, we can deduce, for example, from his photograph of the "Street Doctor," with his tall round hat, his uneven club feet, from the two vigorous ladies who are his doubtful customers, and from the curious sign itself: the complex look and odor of a perished century.

Now the truth of character, we must nevertheless admit, is a value to be tested like any other value. Should it be more highly regarded in portrait photog-

John Thomson
Public Disinfectors
From *Street Life in London,* 1877
Gernsheim Collection, Humanities Research
Center, University of Texas, Austin

John Thomson
Street Doctor
From *Street Life in London,* 1877
Gernsheim Collection, Humanities Research
Center, The University of Texas, Austin

John Thomson
"Strawberries, all ripe, all ripe"
From *Street Life in London,* 1877
Gernsheim Collection, Humanities Research Center,
The University of Texas, Austin

raphy than, for example, a solid or a striking composition? Or a finely scaled range of tones, as detailed in the highlights as in the shadows? Or emotional values like a misty calm or a bright astonishment, or that even more introspective term: poetry? I believe, myself, that truth in character is an absolute essential of great portraiture. It is dangerous, like any other truth; it may wound the sitter, splatter back on the photographer for soiling a public idol; or offend the ubiquitous Third Man, the average viewer; who, if he has political power, may banish it altogether. The career of the twentieth-century German portraitist, August Sander, a fine and almost unknown artist, is an example almost too apt.

The Nazis, that apotheosis of the anxious lower-middle-class of German Europe, did everything with mad logic: they banned as Bolshevik certain music, painting, and books (that were anathema to Stalin, too); and they went on to ban Sander's photographs as "undesirable." The edict was not entirely on aesthetic grounds. Sander's son Erich, as his brother Gustave has related, was a Communist. *Arrests became everyday occurrences, and my brother Erich fled from one hiding-place to another. After spending some time in Paris, he returned to Cologne despite warnings from all sides. And although my parents were in despair over his credulous belief that the horror would soon pass, they helped him produce his leaflets by photographic methods (the party printing presses had long since been seized). As my father did not possess a drying machine the prints were dried outdoors on the roof. A gust of wind must have blown some of them down into the courtyard below, and my brother was arrested the next day by the Gestapo. His library was confiscated, and my father's archives were virtually turned inside out. All our complaints were to no avail —on the contrary: our connection with Erich had labelled us as anti-social parasites. And, understandably, customers were afraid to come to us.*

Around the middle of 1934 we received the news from the Transmare publishers that August Sander's Antlitz der Zeit *had been withdrawn and all stocks confiscated. Even the printing-blocks had been destroyed. My father was furious, and his anger only abated during an excursion into the Siebengebirge district, where he went to take landscape pictures. This inner emigration did him good. Since there was no chance of his pursuing his own line of work, he was obliged to look around for new possibilities. Up in the Siebengebirge he found an enchanting stretch of completely unspoiled land. At night he slept in a sheltered spot in a sleeping-bag, in the daytime he read or went out looking for new subjects. The rest and relaxation which he found in this lonely spot even gave him a degree of confidence when he thought about the approaching trial of his son. The verdict, however, brutally proved him wrong: Erich Sander was sentenced to ten years' imprisonment and an equal period of loss of civil rights, as well as to pay costs.*

August Sander, as a boy, had been an apprentice working in the slag heaps of a mine which his family once owned; he met a photographer, acquired a camera, and began to make portraits as a hobby. Sometime before 1900, he opened a professional studio, and in the course of business, in and near Cologne, made pictures of his customers, but not content with these, traveled to the countryside to make others simply to please himself. Where the early photographers, Nadar for example, had another source of income that gave them freedom to work as they wished; and still others, like Cameron or Stieglitz, lived on inherited income and so could afford the luxury of independent time, the sons and daughters of workmen or small tradesmen were burdened with the necessity of earning a living. Thus, to satisfy what may be called, for want of a whole volume to define precisely what I mean, a truly spiritual need, they labored to create a whole body of work in their spare time; and this was parallel to their commercial work, though undoubtedly affected by it, whether in continuity or in revulsion.

Sander knew very well that he was making portraits of German types, classes, stations, occupations. His only book, in 1929, was called *Antlitz der Zeit*— "Portrait of Our Time." Germany, like England, had suffered a disaster in World War I; but unlike England, it had, for a brief period, been shaken by reversals in the social order: but the rebel leaders were simply murdered by armed bands of ex-officers. The structure of German society remained as rigid as ever. The famous decadence of the twenties, the boldness of intellectual life, the lewd and yet highly moral art of George Grosz and Berthold Brecht—were confined to the small, politicized café life and café theatre of Berlin; these brilliant talents were mere bubbles on the surface of the great, sluggish German soup. Outside Berlin, everything was in order: the poor were poor, the rich were rich, and the police in between were immaculately uniformed. Germany had become a republic, true, but its main institutions, patterned after a Prussian household, remained largely untouched.

Higher education was, in practice, limited to the old aristocracy or to the children of the new: the manufacturers, the speculators, the military and naval hierarchy. Ambitious children of the lower middle

class had a rough time at school, from teachers and students alike, and foreigners such as the Poles, who had lived in Germany for generations, were *streng verboten*. Teachers were drawn from the ruling groups, and naturally taught an inherited, blind, and mystic nationalism; thus the Austrian-Hungarian-German system was self-perpetuating. August Sander's portraits show these types for exactly what they are; which did not take any manipulation on his part. The people he photographed were only too proud to exemplify themselves, as another astute observer, Franz Kafka, notes in his travel diary of 1915: *At the railroad station the hussar in the laced fur jacket danced and shifted his feet like a show horse. Was bidding goodbye to a lady going away. Chatted easily and uninterruptedly with her, if not by words then by dancing motions and manipulations of the hilt of his saber. Once or twice, in fear lest the train be about to leave, escorted her up the steps to the car, his hand almost under her shoulder. He was of medium height, large, strong, healthy teeth, the cut and accentuated waistline of his fur jacket gave his appearance a somewhat feminine quality. He smiled a great deal in every direction, a really unwitting, meaningless smile, mere proof of the matter-of-fact, complete and eternal harmony of his being which his honor as an officer almost demanded.*

This recognition of the type, rather than the individual, is exactly what Sander intended, too; and with the help of Teuton society, he got closer to this sociological notion than any other photographer we still admire. But the typical doesn't quite contain itself; though everyone dresses as becomes his position, bricklayer or industrialist, his armor is not impervious to Sander. Individuality somehow bursts out of the strained seams of a pastry cook; out of the difference in the smiles of the otherwise identical peasant girls with identical dresses, hairdos, and wristwatches. The military cadet decorated with conventional dueling scars across cheek, upper lip, and the tip of the nose —even he has a pathetic quality of self-control. *"Gott mit uns,"* says the belt buckle on the young soldier, but his face is so much a mask that we can smell the fear: indeed, it is 1945.

There never was, though only a monstrous cynic would say there never will be, a time or a culture when the artist was thoroughly comfortable with authority, natural or supernatural. His aims are quite different. One hears ad nauseam of the humble satisfaction of the cathedral builders; but no one has got any solid testimony from the nameless men on those lofty timber scaffolds, laboring stone upon stone in the glorious mathematics of vault and buttress; if they slipped and fell, they descended straight into heaven, but got no further compensation.

Collective work is work, after all, for a collective; it guarantees that the object made will function in its society. It does not guarantee that the object, whether an airplane or a canoe, a villa or a longhouse, will be beautiful; and particularly if we mean beautiful in its most frightening, penetrating sense. Because, yes, function in a physical sense tautologically defines form; geometry expresses the nice interplay between materials and their use; and we find that geometry to be beautiful. But why? No one knows, and let's hope no one will ever find out.

The artist is a clever madman; his truths and his nightmares, his private perceptions and his hallucinations: these he shapes for use in his society in order, simply, to make his bread. But his perception of what precise, detailed, final shape his work will assume—this is a business between his hands and his soul. Otherwise the most pious would be the greatest composer of Passions, and the best horticulturist, the greatest painter of still life.

There is a tension, consequently, between the artist's private, unconscious bias and the structures and necessities of his own culture. This strain I think, is very evident in the novel art of photography, and clearest in the photo-portraiture of caste and class. The photographer bears a triplet of duties: to his own aesthetic, to the truth of the character projected onto his ground glass, and to the final viewer of the portrait, whom he ought to shake and not comfort. It would be wrong to say that the artist is at war with his society—it's more like a wary and armed truce.

Sander was fifty-seven when the Nazis came to power, and there is a comfortable myth that he took refuge in doing landscapes until the end of World War II. This is not strictly true, for in 1936, while his son was in prison, he made the portrait of a young Nazi in Cologne, and in 1938, a solid peasant lad who happened to be a member of the S.S. His reputation had seldom been more than modest and local, but in 1959 his work was remembered by the Swiss editor of the fine photographic and art journal *Du;* and the subsequent reproduction of his portraits made him famous. His own attitude has all the artist's fiercely protective naiveté; he said, "It is not my intention either to criticize or to describe these people, but to create a piece of history with my pictures."

It has always been the popular custom to characterize a nationality as if it were a person; it is patently false that all Germans are methodical, all Frenchmen individualistic. Yet such fallacies have a persistent skeleton of truth. There are certainly differences of

August Sander
Korps student from Nuremberg, Cologne, 1928

August Sander
Pastry cook, Cologne, 1928
Both, Halsted 831 Gallery, Birmingham, Michigan

August Sander
Peasant girls, Westerwald, 1
Halsted 831 Gallery, Birmi

August Sander
Senior high school master, C
Sander Gallery, Washingto

culture, and in an art so sensitive to social change as photography, German class portraiture will be very different from French.

Eugène Atget, who photographed in Paris in the early twentieth century, is a class historian of a special sort: his attitude, to be vulgar again, is very French. His society, just like English or Dutch or German, was caste-bound and compartmentalized; but somehow the French did not make class distinctions a matter of manners and speech, like the English; or a matter of birth and morals like the Germans. In fact, it was possible, by passing the very tough state examinations, to break out of one's father's class and enter, for example, the Polytechnic Institute. French society thus had an aristocracy of mathematicians as well as officers. "Bohemia," that society of classless intellectuals, painters, writers, and actors, which is itself a sort of class, was a Gallic invention, after all. From the garrets of the poor artist, one had the advantage of looking down on the spectacle of life without being so separate from it that one couldn't descend to buy oneself meat and milk.

Atget was an orphan, which is an outsider almost by definition; he went to sea at thirteen, remained a sailor until he was thirty; and then became an actor, though obviously not a great or famous one; nor was it unusual that he had a mistress ten years older than himself. When he was forty-one, in 1897, he moved to Paris for the rest of his life. He tried painting for a year, failed at that, too. Then, observing the current vogue of using photographs as quick studies for painters, he bought a cheap camera that was already old-fashioned. It was a very large, awkward view camera, which required the support of a tripod. He developed his glass plates in the darkroom of his small apartment, five stories up. He posted a sign downstairs: ATGET—DOCUMENTS POUR ARTISTES. Like any tradesman, he not only made photographs to order, but carried an extensive stock so that his customers might have a good choice. Braque used some of them; and possibly Utrillo a great many more. Atget's photographs were exteriors for the most part: streets and parks and trees and monuments, which he photographed, to avoid the trouble of blurred figures walking by, in the rich, empty, lyrical dawn of that riverine city, Paris. His portraits of street people were posed, for his lens was slow and a bit soft at short exposures; but to pose is really not a bad or unnatural thing for a sitter to do. It may actually settle the subject deeper into himself; the mask is there, but it becomes almost transparent: which is a tribute to the gentle, quiet patience of Eugène Atget.

In 1910 he was commissioned to do a set of photographs on the prostitutes of Paris for a book on sexual crime. He set about this work in a characteristic way, posing women in the streets and doorways which were their habitat. There is nothing lurid or imaginary about these portraits. They seem simply to be ordinary working women, wearing the insignia of the trade: high-buttoned boots, a bit of fur, a cigarette—and a kind of smiling defiance. Yet again, as I have noted so often, because it is so crucially important to the art of portraiture, there are two motives running alongside one another in every artist. One is his conscious motive, by which he justifies his life according to the standards of the particular piece of society which is his social territory; but there is the unconscious motive, too, which creates, as it were, the choice within the choice. So the overwhelming, cumulative detail of his shop windows, of his bourgeois interiors, of his buildings photographed before they were to be torn down—these are the marks of that intellectual addiction of the manic photo-possessor; of the collector, not merely of photographs, but of collections of photographs: series of fountains, of trees, of ironwork, of anything; which, put together in one's head, becomes a mental mosaic of Paris herself. Deeper yet, Atget shows—and the prostitutes series is a good example—an unerring, almost architectural sense of composition, where all parts support, by their cross-tension, the vibrating whole.

It is another of the odd turns of taste that his work, which totals perhaps as many as twenty thousand glass plates, was not really seen until the 1920's. When he was seventy years old, in 1926, a couple of his photographs were printed in a surrealist magazine, and the American Berenice Abbott, who was studying with Man Ray in Paris, saw them and fell in love with them. Their fame, their very existence—for gelatine on glass plates dries and flakes off in time—is the result of her work of devotion. I cannot look at these beautiful prints, which she gold-toned as Atget had—as merely a discovery by the ferociously poetic scouts of surrealist taste; they have a gentle humanity which is naturalist, lyric, subtle, and moving —precisely what Berenice Abbott's photographic profile of him truly reveals, plus a certain quiet, prophetic look of old age.

With the possible exception of Benjamin Stone's portraits of the members of the House of Commons (which I have not seen) none of these men, neither the English nor the French nor the German, took any memorable portraits of their own social group. Opening the lens and staring at the ground glass under the black hood was for them like looking through a tunnel into another and more amazing world. There is

Eugène Atget
Marchand de Paniers, Paris, c. 1898
The Museum of Modern Art, New York, The Abbott-Levy Collection, partial gift of Shirley C. Burden

Eugène Atget
Shoelace vendor, c. 1898
The Museum of Modern Art, New York, The Edward Steichen Fund

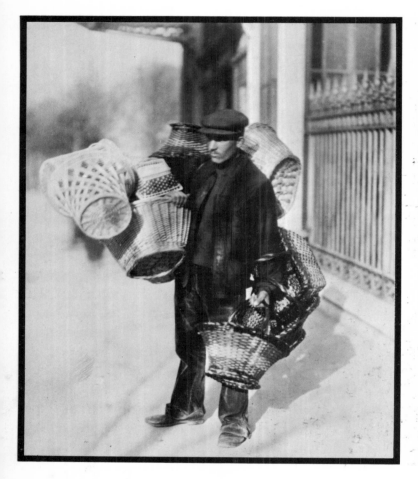

Eugène Atget
Chiffoniers, Paris, 1908
The Museum of Modern Art, New York, The Abbott-
Levy Collection, partial gift of Shirley C. Burden

something of the outsider about every photographer; he is fascinated, appalled, and possessive: as the policeman is of the criminal.

Here we must resolve a paradox: for if the very greatest portraits are accomplished by the use of a warm intimacy with the sitter, so immediately felt as to be instinctive—an expression of the photographer's personality, then how is he also to remain clear-eyed, truthful, and even ruthless? Maybe there is no conflict here, after all. Passion is blind, but not love; and one can be deeply aware of scars and faults even in the most glorious embrace. What is required, then, of the portraitist of caste and class is neither pity nor admiration, but a fine balance of compassion and diagnosis; and both these qualities ought to include the photographer himself, aware of his distance, his prejudice, his envy, and his sympathy.

One must leap into the twentieth century to find such keen sociologists of the eye. The Englishman Bill Brandt is a particularly interesting master of this peculiar profession. To call him English, though, is not quite right; he was educated in Germany, and at the age of twenty-three went to Paris and studied with Man Ray. In this company he was drawn into that curious and unprecedented moral crusade, Surrealism—moral, I assert, because all the comic and frightening explosions of automatic writing, of poetry shouted so as to be devoid of meaning, and Marcel Duchamp's theoretical sewing machines anesthetized on a surgical table, all the feathery, sinister inventions of Max Ernst, all the misread photographs of the gentle Atget, all the fascination with the crayon drawings of children and paranoids—had the same source of anarchic energy: hatred of the society that had just terminated that most surrealist of all theatres—the trench warfare of World War I. In this sense, the deepest feeling common to Surrealists was a nausea at the way things are.

Society, one's own culture, is quite inescapable; even hatred is of course a form of involvement; so it is really no surprise that when as sensitive a man as Bill Brandt returned to England in 1931, he was attracted by the victims of that new bourgeois epidemic, the Depression. He saw the poor and laboring people with intense, yet sweet compassion; there is no consuming fury, even in his famous photograph of the unemployed miner and his bicycle looking for spilled coal. He keeps a sympathetic distance. His friend Cecil Beaton describes him thus: *Bill Brandt is surprisingly different from the preconception one has formed through seeing his photographs. To see him in his room with its dark green walls, his books, solid furniture, the glass polished ancient mahogany camera he still uses, the Victorian knick-knacks, early family photographs, colored prints and surrealistic collages, one would not imagine him being able to foray into the noisy, rugged purlieus of East End pubs, miners' towns or railway cuttings.*

Bill Brandt speaks in a voice that is little more than a whisper. His accent seems as velvety as that of the Viennese or the Scots. . . . His bony features jut from the taut skin, with aristocratic aquiline nose, deeply set eyes of a wonderful sky-blue, and disarming sympathetic smile. In his long-limbed way he is the acme of elegance. . . .

In this sense, Brandt resembles William Faulkner, who, recognizing himself as the educated, alcoholic inheritor of a plantation aristocracy, hates the rednecks and empathizes, as far as he can, with the dignity and "patience" of the southern black. Like Faulkner, too, Bill Brandt is a magician of concrete and domestic detail.

The imposing double portrait of the maids in a upper-class English dining room is as precise about the elegant china, the cut-glass decanter, the three glasses for each setting, the flower-shape napkins, as it is about the two servants. They wear uniforms that are part of the table setting: starched and translucent aprons and pleated caps, but the face of the older woman is sad and severe with long service; the face of the younger, in contrast, is fresh, healthy—and apprehensive. Brandt shows a like concern with other mealtimes and meal places: the "Spanish Dinner" with its cut loaf, bird cage, and photo-portrait within the photo-portrait; and the blackened North England coal miner at the table with his wife, facing plain food and plain utensils, and backed with the busy wallpaper and the lace doily typical of English working-class feminine taste—just as in the United States one could find, in a similar room, a ceramic leopard with a gilded chain.

In very many of Brandt's photographs—one sees it quite plainly in the marvelous, sweet girl washing the stones—there is an idiosyncratic composition: the horizontal plane of the foreground is brought to meet the vertical plane of the background, against which the figure is imposed; and both planes of this L-shaped spatial construction are equally clear and focused. And over it all—and this applies to Bill Brandt's landscapes, too—there is a gentle, sad, yet clarifying light. Helmut Gernsheim, the photohistorian, whose work is especially intimate, writes that Brandt explained to him, in very simple words, his combined moral and aesthetic views: *Most of us look at a thing and believe we have seen it, yet what we see is often only what our prejudices tell us to expect to see, or what our*

Bill Brandt
Parlormaid and under-parlormaid, ready to
serve dinner
Rapho/Photo Researchers

past experience tells us should be seen, or what our desire wants to see. Very rarely are we able to free our minds of thoughts and emotions, and just see with the simple pleasure of seeing. And so long as we fail to do this, so long will the essence of things be hidden from us.

It's instructive to contrast this fine, decent craftsmanship with the splash and fire of a photographer thirty-odd years younger, and the product of a different war and a different society. Josef Koudelka, a friend and pupil of the great Henri Cartier-Bresson, was born and educated in Czechoslovakia. His earliest photographic exhibit was in 1961, the year he took his degree as an aeronautics engineer. Meantime he had been obsessed with two subjects: the theatre and the curious, wandering nation of the Gypsies; and these two interests are actually a great deal alike. The flamboyance of the Gypsy is real enough, but this reality hides the secretive, cruel, xenophobic nature of their tribes and camps; the outsider is feared, but also despised; he is, in criminal slang, the mark.

To some extent, Koudelka accepts this role; certainly the Gypsies whom he followed for years came to be fond of him; that's plain enough in his photographs; but it's also plain that they acted and displayed for him. While Brandt's photography of the thirties has a kind of ingrained sorrow at the quality of life in the modified capitalism of England, Koudelka has an equally powerful antagonist in the state capitalism of Czechoslovakia, whose bureaucracy, modeling itself, one sometimes thinks, on the righteous officials of that other Czech, Franz Kafka, endeavored to abolish the inconvenient Gypsies; and Koudelka is not on the side of order: he loves these mad Romany individualists.

Theatre is perhaps the wrong word for his astonishing portraits; they are more like stills from a future movie, sometimes quiet if glaring, but more often wild with postures and gestures whose meaning we can only guess. What could be more studied, more "arranged," one thinks at first, than the brilliantly dark portrait of the young girl (is she a bride?) with the white dress and the pale flowers, to whose head, like two gigantic square ears, are attached, almost, the crude windows of the house she lives in, and framed behind each of these windows, the listening of two other women. It's theatre, but theatre of the real; which, in the case of the Gypsies, is the reality of their lurid communication.

Josef Koudelka
Bardejov, Czechoslovakia, 1967
Page 256
Josef Koudelka
Velka Lomnica, Czechoslovakia, 1966
Both, Magnum

It's important to face the enigma of the photographic portrait: it's a real person, every detail is real and undeniable, it conveys lots of genuine information—but how real is the totality of all these real facts? The dominant aesthetic of American art, from its beginning to World War II, has been naturalism; this may be true of every rapid and optimistic culture—until it begins to grow inward. Reality: but which reality? It is interesting, in this connection, to compare two remarkable photographers whose life and work both belong to that fascinating, energetic, confused, and often despicable latter third of the American nineteenth century.

Napoleon Sarony, born in Quebec in 1821, turned out to be as short, hypnotic, and theatrical as his namesake. He was first of all a lithographer, and made a great deal of money. When he was thirty-five, he went to visit his brother in England, who was a photographer. After studying art in Paris for a while, he came back to the United States and opened a photographic studio in New York City. He rapidly became famous, not because he was a photographer, for he really was not: the camera was operated by an assistant, notably by the very talented and little-known Ben Richardson. The latter describes how he was hired by Sarony: *I took up photography when I left the sea . . . I read an ad in the paper that Sarony wanted a man and to him I went . . . He was five-foot nothing, with a monkey jacket, Hessian boots and an undyed astrakhan jacket. "Where did you work before?" he asked me. "None of your business," I said. He took his fist and drove it into the counter with a mighty blow. "Go upstairs," said he, "and go to work." Upstairs I went and was there for thirty-four years. . . .*

What Sarony did was comparable to the work of a film director: he cajoled, provoked, mimicked, shouted, and charmed his sitters; his portrait sittings were entertaining, if nothing else. His studio was crammed with objets d'art, including a complete Egyptian mummy, protected by barbed wire so that visitors would not be tempted to tear open the wrapping for souvenirs. He wore eccentric clothes, and his flamboyant manner was particularly useful with theatre people: Edwin Booth as Hamlet, Joseph Jefferson as Rip Van Winkle, Lillian Russell as sexpot, and Sarah Bernhardt—as Sarah Bernhardt. He complained about the Divine Sarah: he had great trouble getting her to the studio early enough to make use of the daylight.

It's worth describing the portrait studio of the time: there was no artificial light of any sort. The main illumination—what is now called the key light—

Sarony
Mrs. John Wood, cabinet photo, c. 1880
George Eastman House, Rochester, New York

259

with their proud proprietors; it includes not only the butcher and the dentist and the undertaker but also another business person: the local madam surrounded by her girls—dressed as Gypsies, circus acrobats, exotic Jewesses, and ballet dancers in tutus—for every taste. I suppose one should think of them as part of the broad, muddy, energetic, and polluted river of popular taste: like *Ben Hur* and the craze for stereo views and patent medicine and the illuminated (with photographs!) novels in verse of Ella Wheeler Wilcox, drenched in erotic tears.

We are, all of us, not so much afraid as envious of the truth: it reveals too much; its manners are common and bold; but we distrust our illusions, too; so we alternate between nakedness and the emperor's clothing; and this pendulum beats in all the arts. An interesting example, and roughly contemporary with Sarony and Bellocq, is the American painter and photographer Thomas Eakins. In 1875 he exhibited a very large and important work, "The Gross Clinic," in which a certain Dr. Gross demonstrated a piece of surgery to an audience of medical students. The subject has many a classical precedent, including a great Rembrandt; but in Philadelphia, ten years after the bloodiest civil war (up to then) in history, his painting provoked a storm of disapproval and hypocritical disgust.

It was, after all, in the main American graphic tradition: realism. And this powerful aesthetic, which dominated American art, both painting and sculpture, from the portraits of the eighteenth century to the social realism of the 1930's, was accepted as good and natural both by the patrons and the audiences of art—the new classes and groups that came gaping into the new museums; what was unacceptable to both was the logical extension of realism into the ugly, the profound, or the disturbing. This is a logical contradiction that still persists in the common American view of art: it must be real—but not too real. What makes it even more contradictory is the fact that realism, which is the natural, easy mode of photography, has, and will continue to have, a particularly strong influence in every American art, not excluding poetry and fiction.

Eakins' painting, in fact, was based on photographs; and Eakins began, in the course of his work as an art teacher, to make photographic studies himself; they are among the most pure and simple of American realist photography. Most are portraits of his friends and colleagues; an especially beautiful one is that of his wife; and there is a whole series of Walt Whitman growing old and ill, "like a poor old blind despised and dying King." Whitman himself told a story about

270

the realist Eakins: that a model had come to his art class, and was posing nude, but wearing a bracelet; whereupon Eakins pulled off the bracelet in a fine rage: he detested artifice, and his nudes, both photographed and painted, have the un-self-conscious quality of humanity unadorned. In this, he was following a steady and corrective American tradition: obscure portraitists like Frank Noell in Alaska, whose photographs of the Eskimo in 1903 were real if artless; like Tom McKee at Mesa Verde in 1900, where the Utes lived among the petroglyphs of an earlier race; or Camillus S. Fly, who worked in Tombstone in the 1880's, and photographed the bold, flat, mustachioed young faces of deputies and desperadoes, not always distinguishable from one another. There is little romancing in these photographers, for they were not gentlemen or lady amateurs, but storekeepers and craftsmen.

Meantime, photography, after the invention of the dry gelatin plate in 1871, had become a lot easier on the nerves—both for the sitter and the photographer. The keen historian Beaumont Newhall, coming as ever to the crux of the matter, once published a fascinating summary of the film speeds and lengths of exposure during the course of the nineteenth century. He gave their equivalence at a shutter opening of F-16:

1839. f/17 40 mins. equals approx. f/16 2400 sec.
1854. f/24 4 mins. equals approx. f/16 120 sec.
1856. f/23 1 min. equals approx. f/16 30 sec.
1880. f/14 4 sec. equals approx. f/16 5 sec.

Each of these advances was the work of an individual inventor, not the research department of a huge company. Invention was a respected way to waste one's life, in the hope of great and sudden fortune. An aged aunt of mine, on learning I spent a good part of the day at a desk anyway, suggested I give up writing; "Turn your mind to patents," she told me. She was only reflecting the opinion of her generation, for late-nineteenth-century and early-twentieth-century America was full of loony inventors—though some were less insane than others.

Edison was a notable amateur; he himself said he knew nothing of scientific principles, and had a man on his staff for this purpose; but he knew, not what people wanted, but what they could be persuaded to want. His contemporary, George Eastman, was also a businessman qua inventor. His film and his small, cheap camera enabled a whole generation of children to become photographers. Using Eastman film and a double camera, an entire entertainment industry was built upon the making and viewing of a peculiar form of three-dimensional photograph: the stereo pair. The

viewing mechanism could be simple enough to be held in one hand, or rich and elaborate with mirrors and traveling loops and a case of precious wood.

These stereos, one of the several precursors to the cinema, are a marvelous curiosity to us now. It takes a strange, blinking adjustment to see the two photographs as one; and then the portions at various planes of focus stand in front of one another in a discontinuity like flats on a stage. The world—and certainly the American world—was hungry not only to see the pyramids of Egypt and the temples of Ceylon, but to take pride in the factories of Pittsburgh and the dizzy cliffs of the Grand Canyon; and they bought for their stereoscopes not only portraits of President Cleveland and the king of Prussia, but also the tinted and delightfully anonymous nudes imported directly from Paris, France.

This hunger was felt by the commercial photographer as well as by the amateur. We have a passion for souvenirs, mementos, minuscule triumphs fixed on a sheet of sensitive paper. This provided a purely local artist, James Van der Zee, the village photographer for the prosperous Harlemites of the twenties, with a decent living and, equally but not more important, with a charming purpose in life. His subjects were his neighbors: the well-to-do blacks described in Carl Van Vechten's *Nigger Heaven*. They were a generation or two or even three after the post-Civil War migration from the South, and two decades earlier than the next and far more potent migration after World War II. They were amused by their ancestors; on Amateur Night at the Savoy in Harlem, if a singer gave too rough and authentic a performance, the entire audience would blossom forth with handkerchiefs spread on their heads; handkerchief-head meant "field-hand black man," and they'd have none of it. Their amusements, their typically American middle-class lodges and uniforms, along with the special enjoyment of life they cultivated between 125th Street and 135th Street, cheerful and easy—all these props and qualities give Van der Zee's portraits a fine, warm, and sympathetic air.

Contemporaries of his, the Byrons, father and son, but especially Percy Byron, did many hundreds of photographs of people who were simply his customers; mostly they were the newly rich, the getting and spending society of metropolitan New York. But he also pursued them into their haunts with a photographic attitude that was cold yet not entirely unkind, intruding into their bathhouses and their carriages and their silly races and their sillier banquets; yet he was also impelled to photograph the peddlers and pushcarts of downtown Hester Street.

James Van Der Zee
Billy, Harlem, 1926
James Van Der Zee Institute, New York

272

James Van Der Zee
Untitled, no date
James Van Der Zee Institute, New York
Page 274
Percy Byron
Richard Hall at work on his portrait of Cathleen
Neilson (the future Mrs. Reginald
Claypoole Vanderbilt), 1902
Byron Collection, Museum of the City of New Yo

Byron N.Y.

Alice Austen
Court curtsy, dancing class, circa 1895
The Staten Island Historical Society

Frances Benjamin Johnston
"The Old Folks at Home"
From an album of Hampton Institute, 1899–1900
The Museum of Modern Art, New York, gift of
Lincoln Kirstein

The well-to-do Alice Austen of the same generation, born in 1886 of a New York family, might easily have been one of the Byrons' regular subjects. Her sympathetic portraits are largely of her own group: the Staten Island middling-rich, with their fine rural houses, their potted plants and picnics and their family holidays and their chinoiserie both inside and out. She was in the tradition of the rich amateur; never worked and never married; after the death of her companion, Gertrude Tate, she lived long enough to become destitute. She caught, in the women of her family particularly, the pervasive sadness under their gentle smiles. Yet, like Byron, she was fascinated by the picturesque poor: they are an exotic nation in their heavy, voluminous, unpressed clothing. And they are always at a distance, a space determined by Austen herself; while the portraits of her own class are always as close as necessary.

Frances Benjamin Johnston was the forerunner of another sort of photographer. Born in 1864, she was of the same generation as Alice Austen. They had in common the circumstance that they lost a father at a very early age, and were raised by their mothers. Johnston was a little, dark, tough-minded, rather pretty woman; she often set up a tent, with the good old Stars and Stripes as a door flap, at county fairs in Maryland or Virginia. Four bold signs announced her business:

FRANCES BENJAMIN JOHNSTON TINTYPES
GENTS! HAVE YOUR PICTURE TAKEN WITH YOUR LADY FRIEND. PALACE OF PORTRAITURE.
ELITE [sic] TINTYPE GALLERY, FRANCES BENJAMIN JOHNSTON, MANAGER
LOOK! LOOK!! LOOK!!! TINTYPES. CHEAP, BEAUTIFUL, LASTING

After an early training in art, she opened a photo-portrait studio in Washington, D.C. She was technically accomplished, but believed that one should "go for inspiration to such masters as Rembrandt, Van Dyke, Sir Joshua Reynolds, Romney, and Gainsborough, rather than to the compilers of chemical formulae." She knew personally the great political families like the early Roosevelts and the Tafts, and almost from the beginning enjoyed a praised and prosperous career.

In 1892 she went to Chicago to photograph the World's Fair, and documented that enormous display of bad taste, so bad and so characteristic, indeed—California's pavilion, for example, was a tower of fake oranges—that it could have been designed by Meret Oppenheim, the inventor (thirty years too late) of the fur-lined teacup. It was the apotheosis

of the newly rich and the newly industrialized America, which, having conquered the Indian, was about to expand into the Caribbean and the Pacific. It was the last wave of that optimistic, ebullient, ruthless, crass, self-improving, Samuel Smilesian triple decade from the Civil War to the twentieth century.

Frances Benjamin Johnston was as enterprising as anyone else, and more so than most. She photographed the great and their great and crowded houses; and did a series at famous schools: at the Carlisle Indian School, at Tuskegee Institute, and at both service academies. They were not meant to be art, but journalism. Her photographs of the black Hampton Institute were taken to show how the grandchildren of slaves could and should better themselves by lining up in desks bolted in straight rows, like the rest of America; fortunately, her instincts tricked her, and we see these portraits now as tender and truthful documents.

But her conscience somehow nagged her, and she went to Pennsylvania and did a series of portraits of coal miners and their children. She even descended into the mines and stood in the oppressive tunnels. But this was the first and last time that she ventured, physically and socially, quite so far.

She survived, unmarried, until almost ninety—a small, irritating woman who hated authority and loved architecture. She was, if not strictly the first, certainly a pioneer of a fresh sort of photographic art: the picture as a document of conscience. She knew—she did the photographs for a story he wrote on President Teddy Roosevelt's children—that much greater, more passionate, and more devoted social photographer: Jacob Riis.

Those timid or lazy critics who resent any connection between an artist's work and his life can make a shallow case, perhaps, with photographers of the abstract like Francis Bruguiere or Brett Weston or the later work of Aaron Siskind, although in each instance a little empathetic social analysis will throw a sharper light on what appears to be only an idiosyncrasy. In the case of Jacob Riis, a strictly formal approach is mere nonsense. He was a Danish immigrant who came to the United States in the middle of one of our periodic economic panics: that of 1870.

Riis was an unemployed and half-employed and homeless wanderer for three years. In 1877 he got his first decent job as a police reporter in New York City and renewed his acquaintance—more than that, his identity—with the poverty of the East Side slums. He hated it: *I am satisfied from my own observation, that hundreds of men, women and children are every day slowly starving to death in the tenements. . . . I*

Frances Benjamin Johnston
"Adele Quinney, Stockbridge tribe. A girl whose
every physical measurement is artistically correct"
From an album of Hampton Institute, 1899–1900
The Museum of Modern Art, New York, gift of
Lincoln Kirstein

Frances Benjamin Johnston
"John Wizi, sioux, Son of Chief Wizi of Crow
Creek, South Dakota"
From an album of Hampton Institute, 1899–1900
The Museum of Modern Art, New York, gift of
Lincoln Kirstein

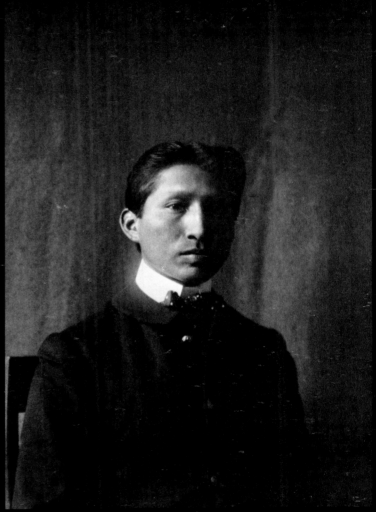

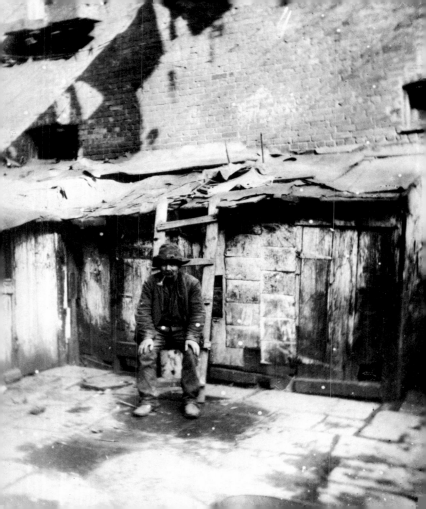

got a picture of the [Mulberry] Bend upon my mind which so soon as I should be able to transfer it to that of the community would help settle the pig-sty according to its deserts. It was not fit for Christian men and women, let alone innocent children, to live in, and therefore it had to go.

It was out of this truly moral fury that he conceived and wrote his book: *How the Other Half Lives* (1890). He intended the photographs to be the proof of his words: they were; but they are considerably more. He wanted to photograph the destitute in their cellars and in their "railway" flats. I have lived in one myself; damp drips down the walls, and there is very little light, because the only windows are in the one room that opens on a concrete alley. Consequently, Riis had to learn to photograph with magnesium flash powder, an uncertain and even hazardous process invented by German chemists.

His sweatshop interiors are composed instinctively, yet are as complex, in their interplay of face and gesture between person and person—including the unseen photographer—as a beautiful six-voice fugue. Or there will be a plane surface: the black, eroded wall of a rooftop exit, to contrast—I believe deliberately—with the belly of a naked child. Still others of his photographs have a stark, inverted T-shape: the vertical figure full of rude emotion, joined to the dreadful horizontals of street or cellar or police station—where he himself had often slept when he was desperate.

Poverty is rarely simple, spartan, and clean; it is mostly filthy, disordered, and cluttered with leaky utensils, used clothing, and the miscellaneous refuse that collects in the obscurity of unlit rooms; and this confusion Jacob Riis hated with all his force. It gave him a curiously narrow and distorted view of the very people he so truthfully photographed: *[The Italian's] ignorance and unconquerable suspicion of strangers dig the pit into which he falls. He not only knows no word of English, but he does not know enough to learn. Rarely only can he write his own language. Unlike the German, who begins learning English the day he lands as a matter of duty, or the Polish Jew, who takes it up as soon as he is able as an investment, the Italian learns slowly, if at all . . .*

I can hardly object that a man's opinions, however blind, have nothing to do with his art; we are all the geometric sum of our contradictions, but this truth is not necessarily pleasant: *[The Jews] come here in droves from Eastern Europe to escape persecution, from which freedom could be bought only with gold, it has enslaved them in bondage worse than that from which they fled. Money is their God. Life itself is of*

little value compared with even the leanest bank account. In no other spot does life wear so intensely bald and materialistic an aspect as in Ludlow Street. Over and over again I have met with instances of these Polish or Russian Jews deliberately starving themselves to the point of physical exhaustion, while working night and day at a tremendous pressure to save a little money. . . .

Of the Chinese, he has an equally numerous set of cliches: *I state it in advance as my opinion, based on the steady observation of years, that all attempts to make an effective Christian of John Chinaman will remain abortive in this generation; of the next I have, if anything, less hope. Ages of senseless idolatry, a mere grub-worship, have left him without the essential qualities for appreciating the gentle teachings of a faith whose motive and unselfish spirit are alike beyond his grasp.*

And to the blacks, he shows a condescension scarcely less crude: *With all his ludicrous incongruities, his sensuality and his lack of moral accountability, his superstition and other faults that are the effect of temperament and of centuries of slavery, he has his eminently good points. He is loyal to the backbone, proud of being an American and of his new-found citizenship. He is at least as easily moulded for good as evil The black "tough" is as handy with the razor in a fight as his peaceably inclined brother is with it in pursuit of his honest trade. As the Chinaman hides his knife in his sleeve and the Italian his stiletto in the bosom, so the negro goes to the ball with a razor in his boot-leg, and on occasion does as much execution with it as both of the others together.*

These views may be condoned, if not pardoned, when one realizes the ugly opinions that the Jews, the Italians, the blacks, and the Chinese had—and often still have—of one another. Territoriality, like that of dogs or hyenas, seems to be an old constant of human nature, and photographers, like anyone else, cross these barriers at some personal risk.

Riis was working in the midst of one of humankind's most extraordinary migrations: the movement of 15 million young and vigorous people from a stifling Europe to a rich, open, harsh, half-civilized America. They spoke in languages America had never heard before—in Russian, Ukrainian, Rumanian, Polish, Italian, and an obscure German dialect of the Middle Ages called Yiddish. Their faces, like all strangers, were powerful, secret, beautiful, and frightening. They were the chosen, and they chose themselves.

But the encouraging fact is that the photographer, face to face with such people, seems to do more beautifully than he knows. It is as if the very passion

Jacob Riis
Scene on the roof of the barracks, Mott Street,
no date
Page 286
Jacob Riis
Iroquois Indians at 511 Broome Street, 1890's
Both, Jacob Riis Collection, Museum of the City of
New York

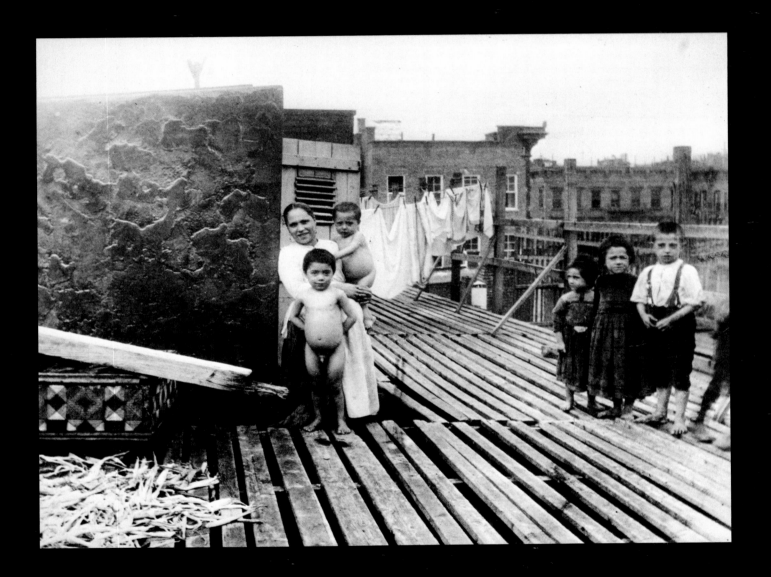

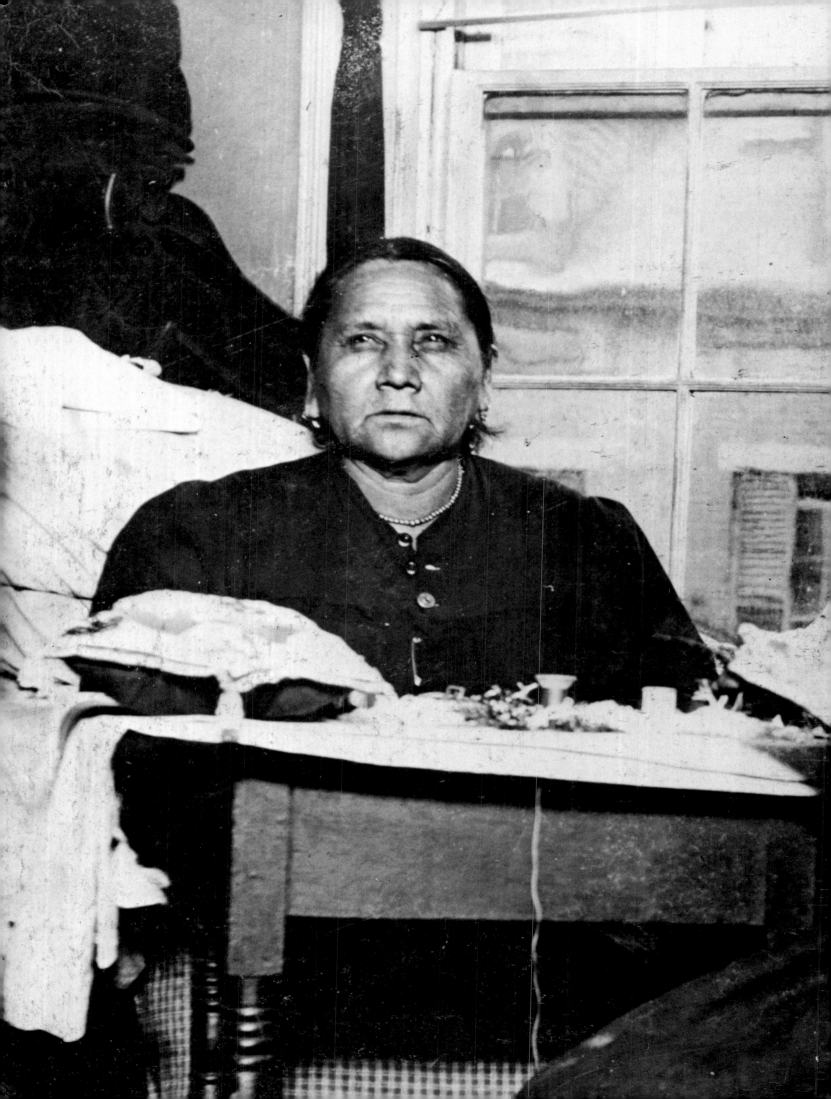

of disgust or hatred or love or curiosity or fear or their various combinations opens a sluice to the slow deliberations of the unconscious: that lurid underworld, after all, is where all art must be melted and cast.

In the same decades, indeed in the same city, conscience was not a member of the Stieglitz group; nor, for that matter, of the Linked Ring in England. But Riis's burning conscience was exactly the irritant that made him labor at his extraordinary photographs, unique in America. He was working in a realist tradition of which he knew nothing, since he thought himself merely a reporter and nothing more; yet it is a tradition to which photography must return, over and over again, to renew its vulgar health.

Even Arnold Genthe, whose major work was coated by a soft eroticism as tactile as brown velvet, reverted to a sharp, direct vision when he photographed, in 1900, the grave citizens of San Francisco's Chinatown; or when he woke one morning to the tumbled and burning streets of the earthquake of 1906. Thus, in the misty region of aesthetic qualities and distinctions, the facts sometimes contradict the truth, for the same artist can see the world—and this seems especially true of photographers—in a number of different ways, and sometimes within the same day. It takes a certain kind of sincere, high but perhaps narrow, intellect to work always in the same fashion; and this quality marks even the greatest painters. Among the purists, I would certainly put that early cameraman of conscience: Lewis Hine. He was born in the rich heart of America, in Oshkosh, Wisconsin, in 1874. He worked by day as a laborer but went to school at night to study art.

The thrust and subsequent flowering of social conscience in America was not entirely a product of moral indignation. It was first of all a consequence of the explosive American industrial scene. Between the Civil War and the year 1900, patents were granted for more than one-half million inventions; ten years later, the U.S.A. had the largest industrial plant in the world. But the human cost has rarely been calculated. We know that many workmen earned five cents an hour. Of course, the numerous children in factory and mine earned far less, generally about half. Oral tradition in my own family records the weekly wage as three dollars. A federal commission reported in 1900 that the "competitive effect of the employment of women and children on men's wages can scarcely be overestimated." It goes against our ingrained idealism, but it appears to be true that the movement against child labor was pushed less by social conscience than by the extraordinary growth of

Jacob Riis
Minding the baby, Cherry Hill, no date
Jacob Riis Collection, Museum of the City of
New York

Arnold Genthe
Chinese merchant with bodyguard, San Francisco
Chinatown, 1900
The Art Institute of Chicago

labor unions, in the effort to give the man in the family a living wage.

The union movement, generally collectivist in philosophy, was often violent; such violence was traditional in America, but the collectivist philosophy was not. A railway executive of the period felt quietly outraged: "The rights and interests of the laboring man will be protected and cared for, not by the labor agitators, but by the Christian men to whom God, in his infinite wisdom, has given control of the property interests of the country." His piety had little effect: between 1880 and 1910 there were upward of 38,-000 strikes, some as bloody as the war between the Homestead steel mill strikers and the operatives hired by the Pinkertons and paid for by the philanthropist (and immigrant) Andrew Carnegie.

Lewis Hine had come to New York to teach botany to the children of the well-to-do, liberal, middle-class professionals at the Ethical Culture School, and would have remained a teacher all his life if the principal, Frank Maury, had not urged him in 1903, to use a camera as an aid in his profession. Hine taught himself how to operate a 4 by 5 Graflex and a 5 by 7 view camera, and never used anything smaller for the rest of his long life. Two years later he got a degree in sociology at Columbia, and simultaneously went to Ellis Island and did his first and great and unsurpassed series on the new tidal wave of immigrants.

These photographs have an astonishing cheerfulness and vigor of a kind that had long been lacking in the art. Broad, Slavic faces, bursting with vitality, the Talmudic intensity of young Jews; babies fat, strong, and smiling—these do not convey the six-week strain of steerage across an unruly Atlantic. They have the energy, not of survivors, but of invaders. And they are seen, over and over again, sharply and intimately: there is no distance of diagonal composition as in Stieglitz' unrepeated masterpiece of 1907: "The Steerage"—photographed, symbolically, from above. Even when Hine gave up teaching and took on a number of social assignments, exposés in fact, for the National Child Labor Committee, the Russell Sage Foundation, or for the *Survey,* a social work magazine, he never changed his optimistic view. Whether he is photographing children tending the long looms in the textile mills of North Carolina, or blotched with coal dust in tunnels a mile deep; or the moustached scissors-grinder on a Chicago street; child and man all show the same straight-backed dignity and handsome endurance of the immigrant.

His portraits of steelworkers in Pittsburgh show them bare-armed, sweating, smudged with ash—but powerful and self-confident. Coburn's photograph of a steel

291

mill in the same town, taken the same year, shows no face, not even a human hand: only the molten pattern of the great bucket pouring a stream of white iron. Hine's response was more human, more true, essentially more decent: which doesn't mean that Coburn's work is contemptible decadence or that Hine's work was narrow and agitational. Photography, and particularly portrait photography, has room for both minds, and for still other, stranger, more disturbing views of reality; and some, unforeseeable, that are surely yet to come.

Between 1909 and 1914, Hine did a series of slum photographs; and here, indeed, one sees ill-clothed, huge-eyed children, clutching a child's traditional support: not mother or father, but the ledges of windows and the frames of doorways. They are certainly sad, but they are not horrifying and they are not desperate; they seem undersized, no doubt they are hungry, and certainly they are dirty; nevertheless, they each have the peculiar force of that one unique human individual.

There are second-rate, merely illustrative photographs, too, of course. Hine's photograph called "Girl and Dying Father," for example, is almost as posed as any Henry Robinson or Rejlander. These can be said to be successful—they fulfill their function. So much for the curious idea, nowhere more fallacious than in photography, that form follows function; it is no more than a silly paradigm of the new industrialization.

But such photographs are few; and the great ones are very numerous. A wonderful example, mentioned earlier but worth examining more closely, even with a magnifying glass, is the street portrait of a woman in 1909. Hine himself captioned it thus: "Italian Immigrant Carrying Home Material for the Entire Family to Process at Starvation Pay."

Now this statement is perfectly true, and the posture undeniably typical; but the photograph is not. This powerful, richly buxom young woman, caught in midstep as one foot lifts off the ground, wears a blouse, a skirt, and an apron that flow in long, luscious full-bodied curves from neck to ankle. Steadied by one rather delicate hand, she balances on her head a dark bundle of unfinished work, whose folds move at right angles to the flow of her clothing. She is almost alone on a street landscape: behind her is a waste strip of miscellaneous, papery rubbish, and this line of chaos is blocked by the regular panels of a black building on the right, and another, smaller, shadowy figure of a second woman, who carries, also on her head, a large woven basket. A pale light slants down from above and to one side; the consequent

Lewis Hine
Three boys in mill, c. 1909
The Metropolitan Museum of Art, New York,
gift of Phyllis D. Massar, 1970

294

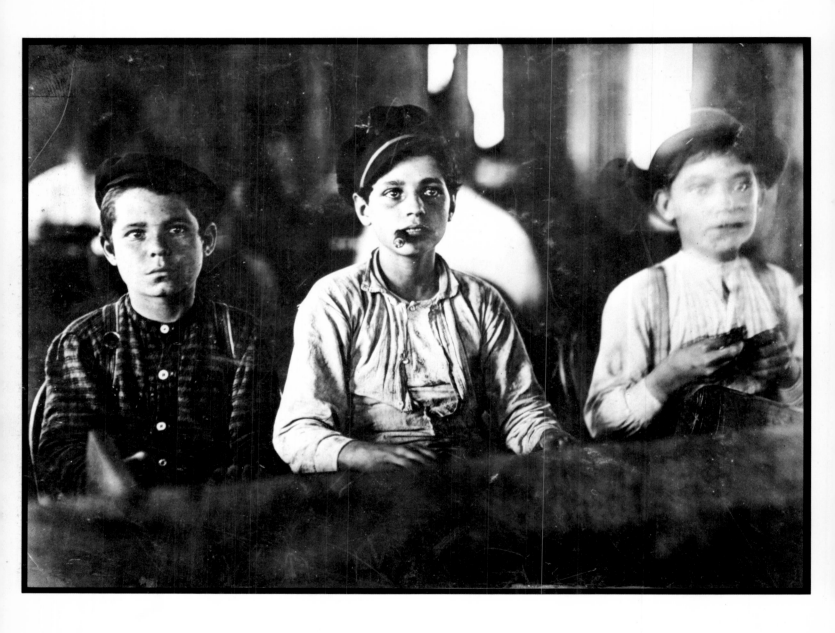

Lewis Hine
Russian steelworkers, Pittsburgh, 1909
The Metropolitan Museum of Art, New York

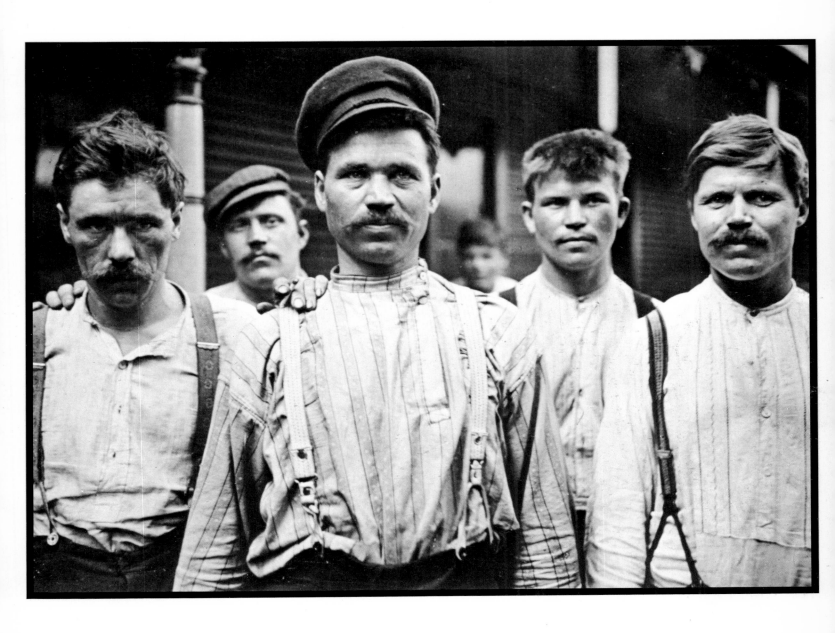

Lewis Hine
Unhealthy tenement child handicapped in every way,
Chicago, 1910
George Eastman House, Rochester, New York

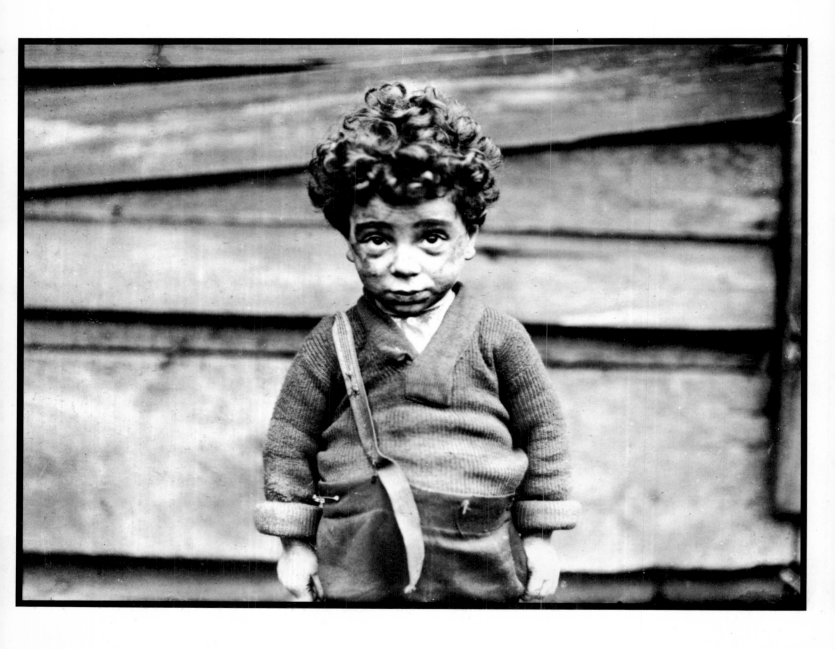

296

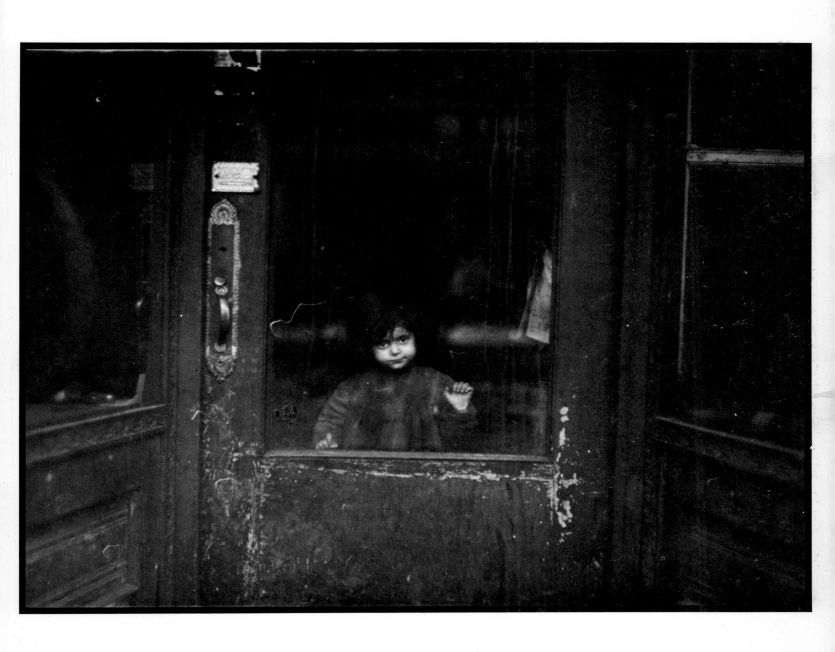

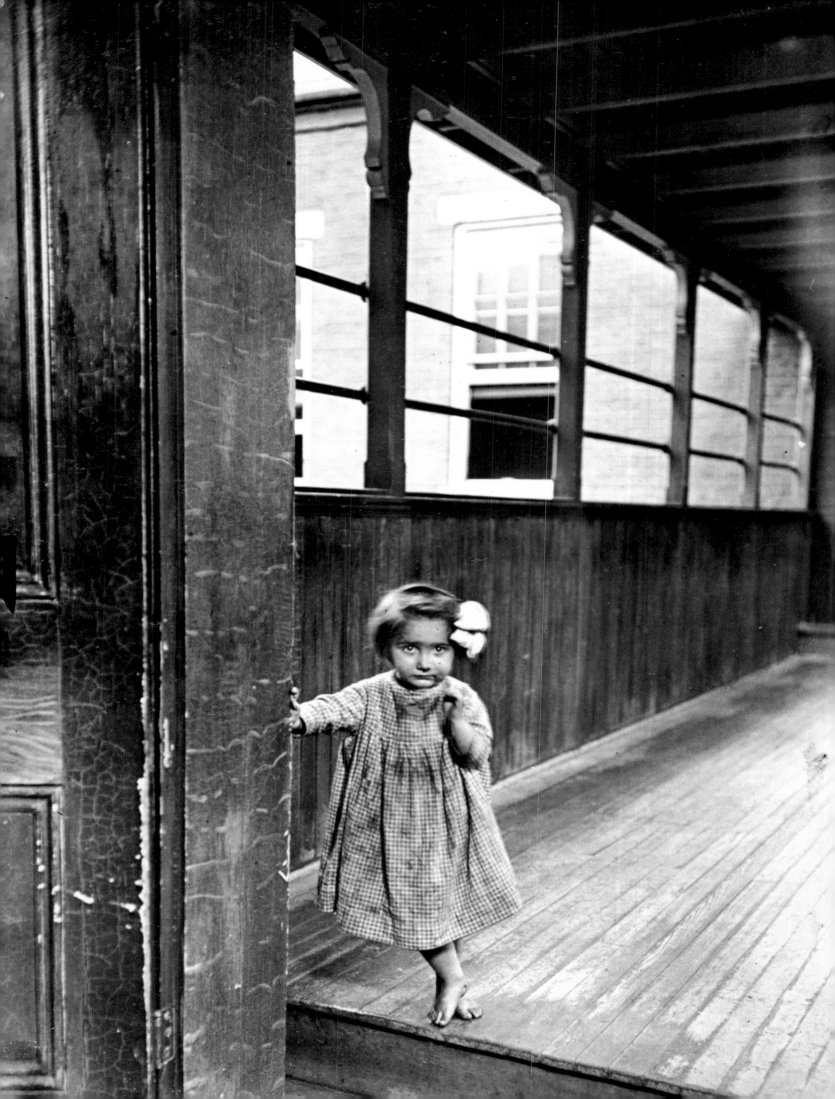

shadow curves over the central figure's solid, beautiful face, leaving her eyes in enigmatic darkness. And a touch of—to us—humorous practicality decorates this epic figure in a mythical street: a sign that advertises: "Hot Frankfurters 2¢ Each." So this photograph is far more, I think, than Hine ever intended; in all photographs, and especially in portraits, reality bursts the limited frame of the cameraman's intention. In the choice of which negative to print, he may, or may not, recognize this central fact.

One of Hine's teen-age pupils at Ethical Culture was Paul Strand. He took a course with Hine in photography; Hine took him to visit the famous Stieglitz in his brilliant gallery; and it is in this context that Strand determined to become an artist in photography. The astonishments at the Armory Show of 1913 had their parallel at Gallery 291; and the organization of the plane surface, which was really all that Picasso, Braque, Leger, Gris, and Matisse had in common, seems to me to have powerfully influenced Strand's aesthetic. His earliest photographs, though still with fuzzed lines in the pictorialist tradition, were much more strongly composed. Whatever the influence they remember, they are still viable works of art; indeed they have a mystery—I am thinking particularly of the famous photograph of a broken picket fence— which appears only rarely in his clear, reasoned work. There is also no question that Strand was influenced by the compositional modes of the painters he saw at Gallery 291. He found them puzzling at first, but Stieglitz was an enthusiastic docent. It was not that Strand imitated the fractured planes of the Cubists or the mountainous sexuality of Gaston Lachaise; but rather that he absorbed and reassembled their discoveries into his own very powerful and much more lyrical intellect.

Very early in his career he went to the New York streets, like his teacher Hine. And like Hine, he chose to go close, very close; he probed to the tragic core of his subjects. But there was one great and historic difference. Where Lewis Hine had photographed with the subject's full knowledge and their proud and often smiling approval, Strand was ruthless and secret. He put a false lens on a real camera and snared the subject with a 90° deception. He manages to deceive us, too, for there is no direct evidence of this cunning in the photograph itself. The portraits he got are among the most powerful and beautiful ever taken, though the people were neither.

The man with the sandwich sign and the star-burst beard is as gnarled and tough as an olive trunk. The old woman wearing the hat with cherries has Strand's own slant-lidded eyes, firm mouth, and introspective

Lewis Hine
Orphan girl, Pittsburgh, 1908
George Eastman House, Rochester, New York

glance. And there is the man in the derby hat and polished cane, huge, apprehensive; and the equally huge woman, yawning; though as you watch and contemplate the white oval of her open lips, you begin to hear an involuntary and terrifying scream. What we have in this series, which Strand did so early in his life, is not simply the work of genius, but the brilliant, insightful pity of the young for what, perhaps, they are one day going to be.

Strand was not—indeed the typical photographer is not—an inarticulate man. His mind had always had the precision of certainty; and this assurance gave him a sharp verbal style as well. He said of photography: *Man having created the concept of God The Creator, found himself unsatisfied. For despite the proven pragmatic value of this image, through which the fine arts of music and literature, of architecture, painting, and sculpture, together with the less fine arts of murder, thievery and general human exploitation, had been carried to great heights, there was still something unfulfilled: the impulse of curiosity in man was still hungry. . . .*

. . . We perceive upon the loveliness of paper a registration in monochrome of tonal and tactile values far more subtle than any which the human hand can record. We discover as well, the actuality of a new sensitivity of line as finely expressive as any the human hand can draw. And we note that all these elements take form through the machine, the camera, without resort to the imbecilic use of soft focus or uncorrected lenses, or to processes in which manual manipulation may be introduced. Nay more, we see that the use of such lenses or processes weakens or destroys entirely the very elements which distinguish photography and may make it an expression. . . .

. . . The camera can hold in a unique way, a moment. If the moment be a living one for the photographer, that is, if it be significantly related to other moments in his experience, and he knows how to put that relativity into form, he may do with a machine what the human brain and hand, through the act of memory cannot do. So perceived, the whole concept of a portrait takes on a new meaning, that of a record of innumerable elusive and constantly changing states of being, manifested physically. This is as true of all objects as of the human object.

Strand was, I sometimes think, an internal exile, a traveler even in his own country; and the same sympathetic outsider when he went abroad. In Mexico, where he stayed in the early thirties, he photographed a film called *Redes* (*Waves*), which is really a series of heroic stills; but at the same time he returned to the practice of making surreptitious portraits with the help of his prism view finder. This Mexican series is very rewarding; still, the people do not have the human ugliness of his earlier New York candid portraits. Instead, they are peasants of monumental size; it's a Mexico that certainly exists, but one has only to compare them with the Mexican work of Helen Levitt or Cartier-Bresson, or with Manuel Alvarez-Bravo's intensely internal work, to realize how much Strand's portraits were filtered and dramatized by his admiration; this is largely true even of his New England series.

Strand's moral position culminated with an American re-enacted documentary film called *Native Land,* whose curious left brand of patriotism is out of fashion today, and whose finest quality is the attitude of Strand's photography, which regards workmen, farmers, and skyscrapers as splendid, heroic, and beautiful. These images move, yet they are not especially cinematic, and thus this work is very much in continuity with Strand's other portraiture. His journeys to Canada and to New England produced a limited number of portraits that would be great in any lesser man's work; but his further voyages in the following years, to a small town in France, to one of the Hebrides off Scotland, to the Italian scenarist Zavattini's home town in Piemonte, and to Egypt, and Ghana—all these quiet, leisurely excursions produced two kinds of portraits; and both are magnificent, though in different ways.

In one sort, there is a troubling similarity: not in the features themselves, not in the choice of age or sex, but in the stance, the attitude toward the lens, the inner bearing; and then, slowly, it becomes recognizable: it's the reflected portrait of Strand himself, his somewhat reserved courtesy, his absolute certainty about himself and his opinions, his watchful dignity. Of quite another sort is the portrait like that of the Gaelic farmer in the tweed hat, or the young boy with the furious eyes in *La France de Profil,* on which the poet Claude Roy comments: "When France gets angry, the world moves." The force of the sitter, young as he is, has bent the great photographer to his will, and that same power strikes again into our minds as we peruse it.

There's no doubt that however we go circling around in the twentieth century, Strand is the monument which we must every so often stop and contemplate. But it is in the second kind of portrait, in his instinctive response to that complex of energy, melancholy, and beauty of which certain people are capable, that Paul Strand begins to match—and always in purely photographic tones—the supreme portraiture of the later Rembrandt.

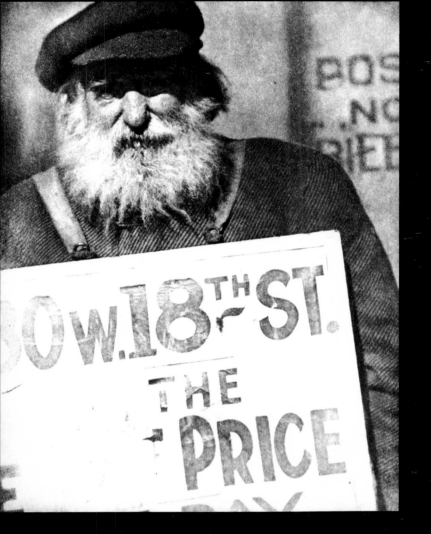

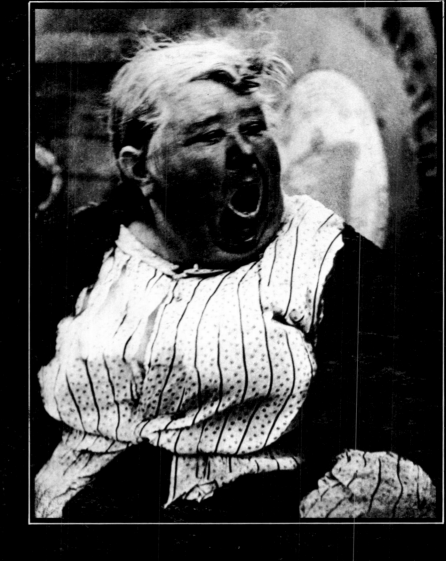

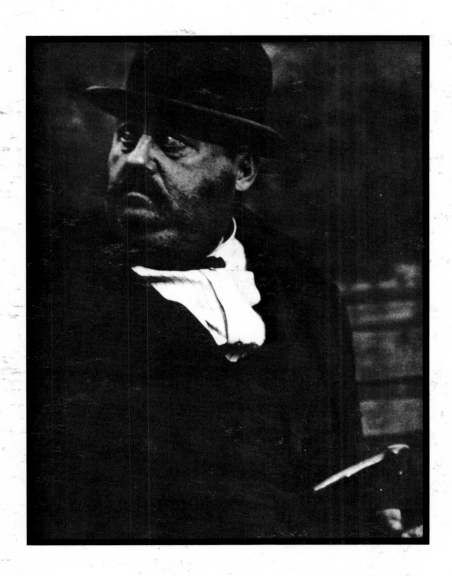

304

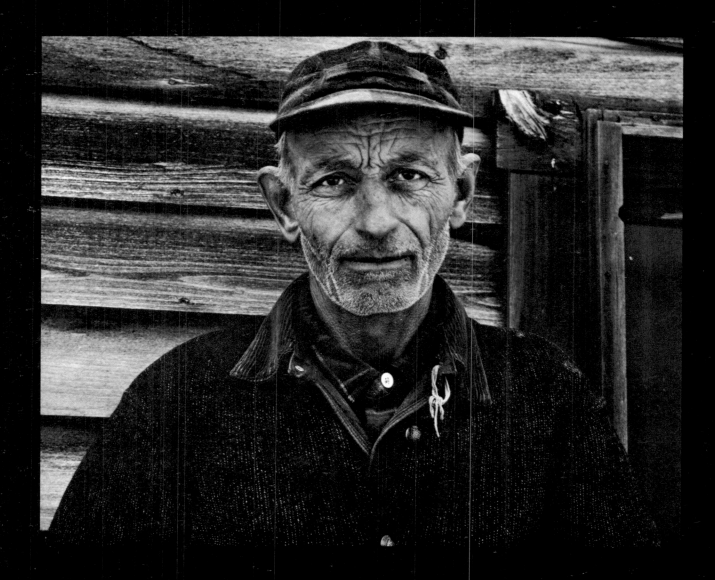

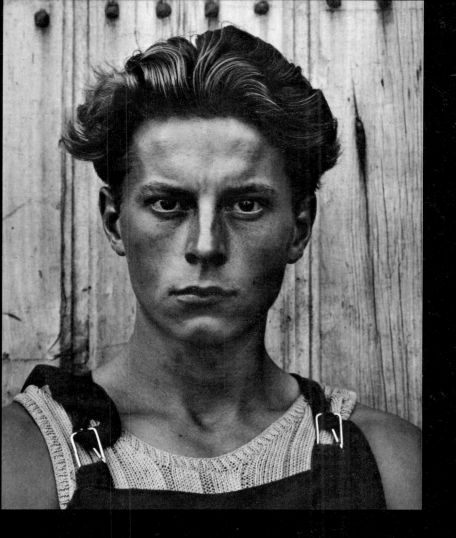

306

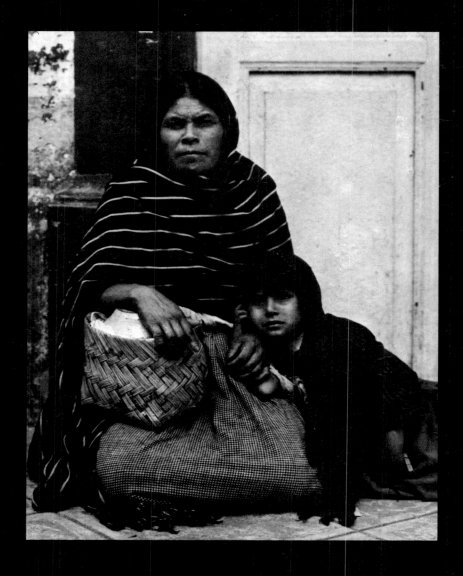

Paul Strand
Tailor's apprentice, Luzzara, 1953
Original photograph © 1971 by Paul Strand

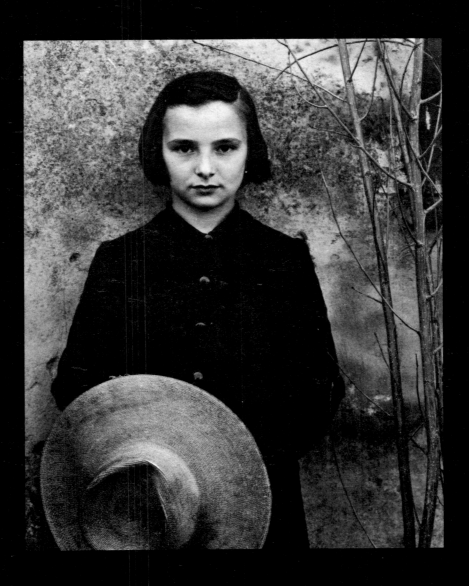

Class and Conscience III: America into the Thirties and Beyond

The strikes and miseries of the 1930's were as traumatic to the United States as any of its wars; and most strongly affected, of all the arts, that most sensitive barometer: the photograph. Because the Depression had two aspects. The first was the sickening downward curve of jobs, and therefore of income, and therefore of money for the next meal. I can testify to the corrosive hatred and inner desperation felt by the unemployed: not only the simple spasms of hunger, but the endless cold or sweating walks to nowhere, the fury in crowded waiting rooms, the harsh and poisonous poetry spit out in everyday speech.

The second phase, overlapping the first, was the general effort to pull us out of these inequities; an effort that the government made especially toward its educated classes. In 1935, roughly the low point of the Great Depression, President Franklin D. Roosevelt, as part of a program to rescue the farmer from the disasters of dust and bankruptcy, created a Resettlement Administration (later the Farm Security Administration) whose director, Rexford Tugwell, appointed a friend and former colleague to the job of keeping a historical record of these hard times and difficult remedies. The man was the imaginative Roy Stryker, whose sociological background had acquainted him with the use of photography as document.

He gave vivid and precise and yet remarkably provocative instructions to his staff: he wanted the suffering of the average American documented beyond disbelief; but he wanted the stringy, humorous American courage to show through, as well: the faces plus the facts: *My so-called official assignment memos—the photographers' shooting scripts—went like this: Bill posters; sign painters—crowd watching a window sign being painted; sky writing; paper in park after concert; parade watching, ticker tape, sitting on curb; roller skating; spooners-neckers; mowing the front lawn. . . . I remember one time when things were pretty bad down in the South and I assigned Carl Mydans to do a story about cotton. He had his bags packed and was going out the door, and I said to him, "I assume you know something about cotton." He said, "No, not very much." I called in my secretary and said, "Cancel Carl's reservations. He's going to stay here with me for a while." We sat down and we talked almost all day about cotton. We went to lunch and we went to dinner and we talked well into the night about cotton. I told him about cotton as an agricultural product, the history of cotton in the South, what cotton did to the history of the country, and how it affected areas outside the country. By the time we*

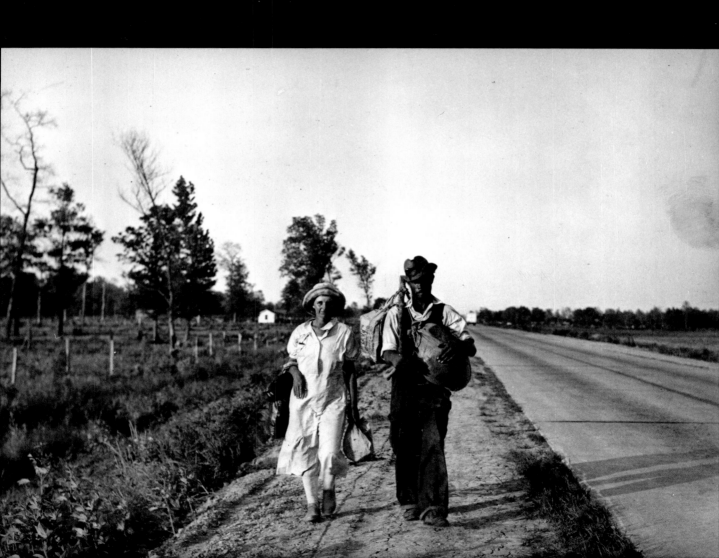

were through, Carl was ready to go off and photograph cotton. . . .

The administration simply could not afford to hammer home anything except their message that federal money was desperately needed for major relief programs. Most of what the photographers had to do to stay on the payroll was routine stuff showing what a good job the agencies were doing out in the field. . . . But we threw in a day here, a day there, to get what history has proved to be the guts of the project. . . . I'd tell the photographers, look for the significant detail. The kinds of things that a scholar a hundred years from now is going to wonder about. A butter churn. A horse trough. Crank-handle telephones. Front porches. The horse and buggy. The milk pails and the cream separators. Corner cupboards and wood stoves. Symbols of the time.

Quite early in the program he called on several well-known photographers: these included Walker Evans, who in turn was a friend of the painter and photographer Ben Shahn, and later, remarkable talents like Arthur Rothstein, whose straightforward portraits have a serious sweetness; Marion Post Wolcott, whose work has a lopsided structure, curiously congruent to the warped shacks, steps, fences, and sagging slums of the South; and Jack Delano, Theodore Jung, Russell Lee, Carl Mydans, John Vachon, and the remarkable Dorothea Lange. This group, some of them for short periods, others for years, produced a total of nearly three hundred thousand negatives. I doubt whether anybody has ever studied all of them, and a fair proportion are certainly unimportant; but the photographic portraits alone are an encyclopedia of country and small town and cabin and field. We read the season of this discontent not only in the squint of narrow eyes and the set, quiet, deeply angry mouth, and the torn aprons and decayed shoes and listless children of the desperately poor; but also in the jowled, easy, humorous cruelty of the sheriffs and the rangers and the bureaucrats.

The tradition of photographing people not in one's own family or station or class, as if they were exciting and exotic specimens: this might easily have been the simple documentary result of these voyages by Americans into America—except for the acerbic poetry of the artist, himself displaced and dangerous. Woody Guthrie had put it very sharply: "They tell me down in Oklahoma that the Indian language ain't got no cuss words in it. Well, wait till they get a little hungrier and raggedier. They'll work up some." In terms of image, the clearest example of this sort of poetry is Ben Shahn. His paintings, for me, always had a graphic facility, an easy palette, and skillful

Arthur Rothstein
Christmas window, Oswego County, New York, 1937
The Library of Congress

311

Jack Delano
Polish family, Mauch Chunk, Pennsylvania, 1940
The Library of Congress

Russell Lee
Refugees in a schoolhouse, Suskeston, Missouri, 1939

Russell Lee
Rancher at county fair, Gonzales, Texas, 1939
Both, The Library of Congress

drawing that would never allow them to go much beyond a lyricism of the symbol. He therefore found it easy to make a living out of commercial art; nor did he ever distinguish it from his personal and unpaid work. He said: *It seems to me that the word "Artist," like "Doctor," ought to indicate a man who, having mastered his tools and techniques, is now a practitioner capable of using them skillfully to communicate ideas.*

His photographs, though, often misbehaved; they were entirely open to the beautiful irrationality of life. He wrote: *I became interested in photography when I was sharing a studio with Walker Evans, and found my own sketching was inadequate. I was at that time very interested in anything that had details. I was working around 14th Street, and a group of blind musicians was constantly playing there. I would walk in front of them and sketch, and walk backwards and sketch, and I found it was inadequate. So I asked my brother to buy me a camera because I didn't have money for it. He bought me a Leica and I promised him—it was kind of a bolt promise—I said, "If I don't get in a magazine off the first roll, you can have your camera back." I did get into a magazine, a theater magazine.*

Now, my knowledge of photography was terribly limited. I thought I could ask Walker Evans to show me what to do, and he had made a kind of indefinite promise. One day when he was going off to the Caribbean and I was helping him into his taxi, I said, "Walker, remember your promise to show me how to photograph?" He said, "Well, it's very easy, Ben. F-9 on the sunny side of the street. F-4.5 on the shady side of the street. For 1/20th of a second hold your camera steady."—and that was all. This was the only lesson I ever had.

He saw, more than most of his colleagues, the fact that reality continually escaped all four edges of his right-angle view finder, and thus of the print as well; which didn't bother him, he loved it, recognized it, used it: was never troubled by the fact that of his trio-portraits (a favorite arrangement) one figure would be the back of a baby's head; or the portrait of a man which would be just as powerful without the upper half of his face; or a woman cut into dusty sections by the separation of an ancient windshield: *We were pretty austere about our job. We had only one purpose—a moral one, I suppose. So we decided: no angle shots, no filters, no mattes, nothing but glossy paper. But we did get a lot of pictures that certainly add something to the cultural history of America. We tried to present the ordinary in an extraordinary manner. But that's a paradox because the only thing extraordinary about it was that it was so ordinary. Nobody had ever done it before, deliberately. Now it's called documentary, which I suppose is all right. But somehow I don't like putting such things in pigeonholes with a label on them. We just took pictures that cried out to be taken. When you spend all day walking around, looking, looking, looking through a camera viewfinder, you get an idea what makes a good picture. What you're really doing is abstracting the forms.* His work has a lot more than he thinks: a magic intensity; and even from a formal point of view, a uniquely complex but emotional figure; a still movement within itself, from face to face. Just because photographs are normally small, we think we can seize them all at one glance. Of course we do; but we must, then, if we are not merely flipping pages, go back and scan the photograph in many winding and crossing pathways. Not all photographs —not even all good photographs—will endure this kind of rediscovery. Shahn's will, and so will the best work of Dorothea Lange and Walker Evans.

Lange was first hired in 1935 by the Rural Rehabilitation Division in California—as a typist; there was, at that time, no provision for photographers. Dorothea Lange's photographs, first published in the San Francisco *News* early in 1936, shocked the illiterate conscience of America: they were visible, lie-proof, tangible, and even (though this was not her intention) sentimental; after all, motherhood is a fact as well as a cliché. Her own account reveals a great deal, not only about this fine, honest artist, but about Stryker's photographers in general: *As we look at the photograph of the migrant mother, you may well say to yourself, "How many times have I seen this one?" It is used and published over and over, all around the world, year after year, somewhat to my embarrassment, for I am not a "one-picture photographer."*

Once when I was complaining of the continual use and resuse of this photograph to the neglect of others I have produced in the course of a long career, an astute friend reproved me. "Time is the greatest of editors," he said, "and the most reliable. When a photograph stands this test, recognize and celebrate it."

"Migrant Mother" was made twenty-three years ago, in March, 1936, when I was on the team of Farm Security Administration photographers (called "Resettlement Administration" in the early days). . . . It was the end of a cold, miserable winter. I had been traveling in the field alone for a month, photographing the migratory farm labor of California—the ways of life and the conditions of these people who serve and produce our great crops. My work was done, time was up, and I was worked out.

316

Ben Shahn
Cattle dealer, West Virginia, 1935
The Library of Congress

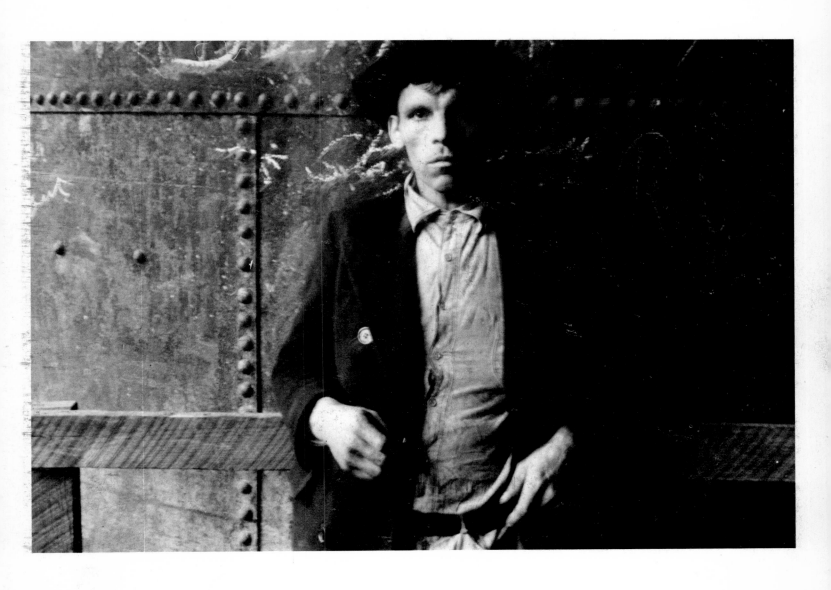

Dorothea Lange
Migrant mother, Nipomo, California, 1936
The Library of Congress

It was raining, the camera bags were packed, and I had on the seat beside me in the car the results of my long trip, the box containing all those rolls and packs of exposed film ready to mail back to Washington. It was a time of relief. Sixty-five miles an hour for seven hours would get me home to my family that night, and my eyes were glued to the wet and gleaming highway that stretched out ahead. I felt freed, for I could lift my mind off my job and think of home.

I was on my way and barely saw a crude sign with pointing arrow which flashed by me at the side of the road, saying Pea-Pickers Camp. But out of the corner of my eye I did see it. I didn't want to stop, and didn't. I didn't want to remember that I had seen it, so I drove on and ignored the summons. Then, accompanied by the rhythmic hum of the windshield wipers, arose an inner argument:

Dorothea, how about that camp back there?
What is the situation back there?
Are you going back?
Nobody could ask this of you, now could they?
To turn back certainly is not necessary.
Haven't you plenty of negatives already on the subject? Isn't this just one more of the same? Besides, if you take a camera out in this rain, you're just asking for trouble. Now be reasonable, etc., etc.

Having well convinced myself for twenty miles that I could continue on, I did the opposite. Almost without realizing what I was doing, I made a U-turn on the empty highway. I went back those twenty miles and turned off the highway at that sign, Pea-Pickers Camp.

I was following instinct, not reason; I drove into that wet and soggy camp and parked my car like a homing pigeon.

I saw and approached the hungry and desperate mother, as if drawn by a magnet. I do not remember how I explained my presence or my camera to her, but I do remember she asked me no questions. I made five exposures, working closer and closer from the same direction. I did not ask her name or her history. She told me her age, that she was thirty-two. She said that they had been living on frozen vegetables from the surrounding fields, and birds that the children killed. She had just sold the tires from her car to buy food. There she sat in that lean-to tent with her children huddled around her, and seemed to know that my pictures might help her, and so she helped me. There was a sort of equality about it.

Whenever I see this photograph reproduced, I give it a salute as to an old friend. I did not create it, but I was behind that big, old Graflex, using it as an

320

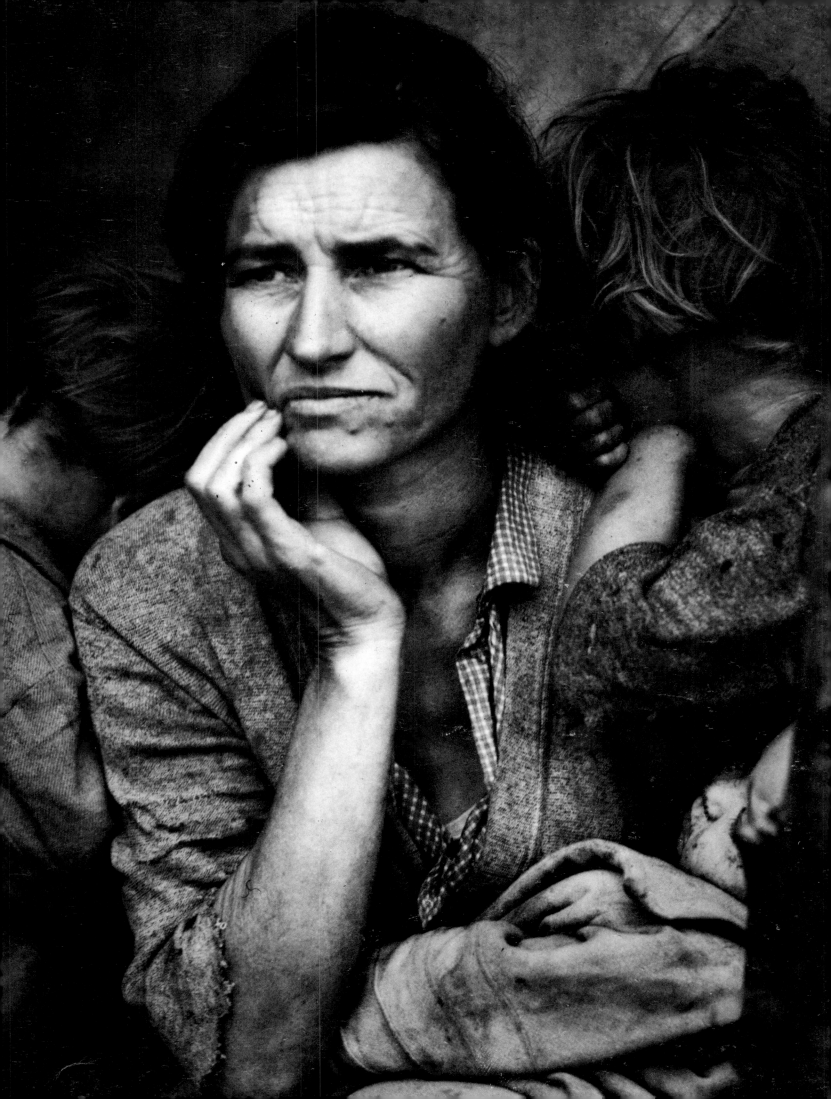

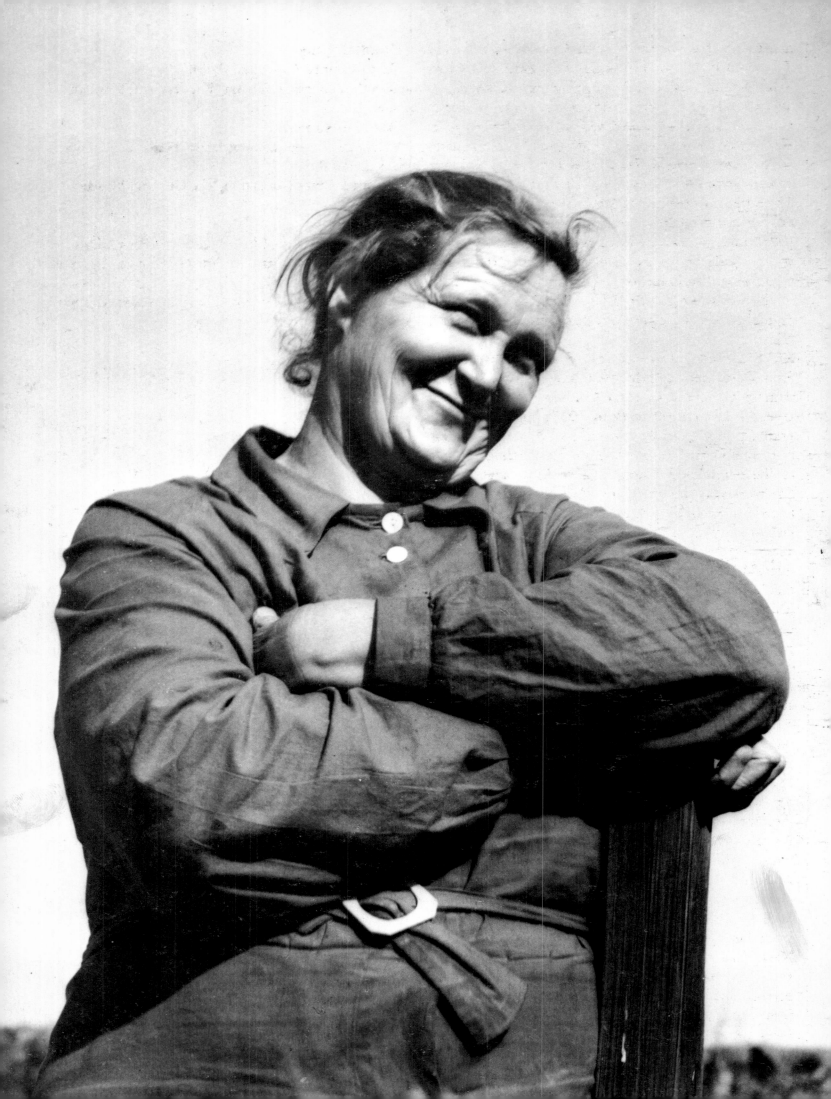

instrument for recording something of importance. The woman in this picture has become a symbol to many people; until now it is her picture, not mine. What I am trying to tell other photographers is that had I not been deeply involved in my undertaking on that field trip, I would not have had to turn back. What I am trying to say is that I believe this inner compulsion to be the vital ingredient in our work. . . .

The splendid outburst of creative work done by her and by her contemporaries, under the combined and really indistinguishable feelings of personal anger and social conscience, have had a very important and entirely justified influence on photography everywhere in the world. One such serious and rather odd photographer of conscience at that period was Doris Ulmann.

She had been a student, first of Lewis Hine (Paul Strand's teacher) at Ethical Culture High School and then of Clarence White at Columbia Teachers College. Strand's critical work in 1917, both verbal and graphic, had effectually destroyed the Photo-Secession; but Doris Ulmann clung to its methods, if not to the sentimental assumptions of its weaker artists. She worked entirely with two big view cameras, 6½ by 8½ and 8 by 10, which used the heavy, old-fashioned glass plates. Neither camera had a shutter; apertures were controlled with a set of bored metal discs, and exposures were made simply by taking off the lens cap. Her lens was soft-focus: but this unjustly derogatory term needs to be more precisely defined. Such a lens can be amazingly sharp, and permit considerable depth of focus, if there is a lot of light, or if the exposure can be long enough to allow it to be stopped down all the way. Even for short exposures or less light, the lens is still sharp for some little distance from the center outward, yet unimportant forms can be blurred out of the composition. So Ulmann's lens was actually a more versatile tool than we think.

She was, from the start, fascinated by character; and therefore portraiture was her first concern. She did gravure portfolios of the medical faculty at Columbia, then at Johns Hopkins, and a third portfolio of American editors. Now there occurs a curious emotional coincidence in her life: her teacher, Clarence White, died; and the same year she was divorced from her husband. She was always an upper-class New Yorker, with all the ample money that goes with this position. This was a lucky circumstance, because she was small, fragile, dark, ill all her life from perforating ulcers, and for many years limped from a knee injury. The singer and folk-song collector, John Jacob Niles, became her close friend and

Dorothea Lange
Tulare County, California, 1938
Dorothea Lange Collection, The Oakland Museum
Page 324

Dorothea Lange
Six tenant farmers without farms, Hardman County, Texas, 1938
Dorothea Lange Collection, The Oakland Museum
Page 327

Doris Ulmann
From the portraits of black people of the Gullah region of South Carolina, made between 1925 and 1934
The University of Oregon Library, Eugene, Oregon

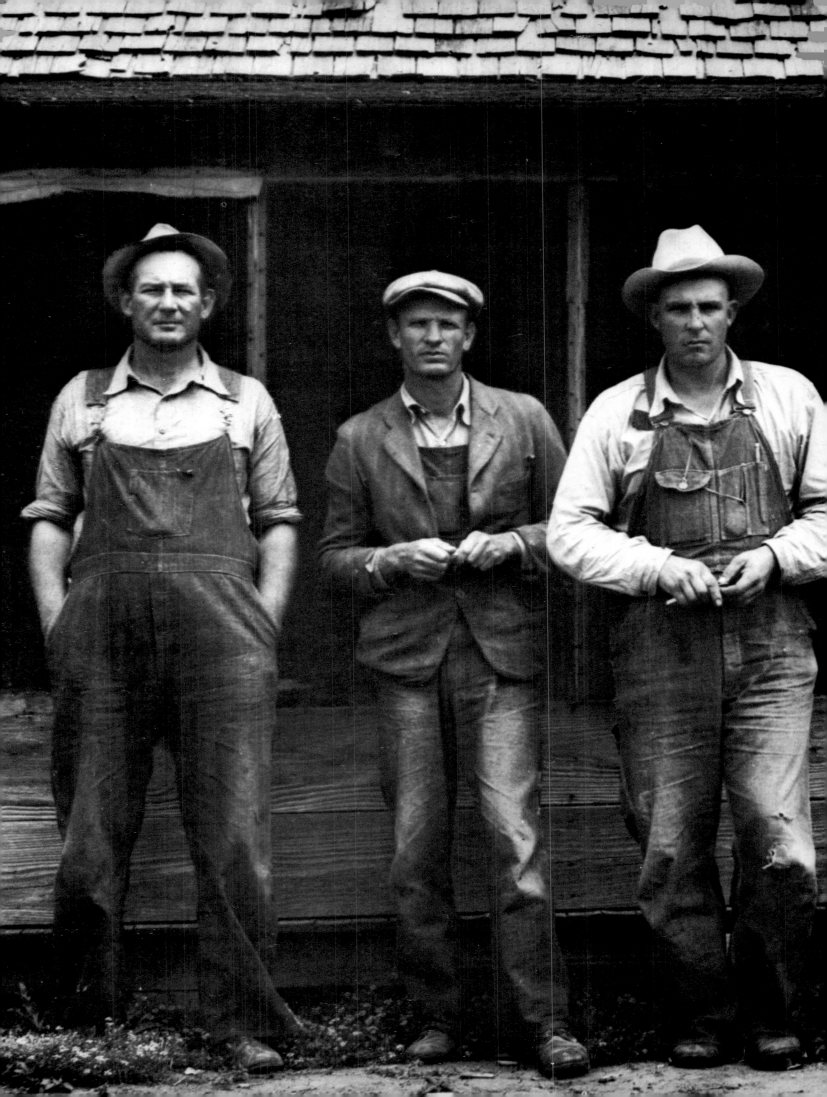

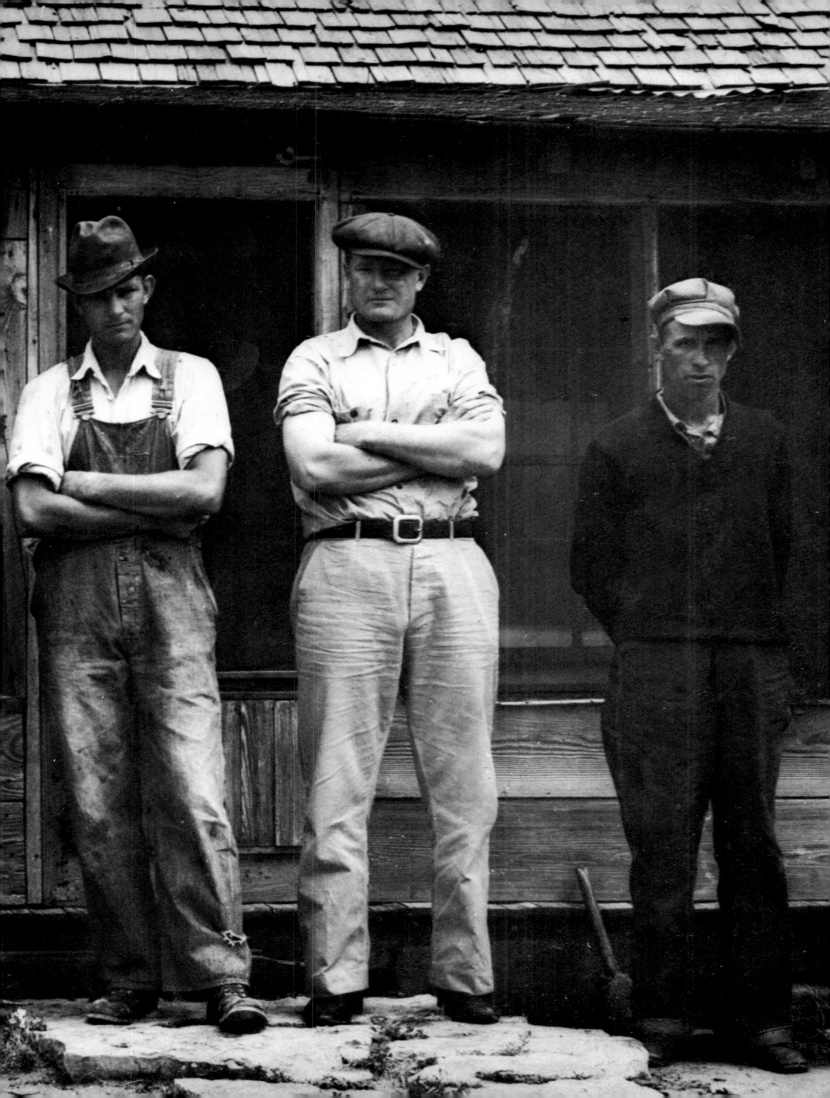

companion; he reports his tender astonishment at her aristocratic habits: *Miss Ulmann had a dressmaker who had served her apprenticeship in Paris. As a result, Doris wore fabulously beautiful clothes . . . After her death we discovered, in what I had thought to be a wine-closet, more than 50 pairs of shoes, many of which had never been worn. . . .* It was her chronic illness, perhaps, that made her seek the solace of these luxuries.

After her divorce, she began a series of automobile journeys in her Lincoln limousine, driven by a German chauffeur who had worked for a general on the Russian front. These travels away from the natural geography of her group were adventures into the last of the aberrant communities of America—the Shakers and the Mennonites; but her base was always a good hotel with a suite of two rooms, one of them darkened so she could load the plates into their wooden holders, and afterward develop and fix them. Soon she ventured farther, staying at fashionable southern resorts, but driving every day by the back roads to take portraits of isolated people in the doorways of their weathered shingle houses. The "filmy summer dresses" that she wore were not envied but fingered and admired by her sitters.

Prompted by the southern novelist Julia Peterkin, she did a book of portraits of an isolated group of blacks, the Gullahs of coastal South Carolina, who spoke a quasi-African dialect of their own. These photographs, with three or four exceptions, are good but not penetrating; one feels not only the gulf between northern white lady photographer and rural black laborer, but the memory of slavery, of two-hundred-year wrongs; and the use of a certain cold and traditional dignity, the better to resist the inquisition of the lens. Ulmann did a far better series on the Appalachian folk; though they are the white descendants of the original thieves and prostitutes exiled from England, they are just as proud and touchy as any Gullah. I myself stopped at a cabin in those hills, knocked politely at the bottom step of the porch stairs (one is never so crude as to knock on a door), and talked for some minutes to a young woman who leaned on the warped porch pillar, and smiled at me with a mouth of lost teeth; till her mother came out then and stood in the doorway and told me, "I think you been here just about long enough." So it must have taken the patience of repeated visits for Doris Ulmann to get her portraits; and they are very beautiful, real, moving, and communicative.

She had opened a photographic dialogue between herself and these lonely second-growth hill people. They had preserved the tradition of showing, by face and posture and clothing, the way they inexorably were—worn, boney, comprehending, and enduring. It's a series that deepens as you study and restudy it. To me, it has come to stand with the greatest portrait series ever taken, with the Hill-Adamsons, the Nadars, the Southworth-Hawes, and above all, the Strands.

Indeed, Strand is one of those monuments that one sees from everywhere in the changing landscape of photography; another such giant, though of a different, more acidic, more aristocratic kind was Walker Evans. He was one of the original F. S. A. people: but his conscience and his art made a difficult mixture—since both were of a sophisticated kind.

There were at that time—in the late twenties—two quite different worlds which the photographer might choose to inhabit. One was the very powerful and influential aesthetic of László Moholy-Nagy, the early (1912) Francis Bruguière experiments, and the later work of Coburn. There are signs of this obsession with abstract design even in Strand's very earliest work: the intersecting clay bowls or the great square black holes of the windows in a government building. We gave the latter a frightening social significance afterward, but of course that was in our own vision, seeing it through the filter of the stormy decade of the thirties. Most abstract photographs do have a powerful purity—paradoxically because they are arrangements of real objects; but a great many are simply tricks done in the darkroom, and these vortigraphs and photograms, thought to be so astonishing at the time, now seem juvenile.

Evans never showed any interest in this narrow tendency; he chose another, and one far more suited to the times. He, and others of the F.S.A. family, were influenced—often more deeply than they knew—by the sturdy nineteenth-century American tradition that encompassed not only Eakins but the still-lifes of William Harnett and John Peto. For these paintings were not merely *trompe l'oeil* (itself an imitation of the strong light and magic immediacy of the daguerreotype that flourished during their earliest years)—they were also, if humorously, intended as substitute portraits: the objects added up to the man.

Closer to Walker Evans in time and in social climate were the painters John Sloan and Robert Henri, and closer yet, Reginald Marsh. The latter's strongly painted "Subway Express" (1929) reminds one of Evans' subway series, and indeed—such is the rich cross-fertilization of American photography and American art—we see the same use of vulgar objects like newspaper headlines, and the same dissection of figures by the sharp edge of the frame. So it was not merely the Depression that turned Evans toward the

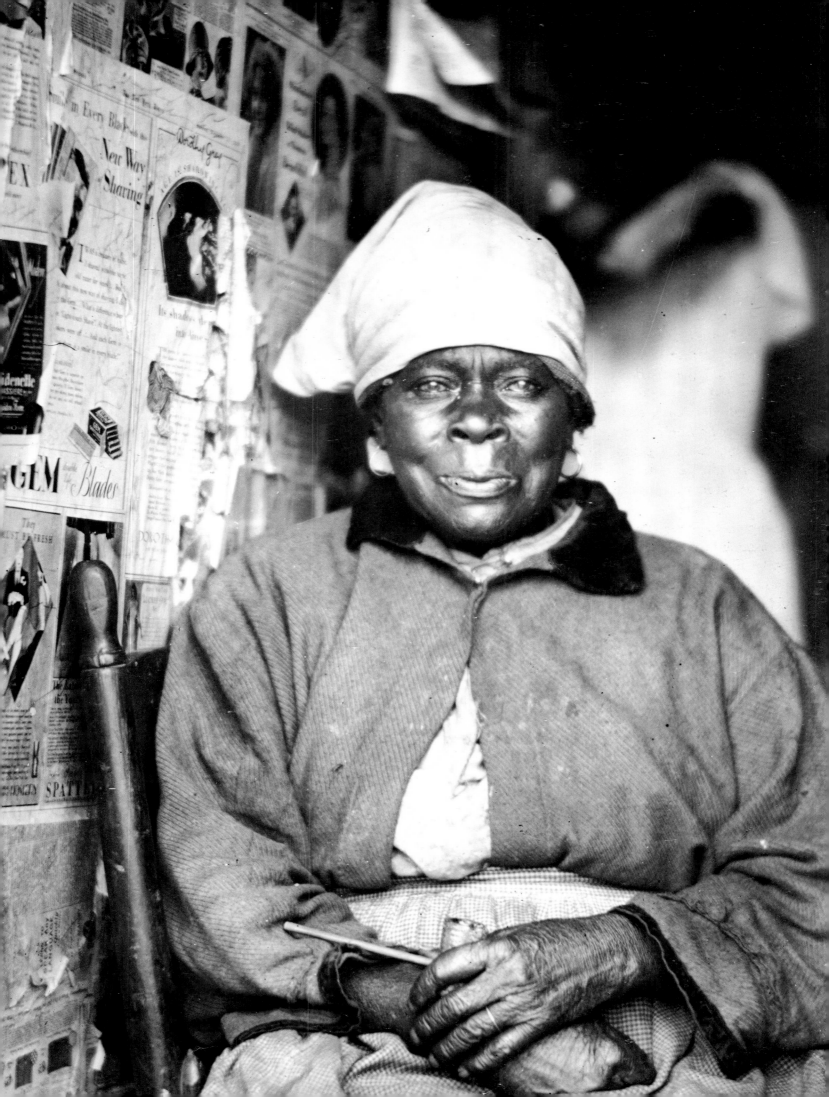

Doris Ulmann
From the Southern Appalachian portraits, made
between 1925 and 1934
The University of Oregon Library, Eugene, Oregon

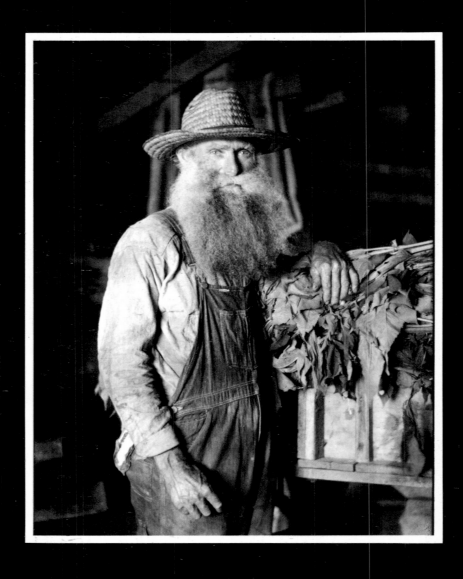

Doris Ulmann
From the Southern Appalachian portraits, made
between 1925 and 1934
The University of Oregon Library, Eugene, Oregon

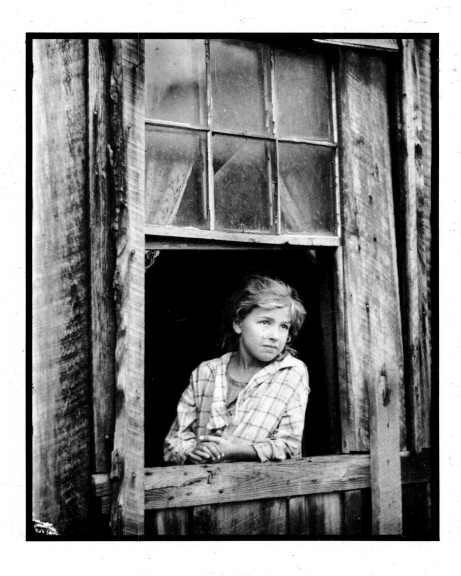

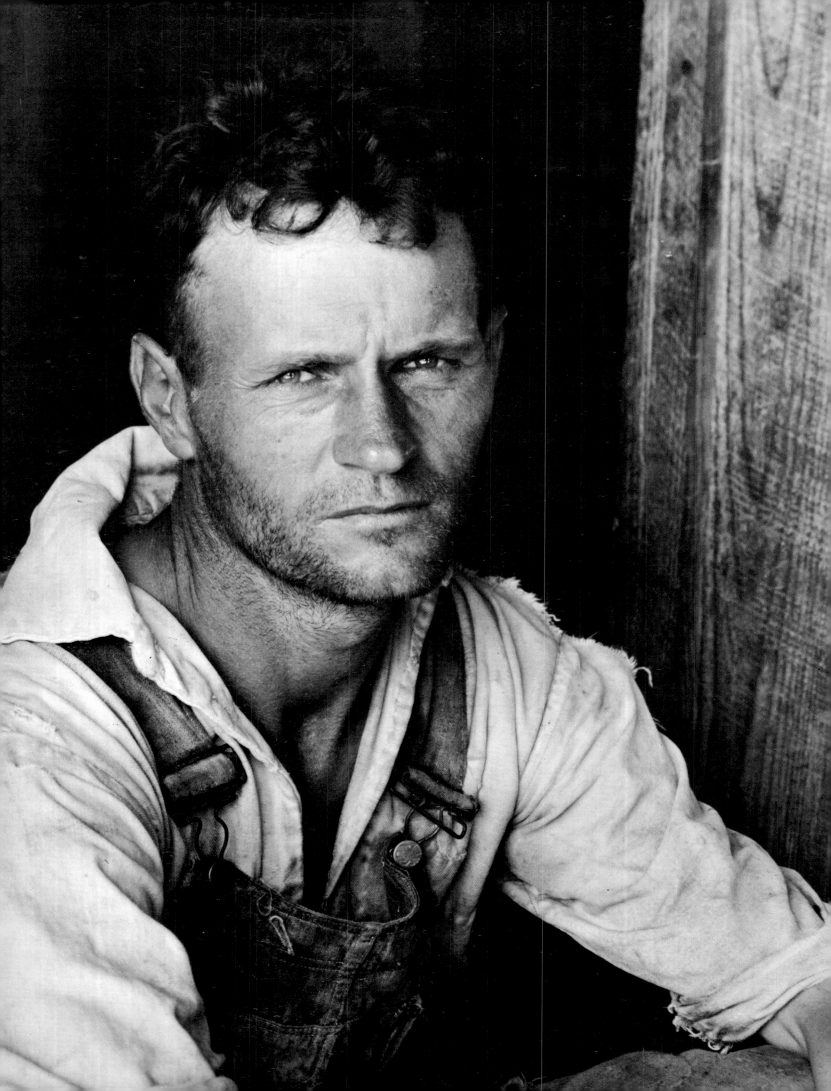

Walker Evans
Floyd Burroughs, a cotton sharecropper,
Hale County, Alabama, 1935

Walker Evans
Landowner, Moundville, Alabama, 1936
Both, The Library of Congress
Page 332
Walker Evans
Girl in Fulton Street, New York, 1932
The Estate of Walker Evans

American streets and the people who sit, walk, and work in them. As early as the twenties, his photographs were famous and were shown publicly as works of art; and admired and absorbed by a generation of photographers just out of their teens. His photography compelled their attention by a combination of reticence, delicacy, and a bitter surgical honesty; what seems the most casual element becomes, as we study it, the irreducible center of the photograph.

Look at the remarkable "Girl in Fulton Street," where the central figure is the half-turned head with its masklike hat in the style of 1929. The face itself has a tragic and almost ferocious sensitivity, as if it were a kind of self-portrait of the artist; yet see the other details: the three anonymous hats of the men just beyond, a steel arm of a crane, and especially the edge of the store window on which the girl is leaning, where the mixed and illusory reflections provide a kind of strip of confusion against which the girl's face looks back with such intensity.

This method of providing a marginal area of contrast runs through many of his photographs. And, by this means, Walker Evans reveals a certain hideous miscellaneity of American life: the used cars abandoned on a field; a confused and helpless back room, revealed through an open door; the tires, tubes, and spare parts displayed on the front of a garage; and the magic advertising words, the names, the signs, ubiquitous, ugly, nonsensical, and therefore magically powerful. Inside this macabre world, the photographer has isolated a series of American faces. Few are seen with pity; some are too brutal (the legionnaire with the mustache), some too brutalized (the black-faced dock worker), but the effort of the artist has been simply to expose, and that is a great deal.

Here the special quality of photographs, that they are also facts, provides the ingenuity and sensitiveness of the photographer with the merciless tool of truth. Evans wishes to contrast the square wooden boxes of company towns with the involuted, delicate fantasy of certain American architecture. But the latter, placed side by side with the harsh force of the streets in which people live, become dead, pleasureless relics, ornate as tombstones. His interiors are as individual as faces, different in Alabama than Connecticut; the somber, lyric "Factory Street in Amsterdam, N.W.," or the "Church of the Nazarene," each concentrates, in its burning contrast of black and white, the religious hysteria and the degrading poverty from which it springs.

So the world of Walker Evans, across a half-century of careful work, has always had a certain inner constancy: an indirection expressed directly, a surrealism expressed realistically, an aesthetic that values magic —but without sleight-of-hand; and, finally, a conscience almost stripped of compassion. Yet it's not without a very real passion, expressed in a high and difficult aesthetic; I mean that peculiar quality, often mistaken for tact, or even for outright coldness; and possessed only by the very greatest of graphic artists: *passion at a distance.*

335

Astonishingly like the life of a cell or an animal, the useful pulse of a particular aesthetic is governed by two curves: an inner and an outer; the inner is the curve of growth, vitality, maturity, decay, and death; the outer curve is the particular social context of which the inner movement is only a part, and generally a very minor part, at that. So the continuity of photography with a social purpose went beyond mere social circumstances, and continued into the body of work of many young photographers—largely in New York—in the late thirties and into the decade after World War II. One of the most individual of these, in my opinion, is Morris Engel: his photographs are social documents only in the sense that all faces are a kind of social document; he found an apprehensive, mournful courage in all his sitters.

This work was done around the socially conscious Film and Photo League; patterned out of European experience, it had a "fraction," a group of Communist members who endeavored to guide it: and this was the excuse for the pre-McCarthyian attack upon it in the late forties; though the fact was that this Communist party group had about as much influence, except maybe in their own opinion, as the tail upon an elephant.

Just as what counts in Cubism is not the theory but the artist: Braque and Picasso; and in the Blue Riders, what counts is the maverick Paul Klee; in the romantic European music of the nineteenth century, Beethoven, not Kuhlau or Weber. So in the Photo League, what counts today, thirty years later, are the artists. The generally high professional standards of the league attracted a great many people of excellent, if not spectacular, quality. Its undoubted influence was exerted by a broad and tolerant interpretation of what is meant by conscience; I quote here from the statements of some of its members:

LOU BERNSTEIN: *I thought of photography as a means of self-expression and the league's philosophy suited me because it emphasized the expression of personal viewpoints, even in the photographs we took of social conditions . . .*

JEROME LIEBLING: *Since I was a city boy I liked the League idea of going into the streets to photograph New York. In 1949 I was in Paul Strand's class at the Photo League, where we documented the area near Knickerbocker Village, a Manhattan housing project that had been built in 1934 on the site of a notorious slum. By the time we photographed it 15 years later, new decay was evident. By shooting this youngster without much environmental detail, I wanted to invite the viewer's sympathetic interest in him, from his curious gaze to his gracefully crossed*

339

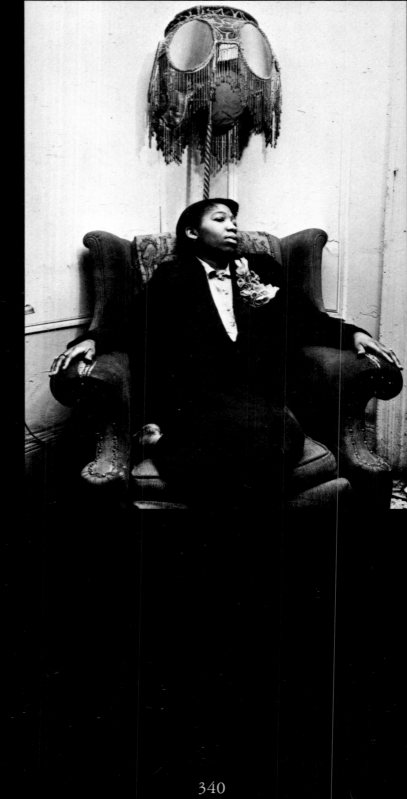

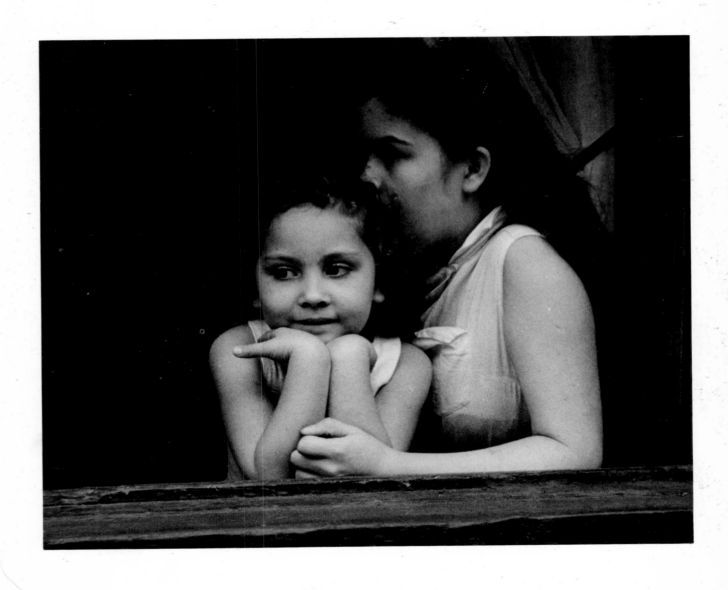

341

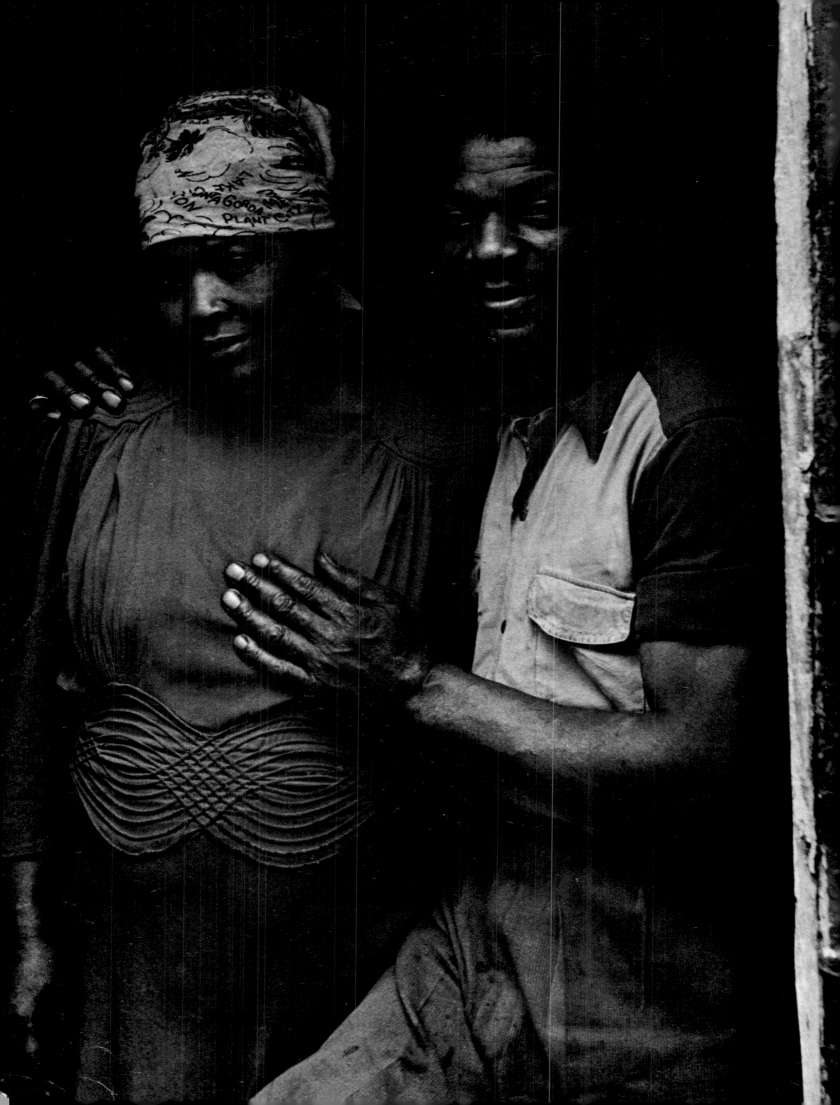

hands to the poverty betrayed by his cheaply made, broken shoes.

WALTER ROSENBLUM: *I took pictures of the kids who hung around the candy store on the lower East Side block for six months, so I knew them pretty well, including this boy. . . . I wanted to express the strength of character in his face, the toughness his spirit had developed, growing up among those tenements in the background.*

These thoughts, indeed, are so much in harmony that they seem part of a composite statement. Nowhere do these photographers express much interest in the formal qualities of the photographic print; in their work one rarely looks at the picture plane, but through it. An exception is the work of Aaron Siskind. The best of these photographic portraits are the ones that survive the collapse of a particular cause; they still affect us because they are aesthetic composites: they combine human insight with the special beauties of silver atoms deposited more or less densely on paper, and with a strong compositional structure within this flat, small, four-cornered form. Engels has this multiple gift, and so does Aaron Siskind. Later in his career, Siskind knew a number of New York Abstract Expressionists, and Franz Kline was notably his friend. Siskind adopted from him the black and white structures of his great canvases, in which the enormous brush strokes delineate a network of decayed girders; and in this black mode, Siskind made huge photographic close-ups of the city, of eroded paint, paper, and iron—iconography of an alphabet long forgotten. Looking backward from these famous prints, we can see, in his early work in the Photo League, the personage gripped by the architecture of chair and lamp, which form quite another dark and powerful creature that holds the human being in its embrace. In the surreal realism of this work we can see the influence of that twentieth-century American colony: Europe.

Each transplant of European ideas into America, and vice versa, has been amazingly viable: proof of the energizing influence of any new aesthetic, illusory or not. Photography has been more international in its migrations than any other art; it is comparable to science in its freedom from national color, and this is true from the very invention of a photograph right up to and into any possible future. In 1929 Edward Weston had helped with an exhibit of realist photography in Germany: where, since it coincided with the taste of the New Objectivity, the work of the Americans was tremendously admired. In turn, there had been, in the early thirties, a profound technical influence: the street work of Brassaï and Cartier-Bresson. In the late thirties and early forties, there was a direct political influence: the moral collapse of Europe, the frightful rise of the Nazis, and the subsequent persecutions and massacres, in and out of uniform, which drove whole groups of Central European intellectuals across the sea to the U.S.A.

One remarkable émigré was the Russian photographer Roman Vishniac: at the age of seven he had already focused his camera, through the objective of a microscope, on a cockroach leg. He left Moscow in 1920, after getting his medical degree; his family, who held government posts under the fallen Kerenski, had left two years before. At first, he lived with his wife and children in Berlin, where he became a specialist in endocrinology; meanwhile, he made portraits to increase his income. That recurrent sickness of Europe, anti-Semitism, began to spread virulently in Germany; in a long act of defiance, Vishniac deliberately went to Poland, to the Baltic states, to Hungary and Czechoslovakia, and made thousands of negatives in the ghettos; it was an act of spiritual self-preservation, without financial reward, and without much recognition, either (he published a selection in 1947).

This series of portraits is of people who seem to have been preserved intact from a winter in the seventeenth century. The time, though, was 1936, '37, and '38; and every one of these faces: the Warsaw girl and her grandfather, the powerful, tragic Lublin wife with the eternal gray, ragged shawl over head and shoulders, the cheerful little boys in the synagogue, black-capped, long-haired, with the old argumentative books open before them to memorize—all these, you realize as you look at them, will reappear in the skeleton people of the concentration camps.

Exile is a form of surgery, and if one recovers, one changes, too. Vishniac, in America, photographs almost nothing now but expressionless and innocent fish, squid, and protozoans. An exception is his portrait of Albert Einstein: *It was a singular experience. An idea had suddenly come to him, and the room was filled with the movement of the great man's thought. I waited several minutes, and then, when I saw that he did not intend to say anything more to me and that he was off in a world of his own, I started taking pictures. And the background of those pictures was nothing but empty shelves. Unlike the studies of most scientists in Princeton, his had no books at all in it— he had nothing to work with except the pad, the pencil, some notes he had taken from his pocket, and a blackboard he had been using to figure out formulas. Not only was he not posing, he was not aware that I was there. It was an ideal situation for a portrait photographer. Here was the real, unposed personality*

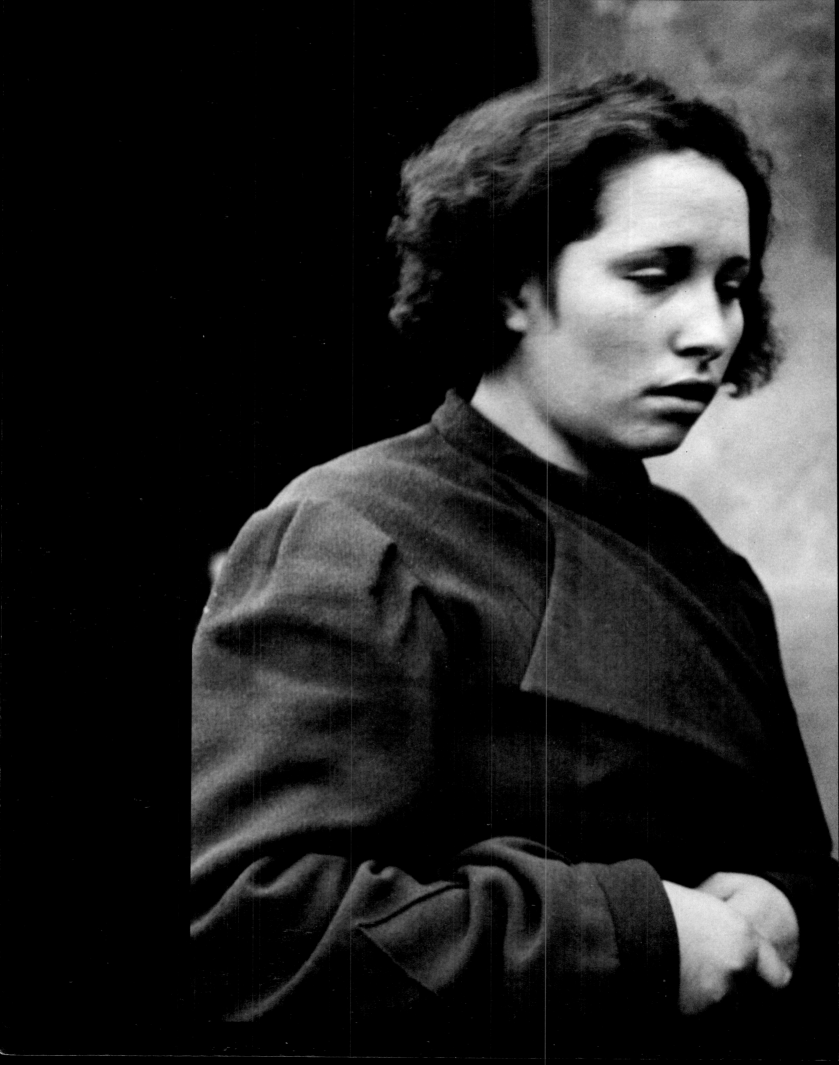

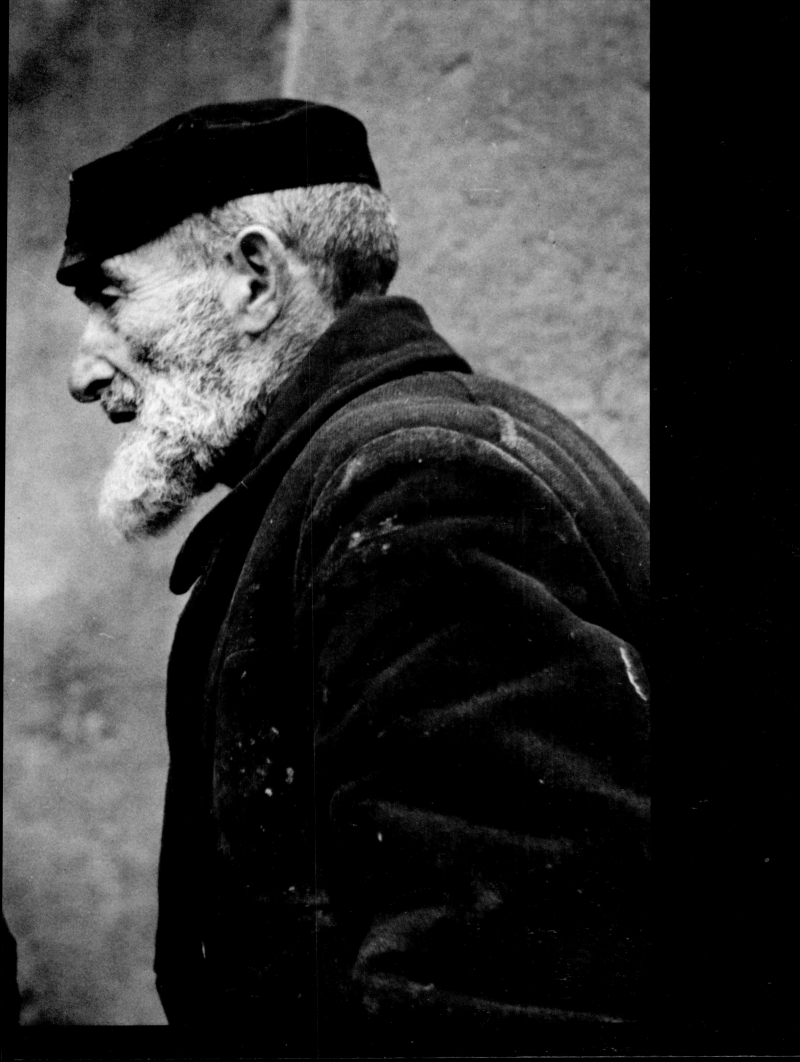

Marion Palfi
Wife of the victim, Irwinton, Georgia, 1949
The Witkin Gallery, New York
Page 348
Elliott Erwitt
Las Vegas, 1957
Magnum

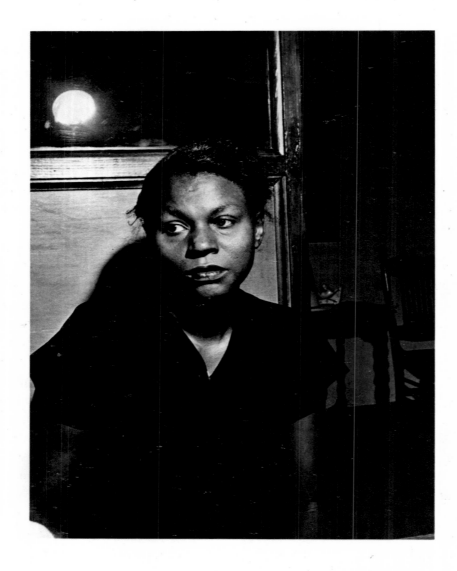

of a genius. I was full of emotion, and very, very elated. It's a fair portrait; but not to be compared with, for example, the man in the dark doorway of a ghetto. Yet he describes an experience, both the watchfulness and the elation, very characteristic of portraiture: for it's an art whose critical moment of exposure is not technical but psychological.

Another exile from Germany, although of quite a different background, was Marian Palfi. Though descended from a Hungarian aristocracy who were settled in Vienna for centuries, Palfi's brother Victor was prominent in the radical theatre of Berlin in the twenties. Though she was a popular beauty at the time, made famous by her picture in the Ullsteins' magazine, *How to Remain Young and Beautiful,* the triumph of Hitler and the deracination of her family proved that the nightmares of the left were only too real. She had taken some photographs in Germany; in Holland, the first place of exile, she opened a portrait studio, but with the approach of the Nazis, she emigrated to the United States. Living and working in New York at a routine photo-finishing job, she began to take a considerable number of portraits; fixed in her forehead, she had the third eye of social conscience.

This is not necessarily and invariably a good thing, because it can lure the portraitist into photographing a person simply for the good it will do him; and there is no guarantee it will not be mediocre in every other respect. I'm certain, from talking to her, that Palfi would not agree; to her, the moral obligation of the photographer is primary. Yet, again, as in Riis's work and Hine's work, there is a poet curled inside the journalist. For example, Palfi went quietly, which was more courageous than most of us, to the little town in Georgia where a black man had just been dragged out of jail and shot. Is her portrait of the victim's wife any different from the numerous white faces she photographed that same spring of 1949? The answer must be equivocal. The widow is beautiful, both because she is, and because Palfi thinks so. But there is no doubt of Palfi's hatred of small town power: mayor, publisher, overseer, postman. Yet the camera sees what rage denies: the purblind caution in everyone's look, white or black.

In her photographs of the victims: American Indians, abandoned children ("it's like the murdering of little angels," she commented), of the old people condemned to white-walled prisons—Palfi works out of a strong and generalized indignation. Yet, and surprisingly often, a contradiction sounds its deep pedal tone; and we hear the sinister harmonies of human character, where the victim can be almost as brutal or stupid as the petty tyrant can be kind or helpless. In such portraits—I'm thinking particularly of a double one: a Puerto Rican boy in New York City paired with a lady cashier, poeticized behind glass, and both linked by aspects of the movie daydream—Palfi's work makes us feel a compassion for the fundamental human dilemma: for our illusions and our mortality: about which little can be done.

Far stronger and more pervasive—perhaps because they are easier—are the European attitudes that go back to the antibourgeois loathing and anarchic hatred that was the consequence, among intellectuals and artists, of that ancient conflict: World War I. Thus the nineteenth century inheritance of Thomson and Sander, who were photographic collectors, one might even say maniacs, fascinated by types and classes, has taken a Dada twist in the work of our contemporaries. They feast on the clinging, plump, lightly perfumed flesh of the middle classes; fascination and disgust are combined in the work of men like Elliott Erwitt and Les Krims. My next-door neighbor has a collection of fine rifles and a den full of glass-eyed heads of animals he has proudly shot behind the ear: his view of Krims' grinning hunters would be the exact opposite of mine—and probably of the reader's; we identify with the deer, which, I submit, is certainly not normal. Erwitt has gone to the playgrounds, Miami and Las Vegas, to stalk his middle class: they are funny and pitiable, but would never, if they saw their portraits, think so themselves; and maybe, just maybe, our view is as arbitrary and group-directed as theirs. Let us at least admit the possibility, for example —that all old ladies with rimless glasses are not blue-haired monsters of self-deception.

For example, I photographed the part owner of a service station, who could not have been more typically American, with all the optimistic virtues that belong to this self-constructed ideal. He was a Boy Scout leader, a fairly regular churchgoer, and the father of three boys, each of them sturdily athletic and not excessively bright. But this man was living a totally false life in his marriage; he was infatuated with a girl thirty years his junior and was spending the family savings on a mad business venture of which the girl was the president and treasurer. Any portrait of him would, I think, reveal something of this ambiguity.

This is in no way an exceptional instance. Everyone who has lived a sufficiently long time has a similar complexity either of event or personality. If you listen with any decent respect, they will tell it to you; cannot, in fact, be restrained; and you yourself will be rewarded by experiencing a chilling astonishment;

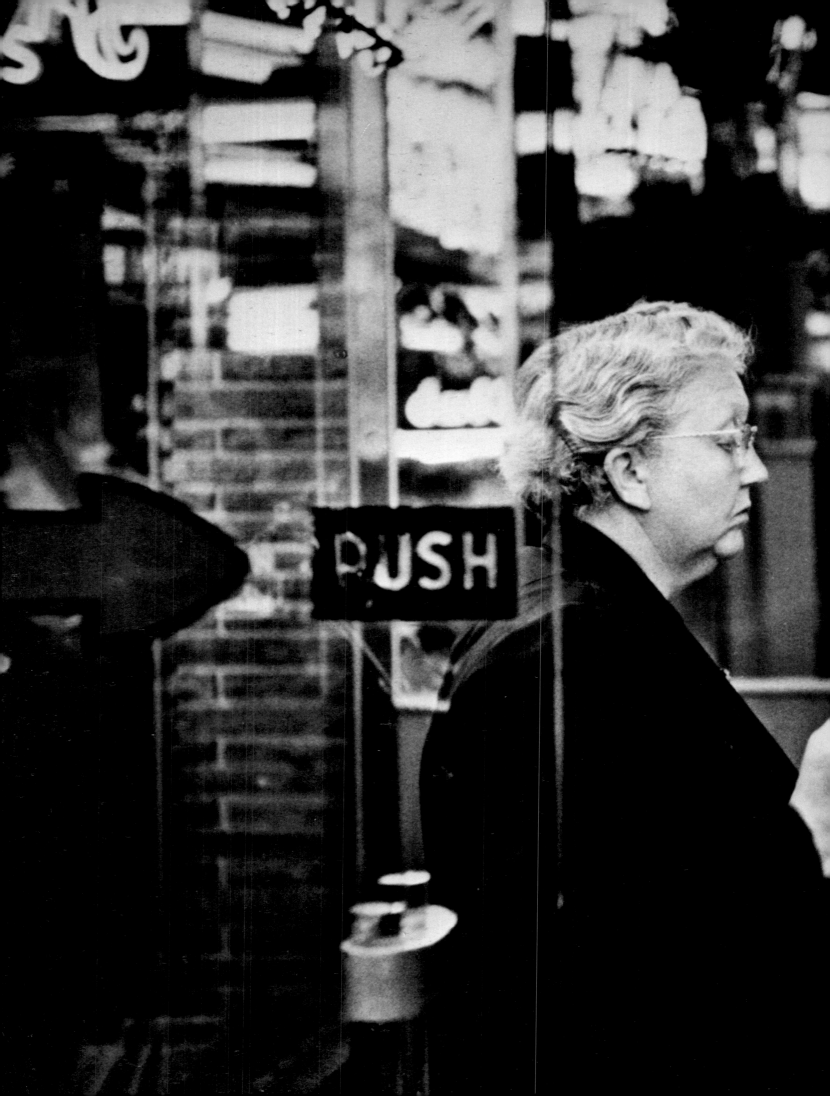

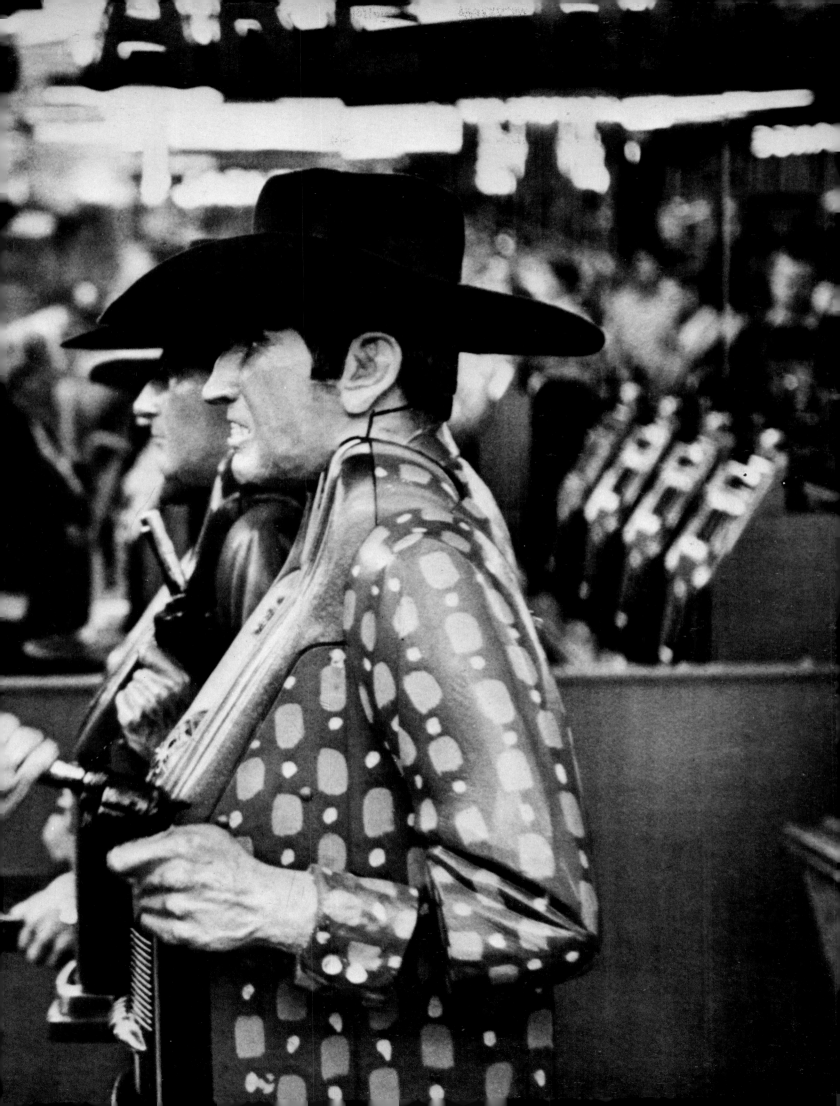

and if you photograph them, you will try, or at least ought to try, to bring your respect and astonishment into focus within their portrait.

Diane Arbus, whose work spans the period of less than fifteen years before her death at the age of 48, did have something of this deeper view: *My favorite thing is to go where I've never been. For me there's something about just going into somebody else's house. When it comes time to go, if I have to take a bus to somewhere or if I have to take a cab uptown it's like I've got a blind date. It's always seemed something like that to me. And sometimes I have a sinking feeling of, Oh God it's time and I really don't want to go. And then, once I'm on my way, something terrific takes over about the sort of queasiness of it and how there's absolutely no method for control. If I were just curious, it would be very hard to say to someone, 'I want to come to your house and have you talk to me and tell me the story of your life.' I mean people are going to say, 'You're crazy.' Plus they're going to keep mighty guarded. But the camera is a kind of license. A lot of people, they want to be paid that much attention and that's a reasonable kind of attention to be paid.*

There are always two things that happen. One is recognition and the other is that it's totally peculiar But there's some sense in which I always identify with them.

She had a personal notion of the way people see each other: *Everybody has that thing where they need to look one way but they come out looking another way and that's what people observe. You see someone on the street and essentially what you notice about them is the flaw . . . Our whole guise is like giving a sign to the world to think of us in a certain way but there's a point between what you want people to know about you and what you can't help people knowing about you.*

Arbus did almost no photography until in her thirties. Her first photographs were of Coney Island, and of children—each of these in its own way a funny kind of village. Her first paid assignment was a study of New York City eccentrics for *Harper's Bazaar;* and the next fifteen years of her work is remarkably consistent: *For me the subject of the picture is always more important than the picture. And more complicated. I do have a feeling for the print but I don't have a holy feeling for it. I really think what it is, is what it's about. I mean it has to be of something. And what it's of is always more remarkable than what it is.* One is obliged, therefore, to examine one's own relationship to her subjects, and not merely to her prints. And this is not easy to specify; at first I felt disgust

Diane Arbus
Girl with a cigar in Washington Square Park,
New York City, 1965

and admiration flipping back and forth. Then the emotion powered by her prints settled down into an alternation of shock and recognition. The truth is in her work, but a truth not easily digested.

She was interested in uncovering and recording the moments, whether private or public, in which people become most singular. *I do feel I have some slight corner on something about the quality of things. I mean it's very subtle and a little embarrassing to me, but I really believe there are things which nobody would see unless I photographed them.*

For all its defects, a social, or more usually a sociological, viewpoint gives the camera a direction, and the shutter a moment of choice. Whether that choice is good or bad, sentimental or cruel, is a decision of the whole head, not merely the eye. America has always been especially rich and especially vulnerable to such choices. In the state of Texas, the young photographer Geoff Winningham, moving past horror and fascination, discovered a world of plain faces and fancy boots; it is really a sort of theatre, and in particular the theatre of professional wrestling, where the fans are a Greek chorus of terrifying power.

What the portraitist feels when he photographs a performer in public is that strange, halfway participation of the audience in the drama. They are powerless, and it irks them, but they would not really want the responsibilities of the stage. They are reduced to gestures which they know are quite without consequence, so their ferocity is all the greater. We think, following a certain academic fashion, that television, which splinters the audience into mute families, has somehow changed this visual antiphony between spectator and hero-victim. That's not true, and it is especially not true of the enormous American lower middle class. Not baseball or football, but—after horse racing—stock car racing, with its hope of flaming crashes, is the top attraction of all sports. Roller derby, a loud and monotonous and circular rhythm broken by prearranged fights, has its thousands of shrieking partisans. Spectators of both sexes circle the boxing matches, holding newspapers to ward off the ringside blood. An old woman in the bleachers at the wrestling match, caught up in the ritual three-fall drama, pokes out the bottom of her Coca Cola cup, and using it as a megaphone, screams at the Japanese heavyweight, "You yellow punk, remember Pearl Harbor!" Politics, too, has its games and its audiences.

We think, instinctively and mistakenly, that portraiture is a quiet operation. We imagine a relative calm before the exposure, both in the photographer and in the subject. That is no longer true, if it ever

Geoff Winningham
Miss Appaloosa Queen, 1972
From *Going Texan*
Page 358
Geoff Winningham
Mil Mascaras in defeat, 1971
From *Saturday Night in the Coliseum*

was. The camera has shrunk to a handier size, or it is hidden farther away, using telephoto lenses to spy into the thickness of emotion. At sports or theatre or election rallies, the portraitist is in the very arena of a pseudo-life. It is violent, noisy, rich, surprising, but always within the boundaries of a ritual; races, matches, and such public events as the taking of hostages—all have an Aristotelian unity of time and space. They each rush forward to a decision: win or lose. The photographer doing portraits of the principals in this circus of expectations cannot avoid the audience; their black, gasping, open mouths, though turned quite silent in the photographer's darkroom, are nevertheless essential to the truth. They are as much a part of the performer's portrait as the sweat running down his back.

W. Eugene Smith is a much sadder and darker photographer. Smith typifies the social attitude and the technical accomplishment of the photographers who formed a constellation around *Life;* but of course he's more than that—he's the lyricist of his own nature; he has a darkness and a shyness which is the badge of the morally wounded. But he shows the other side of the medal, too: a fury that can reveal François Duvalier, the voodoo dictator, at his desk in a proper dark business suit, defended by his Bible and his two heavy revolvers; or the hateful white-face of two Ku Klux Klansmen. Yet the bulk of his portraits are deeply sympathetic; there is no cold ambiguity or intellectual irony in his work. It is either hate or love.

The result is a beautifully concentrated drama, whether of the birth of a baby assisted by black midwives in North Carolina, or Spanish mourners at a death bed: it's the drama of ordinary, simple (one almost thinks: too simple) human beings. The light is natural, but intense; it resembles the Biblical drawings of Rembrandt; and this intensity, as in Rembrandt, derives its drama from very large areas of black. Naturally, not all Smith's photographs have these particular structural values; a photographer, makes so many negatives that the exceptions outnumber the rule. But on the whole, darkness, with explosions of white, is the expressive color of his work.

Among all the technical fashions in photography, the social tradition in portraiture seems imperishable. Because of the nature of our human society, stretched and torn by our own lust for dominance and submission, caught in the weird logic of nature that has allowed one species to rule the planet, a series of catastrophes are quite inevitable. Mass events are, after all, composed of things that happen to individuals; and the faces of men and women wear not only the livid scars of these events but, superimposed

upon them, the lines of dignity and resistance that are our psychological treasure.

Bruce Davidson's portraits are in some way melancholy, perhaps because they are colored by the private darkness of desire: that old and delightful trick that evolution has invented. Touching: this is the common theme of much of Davidson's work, and particularly true of his Harlem series. These have been much criticized by people who see in them the arrangements of Davidson's mind, rather than the culture of poor blacks and Puerto Ricans. Certainly there is a degree of manipulation here, but it is governed by an emotional truth; and one that is based on the solid information of the eye.

Interiors, more than streets, are constructed out of bits and pieces. Davidson is particularly sensitive to the surroundings of his subjects: the cracked Christ in the frame, the TV in its frame, the lace curtain in the frame of the window over the street. Just as often the interior is simply messy, and among or on the tangled heaps of this debris of living from day to day are the inhabitants. They are mostly dark, and their skin tone gives an especially warm darkness to every face and body. Davidson's people are physical, close, brutal no doubt, but also deeply affectionate, nothing like the separated, lonely asteroids of Ulmann's Appalachia.

Davidson's Welsh portraits seem deeply reflective of the misted soft hills, the brick streets of the mining town, the seriousness of children, the hands of the men hanging work-heavy over their knees. All these seem to us to be beautiful and true; but we viewers are aliens, mostly, too; in the nature of our society we are part-time foreigners to one another. So the separation of art, what I have described as Walker Evans' passion-at-a-distance, may be our fortunate necessity.

Danny Lyon, in his portraits of nameless black workmen, discovers a sort of joking beauty. One has only to sit down to a sidewalk lunch at a construction site to realize that Lyon is telling a universal truth; the jokes, of course, may be personal, the prejudice ugly, but the strength, generosity, and compassion is instant and nearly universal. In prison, both these sides of anonymous people are violently exaggerated. Nobody who has had the slightest acquaintance with criminal life can deny the stupid cruelty—not only from guard or policeman, but from prisoner to prisoner. Jails are vile by nature; to put a restless, wandering, sexually active mammal into a small, square, sterile cage is a torture devised by our paranoid turn of mind. Yet, even in prison, the kidding and the friendships and the small joys of working people are to be found. The tattoo, for example, is a plain assertion

of self; it is a graffito inscribed on one's own skin. But the world of prison is opened with difficulty by any outside observer; and the barriers are not only the warden's; prisoners are generally from the lowest tenth on the economic scale, and this tenth looks upward with hatred, silence, and suspicion. Danny Lyon did manage to break through this wall.

Now sensitive lenses and rapid film and small cameras can be used in a much more leisurely way; even in the old-fashioned, studied, arranged, and repeated pose. Groups especially then become much easier to handle, and the shift in body position that accompanies the shift in the play between person and person can be slowed down, frozen so to speak, so they can be examined before being photographed, and rearranged and recomposed without the assistance of that blind genius: chance. A fine example is the series of posed portraits done by Elaine Mayes in a poor district of San Francisco that was, for a few years, inhabited by the "Woodstock Nation"; the sixties generation of young men and women—and a surprising number of children and dogs—all of whom dropped out of middle-class life, and who generated a whole cluster of beliefs, music, and clothing, whose habits were as binding on its members as in any other closed society. But their ease, their energetic indolence, their open good humor, their slack posture, their hirsute sexuality: all these pour out of Mayes's group portraits and make them all and individually attractive.

The recent group portraits of Neal Slavin are rather less compassionate: not that compassion is always a photographic virtue. The mordant poetry of early Cartier-Bresson or Walker Evans is born out of astonishment, not kindliness; yet its not scorn, either. A dilemma troubles all of Slavin's work; one is pulled between amused affection and a snobbish fear. Because the group is our refuge and our tyrant. Maybe the ambiguity that we face in looking at the collective portrait of the International Society of Bible Collectors, the Star Trek Convention, the Capitol Wrestling Corporation—is precisely the ambiguity we feel toward our nation; indeed, when we study a whole wall of Slavin's work, we compose an immense collective contemporary portrait in which, disconcertingly, our own faces are missing—or so we like to think.

Quite different are the affectionate portraits done by midwestern photographer Enrico Natali, they are central in more than one sense. They are quite simply, plainly, frankly, the American middle-class; they are neat, shaved, friendly, affectionate, good neighbors, good smilers, good eaters. In Natali's view, there is no morbidity here; neither rich nor poor; obviously he neither hates them nor finds them fantastic. There is no doubt that for Natali middle America extends from coast to coast.

This novel photographic form: the depiction of types rather than individuals—gives us a whole variety of photographs taken from a narrow class position, whose defect is a lack of true and deep comprehension; but whose value is a certain objectivity, an acuteness of outside vision. I don't know of any large instance where it has affected social change; mostly the opening and closing of a camera shutter is a consequence, not a cause, of the blundering forces of social history.

But the triangle we have emphasized: sitter, photographer, viewer, and therefore the portrait itself, is twisted and altered by the social condition of each corner of that three-part relation. And isn't this just as true of the classic portraitist—of D. O. Hill, Nadar, and Cameron? Not quite, not really; for, in fact, they photographed mostly the members of their own circle; and when they did not, they often failed. Their equipment was simply better suited to a long, quiet, interpersonal relationship between portraitist and sitter.

The photographic view of one class by another (generally from above) is a fact, whether the work is prodded by conscience or not. Brilliant photographs have been made from this position; and, like an intelligence operation, it is best done quickly and unobtrusively. That is just as true in republican America as in autocratic Russia. Certainly there are levels, distinctions, titles, stations, and classes in the U.S.A., too; the difference is that the children of one group do, in fact and rather frequently, rise or fall into another. This very mobility of one's class position gives the artist in such a society a kind of daily caution, a learned objectivity; he need no longer wholly identify with the sitter, and the sitter, in turn, is often found as suddenly as a bird or an insect, and is caught and fixed in the confusion of the open street.

The curiosity, and more than that, the furious photographic hunger: to capture forever that other person, that blind man, doctor, Indian, statesman, gunman, aged recluse, and poor pretty child—types as common as one's next door neighbor, yet somehow still alien and powerful and secret; and to imprison their gestures, to freeze them in a rectangle of glass or paper—that is a new experience for the human race; as strong and disconcerting as the acquisition of a third hand.

W. Eugene Smith
Nurse-midwife, Maude Callen,
North Carolina, 1951
Original photograph © W. Eugene Smith

W. Eugene Smith
Death scene, Spanish village, 1951
Original photograph © W. Eugene Smith

363

Bruce Davidson
East 100th Street, New York City, 1966

Bruce Davidson
Wales, 1965
Both, Magnum

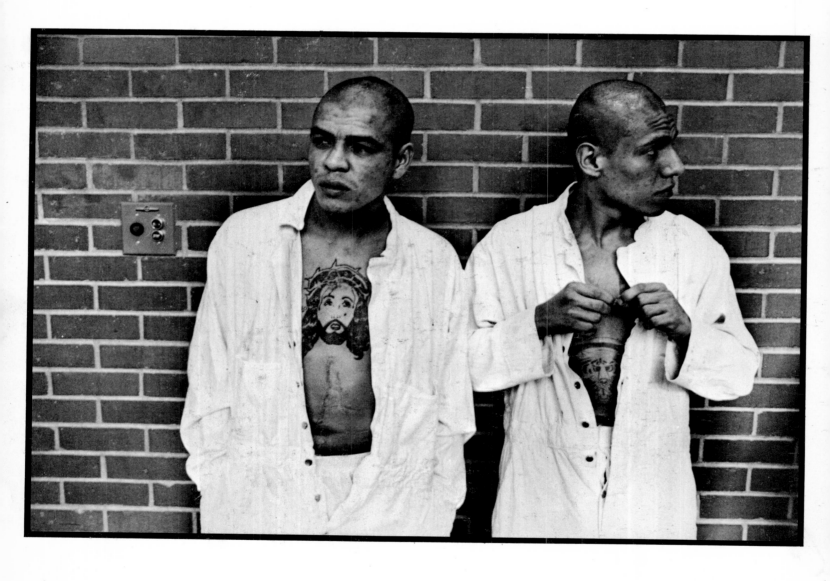

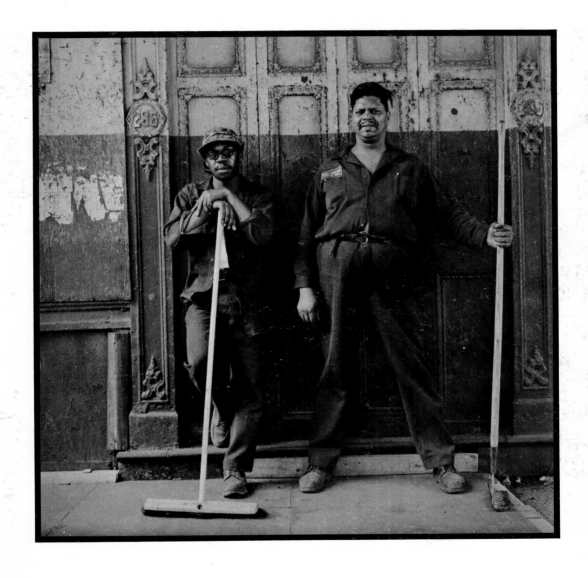

368

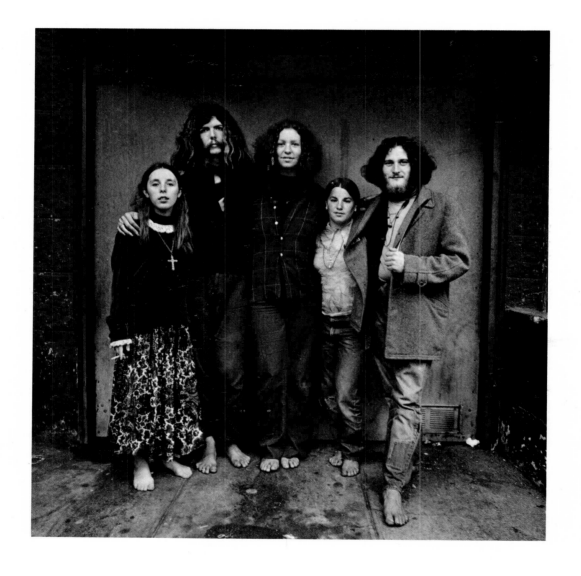

Elaine Mayes
Haight Ashbury, San Francisco, 1968

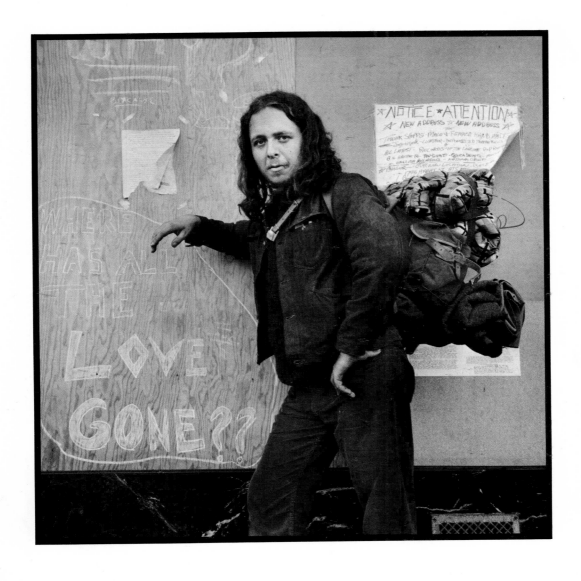

370

Inside or Outside I: The Studio Portrait in the Twentieth Century

Every voyeur knows, as a practiced connoisseur of reality, that underneath the amusement and the astonishment and the pleasure there is a subtle fear of what the truth will reveal. The camera is itself the very focus of this problem: it transmits the real world —but how much of it can we endure? Portraitists deal with this problem in two ways: either by rushing furiously past the event, firing their Leicas or their Nikons like gunners in a war plane; or by bringing reality into a closed, controlled space, not necessarily indoors but anywhere that time and light can be controlled. Inside or outside, this is the essence of the studio approach.

Studio portraits, then, have been taken since the earliest period of photography. This way of thinking, and the large degree of control by the artist, connects immediately with the solid tradition of studio painting. The doorway as a set, the sun or the open sky as a source of light: these were replaced by chairs, drapes, pillars, bear rugs—and skylights which could be draped or undraped. These in turn gave way to great sheets of colored paper and a whole armamentarium of floods, strobes, spots, and reflectors. But what effect, then, did this luxury, this exuberance of technique, have on what I believe to be the only important criterion: does the portrait convey the character of the sitter, and strongly enough to cross the gap of culture and continent and affect us, the anonymous and greedy viewers? If it does, then whether the photograph was taken in the studio or in the street is interesting and even important, but not basic.

It is, in truth, so general a method that any selection, especially out of as much of the twentieth century as we have survived, tends to be too generous to be easily digested. So we divide their number, somewhat arbitrarily, into three courses. The first is that crafty studio work, indoors or outdoors or in the subject's own territory, that is generally commissioned and paid for: just as portraits have been bought since the tombs of the Egyptian dynasties.

Technical apparatus is never wholly without influence on style, even if generally not decisive. In a modern commercial studio, one is amused, rather than merely appalled, by the battery of lights, screens, scrims, and shutters; the harassed young assistants; the audience, on occasion as many as a dozen, from the ad agency or the magazine; and the cost accountant; and the two total strangers who address the photographer by his first name; the hurry, the irritation, the hundred details of finicky adjustment. One thinks, and a little unfairly, that the marvelous artificiality of the portrait is really a product of the apparatus rather than of the photographer, and would do as well with-

out him. I say unfairly, because there are photographers working with these crowded techniques who do get—not to the heart of things: *lacrimae rerum*—but far enough to fascinate and even move us.

But in this theatricality of studio arrangements to produce theatre, one smells that subtle and pervasive attractant: money. Less money equals less fuss, studio or not. Have you ever gone to get your passport photo? Money, here, is a little short. You are put on a stool in a studio with three rusty floodlights, only one of which works on this particular afternoon; and a small camera on a tripod, and you are asked to stare at a man with gray hair and a large mustache who is obviously dying for a postprandial nap. "You got a good head a hair on you," he flatters his customers. "Some people—I had a lady in here you wouldn't believe." He also tells you not to look so sour or they won't let you back into the country; but the four prints he gives you, ten minutes later, are portraits of your true self: that lovable monster.

So, obviously, there are all sorts of studio portraiture. The craftsmen of this popular local art have by no means been displaced by the great technicians; but the latter cost a great deal more; in fact, you cannot afford them unless you are a friend or a lover or a magazine—or a superstar of politics or rock or film who can take it off as a business expense. The artful trade of photographing the famous has its own technical criteria, and these are sharp, competitive, and even nasty. They are based on the culture of the fashion magazines, which provide a good living for the studio photographer. Changing fashion in clothes demands changing fashion in photography; it would be interesting, though not provable, if the reverse were true. There's no doubt, though, that we associate and therefore confuse the two into one image.

Can we, for example, really separate style from image in the photographs that Baron Adolph de Meyer took in the twenties, say of Mary Pickford on a pillow, both of them literally glowing with erotic innocence; or the innumerable fashion photographs with the model—famous or not—posed with left hand on hip: and not a naked hand either, but one whose lax line was enveloped and modified by a handkerchief or a cloth flower. The artificiality is endearing. Characteristically, the Baron was neither born nor married into the title; he acquired it by the labor of his fashionable personality.

He was born in 1868 in Paris, and by the time he was seventeen he was attached to the rich and happy entourage of the English playboy King Edward VII. He got his barony from an obscure German prince so he could attend the English monarch's coronation;

for in Society it is nothing so vulgar as what one does that has any real importance, but where one appears; in this, it is like a photograph of the Kremlin or the Peking hierarchy.

De Meyer was a very handsome and intelligent young man, endowed, too, with the delicately romantic taste for homosexual life in pre-World War I London. His photographs were famous, but in a very limited circle; they were studies of his friends, and his friends sent him to their friends, who returned to de Meyer to be equally fashionable. He photographed them, too, with a lens that deleted, at the center, any defects of skin or age; yet sparkled with refracted light at the edges. But not all his portraits were simply kind; certain ones were darkly astonished by their subject. One of them, printed by Stieglitz in an early *Camera Work*, was a photograph of the Marchesa Casati, an eccentric beauty who lived, naturally enough, in a sinking palace in Venice.

The death of Edward VII and the vulgar carnage of World War I did not destroy Baron de Meyer's tiny world. His work had long been admired by the founder and publisher of the postwar *Vogue,* Condé Nast, who began to replace fashion drawings with de Meyer's photographs. And though very few of the fashion photographers of today make use of his methods, the spirit of his work is still admired and imitated: to make porcelain gods and goddesses of his subjects and put them in the pantheon of the magazines that sell clothes that no one buys.

Cecil Beaton says, "De Meyer seemed to live and work with consummate ease. It is difficult to turn out a flow of romantic photographs, yet he managed to sprinkle upon the most unprepossessing subject—a little stardust." This is not, by the way, too inaccurate an estimate of Beaton himself. Like the Baron, Beaton is handsome, slender, and clever: all fashionable virtues. Like de Meyer, who was an interior decorator, Cecil Beaton has other and related talents: he is a remarkable theatrical designer, and a draftsman, as well as a sharp and accurate writer. How acute he is, for example, on his friend Greta Garbo: "It's hard to remember all her originality. She invented instinctively so much that is now fashion. Her beauty was at its peak after she left the screen. Undisguised by cameramen, her tenderness and sensitivity could show through. Garbo's beauty, because it is innate and growing, cannot fade."

Cultivated and civilized photographers of this sort are rare even in England; the art of portraiture in that country, in the nineteenth century, once it passed beyond John Thomson and Sir Benjamin Stone, fell into the foggy discontinuities of the Linked Ring.

Baron Adolph de Meyer
Marchesa Casati
From *Camera Work,* No. 40, October, 1912
George Eastman House, Rochester, New York

Baron Adolph de Meyer
Mrs. Brown Potter
From *Camera Work,* No. 24, October, 1908
Helios Gallery, New York

There was no great brilliance in English studio portraiture until we come to Cecil Beaton. Born in the first decade of the twentieth century, he began serious work sometime after World War I. Trench warfare, which for more than four years resembled an Armageddon of underground rats, bled English upper-class society almost to death; for officers and men died in the same holes. Yet class distinctions were by no means abandoned after 1918. The English cannot live without them; and it may be that a social animal is lost without a secure hierarchy of distinctions.

Beaton's particular village was the theatre and the fashionable half-world that lived in its minuscule suburbs. When he photographed the poet Dame Edith Sitwell, he gave her a luxury of dress, of fat jewelry, and of languid gesture that is—and this was his commentary—even more exquisitely artificial than she was herself. Off the tripod or not, in the studio or in the sitter's home, his camera was consciously set, rigidly composed, and perfectly content to use the same Rorschachian mirror tricks for a careless, supremely intelligent genius like W. H. Auden, whose face was as weathered as the Welsh hills, as for the actress Gertrude Lawrence, whose reflected face simply redoubles her charm.

Yet his portrait of Aldous Huxley invites our recollection not of those wicked young novels, *Antic Hay* and *Chrome Yellow,* but of Huxley's blindness in age; and not that alone, but also his obsession with drugs which, he expected, would tear open the barriers of consciousness and let man see the universe, past and future. Luckily, the attempt was in vain; and in what seems, at first, to be merely a tricky prop, one feels, in looking at the photograph repeatedly, the pathos of the Faustian man. So Beaton has kept the brilliant mannerisms of fashion photography but goes beyond them, even while using them, as in the extraordinary portrait of Alice B. Toklas and her doppelgänger, Gertrude Stein, connected by a broken wire.

George Platt Lynes was a close friend of Beaton's. Within the limits of his rather gentle taste, he did an honestly romantic sequence of portraits, from Lillian Gish between two alabaster nymphs to Bertrand Russell with an emanation of smoke from his head; and from Cartier-Bresson cast as a sensitive teen-ager to Auden in a moment of absolutely uncharacteristic neatness. Lynes lived and loved in international high society, but he was quite American in his boyish adorations and enthusiasms. He was mad about dancers, particularly of the ballet; but he tired of living in New York, which was the lucrative center for fashion photography, and exiled himself to Los Angeles, where he joined another set of famous friends.

Like Weston and like some few other American photographers, he deliberately returned to the nineteenth-century tradition of the large (8 by 10) camera, which permitted very beautiful and exact contact prints; but the subject matter and the studio interiors, arranged often by his friend the stage designer Tchelitchew, created a world inside a cultural greenhouse.

The orchidaceous style of this life, of this set of values, exposed in a studio and printed on glossy paper, still has a surprising influence in the real world: less on photography, except for those directly involved, than on the American idea of how one ought to live—if one had the money. Because Lynes and Beaton and Hoyningen-Huene and Halsman were supported and guided by a kind of magazine, published both in the United States and Western Europe, that allows us, the admiring outsider, to look into the artificial and partly self-imaginary world of theatre, film, fashion, homosexuality, and the very rich. *Vanity Fair* was one of these, and currently there is *Vogue,* and even more rarefied, *Harper's Bazaar.* There is great fun and charm in the anonymous writing of the captions; and the photographic portraits, extremely well paid, have these qualities too; plus the extra twist of depicting the mask of the subject so obviously that the mask, sometimes, slips off.

Nickolas Muray, born Hungarian and an emigré to the New York offices of *Vogue,* was a fine portraitist of this sort. His Gloria Swanson has the pure twenties sex of a girl off the streets; while his George Herman Ruth looks like a portrait of baseball itself—that slow, sun-baked or floodlit and somewhat spasmodic game played in knickers by outsized and overpaid boys.

Edward Steichen was another contributor to the fashion magazines. He wrote: *During the thirteen years of my own portrait activities for* Vanity Fair, *although the accent was on the performing arts, the almost daily procession in portraiture also brought in distinguished persons in many fields. The subjects to be photographed were selected and sent to me by the editors of* Vanity Fair. *Usually, these subjects were in the public eye at the moment, for one reason or another. So, in a sense, the portraits I made of them belonged to the field of photo-journalism. Most of the time, I had never seen these people until they walked into the studio . . .*

Still, his work was never mediocre; it had, if not insight, something always more popular: flair. Jacques Henri Lartigue, from his small boy's height, had

Cecil Beaton
Gertrude Stein and Alice B. Toklas, c. 1940

Cecil Beaton
Aldous Huxley, no date

379

Cecil Beaton
Gertrude Lawrence, 1930

381

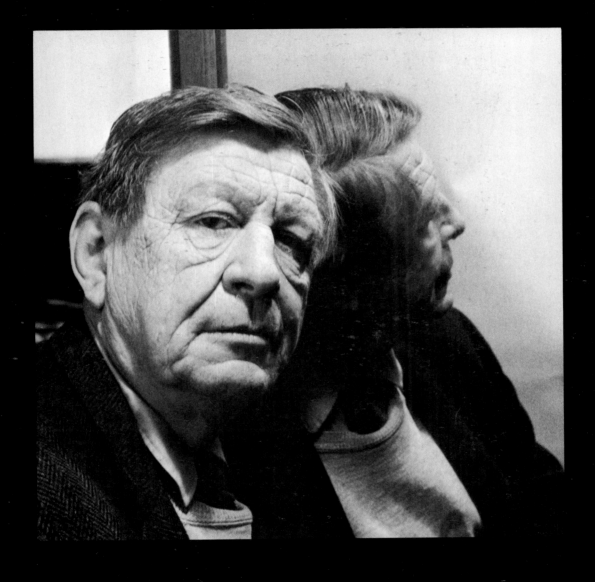

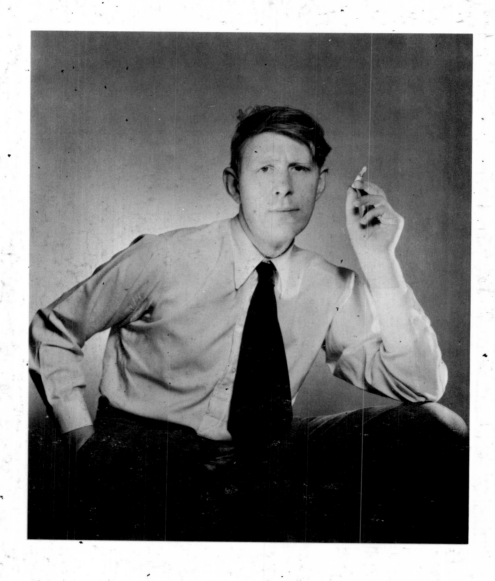

George Platt Lynes
Henri Cartier-Bresson, 1935
The Art Institute of Chicago

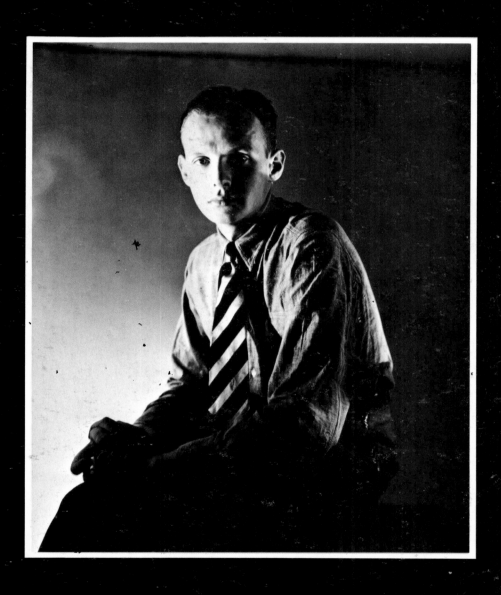

Nickolas Muray
Babe Ruth, c. 1927

Nickolas Muray
Gloria Swanson, no date
Both, George Eastman House, Rochester, New York

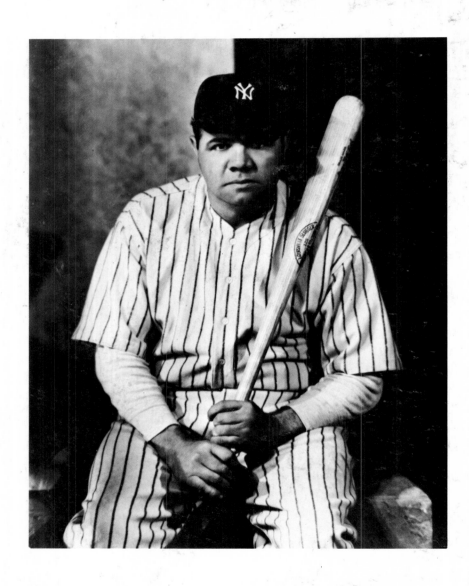

photographed women sweeping past him with a susurration of skirts and faces tattooed with tight elaborate veils; and Steichen, in 1924, two decades and a whole culture away, separated by a war and an Atlantic Ocean, photographed a woman with a veil, too; but this was the head-on stare of the bold actress, Gloria Swanson, and the veil was now only a flowery filter across the lens of the studio camera. It has lost its human context; it is a way of viewing, a brilliant communication between the viewer and the photographer, but one in which the sitter is nearly irrelevant. Steichen was, like a surprising number of photographers (maybe because they had to take arms against an antiphotographic bias of the critics), an articulate man. He wrote: *Photography is a medium of formidable contradictions. It is both ridiculously easy and almost impossibly difficult. It is easy because its technical rudiments can readily be mastered by anyone with a few simple instructions. It is difficult because, while the artist working with any other medium begins with a blank surface and gradually brings his conception into being, the photographer is the only image-maker who begins with a picture completed. His emotions, his knowledge, and his native talent are brought into focus and fixed beyond recall the moment the shutter of his camera has closed.*

Not the least of Steichen's literary virtues is that of plain contradiction—because his technical brilliance began with painting, and he never hesitated, certainly in the early decades, to bring a paint brush into the darkroom. In the July, 1905, issue of *Camera Work*, which he edited with Stieglitz, he reproduces, in beautiful gravure, two of his portraits, one of a young man, the other of Rodin in 1903. Both show the swirls of brushwork on the negative; and why not? I believe we ought to judge by force and effect, and not by snobbery, either against mechanical means or the conscious intervention of the human hand. Steichen continues: *It has sometimes been said of the work of certain portrait painters that, by prolonged study and work with the model, they were able to produce a synthesis of the sitter's complete personality. But here we must remember that it took great writers like Balzac or Proust volumes to bring us a living portrait of a person. To imagine that a visual artist in any medium could condense a complete portrait into one picture is putting a strain on logic. Every human being has the capacity for both laughter and tears, and there is no point halfway between that combines the infinite range of human complexities and contradictory states of heart and mind involved in the human condition. However, the vocabulary of photography offers greater potential for the making*

Edward Steichen
Gloria Swanson, New York, 1924

Edward Steichen
Sunburn, New York, 1925

Edward Steichen
Gertrude Lawrence, New York, 1928

Edward Steichen
Alexander Woollcott, New York, 1933

Edward Steichen
Alexander de Salzman, New York, 1932

of complete portraits than any other visual art. The simplicity and swiftness of the photographic process permits an almost limitless number of photographs to be made reflecting endless sequences of moods and conditions.

Three men of our own decade have a particular mastery of studio technique, and know and are influenced by one another as well as by the generally extraordinary art editors of the fashion magazines (one of whom, Alexey Brodovitch, actually held weekly classes for his photographers). Yet they remained very strong individuals, and all the more successful for that reason. It's a fascinating if private form of drama to compare Arnold Newman's portrait of J. Robert Oppenheimer, taken in 1948—alert, confident, with the aristocratic ease of the top intellects, which in America are, or were until recently, mostly scientists—with the sad portrait taken by Newman in 1958. It is not merely the wear and tear of life that has changed the eminent doctor; it is the wrenching of self into a moral straitjacket.

Arnold Newman is from New Jersey, a state with an odd mixture of rural hills and rose-colored nineteenth-century factories and the smoky stink of industrialized marshes; he was once a painter himself, and he shows the concern of the post-World War I generation for the reorganization of chaos into art. Many of his portraits resemble, structurally, the works of the painter Stuart Davis, who had similar aims. Newman's many photographs of painters are not, in general, studio work; like the portrait of Oppenheimer, they are taken in their natural habitat. But a painter's studio is already a partly artificial place; and even in his portrait of Grandma Moses one feels the deliberate arrangement of the teapot, the fern, the hooked rug, the rocker, the dotted Swiss curtains, the foliage outside—even though none of them, possibly, were arranged. *The subject of a photographic portrait must be envisioned . . . in terms of the twentieth century, of houses he lives in and places he works, in terms of the kind of light the windows in these places let through and by which we see him every day. We must think of him in the way he sits and the way he stands in everyday life . . ."*

His portrait of Georges Rouault conveys the essence of the painter's work, if not his personality. Rouault's face, with its deep, dark, broad shadows, his hat that transmits, like the cathedral windows he studied, a blinding light as of the Holy Ghost—these are obviously a tender but highly conscious arrangement by Newman. The painter of the portraits of Christ and of Satan, equally tragic, has the humility here of a nameless craftsman; but the technique of Newman's

portrait is by no means humble: it is done by a brilliant and very mid-century mind.

Irving Penn is a portraitist generally more comfortable in his own studio than in others'. He has adopted an aesthetic peculiar to photography. No other art deliberately pilfers, at intervals, the methods of its primitive masters; it's like the purist ideas of the Englishman Morris, or the youth communes of America in the late 1960's—the belief that return to the pioneers means beauty and truth. But crude illusions often generate fine art. Penn wrote: *I share with many people the feeling that there is a sweetness and constancy to light that falls into a studio from the north sky that sets it beyond any other illumination. It is a light of such penetrating clarity that even a simple object lying by chance in such a light takes on an inner glow, almost a voluptuousness. This cold north light has a quality which painters have always admired, and which the early studio photographers made the fullest use of. It is this light that makes some of these studio portraits sing with an intensity not bettered by later photographers with more sophisticated means at hand. Electric lights are a convenience, but they are used, I believe, at the expense of that simple three-dimensional clarity, that absolute existence that a subject has standing before a camera in a north-light studio.*

In my early years as a photographer my studio was in a New York office building, in an enclosed windowless area where electric light simulated the light of sky. In this confinement I would often find myself daydreaming of being mysteriously deposited (with my ideal north-light studio) among the disappearing aborigines in remote parts of the earth. These remarkable strangers would come to me and place themselves in front of my camera, and in this clear north sky light I would make records of their physical presence. The pictures would survive us both, and at least to that extent something of their already dissolving cultures would be preserved forever.

I can say that even at that time I found pictures trying to show people in their natural circumstances generally disappointing. At least I knew that to accomplish such a result convincingly was beyond my strength and capabilities. I had come to enjoy and feel secure in the artificial circumstances of the studio, and had even developed a taste for pictures that were somewhat contrived. I had accepted for myself a stylization that I felt was more valid than a simulated naturalism. In this fantasy of mine that would take me and my studio to far places, I preferred the limited task of dealing only with the person himself, away from the accidentals of his daily life, simply in his own clothes and adornments, isolated in my studio. From himself alone I would distill the image I wanted, and the cold light of day would put it onto the film.

Penn has traveled in Crete, in Africa, in the high country just south of the Himalayas, and to these places he took with him a portable studio—a tent whose roof could be rolled back to admit the bright, diffuse north light: *Taking people away from their natural circumstances and putting them into the studio in front of a camera did not simply isolate them, it transformed them. Sometimes the change was subtle; sometimes it was great enough to be almost shocking. But always there was transformation. As they crossed the threshold of the studio, they left behind some of the manners of their community, taking on a seriousness of self-presentation that would not have been expected of simple people. . . . I am struck by the fact that the one characteristic all these various people seemed to have in common is that they rose to the experience of being looked at by a stranger, in most cases from another culture, with dignity and a seriousness of concentration that they would never have had ten or fifteen feet away, outside of the studio in their own surroundings.*

Penn used the same light, the same Rolleiflex, the same Tri-X, on portraits of that two-wheeled centaur, the Hell's Angel; of that deceased tribe, the flower children of San Francisco; of Moroccan women in their sacks like murderers hooded before they are hanged; and of a Parisian nude as solid and triumphant as a Wagnerian soprano. Even in the portrait of the three Asaro warriors in New Guinea, with their body-length arrows and their mud-faced masks, the men are posed standing on and in front of the open width of the broad standard roll of studio paper.

How "true" are these portraits? Quite as true as Sander's work: the subjects are strongly typical of their tribe and station. And there is, just as with Sander, something more: they are like the inventions of Julia Cameron—they are the photographer's fantasy made concrete. Penn's realist dreams are not sentimental, but frank, head-on, and yet tender. The beauty and the mystery are there—but not the terror. In the brilliance of his work (much of it on assignment for *Vogue*) we can see the second element, the photographer, taking the dominant role. So the sitter's own costume, the sitter's own magically powerful mask, are not removed, but neither are they pierced; they've become the furniture for the delicate tableaux of Penn's mind.

That doesn't happen with Richard Avedon, who is a far crueler man, even an intellectual clown at times,

396

Irving Penn
Three mud men, New Guinea, 1970
Original photograph © 1974 Irving Penn

Richard Avedon
Jacob Israel Avedon, businessman, Sarasota, Florida, 1972

Richard Avedon
June Leaf, sculptor, Mabou Mines, Nova Scotia, 1975

to be easily hosed down, the grimace of anger, the eyes white with fear, the warped and rubbery mask of the face.

Upon entering a gallery of Avedon's very much and very beautifully enlarged portraits, and then upon leaving for the disorderly green and concrete of the outside world, and even more in remembering the brilliance of the images, one is struck by the dichotomy between Avedon's intention and his result. He went to his friend the photographer Robert Frank's isolated house in Nova Scotia, and recounted his experience: *I had never met June, the woman he lives with. We all spent a day together collecting stones by the sea, and I kept watching her. When she took me into her studio and showed me her work, all of a sudden, from a rather silent woman, this knockout of a person came out.*

She seemed surprised when I asked to photograph her. What I found extraordinary in the sitting was her complete lack of narcissism. What came forward was not the fact that she has a beautiful face—which she has—but her quality as a woman. An intricate woman who was totally unaware of her physical beauty in front of the camera. It was very different from photographing a professional beauty who feels the success of the moment depends on her physical self.

Yes; but there is something more to her photograph than that; and what it is, I believe, is true of all of his photographs taken during the last decade: they are—photographed against this blinding white field, this aura of strobes saturating seamless paper—figures as if from the pages of the Mahabharata: all demons and demigods and supernatural heroes and bisexual divinities, some ferocious, some grotesquely kind, and some few supernal. Names, presences, and powers, they are the collective icons of our time.

and contact prints of the full negative; but Cunningham never paid too much attention to these criteria; she simply cropped if she wanted to. Anyway, F-64 was not the bold, assertive, argumentative movement that is often implied—by the name, I suppose. It was a very loose association, as much for the profit and convenience of having a common gallery (Weston said as much) as in recognition of the fact that everywhere in the world the gentle blur of Pictorialism had been replaced by a return to the depth and sharpness of the earlier, realist photography.

Every movement has its own life span: its loud childhood, its mellow and crowded maturity, its weak decline. How long it lives depends on how rich the material its particular conventions will have discovered. Nevertheless there are, in portraiture certainly, a set of invariables that persist through every change of aesthetic fashion. As Imogen Cunningham wrote in March, 1914: *One must be able to gain an understanding at short notice and close range, of the beauties of character, intellect and spirit so as to be able to draw out the best qualities and make them show in the outer aspect of the sitter. To do this one must not have a too-pronounced notion of what constitutes beauty in the external, and above all not worship it. To worship beauty for its own sake is narrow and one surely cannot derive from it that aesthetic pleasure which comes from finding beauty in the commonest things.*

This was a quite American way of looking at the world; and though such a view is not dominant in the American arts at present, it was common once, particularly in the West, which retained, because industrialization was delayed in that part of the country, an earlier, simpler, more naive, more honest—and somehow more mystic view.

And there are still large parts of America, for example, that are as empty of man as they were before the Indian invasion from Siberia. The desert with its ancient eroded rocks and the tall white candelabra of yucca, the western hills yellow each spring with Spanish broom, the stone domes and natural bridges of the Rockies and the Sierras, the volcanoes and their fields of brown ash, the ocean cliffs and surf, the sea islands alive with black, awkward mammals at their breeding beaches, the trees altered by wind or lightning or forest fire, all these are a photographic world whose very rhythm is different from the instantly varied visuals of Paris or New York.

So in the American West a whole group of portraitists, affected by this light and this landscape, developed their own style and their own set of lifelong assumptions. Edward Weston, who had come from a suburb of Chicago to a suburb of Los Angeles, in the beautiful early part of this century, was, and in an important sense remained, a small-town boy. He had a portrait studio in what was then called Tropico, and photographed all comers: including children both alive and dead. Nancy Newhall wrote, in her notes for a biography she never lived to complete: *His windows were all correctly veiled by adjustable curtains; and he had a headscreen and a reflector for further modulations. He had a huge, lumbering 11 x 14 studio camera, with a reducing back, and one of the new soft-focus lenses, a Verito of 18" focal length. The first week brought him one dollar for a dozen postcards.*

A small, gentle person with violent insides, he sometimes had trouble, like any tradesman, with his customers. He wrote one of them a bitterly explicit answer to his complaint: *I have not forgotten that you followed me into my workroom and tried to beat me down on my prices. . . . You had every opportunity to understand my work before leaving the sitting. . . . So your complaints about the face being "much shaded" and the "picture not posed properly in the center"—are of course valueless. All through my work you could have found my subjects posed in every possible corner—even so far as to cut off part of the head if I so wished—in fact you will find them placed, as a rule, everywhere but in the center—which is usually not at all proper—and so far as shading— you could have seen them so heavily shaded as to lose entirely one side of the face so as to portray the eyes as simply two shadowed spots. However this is all waste effort trying to explain for your statements only expose your ignorance . . . I never make two sittings alike—this is not a "picture factory"—Note the difference in handling between your pictures and Mrs. Long's. People do not come to a little shack in the country and pay several times as much as they would for most work in Los Angeles—and then try to dictate how the pictures should be finished—Now being of a genial disposition and anxious to please even those with no understanding of my work . . .*

This letter (a draft, there is no proof it was ever sent) was dated August 21, 1920, a time of great turmoil in Weston's life. On the one hand, he had a wife and four small sons to support, so his methods of portraiture had to fit the reality of his economics. Nancy Newhall has stated the case with her customary specificity: *If portraiture is one's bread and butter, one realizes very shortly that vanity provides the butter. But if Edward was ignorant, he was ingenious. He hid humps, bumps, bosoms and bones by swathing his sitters in chiffon scarves. In cases of absolute emergency he vignetted away everything but the head. The*

418

Verito lens helped, all along the way. Wide open, it gave a happy softness and dissolved all but the most persistent freckles, wens, and crows' feet and Edward was a deft retoucher with a strong regard for actual re-modelling. Enlarging his improved negatives through the Verito, stopped down just short of sharp, and printing on matte paper, he hid the last traces of his almost invisible pencil work. Customers gazed on the results with pleasure, unaware that anything had been removed, and convinced that here, at last, was a photographer with sense enough to photograph them as they really were.

At the same time, he was, through his remarkable partner and assistant, Margrethe Mather, acquiring the values of the tiny intellectual bohemia of Los Angeles in the twenties. In this society, he met a silent-screen actress of great beauty and intelligence, and went with her to Mexico.

There is no doubt that Tina Modotti was a formidably interesting woman. By no means the intellectual that Mather was, she was sensitive, encouraging, passionate, and voluptuously beautiful. Weston was very much in love with her, but she had no intention of being faithful to one man, not at that time of her life. Past and present, her experience had been striped alternately with sadness and sensuality. Her affairs troubled Weston very deeply; she never made any effort to hide them; her friends visited her room overnight—a room just two doors down the patio in the house she and Weston occupied. Weston's view of her was romantic and yet true: that she had sold herself to the rich and given herself to the poor. On one page of his (unexpurgated) journal occurs the most famous passage in photographic literature: *The night before we had been alone—so seldom it happens now. She called me to her room and our lips met for the first time since New Year's Eve—she threw herself upon my prone body pressing hard—hard —exquisite possibilities—then the doorbell rang. Chandler and a friend—our mood was gone—a restless night—unfulfilled desires—morning came clear and brilliant—"I will do some heads of you today, Zinnia"—The Mexican sun—I thought—will reveal everything—something of the tragedy of our present life may be captured—nothing can be hidden under this cloudless cruel sky—and so it was that she leaned against a whitewashed wall—lips quivering—nostrils dilating—eyes heavy with the gloom of unspent rain clouds—I drew close to her—whispered something and kissed her—a tear rolled down her cheek—and then I captured forever the moment—let me see f.8- 1/10 sec. K 1 filter-panchromatic film—how brutally mechanical and calculated it sounds—yet really how*

spontaneous and genuine—for I have so overcome the mechanics of my camera that it functions responsive to my desires—my shutter coordinating with my brain is released in a way—as natural as I might move my arm—I am beginning to approach an actual attainment in photography—that in my ego of two or three years ago I thought to have already reached—it will be necessary for me to destroy, to unlearn and then rebuild upon the mistaken presumptuousness of my past—the moment of our mutual emotion was recorded on the silver film—the release of those emotions followed—we passed from the glare of sun on white walls into Tina's darkened room—her olive skin and sombre nipples were revealed beneath a black mantilla—I drew the lace aside——

The double impact of his passion for Tina Modotti, along with the equally expressive force of the strongly colored personalities of Mexican intellectual life, stimulated a series of portraits that were explosions of liberated genius. They are done with a 4 x 5 Graflex, very close and at moderately fast exposures. He no longer used the soft Verito but a cheap old-fashioned Rapid Rectilinear. To change aperture he had to insert one of a set of metal discs, each with a proper size hole; and he generally chose a stop equivalent to about F-64. He made contact prints; or enlarged, but not much. What counted, as ever, was the metaphoric shock that passed between him and his subject.

In this Mexican series, one feels the brutal directness, the energy and beauty of a fiercely human personality. We look at a face, but feel as if we were inside the head. Yet these are not portraits of peasants or soldiers or students—and this at a time of social whirlwinds in Mexico—but of his new friends and their circle: remarkable enough, of course. Weston made a fair number of portraits after his return to the United States, when he had settled, finally, in the idyllic town of Carmel, on the Pacific coast of California; indeed, he earned his living from the tourists every summer, but he had them sign a stern agreement: "It is understood that prints are to be finished according to my personal judgment."

The truth is, though, that the portraits of his hated and bitterly necessary customers are not too much better than skillful. His contemporaries solved this problem by cluttering up their portraits almost as though they were interior decorators; or, if their forte was huge close-ups, like those done by the famous Canadian Yousuf Karsh, they sprayed an enamel of light on the poor human features; but Weston could not amuse himself with these successful games. His best portraits are the product of his perception, his delight in fact. He would not, in his maturity, soften a

421

woman's lines or remove the dark wart from a man's temple; and he argued fiercely, and at last broke off relations with an intimate friend, on this, to him, very personal issue of the focus of truth.

The friend was Johan Hagemeyer, an archetypical Californian of that period. He was born in Amsterdam, was influenced by Tolstoy and his English disciple Edward Carpenter, became a vegetarian, and moved to California in 1911 to start a dwarf-fruit plantation. He'd met the famous anarchist Pëtr Kropotkin in Europe, and when he went to San Jose, California, he joined a small group of intellectuals who were anarchists. He knew Emma Goldman, Bill Haywood, and Max Eastman. Like everyone else, he was an amateur photographer, and when he went to New York City in 1917, he met Alfred Stieglitz, and the painters John Marin, Abraham Walkowitz and Arthur Dove, each of whom were reviewed and reproduced in the thick, opulent pages of *The Dial*. He read a great deal of Jung, and his taste in music was Monteverdi, Palestrina and Bach; and it is very likely that he introduced Weston to these masters. From 1917 on, Weston and he were intimate friends, and both lived in the resort town of Carmel among a common circle of acquaintances. Hagemeyer's portrait of Robinson Jeffers belongs to this period and is, in its rugged, open-shirt romanticism, truer than Weston's portraits of the same poet.

The connection of Edward Weston and the very fine and hardly known Mexican photographer Bravo is a little more curious. Manuel Alvarez Bravo was a movie cameraman as well as a still photographer; more to the point, he was known in the great circle of Mexican mural artists of that time and photographed their works. Thus he met the Russian director Sergei Eisenstein in Mexico, and pinned him down at one moment of his characteristic intensity, with his knees spread apart like a butterfly's wings. The clarity and unconventionality of Bravo's Mexican work, free of the sombrero worship of some photographers, and conveying a very personal surrealism, never got him the repute he deserves.

He was born in 1902 in Mexico City, worked as an accountant for the Mexican government, which was always a prime employer of intellectuals, and began to photograph while laboring as a government typist. In 1931 he became a full-time photographer and, while still in Mexico, met and was influenced by two contradictory geniuses: Cartier-Bresson and Paul Strand, who were themselves firm friends.

Weston never met Bravo while he was in Mexico; but in 1929 Bravo sent him a package of prints, on which the signature was M. Alvarez Bravo. Weston

Johan Hagemeyer
Robinson Jeffers, Carmel, California, 1932
The Metropolitan Museum of Art, New York, gift of Estate of J. Hagemeyer, 1962

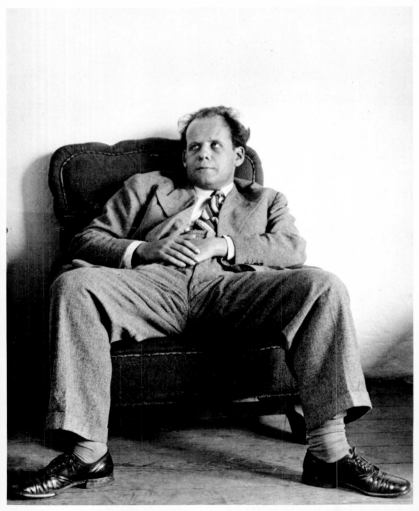

was certain the photographs were done by his former friend and mistress Tina Modotti; so he wrote the following reply:

CARMEL, CALIFORNIA

4–30–1929

To M. ALVAREZ BRAVO—

Greetings—

Pardon me but I am not sure whether I am addressing —Señor, Señora or Señorita?

I am wondering why I have been the recipient of a very fine series of photographs from you? Were they sent for the exhibit in Germany which I collected for the West Coast? If so, they are too late. Were they sent for my inspection, and other interested photographers? If so, I certainly appreciate the gesture!

But no matter why I have them, I must tell you how much I am enjoying them. Sincerely, they are important,—and if you are a new worker, photography is fortunate in having someone with your viewpoint. It is not often I am stimulated to enthusiasm over a group of photographs.

Perhaps the finest, for me, is the child urinating: finely seen and executed. Others I especially like are: the pineapple, the cactus, the lichen covered rock, the construction, the skull.

I will not write more, until I hear from you,—some explanation, and word about yourself.

The photographs were delayed in reaching me, because of some correspondence with the "U.S. Custom House." Awaiting your answer, I am.

Cordially,

EDWARD WESTON

Ansel Adams, a constant friend of Edward Weston's, was born in the same year as Bravo; and while Bravo reflects the somewhat sinister and tragic sensuality of the Mexican intellectual, Ansel Adams is, at first study, and like Imogen Cunningham, a hardy, cheerful, ebullient outdoorsman of California. Yet this is only a fraction of the truth. Though Minor White says, "He begrudingly writes on photographic aesthetics—he says his photographs define that better," Adams nevertheless has written extensively on very difficult issues, both aesthetic and technical. Indeed, he is convinced of their intimate connection.

He noted, in describing Weston's portrait of Guadelupe Marin de Rivera, that "here we have an image that suggests sharpness, etc., which is really not optically crisp." His writings on the mathematical theory of photographic scale, on exposure and development, are extraordinarily precise, and at the same time provocative. His definition of concepts like *acutance*— which he defines as micro-density differences in the image, or the sharpness of the line or zone between

Ansel Adams
Georgia O'Keeffe and Orville Cox, Canyon de Chelly
National Monument, Arizona, 1937

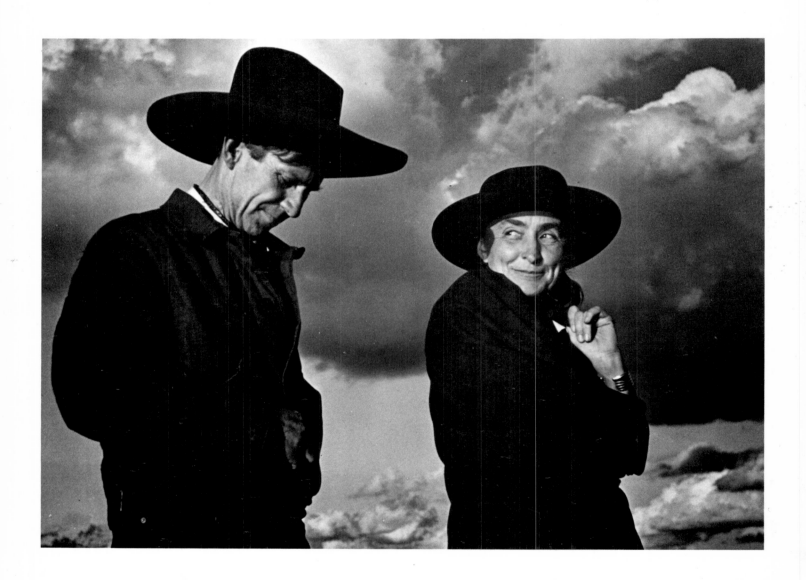

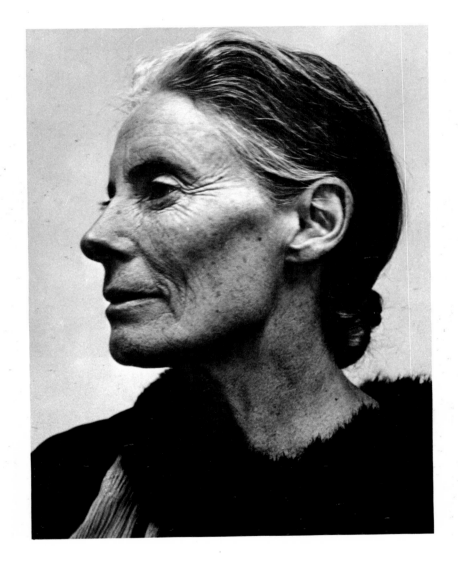

light and dark points—is combined with his recognition that the "essential elements of creative vision [are] a complex of time, space, and love."

Love, as most of us know, is graded with difficulty; it has the binary quality of Yes, No. One can feel its presence in the two portraits reproduced here. Ella Young is Adams' technically brilliant tribute to American ancestors, and it has the same poignancy and proud nostalgia as the tribute of another Californian, Martha Graham, in her dance "American Document." A billion snapshot portraits have the subject's face nearly severed by a smile, but it's rare in fine professional work; Adams has done it, though, in the double portrait of Georgia O'Keeffe and Orville Cox; the famous southwestern painter is smiling back at, one is certain, Adams' own wicked grin. He said, in 1975, "It is hard to avoid personalities, because the *personal* element enters into all human effort, especially in the arts. We have the personalities of the photographers as well as the personalities of clients and spectators." This peroration should be read in the context of his lecture in 1958: *Perhaps we are now discussing definitions which transcend the power of words to clarify. But it is very important to think about them because we can enter upon dangerous grounds through insensitive attempts to be sensitive! There is nothing more sacred than the inner self, both of the perceptor and that of the spectator. To verbalize an image is to blight it. Here, in this important area of thought, one must have sound definitions—but they must be his own. They must be realized not in words but in the terms of the medium itself.*

Suppose, for a moment, that we dichotomize the complexities of American culture, and describe Ansel Adams as typical of a photographer who discovers America with the eyes of an itinerant nineteenth-century western photographer; then perhaps we can cite Berenice Abbott as a sort of photographer who, like the eighteenth-century American elite, looked to Europe as the antidote to her childhood. She left Ohio for Paris and Berlin in 1921.

There is no doubt that General Pershing and his million troops, Americans sent for the first time in American history to a European war, reawakened our nostalgia for the sinful beauties of the old continent and its moldering, enduring cities. Gertrude Stein and Man Ray and that pseudo-hick Ezra Pound and T. S. Eliot and Ernest Hemingway were simply the famous among the many unknown exiles. James Joyce, emigrant from an island which had almost as many Irish as Boston, was writing *Ulysses,* which appeared serially, from April, 1918, on, in an avant-garde American magazine, *The Little Review,* edited by Margaret Anderson and Jane Heap. When these two women were convicted of obscenity in an American court, and copies of the magazine were literally burnt, Joyce got Sylvia Beach, another American, from Princeton, New Jersey, who had a bookstore in Paris, to print the whole of his novel in the famous clandestine blue-paper-covered edition.

One would think this colony of expatriates would all have known and enjoyed one another; not quite so: Gertrude Stein met Joyce only once, and Hemingway wrote of her impression: "Joyce reminds her of an old woman out in San Francisco. The woman's son struck it rich as hell in the Klondyke and the old woman went around wringing her hands and saying, 'Oh my poor Joey! My poor Joey! He's got so much money!' The damned Irish, they have to moan about something or other, but you never heard of an Irishman starving." The only haunts that these exiles had in common were the studios of the photographers, in particular Man Ray and one of his pupils, Berenice Abbott.

Though she had come to study sculpture with Émile Bourdelle, she became an assistant in Ray's studio when she was twenty-six. It was in his circle of surrealist and Dada artists that she first saw the photographs of Eugène Atget. His corsets in dark shop windows seemed to be works of the unconscious mind, satiric, joking, and a bit frightful; but Abbott studied and saw the tenderness in the obsession of his thousands of prints and negatives of Paris; and after his death, she began to collect them.

When I visited Berenice Abbott in her New York studio many years later, she was saddened by the terrible fact that the gelatin had begun to crack and peel from the surface of these large glass plates; and at the time she could find no money anywhere to humidify and preserve them. Her love for these Atgets is a key to her portraiture; without softening the truth, she gave the sitter her attentive affection. While her New York photographs, mostly empty streets and buildings, taken after her return to the United States in 1929, have a certain dark brilliance, as if we were looking at them in a polished glass case, her portraiture has no screen between herself and the sitter. They are at ease with one another.

Her series of portraits of Joyce, some taken after his operation for glaucoma, preserve his indrawn, shy egotism. Jean Cocteau (one suspects that the prop is his) is photographed from a sweetly maternal angle, like a mother taking a picture of a child with his doll. Abbott's theoretical attitude was a good deal sterner, was, indeed, in contradiction to Man Ray's idea of the

Berenice Abbott
Eugène Atget, Paris, 1920

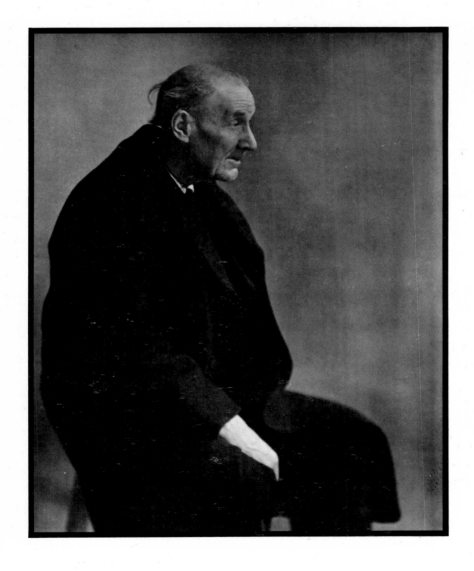

429

camera (and of a lot of other arts) as a superior sort of toy: *Many photographers spend too much time in the darkroom, with the result that creative camera work is seriously interfered with. The stale vogue of drowning in technique and ignoring content adds to the pestilence. . . . what then makes a picture a creative piece of work? We know it cannot be just technique. Is it content—and if so, what is content? These are basic questions that enlightened photographers must answer for themselves.*

Let us first say what photography is not. *A photograph is not a painting, a poem, a symphony, a dance. It is not just a pretty picture, not an exercise in contortionist techniques and sheer print quality. It is or should be a significant document, a penetrating statement, which can be described in a very simple term—selectivity.*

To define selection, one may say that it should be focused on the kind of subject matter which hits you hard with its impact and excites your imagination to the extent that you are forced to take it. Pictures are wasted unless the motive power which impelled you to action is strong and stirring. The motives or points of view are bound to differ with each photographer, and herein lies the important difference which separates one approach from another. Selection of proper picture content comes from a fine union of trained eye and imaginative mind.

To chart a course, one must have a direction. In reality, the eye is no better than the philosophy behind it. The photographer creates, evolves a better, more selective, more acute seeing eye by looking ever more sharply at what is going on in the world. Like every other means of expression, photography, if it is to be utterly honest and direct, should be related to the life of the times—the pulse of today. The photograph may be presented as finely and artistically as you will; but to merit serious consideration, must be directly connected with the world we live in.

What we need is a return, on a mounting spiral of historic understanding, to the great tradition of realism. Since ultimately the photograph is a statement, a document of the now, *a greater responsibility is put on us. Today, we are confronted with reality on the vastest scale mankind has known. Some people are still unaware that reality contains unparalleled beauties. The fantastic and unexpected, the ever-changing and renewing is nowhere so exemplified as in real life itself. Once we understand this, it exercises a dynamic compulsion. . . .*

Miss Abbott's teacher, the intellectual athlete Man Ray, would not have denied her passion for the surprises of reality; but it interested him very little—

Now we group together a convenient set of twentieth-century portraits that were made (reluctantly and fearfully, one sometimes suspects) within the photographer's own circle of friends; and these were generally famous and potent personalities. This consistency of mode does not, however, make for a consistency of method.

No possible classification can be any more than a convenience to the anthologist; life slithers out of our files, whether temporal or aesthetic; and in particular, there isn't a studio photographer in the world who has not burst out into the sunlit alley, at some time or other, and photographed the blur of the stranger passing by; Edward Weston took snapshots at parties; and Cartier-Bresson, the saint of street photographers, did a number of unobtrusively stylized interior portraits. "Consistency," wrote Emerson, "is the hobgoblin of little minds." Still, since Beethoven wrote bagatelles, should he be classified as a bore? Or Bach as a thief, because he plagiarized Vivaldi and Albinoni —and himself? Is Goya a realist portrait painter or a haunted fantasist? Is Tolstoy a historian-novelist, or a miniaturist of vapid moral tales?

And the excitement of inconsistency is to be found not only in genius, but in the merely talented as well. Here is Arnold Genthe, whom Beaton describes as "a delightful grey-white-haired, guttural gentleman with a cold in the nose and a protruding lower lip . . ." —a portrait not exactly in marble.

Genthe was born in Berlin in 1869, and at twenty-five got a degree in philology. He did no camera work till he was hired as a tutor to come to San Francisco in 1895; he bought a camera to use as a hobby. By 1897 he had become a professional portraitist. He shared the pre-World War I European taste for the exotic, and he took photographs while walking in San Francisco's extensive Chinatown, the ghetto that was the living remnants of the "yellow peril"—labor imported to build American railroads. His studio was destroyed on that morning in 1906 when San Francisco shook itself into flaming ruins. His photographs of this event, done with a camera borrowed from a wrecked camera store, have the massive choreography, in the grouping of darkly dressed civilians staring downhill toward the smoke, that reminds one of the early spectacular silent German films.

In 1911 he moved his studio to New York City, and his portraits of celebrities date from that time. Like so many photographers of the early twentieth century, he had more than a professional interest in dancers. Clouds of young women followed in the ecstatic footsteps of Isadora Duncan, and Genthe photographed them—often in the muted tones of early color. Their

Richard Avedon
William Burroughs, writer, New York City, 1975

Richard Avedon
John Martin, dancer, New York City, 1975

Man Ray
André Breton, 1931
The Museum of Modern Art, New York

435

Man Ray
Kiki, 1925
Kimmel/Cohn Photography Arts

436

except in his portraits. He was a Philadelphia boy, born in 1890, who changed his name; "What it was is nobody's affair." It was in the United States that he met Marcel Duchamp, the French artist who made plumbing history by converting the male urinal into an unfamiliar work of art in 1917; but Man Ray was already precocious, a quality he kept throughout his life. "It seems that I began to paint at the age of seven, to everyone's consternation. I escaped to New York and having run through several fortunes as a coal merchant, chairman of the chewing gum trust, modern architect and banjo player, I returned to my first love, painting, and have been faithful ever since." He was, as people have pointed out only too often, the Dada of them all; this anarchic movement had begun simultaneously, and before World War I, in Zurich, Barcelona, and New York. Surrealism, its heavier cousin, became ponderous and political; André Breton, once author of *Revolver with White Hair*, now wrote like this: *Beyond the obligations which men impose on themselves when by human organizations they seek to serve what they believe to be the truth, the earth turns upon its hinges of sun and of darkness. Nothing can prevent Surrealism from believing that the last glance of the men and women who fell in July, 1936 before Saragossa holds within itself the whole future. The whole future, including the firm hope that Surrealism, as the only intellectual effort at present extending and cooperating on an international scale, holds out for the liberation of the human spirit.*

In a way, he's right: for he most often used the camera as a graphic tool; or even made photographs directly in the darkroom by putting objects, an open scissors, for example, on sensitive paper. His portraits, manipulated or not, are very clever and perceptive: Duchamp, of course; James Joyce—"He was very patient," because the glare hurt his feeble eyes; a number of sensuous women; a fine Braque; Nancy Cunard, publisher of the Hours Press and loaded with bracelets like a Bengali with her future dowry; and a stubborn, powerful, ultraromantic Schoenberg.

Man Ray sold these photographs to fashion magazines; but continued to live in Paris till World War II, when he undertook the journey to a second exile—to Hollywood, California. His apartment there was full of inventions; one I remember especially was a guitar fixed on a slant, with the opening fitted with a large, cheap magnifying glass, and the back panel taken out and replaced with a ping pong ball on a string; when the ball moved, you saw it expand and contract through the lens. Attitudes are more contagious than theories, and the playful, mocking spirit of Duchamp,

via Man Ray, has entered the photographic vocabulary: in other hands it has become that very commercial combination of chic, technique, and malice, which allows the portraitist to balance money in one hand and integrity in the other.

So middle-class culture is very powerful; it first feeds its enemies, then swallows them. The German-born Bauhaus is a case in point, but it did produce a number of fine talents along the way. The Hungarian artist, László Moholy-Nagy was a Dadaist in Berlin in 1920, and only in 1923 joined the faculty of the Bauhaus. When Gropius left, so did he, and founded a New Bauhaus in Chicago in 1937; photographers were attracted by his intellectual restlessness, his experimentation with novel technical means, and his mixture of arts ordinarily considered separate.

The Bauhaus' twin precepts—the insistence on the importance of craft, along with the somewhat contradictory idea that simple, functional design would cure the ills of industrialization—were already the hidden assumptions of naturalist photography, expressed earlier by William Morris in the smoky England of the 1880's. The Bauhaus applied them particularly to architecture, but these ideas spilled over into other crafts. Moholy-Nagy wrote: "Today spatial design is an interweaving of shapes; shapes which are ordered into certain well defined, if invisible, space relationships; shapes which represent the fluctuating play of tensions and forces."

Yet the simplicities of Bauhaus design are intrinsically hostile to photography; there was no photography department as such in the Bauhaus curriculum until 1929. The results were predictably abstract, not uninteresting in themselves, but not very rich in portraiture; which must rely, in my opinion, on the much older and more complex traditions—aesthetic, psychological, human, not technical—of the daguerreotype and the talbotype; and, let me say the unfashionable, of portraiture in painting.

A man whose work is squarely founded on such traditions is the Englishman Bill Brandt. He, like Beaton, photographed the Sitwells (there seem to be more portraits of this exquisite family than of anyone else in England), but he chose to keep them in a room full of class detail. In his photograph of Caitlin and Dylan Thomas, the old, cheap, genteel table and its bread and wine and silver pitcher are almost, by the solidity of their presence, solid characters, too. Brandt takes precisely the same care with a lady as he does with the two anonymous housemaids in his famous portrait: each, like Max Ernst before his rococo mirror and Francis Bacon in an open, sodden landscape, is

Man Ray
Arnold Schoenberg, Paris, 1927
The Art Institute of Chicago

Man Ray
Princess Bebesco
The Art Institute of Chicago

Bill Brandt
Francis Bacon walking on Primrose Hill, London
Rapho/Photo Researchers

443

set in his own comfortable place. *I always take portraits in my sitter's own surroundings. I concentrate very much on the picture as a whole and leave the sitter rather to himself. I hardly talk and barely look at him. This often seems to make people forget what is going on and any affected or self-conscious expression usually disappears. I try to avoid the fleeting expression and vivacity of a snapshot. A composed expression seems to have a more profound likeness. I think a good portrait ought to tell something of the subject's past and suggest something of his future . . .*

This is certainly in the tradition of Thomson and Stone: the insatiable interest of the English in the shifting particulars of class and station. Bill Brandt, though, is more than merely a skilled perceiver; still less the enigmatic, brooding mystic that some take him to be. It is true that he learned photography in the late twenties at Man Ray's studio in Paris; but he was struck by the lightning of the French school of documentary photography: Cartier-Bresson and Brassaï. He returned to portrait work at the end of World War II, in 1945. Neither wholly mystic nor wholly realist, he has developed his own nature, and it is somehow quite somber. One feels this even in the technically brilliant nudes, whose wide-angle distortions and extreme depth of focus are simply the stretching of a mind that taught itself, more and more as he grew older, to think like a camera.

When young photographers come to show me their work, they often tell me proudly that they follow all the fashionable rules. They never use electric lamps or flash-light; they never crop a picture in the darkroom, but print from an untrimmed negative; they snap their model while walking about the room. I am not interested in rules and conventions. Photography is not a sport. If I think a picture will look better brilliantly lit, I use lights, or even flash. It is the result that counts, no matter how it was achieved. I find the darkroom work most important, as I can finish the composition of a picture only under the enlarger. I do not understand why this is supposed to interfere with the truth. Photographers should follow their own judgment, and not the fads and dictates of others. Photography is still a very new medium and everything is allowed and everything should be tried . . .

Everyone, naturally, fashions his theory after his practice. *Brassaï is reading his manuscript to me. He is telling me about a time, a place, a* MOMENT *when a certain picture is possible and how if one fails then, one can no longer return—neither the next day, week or year—to recapture it. And my imperfect French suf-* *fices in grasping one succinct phrase . . . "Photography in our time leaves us with a grave responsibility. While we are playing in our studios with broken flowerpots, oranges, nude studies and still lifes, one day we know that we will be brought to account: Life is passing before our eyes without our ever having seen a thing."* (La Photographie en tant que Creation by Brassaï.)

Brassaï—"The man from Brasso," the university town where he was raised, was born Gyula Halász of Hungary. He studied art in Budapest and then in Berlin. Son of a university professor who taught French, he had come to Paris first as a little boy, and stayed for a year with his father. The attitude of simple wonder never left him.

The mosaic of the brittle Austro-Hungarian Empire had fallen apart in World War I, and after the Bolshevik revolution led by Béla Kun was crushed in its turn, the atmosphere of that already backward country became intellectually stifling. Brassaï left for Paris in 1923, earned his living as a journalist, and wrote and painted in his spare time. Only in 1931, and simply to illustrate an article, did he borrow a camera from another Hungarian exile. He detested the machine—until, almost involuntarily, he fell in love with it. He compared his emotion to the story of Isadora Duncan, who hated the pianist who was hired for her by her rich lover, until a bump during a taxi ride threw her bodily into the pianist's arms: love at first knock.

Brassaï was one of the pioneers in the use of the small Voigtländer and the larger Rolleiflex, and cameras which were relatively inconspicuous; meantime, film had become fast enough to use at night, illuminated by the brilliant and artificial joys of Parisian evenings. Cities are, of course, a kind of labor-saving, space-saving device; a Parisian neighborhood that is thoroughly petit bourgeois by day will shut up its shops, open its cafés, and with the greatest naturalness become, by nightfall, the hive of an irascible swarm of transvestites. Brassaï, mild, with protuberant eyes, wearing the costume of the ordinary, was drawn to Montparnasse in particular. When, in 1933, the prints for his first book, *Paris de Nuit,* were spread out on the bed and floor of his apartment, his friend Henry Miller came to visit and, with the understatement of his enthusiastic ego, declared that they were "illustrations to my books."

Brassaï was well known among the avant-garde artists of that period; in 1932 he made portraits of Picasso, feisty and square shouldered; of the sleekly handsome Dali; Edgar Varese; of Miller in his gangster felt hat; of the singer and model Kiki, as pretty as an artificial

flower. The remarkable listener and historian, Nancy Newhall, quotes Brassaï: "I invent nothing; I imagine everything"—which is a very Dadaist statement, and not, I think, to be taken as anything but an intellectual handstand.

Fascinating is Lawrence Durrell's account of a portrait session with Brassaï: *Brassaï found the light too harsh; we turned almost everything off. The camera, it appeared, was fond of shadow. Well, with this vexing business of light regulated, and his camera aimed at me in a corner of the sofa, Brassaï sighed and sat down in his chair, for all the world as if he had finished the job and was relaxing for a smoke: But he had not begun. Quietly, absently he started to talk to the Americans about photography in general, all the time keeping track of me with that hawk's eye. While he talked he reflected. . . . "Yes, I only take one or two or three pictures of a subject, unless I get carried away; I find it concentrates one more to shoot less. Of course it's chancy; when you shoot a lot you stand a better chance, but then you are subjecting yourself to the law of accident—if accident has a law. I prefer to try and if necessary fail. When I succeed, however, I am much happier than I would be if I shot a million pictures on the off-chance. I feel that I have really made it myself, that picture, not won it in a lottery." All the time he was watching me, studying me in a vague and absent-minded fashion. . . . "I want my subject to be as fully conscious as possible—fully aware that he is taking part in an artistic event, an act. . . ."*

Suddenly, with a surprisingly agile movement across the room the maître came up to me and said: "There, just like that; just what I want. Now!" I had apparently moved into a position which suited his book. He sat down, focused, and told me to look dead into the camera and hold it. Only when he approved of the expression on my face did he fire. And that was all for the day. . . .

He never gave up drawing, though; indeed, his nude studies are rather skillful; by 1967, when he was a year older than the century, he began to combine photographs with other graphic means, making composite images he called Transmutations. His eye, it seems, after many thousands of exposures, had become satiated with reality.

Another Hungarian who came to Paris was André Kertész; but he moved again and entered the United States via that Ellis Island of photographers, the Condé Nast group of publications, where he worked for *Harper's Bazaar*, creating portraits spiced with a light and ironic enjoyment of personality. His photographs of the women are especially witty: Kiki twists on the couch like the cat woman she sometimes played in the cafés; and the Chagall portraits have the one-sided smile and the egotistical naïveté of that village master. His group portraits of sheep are just as kind, and just as funny. His book, *André Kertész, Sixty Years of Photography, 1912–72*, is quite simply a collection of pleasures. Even his inarticulations are delightful: *I talk with my photography—this is the only way. Look—my book—no text—I don't want text. People wrote too many things over my work—perfectly all right. Well—I'm very happy. Myself—I don't think talking—I did the thing the way I wanted—or maybe —you don't ever do one hundred percent—mostly with photography you are limited point of view—technical expression—but explication, no. I don't care. It's the same story—people ask why you did—why? I don't know. I did, I felt, I did.*

He added, when asked what advice to give a photographer: *. . . Try to be honest with yourself. You understand, don't make artificial—so called artificial makeups, try to work in the way you feel—and don't show up for yourself. And the first thing is learn the technique perfectly—very perfectly. If you have the technique in your little finger it's no problem. Instinctively if you work—you can express yourself.*

His technical story has a delightful specificity: *In the time I began, 1912, there were no miniature cameras. We had small cameras, 4.5 x 6 cm., and this is what I used. From the beginning I never wanted to use the big camera—always small. It was very natural. We didn't have film, we had plates. I did the whole war with glass plates. It was not enough going around with the official thing—plus I had the glass negatives and metal holders and everything. It was extra—I sacrificed. We didn't go out with, you know, with 36 holders—you have 12 holders—18 maximum—too much. Alors, this way it was normal—if we did something we knew what we were doing—not playing around the way you now have in the modern 35mm. film—is nothing, no never—I was very surprised when at the time I discovered how they work a 36 roll for one shot or two shots. It's ridiculous, ridiculous, but look it's a Hungarian saying, "the blind chicken find grain too."* [Kertesz uses his finger like a chicken's beak and tap, tap, tap, taps the table.] *This is the way people are working here—a thousand shots and two are excellent—it is the way.*

Living in Paris, but somewhat later, and fascinated, as were Brassaï and Kertész, by the expressive world of the streets, was the extraordinary Henri Cartier-Bresson. Though he became the most famous and influential of the outdoor photographers using miniature, hand-held cameras, he differs from them by the

Brassaï
Henry Miller, Paris, 1932

Brassaï
Edgar Varese, Paris, 1932

Brassaï
Jean Genêt, Paris, 1955

Brassaï
Picasso, Rue de la Boetie, Paris, 1932

448

André Kertész
Piet Mondrian, Paris, 1926

André Kertész
Satiric dancer, Paris, 1926

450

acute consciousness of his vision, and his exact and often pleasurably epigrammatic way of writing and talking and thinking. His street work will be taken up more fully at a later point; but let him speak, now, only of his portraiture: *The most difficult thing for me is a portrait. It's not at all like someone you catch on the street. It's the person agreeing to be photographed. And it's like a biologist and his microscope. When you study the thing, it doesn't react the same as when it's not studied. And you have to try and put your camera between the skin of a person and his shirt, which is not an easy thing. But the strange thing is that you see people naked through your viewfinder. You steal something and it's sometimes very embarrassing.*

One recognizes here the characteristic tone of the French intellectual—sharp, smiling, knowledgeable: *I remember once I took a portrait of a well-known writer. When I arrived at her home she said, "You took a very good portrait of me at liberation."*

Liberation was in '45, a long time ago. So I thought, she remembers that in those days her face wasn't the same. She is thinking of her wrinkles. Dammit! What shall I say?

I started looking at her legs. She pulled her dress and said, "I'm in a hurry. How long will it take you?"

"Well, I don't know," I answered. "A little more than a dentist and a little less than a psychoanalyst." Maybe she had no sense of humor. She just said, "Yes, yes, yes." I clicked two, three times and said goodbye. Because I had said the wrong thing.

It's always difficult to talk at the same time that you observe with intensity the face of somebody. But still, you must establish a contact of some sort. But with Ezra Pound, I stood in front of him for maybe an hour and a half in utter silence. We were looking at each other in the eyes. He was rubbing his fingers. And I took maybe all together one good photograph, four other possible ones, and two which were not interesting. That makes about six pictures in an hour and a half and no embarrassment on either side.

You have to forget yourself. You have to be yourself and you have to forget yourself so that the image comes much stronger—what you want and what you see—if you get involved completely in what you are doing. And not thinking. Ideas are very dangerous. You must think all the time, but when you photograph, you aren't trying to push a point or prove something. You don't prove anything. It comes by itself.

Henri Cartier-Bresson
Ezra Pound, 1971
Page 454
Henri Cartier-Bresson
Henri Matisse, 1944
Page 456
Henri Cartier-Bresson
Truman Capote, 1947
All, Magnum

Inside or Outside III: Intimate Visions

This third group of twentieth-century portraits has, I believe, an even deeper purpose, if not a deeper accomplishment. It aims the deadly camera at one's daughter, son, wife, parent, lover; and the swamps of intimate love lie invisibly on the print. Not that the photographer need be conscious of this quality; his mind walks on safer, loftier ground: *There is nothing mysterious about space-time. Every speck of matter, every idea, is a space-time event. We cannot experience anything or conceive of anything that exists outside of space-time. Just as experience precedes all awareness and creative expression, the visual language of our photographs should ever more strongly express the fourth-dimensional structure of the real world.*

As one can see from this statement by Wynn Bullock, photography still carries the guilt of heresy; though declaring itself free, over and over again, of the vile criteria of painting—or, to be more exact, of graphics—it periodically turns back and imitates those ancestral institutions. So, from the beginnings of photography, from the gentle man Talbot and the daguerreotypists, there was, and continues to be, an impulse to be pure and photographic, and a contrary impulse to look like a fresh variety of visual experience. The conflict, I think, is fallacious; but it's not the first time a fallacy has produced good art.

Bullock has combined these two impulses in his photographs; he has gained a dark luminosity of ideal pattern, without sacrificing the infinities of detail to be discovered only in the real. In a way, his work is a condensation of his life.

He came to California at the age of five, and like Ansel Adams, was at first interested only in music; in fact, he studied and performed in Europe, and rather successfully, as a young tenor. He was restless in that extrovert profession, and he came back to the United States in 1929, went to law school, and sold real estate for a living. Though he took his first photograph that year, he got no professional training until 1937. He saw and was immensely attracted, at first, by the redoubtable Moholy-Nagy's abstract photographs. This sort of work implies a great deal of darkroom manipulation, and Bullock's images of the 1940's were solarized, or reversed, or overexposed, or underdeveloped. *At forty-two I decided to become a photographer because it offered a means of creative thought and action. I didn't rationalize this, I just felt it intuitively and followed my intuition, which I have never regretted.*

Bullock went to live in the Carmel-Monterey area of California, where he met Edward Weston in 1948, and saw his astonishing prints: which combined luscious reality with an abstract sexual idealism.

Wynn Bullock
Kaye, 1958

1

Bullock adopted the whole ceremony of the F-64-ites: 8 by 10 view camera, direct contact prints, composition unaltered by cropping—all this though Weston himself used smaller cameras, particularly in portraiture, enlarged when he felt he needed to do so, and even cropped, on occasion. By 1960, though, Bullock tired of this narrow discipline, and used a Rollei and even the smaller negatives of the Leica and the Nikon. *The camera is not only an extension of the eye but of the brain. It can see sharper, farther, nearer, slower, faster than the eye. It can see by invisible light. It can see in the past, present and future. Instead of using the camera only to reproduce objects, I wanted to use it to make what is invisible to the eye—visible.*

Bullock was, like his contemporaries, obsessed by the natural forms he saw in California. Photographically, he responded to their black, interior energy, rather than to the brilliance of their surface, and he frequently allowed a child or a woman to enter the mystery of leaves and shadows. True, his portraits are sometimes taken inside, but generally they have a view toward the outdoors, through doorway or window; or they look from the outside in; and the subjects are often nude.

Can a photograph of a naked person be a portrait? Bullock, another highly articulate and conscious cameraman, has approached this basic problem straight on: *To make a photograph of the human body express something more than mere physical nakedness or suggestive sex, one has to look for qualities that make the human body a natural and beautiful part of nature. The nakedness of a body is as natural as the nakedness of a tree. However, both relate basically to external reality—mere physical existence. In neither poetry nor photography is this the subject of the mind's eye. If it were, a particular body or tree would be as meaningful as any other body or tree. With all things meaning is basically the sum of their qualities and so the poet and the photographer whose works are sensitive reveal these inner truths. These inner truths are an intuitive rather than an intellectual expression. . . .*

The qualities of the form of the figure, the qualities of the woman, if she be a woman, these are the things I search for and try to relate to a natural environment that has qualities of light and forms that make the figure and the background one in meaning. Here the single picture is like a poem. Here the intimate experiences of life find meaning whether in words or visual images.

This fusion of abstract form and human meaning in the fire of light: here is the answer to the old, basic photographic dilemma—how to make form out of

460

wild, chancy, beautiful, surprising, untidy reality. The answer, but not the specific daily solution; the question must be resolved day by day, image by image, over and over again; and most acutely, most painfully if one fails; and if one succeeds, most joyfully: in making a portrait of a person. Harry Callahan, born a decade later, puts it this way: "It's the subject matter that counts. I'm interested in revealing the subject in a new way to intensify it."

Callahan, like Bullock and like so many other photographers of those decades, came to the art with another background. He studied engineering, and made his first photograph when he was twenty-six. In 1946, he, too, was struck by the flat discoveries of Moholy-Nagy, and went to see him. As a consequence, he became a teacher in photography at the Chicago Institute of Design. He has done a whole series of photographs that are not, as Bullock believed his to be, four-dimensional, but deliberately planar. The material is common: the fronts of warehouses, the empty aspect of cities; they seem almost, if not quite, drained of human feeling, though not of human history. Even the open solidity of a tree is forced, by multiple exposure, to make itself flat. Yet there remains a kind of dry, sad loveliness in these compositions; and his portraits alter mere graphic beauty in the service of his most intimate feelings. He wrote, in 1946, at the beginning of a long academic career: *Photography is an adventure just as life is an adventure. If man wishes to express himself photographically, he must understand, surely to a certain extent, his relationship to life. I am interested in relating the problems that affect me to some set of values that I am trying to discover and establish as being my life. I want to discover and establish them through photography. This is strictly my affair and does not explain these pictures by any means. Anyone else not having the desire to take them would realize that I must have felt this was purely personal. This reason, whether it be good or bad, is the only reason I can give for these photographs.*

The photographs that excite me are photographs that say something in a new manner; not *for the sake of being different, but ones that are different because the individual is different and the individual expresses himself. I realize that we all do express ourselves, but those who express that which is always being done are those whose thinking is almost in every way in accord with everyone else. Expression on this basis has become dull to those who wish to think for themselves.*

I wish more people felt that photography was an adventure the same as life itself and felt that their

individual feelings were worth expressing. To me, that makes photography more exciting.

This deep theme, this troubling and recurrent problem, the connection between life and art, is a critical, even a catastrophic, point in photography. We know that, among all living or dead species, we alone make art; but is it a sign of health or a sign of madness, paranoid in the complexity of its order and detail? But even if the latter were true, and we were condemned to project our distorted view of the real universe, should the pieces we construct be strictly symbols? Or simulacra, more or less perfect? Or patterns purged of all but graphic or musical order?

If we look at Philip Perkis' portraits of his daughter, we can see all three of these elements. Graphically, we become aware, in one of them, of the arch of black above the oval of the face, itself enclosing the stretched circles of the dark iris of each eye; and this arch, modified as it reaches the bottom of the photograph, serves to press and confine the two sharp apices under the arms; a similar but different symmetry is constructed in Perkis' double portrait. But that is only one of our three aspects.

The second is obvious, too: we respond, as human beings, as parents perhaps, or possible parents, to the photographs of these vulnerable, delicate, beautiful children; we reach out to love them for the tiny minutes we can give their portraits—because they are the symbol of our deep relationships to the children we already know. In this sense, the photograph is a symbol.

But beyond that, there is a third component: the fact that we respond to the image as if it were the person himself, as if the photograph were merely the instrument of the transmission that occurs in real life between ourselves and others.

I would suggest that photography can solve this old philosophic problem; that a photograph, that instantaneous complex of information, should be a resultant of these three forces: of the emotional symbol, of an abstract pattern with its weights and counterweights, and of life in its (*vide* Bullock) four dimensions reduced to the plane of two, and confined within a rectangle.

Perkis, from the level of twenty years in photography, puts it a little more simply: *It seems that photography now is caught in the hooks of the contemporary art world, and seems to continuously apologize for those qualities which are its very strengths . . . I feel that photography has the possibility of being what might be called a "basic visual function," or put another way: the eye, when guided by the mind and feelings and having an intelligence of its own.*

Philip Perkis
Untitled, 1970

In this sense, let's examine the emotionally saturated work of Emmet Gowin. In the intensity of his vision, we can sense an older pattern of family life—everyone wound up inside everyone else. For all its inconstancy, this is the American family structure once common in rural life, and which still survives in small towns bypassed by the freeways, and most especially in pockets of the southern hills. The writer Flannery O'Connor has the exact tone, for example, in the opening paragraph of her story "Good Country People": *Besides the neutral expression that she wore when she was alone, Mrs. Freeman had two others, forward and reverse, that she used for all her human dealings. Her forward expression was steady and driving like the advance of a heavy truck. Her eyes never swerved to left or right but turned as the story turned as if they followed a yellow line down the center of it. She seldom used the other expression because it was not often necessary for her to retract a statement, but when she did, her face came to a complete stop, there was an almost imperceptible movement of her black eyes, during which they seemed to be receding, and then the observer would see that Mrs. Freeman, though she might stand there as real as several grain sacks thrown on top of each other, was no longer there in spirit. As for getting anything across to her when this was the case, Mrs. Hopewell had given it up. She might talk her head off. Mrs. Freeman could never be brought to admit herself wrong on any point. She would stand there and if she could be brought to say anything, it was something like, "Well, I wouldn't of said it was and I wouldn't of said it wasn't," or letting her gaze range over the top kitchen shelf where there was an assortment of dusty bottles, she might remark, "I see you ain't ate many of them figs you put up last summer."*

Now, distorted or not, the domestic images of Emmet Gowin do correspond to reality, and not merely his own reality. They are, beyond their pattern and beyond their strong, almost odorous intimacy, replicas of the real thing. But the real thing, the real wife, the real wall, the real children, have a visible infinity of detail; and one to one, each infinitesimal bit in the real scene can be put in correspondence with a similar tiny bit in the plane of the photograph. This kind of mental operation, first discovered by the mathematician Georg Cantor at the beginning of this century, helps us handle the business of infinite numbers; and yet it is so simple and intuitive that we can use it to define the limits to which a print can go and still be called a photograph. Briefly: nothing ought to be called a photograph unless the greatest part of its image can be put in one to one correspondence with

the richness, the infinity of the real world from which it is derived. A drawing or a painting, however "naturalist," cannot pass this test. And if the photographic print is low or lacking in such correspondence, it may be striking or satisfying or even fashionable; but it's simply not a photograph any more.

There is not, in photographic portraiture, much work that calls this test into play. The texture of skin, the minute, expressive muscles under the face, the waves or wires of hair that shift with the slightest change in posture of head or torso, the folds at the knee, at the elbow, the precise elaborations within the groin, the position, slack or tight, of the fourteen knuckles on each hand: all of these are as rich in detail as Judy Dater's friends and models. She is of that current generation to whom all of a person's body is a valid expression of character.

And the personalities of her young people have a new thing in common: it is a West Coast ease of manner, combined with a special San Francisco exoticism of dress and make-up and hair style; it's one more renewal of the bohemia invented by Henri Murger in nineteenth-century Paris; and like the young painters, writers, models, and friends of that early and splendid photographic time, is based squarely on two things: contempt for, and bred from, the middle-class world. Sex is the great spoon that stirs this marvelous part of our society; one can read it in the multiple rings, the decorated boots, the fashion of old-fashioned clothes; in the relaxations of lying or sitting or leaning as a characteristic posture, in the carefully unprocessed hair, and the unselfconscious moles and freckles.

Judy Dater, born 1941 (she gives the exact hour, 1 presume for astrological reasons) in Hollywood, was raised in Los Angeles; her parents were part of that post-World War II migration to the shores of the mild Pacific. She taught school there briefly, and turned to photography under the powerful influence of Imogen Cunningham. One senses, in fact, more than mere tutelage; there is a smiling, ironic romanticism common to both women's work. Cunningham, too, was fascinated by the nakedness of the nude, the vulnerable human skin in a world full of hostile surfaces: in Cunningham, rocks and leaves and trees; in Judy Dater, people pose bravely against or on brass beds and in front of wallpaper and dressing tables, mirrors and folded umbrellas, and (a bit of a gimmick, this) a funny framed glass-covered photo of a full field battalion of foot soldiers. Clothes, on the other hand, mean a great deal to Dater; she will even go and pick out clothes from her sitter's closet to make a more striking portrait. Anne Tucker, in her book

omniscient photo historian, relates that the inventor was arrested for pointing it at the queen. A miniature camera that was actually concealed in a pistol was invented in Paris in 1886, but when lifted and held up to take its tiny photographs, could hardly be called inconspicuous. In a sense, all these clever cameras were no more than novelties, adult toys—a description which, without prejudice, still applies to cameras of every size. The amateur, playful use of the camera is a fact inherent in its nature.

By 1871, the invention of the dry plate allowed the photographer to expose his negatives in rapid succession, without having to dash back to his light-proof box to dip squares of breakable glass in sticky solutions. Still, even with this improvement, the prints were made in a contact box, and were therefore the same size as the negative. So, in fact, a second camera —the enlarger—had to be invented to bring the prints up to a natural size, where they could be seen and handled at a comfortable distance.

It is remarkable how acute (perhaps because it is obvious) was the contemporary view of these miniature inventions: Newhall quotes the comment of a visitor to the factory of one of these inventors: *M. Carpentier can be proud of his work; he has realized his dream: to produce a camera of extreme simplicity and irreproachable construction, to obtain images of a sharpness and definition such that the final enlargement may furnish perfect results to give the scientist a powerful working tool, the amateur a faithful travelling companion with which he can keep forever charming souvenirs of the countries he has travelled through, to furnish to all a means of fixing fleeting images which, up to now, have been preserved by thought alone.*

Yet the photographs of this period—the last one-third of the nineteenth century—do not, with some exceptions, show anywhere near the same sensitivity as this comment. There is as yet no grasp of the absolute change made possible by this miniature and inconspicuous machine, whose exposures were a very thin, and increasingly thinner, slice of time.

The experience was unique because it let the photographer make portraits of people within a time frame too brief for them to have any important connection with the portraitist; and this can be turned to a curious advantage. The subject of the portrait may be deceived, or they may see and hate and even resist the photographer: it's no use—the picture is already hidden in the film. So this sort of photography becomes a guerrilla operation—which is one way to cross the protective barrier that, even in the closest society, still separates person from person.

Yet there has long been a mistaken connection between the street photographer and the miniature camera. The latter does not govern style—it merely permits it. One can take perfectly rested portraits with a Leica; its advantages are its many exposures before reloading, and its easy concealment; these are characteristics that permit a new way of looking, but do not require it. The real advances and retreats in art must take place in the human brain, whose billion connections have evolved to cope with the infinities of the real world.

There seems to be at least a generation between the invention of a new device and its use in the arts, and it is not until the late 1880's that we find portraits that make use of the speed and subterfuge of these new devices. Count Giuseppe Primoli, an Italian who was brought up in Paris, made do with a camera using 4 by 5 glass plates. His visual greed was enormous: he exposed some 30,000 negatives, most of them in the streets of Paris, those slightly raised platforms on which the actors and the spectators are the same. His prints have the selection of a sarcastic mind. They are composed around the quality that all subsequent work has and must have: the magical, slightly acid poetry of chance.

Cities, their pattern of spasmodic movement and their kaleidoscope of strangers' faces—this is the first cause and the constant nourishment of the street photographer; of the man or woman—or child—with a camera as light and quick as a butterfly net. Jacques Henri Lartigue, born in 1894 was, like Count Primoli, not the sort of vigorous, vulgar craftsman that opened photographic studios all over Europe and America,— but, very simply, a rich kid. He was given a view camera when he was six; and a miniature camera when he was seven. Children, as we may not remember, are at least as video-sexual as the rest of us; and Lartigue took fine pictures till he was at least fifteen. From the first, he was fascinated by two things: the absurd grace of stopped movement—and the seductive mystery of Parisian women, dressed in the furs and embroidered veils of that lovely time, and sweeping behind them the long skirts which were a slightly raised curtain over the erotic, tantalizing little late-nineteenth-century drama of the foot and the shoe.

But equally he loved, like any clever child, the silly adults (his cousins, mostly) diving down staircases or into summery water. These delicious, flying, plunging, walking, lounging creatures of the Bois de Boulogne and the country villa and the race track and the airfield, were really snapshots for the family album. Only in 1962 were they shown publicly. So they are part of the early and still strongly persistent tradition of

Giuseppe Primoli
The Japanese doll, Rome, c. 1898
Fondazione Primoli, Rome

478

Jacques Henri Lartigue
Paris, 1910
Rapho/Photo Researchers

481

Jacques Henri Lartigue
Simone, no date
Rapho/Photo Researchers

482

483

Brassaï
Cou 99, Longchamp, 1931

the amateur in photography. As John Szarkowski of the Museum of Modern Art has remarked, every photographer, no matter how mediocre, has made at least one marvelous print. We have before us the future exploration of the treasures in other and nameless scrapbooks; they remain to be discovered in their immense millions; and if we are lucky, maybe there will be some that will, like these, astonish us with their wit and delight us with their purity. They are like the works K.1 through K.200, the early Mozart. Still, we must not make the contrary mistake of expecting that the amateur can give us the trembling thrill, the finality and lyric beauty that would correspond to his mature quartets. The inevitability of such work is the business of the professional.

One of the best and at the same time most charming of the professional street photographers is Brassaï, whose career we have already discussed along with his somewhat more formal portraits. His street portraits are not all that different, for Brassaï's astonished eye is one of the constant elements of his lens. His tastes led him, at first, like Charles Baudelaire, to that alternate city that Paris becomes at night, when the street lamps and the overflowing illuminations of the cafés change the long, open vistas that Napoleon III had decreed (so his soldiers could fire straight ahead of them as they marched) into brilliant, separated clots of humanity. Brassaï prowled Montparnasse, particularly, for years, and his first book was a selection out of thousands of consequent images—all portraits. He wrote: "I make no comments with my camera. My camera sees all different kinds of people and with impartiality fixes them on the negative. Here they are, the apaches, the male and female homosexuals, the eccentrics. Whatever I see and I feel about people, the camera sees . . ." What is it that is so extremely moving about the young couple in the café? It is not, I think, a quarrel that widens the physical angle that separates the gaze of one from another. It is something more profound than merely angry or indifferent words or even the lassitude of time spent on wine; one feels, somehow, and at the same time, the sadness and the beauty of the contact between male and female. Brassaï has transmitted to us, through his photograph, a recognition of ourselves.

He has a precaution, though, for the photographer committed to a similar mission: *To keep from going stale, you must forget your professional outlook and rediscover the virginal eye of the amateur. Do not lose that eye; do not lose your own self. The great Japanese artists changed their names and their status ten or even twenty times in their ceaseless efforts to renew themselves. It is not right that the originality*

Brassaï
Bijou of Montmartre, 1932

Brassaï
Porter, les Halles, 1939

Brassaï
Girl at billiards, Montmartre, 1933

Brassaï
Quarrel, 1932

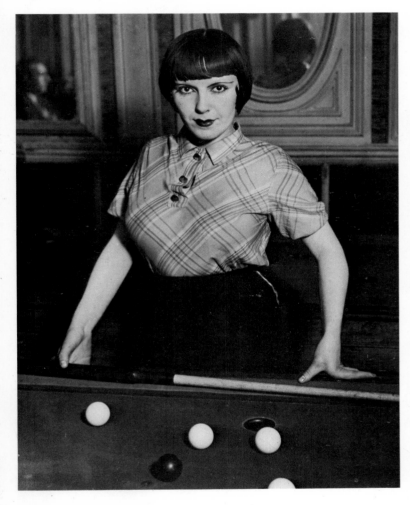

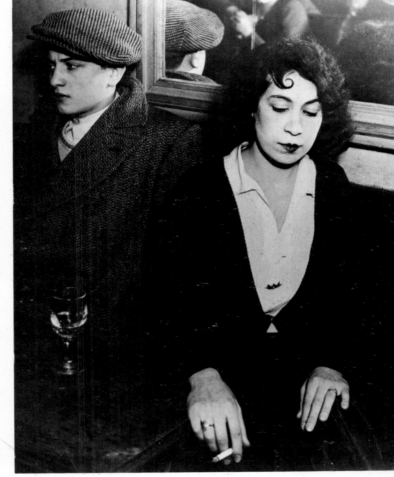

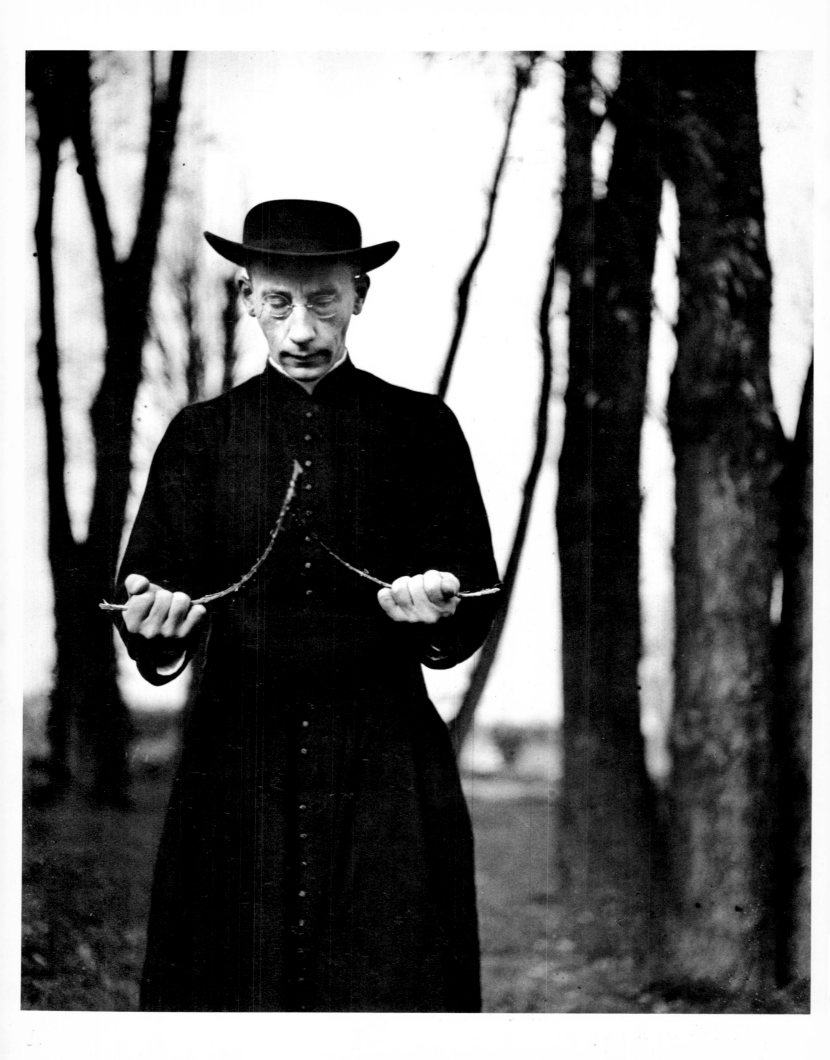

of that first vision should become a trick of the trade, a formula a thousand times repeated.

André Kertész, whose nonanonymous portraits appeared in an earlier chapter, was a countryman of the ex-Hungarian Brassaï; in fact it was he whose encouragement made a photographer out of his artist friend. Kertész was born in 1894, and was destined to be the heir to a banking fortune. World War I, which exploded Central Europe into nationalist fragments, ended this career for good. He had already been passionately addicted to the camera, and while serving in the Austrian army, did a recruit's diary in photographs, which was destroyed in the fiery Hungarian revolution of 1918. These were done with an old-fashioned view camera; and it was only in 1928 that he acquired a Leica.

It's not one city that we construct out of the Kertész prints; it's a universal metropolis, the child of the mutual admiration of Paris and New York. The people in this composite city have been chosen by an eye that was instantly applauded by his friends: those omnivorous artists, the French Surrealists. The ghostly statue that drives, without hands, the laborer strapped into harness like a horse; the childlike street violinist and the bald, aged child; the priest prospecting for underground water with the aid of that lewd sign of the Devil, a forked twig: these are the images of ordinary life, but twisted out of normality, not by Kertész but by themselves, into a subtle madness that one encounters on a city street.

Robert Doisneau was part of that same tradition, basically French and Surrealist in its canons of taste, even though he was born a generation later, in 1926. It must be remembered that visual, antibourgeois wit, like his photograph of a pigeon clutching the penis of a (consequently?) fist-clenching statue on a national monument, was a constant aspect of the French avant-garde from its beginnings in the 1830's.

Doisneau, of course, is not really angry. He smiles, and expects us to smile back. His subjects are never grave; they are preoccupied, as we all are, most of the time, with the manipulation of trivia. And there is no trace in Doisneau of his early occupation as a painter and draftsman; the photographs are not good examples of lighting, or of Ansel Adams' "acutance"; certainly none of them is everywhere optically sharp; and his prints, though good, are not examples of how to "dodge" in the darkroom. He is after a funny, sweet sampling of what we are.

Another and far more unusual and complex mind came out of Paris: Henri Cartier-Bresson. Certain decades and places are the vortex of tornadoes of creative energy; this was certainly true of France in the mid-

André Kertész
Father Lambert, France, 1928

André Kertész
Accordianist, Esztergom, 1916

André Kertész
Wandering violinist, Hungary, 1921

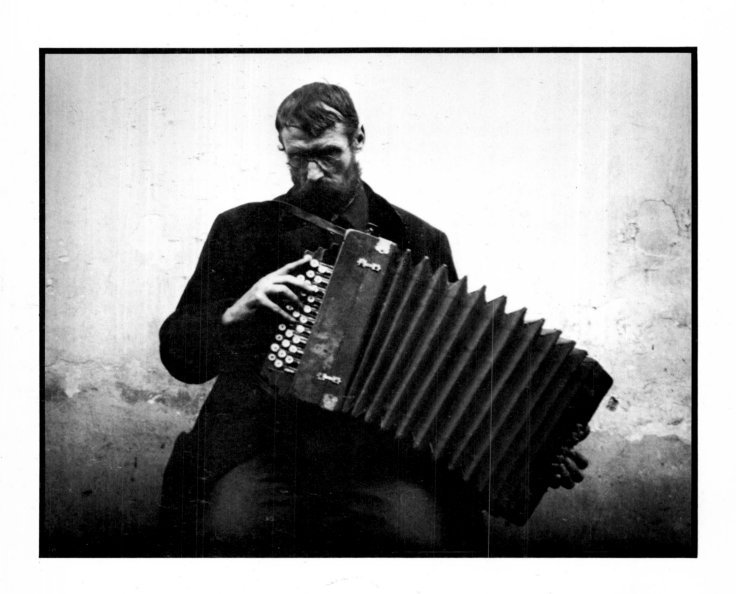

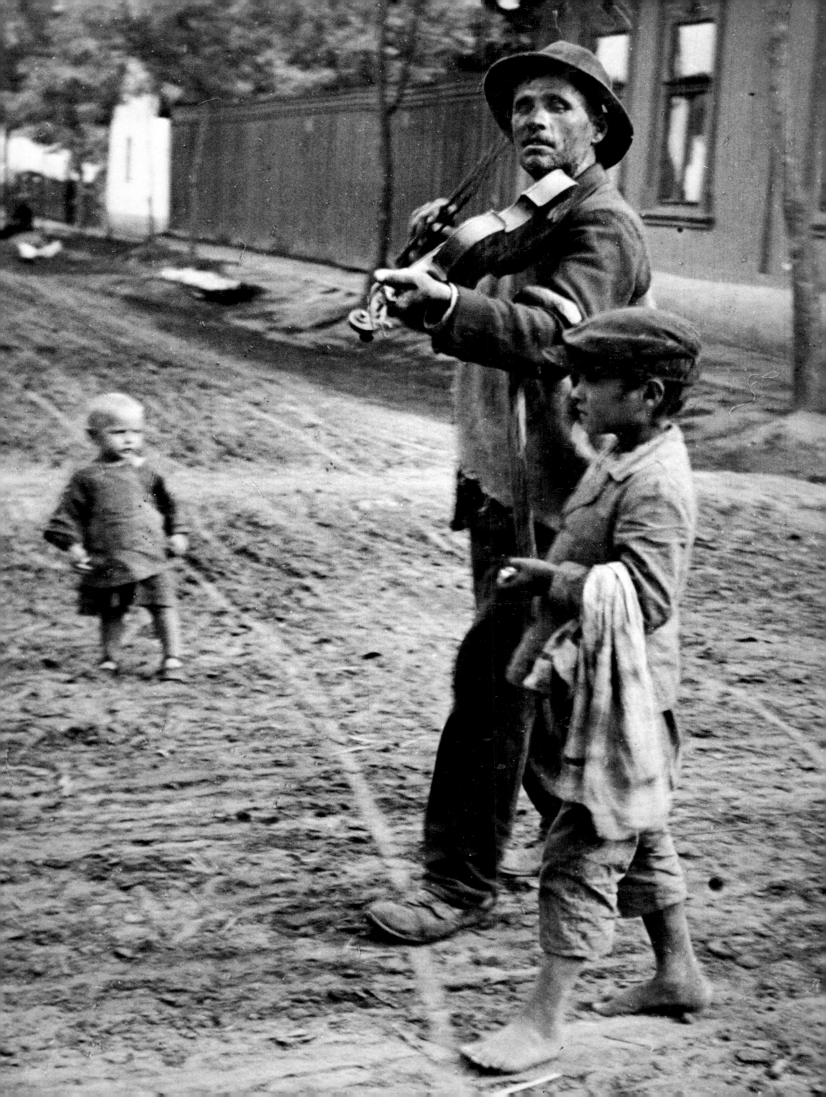

492

Robert Doisneau
Boulevard Rochechourd, Paris, no date
Rapho/Photo Researchers

twenties, and immediate postwar Europe, in revulsion from the past, had given birth to a number of almost fatherless creeds. One was the aesthetic successor to Dada. But Surrealism was less playful and more ferocious; it remained antibourgeois, but celebrated the order of madness and nightmares and chance. One of its best poets, Tristan Tzara, wrote: *A form plucked from a newspaper and introduced in a drawing or picture incorporates a morsel of everyday reality into another reality constructed by the spirit. The contrast between materials which the eye is capable of transposing almost into a tactile sensation, gives a new dimension to the picture in which the object's weight, set down with mathematical precision by symbols, volume and density, its very taste on the tongue, its consistency, brings before us a unique reality in a world created by the force of the spirit and the dream.*

One can see, then, why both the "naive" (naïveté itself is a Surrealist virtue) photographs of Atget and the sophisticated darkroom manipulations of Man Ray were assimilated side by side. Henri Cartier-Bresson, studying with the painter André Lhote, saw and was moved by the work of both of these photographers, as well as that of Brassaï; but he himself did not use a camera till his journey to Ethiopia and West Africa. Recovering in Paris from a severe tropical fever, he began to use an early model of the Leica; it could be held inconspicuously in the hand or in the crook of one's elbow. To render it even more unrecognizable, he covered the metal with black tape. His photographic work for the next two years, then, has the feeling of being seized rather than merely taken; he worked from the psychologically alien, hostile, and satiric viewpoint of the Surrealists; and found macabre treasures of humanity, caught in the midst of their rhythms, in the France of the early Depression, in Poland, Germany, Italy, and Spain. "I feel very close to Surrealism," he said recently, " but I never mention Surrealism. It's my private affair." This serious joke is very French, and very intellectual, too; and Cartier-Bresson is anything but a primitive.

One can see the viewpoint of Surrealism toward reality—as something indigestible that must be added to the cooking of a work of art—most clearly in Cartier-Bresson's early portraits, particularly of anonymous people. A most remarkable series was made in the courtyard of a Barcelona whorehouse; the very long spiked heels of the women are drawn up with the knee bent so the point presses into the naked thigh; the male prostitute "poses" mockingly with forks and knives. Another and very famous early photograph is that of a small boy in front of one of those eroded European plaster walls, which are the

chance precursors of Action painting. The boy's head is bent back in ecstasy; we generalize, in spite of ourselves, and identify his posture and his joy with the universal experience of intense happiness. The fact is that the boy was merely gazing upward because he had thrown a ball into the air; the ball is forever beyond the frame; so maybe the emotion is universal, after all. One continues to feel this elliptic joy in Cartier-Bresson's photographs: one's mind moves from the specific to the general and back to the specific again. Even so placid a photograph as the family picnicking on the banks of the Marne, taken on assignment for the left-wing weekly, *Régards,* to illustrate the joys of leisure and to support the movement for a forty-hour week, bites back at the spectator; the bucolic scene is redolent of digestive garlic and the oily whiteness of sweat in the afternoon.

Cartier-Bresson, like many photographers of this century, was a constant traveller—and a constant alien. He first came to New York City for his exhibit at the Julien Levy Gallery; from there he went to Mexico, where he met the great photographer Bravo, and where the fabulous women of Tehuantepec called him, in awe and admiration, "Man-with-Face-Colored-Like-a-Boiled-Shrimp." He returned to New York for some time, and had a joint show with Walker Evans. In 1936 he became Jean Renoir's assistant, and appeared briefly in that masterpiece *La Règle de Jeu.* His sympathies were always toward the left, and in 1937 he returned to Spain during the civil war, and himself directed and photographed a powerful film on the young and the wounded.

Captured by the Germans in the French collapse of 1940, he escaped three times and was caught twice; some of his negatives were lost; most, luckily, were not. There is no doubt that the satiric edge of his early photography was sheathed as he grew older; sometimes that is an improvement, sometimes not. But all his photographs show an extraordinary (and certainly rapid) control of composition: *The same rules of composition apply to both painters and photographers; both are confronted with the same visual problems. Just as one can analyze the structure of a painting, so in a good photograph one can discover the same rules, the proportional mean, the square within the rectangle, the Golden Rule, etc. That's why I like the rectangular dimension of the Leica negative, 24 by 36 mm. I have a passion for geometry. My greatest joy is the surprise of facing a beautiful organization of forms, the intuitive recognition of a spontaneous—not contrived—composition; naturally with a subject that moves. I think it's only when handled this way that a subject takes on its full significance.*

Henri Cartier-Bresson
Mexico, 1934
Magnum

Henri Cartier-Bresson
Alicante, 1932
Page 500
Henri Cartier-Bresson
Calle Cuauhtemoeztin, Mexico City, 1934
Both, Magnum

Henri Cartier-Bresson
Gypsies, Andalusia, 1933
Magnum

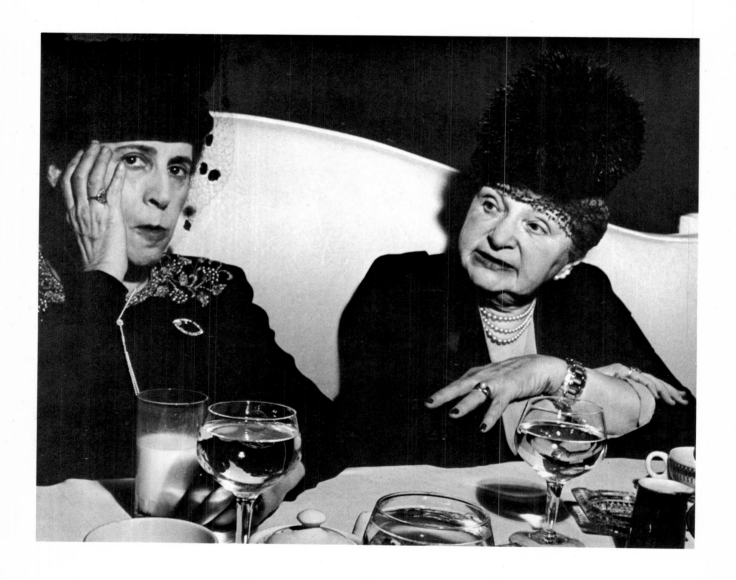

I never crop a photograph. If it needs to be cropped I know it's bad and that nothing could possibly improve it. The only improvement would have been to have taken another picture, at the right place and at the right time. Distance also is very important: the distance at which the photograph as a whole is taken, and also the distance between one element in the picture and another. Such relationships vary as much as the tonality of a voice heard nearby or far away.

Unlike the painter, however, who can work at length on a canvas, we have to work by instinct and intuition, within a split second. We have to catch the specific detail. Our procedure is analytical, whereas the painter achieves his effects through meditation and synthesis. We have to situate ourselves with respect to the subject; we have to have a point of view, we have to absorb ourselves in it. To me the camera is a prolongation of my eye. The instantaneous combination of eye, heart and head. . . .

By the testimony of many young photographers to whom I have spoken, his work has been the major influence on photography for thirty years. The age of the amateur, the man who devotes his life to a hobby, is nearly over; Henri Cartier-Bresson represents a new breed of photographer, the truly civilized and highly conscious man: *One has no right to use tricks or to play around with reality. We are always struggling with time: whatever has gone has gone forever. The time element is the key to photography. One must seize the moment before it passes, the fleeting gesture, the evanescent smile. For it is impossible to "start again." That's why I'm so nervous—it's horrible for my friends—but it's only by maintaining a permanent tension that I can stick to reality.*

My photographs are variations on the same theme: Man and his destiny. No one is infinitely versatile; each one of us carries within himself a particular vision of the universe. It is this view which makes for the unity in our work and ultimately, its style. To me liberty is a strict, self-imposed framework: the discipline of respect for reality. Within it, however, there are infinite variations. I weave around the subject like the referee in a boxing match. We are passive onlookers in a world that moves perpetually. Our only moment of creation is that 1/25 of a second when the shutter clicks, the signal is given, and the knife falls. We are like skilled shots who pull the trigger and hit their target.

This kind of work—shy, secretive, and aggressive; the hunter's falsely indifferent approach and the quick, repeated, accurate shot: these seem more characteristic of the male photographer than the female. Nothing could be more wrong. Women—Lisette Model is a classic example—are as keen pursuers of the image as men; and, in fact, as the social anthropologist Margaret Mead has noticed, are more sensitive because more socially attentive. Model, like many of the men we've examined, began in another art: *The most important thing that you must remember is that I was a musician. I studied composition with Schoenberg. He was the only teacher that I ever had. . . . In 1937 I was living in Paris and I took up painting. Everyone in Paris painted. One day a friend said to me: "Lisette, you know what they are saying in Russia? Art no longer exists. You had better find something to do in the world that is coming. You better find a way to make a living". . . . I never took a photography lesson in my life. All I thought was that I had to support myself and if I learned to be a darkroom worker that would be enough. . . .*

She came to New York and applied for a darkroom job with the very fine and very American photographer Ralph Steiner: *Do you know what he said? "You must be crazy! What do you want a darkroom job for? Don't you realize that these are important pictures?" Well, darling, to tell you the truth I didn't know what he was talking about. He published some of them in a seven- or eight-page portfolio. That was my downfall! . . . You must understand, my dear, I work by attraction. There is an old expression that goes . . . a dog goes to this tree and not to that one. Many photographers like Bresson and Diane [Arbus] are absolutely drawn to what they see. They must photograph these things. For example, Diane would have the idea to work with people with tattoos and for months she would think about this. Then she would go out searching for this subject and take the pictures. In order to be a functioning photographer there have to be a lot of characteristics that make up the whole person. This I can tell you from my experience of twenty years of teaching. It is totally different for each person. Some are physically strong, some feel the intuitive, others take pictures and cannot get themselves in print. I have remained as awkward and unmechanical as I ever was.*

It is obvious that photography is the new medium. A projection through light. Photography is the art of the split second. To reveal the twentieth century you must have what Schoenberg called a modern nervous system. That is, you must have both of your feet in this time. Not one foot in the romantic nineteenth century and another foot here. Some have it, many do not, and there is nothing that can be done about that. A more lyric and somewhat aberrant poet of the Leica, whose work is just becoming famous—is Helen Levitt. She has nearly always, and certainly in her

Helen Levitt
New York City, no date

recent color portraits, gone boldly into the crowded currents of New York City life. This is not an easy venture—as any photographer who has tried it and survived will tell you; one has to pump up one's courage every time, to break that awful membrane between thought and action; between quiet and noise; between preconception and the brutal excitement of reality. Nowadays the city is no longer passive anywhere. People are wise enough to spot that glistening, singular eye. So the photographer goes about mentally armed, hoping the weapon will not be noticed.

One sees, even in those of her portraits that are not stolen but requested, a movement implied, as if they were stills from an imaginary film. And one of the protagonists in that film is the unseen photographer herself. She will glimpse, guess, follow, casually approach, and even enter these shifting groups. She is careful not to interrupt their sidewalk dramatics, but will seize precisely those fractions of a second which are the pinnacles of what is happening or is about to happen. Looking at them afterward, on the thirty-six-exposure contact sheet, she has a choice again—and this choice is governed by an unerring and hypercritical taste. She is terribly honest about her own work and that of her contemporaries; a full analysis of her work would have to include that really remarkable film *In the Street*.

Helen Levitt is a native New Yorker; she doesn't live on the streets where she hunts, but she knows their colors and their rhythms with the intimacy of childhood. She's not been immune, either, to that recurrent crisis, so common to photographers, when their material appears to have been exhausted. A change of country, voluntary or not, often helps. This is the one advantage that the photographic exile has over the native. It takes a fresh eye like Robert Frank's to view us clearly again—and impale us on a ray of sinister light.

He had come to the United States from Zurich in 1947; thus he was not an exile for political reasons. At first he did considerable work for *Harper's Bazaar,* accepting the bias against the ordinary that is common to that social mini-climate. Eight years later, he got a fellowship and traveled the small towns of America and photographed the provincial life he saw there; to him, a Texas five-gallon hat and a Hassidic yarmulke are equally odd. His vision is acute and resolutely foreign: a flag flaring between two windows during a Hoboken parade is an object of wry astonishment; the gigantic juke box and the tiny baby in Beaufort, South Carolina, is a surrealist *objet trouvé*—a monstrous curiosity found by the eye. Everything he shows, thus, truly exists, but is invisible to any but a

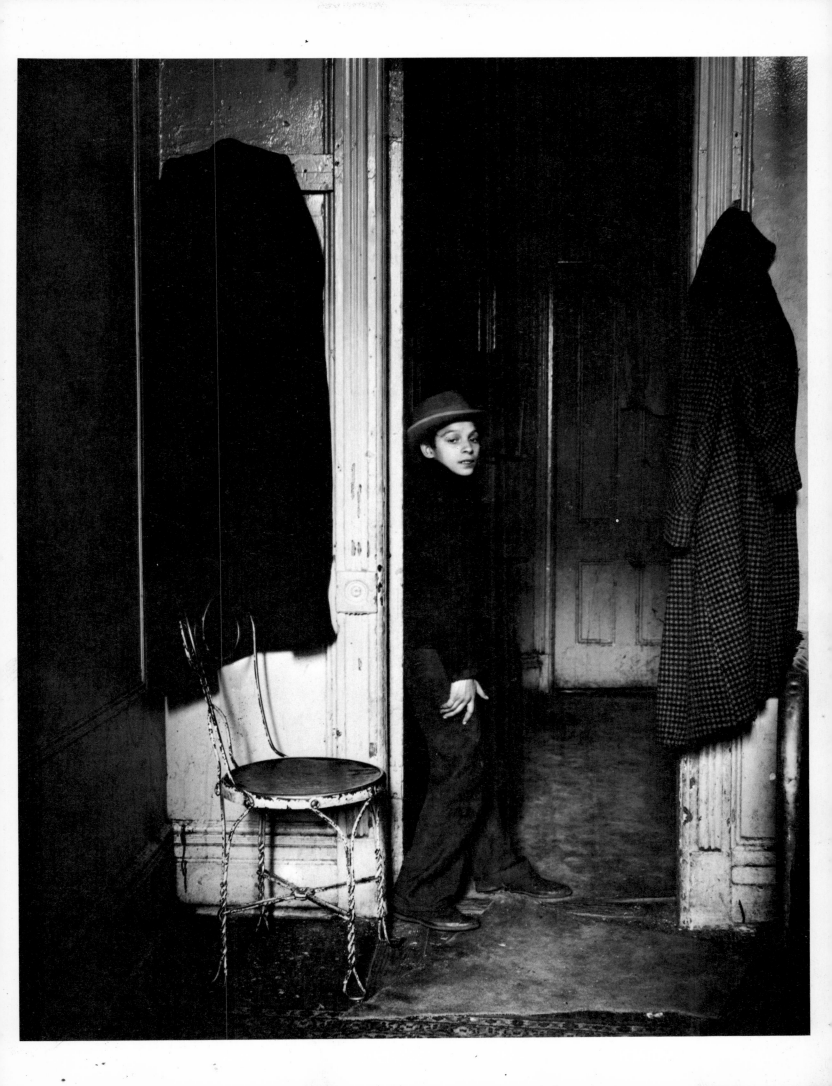

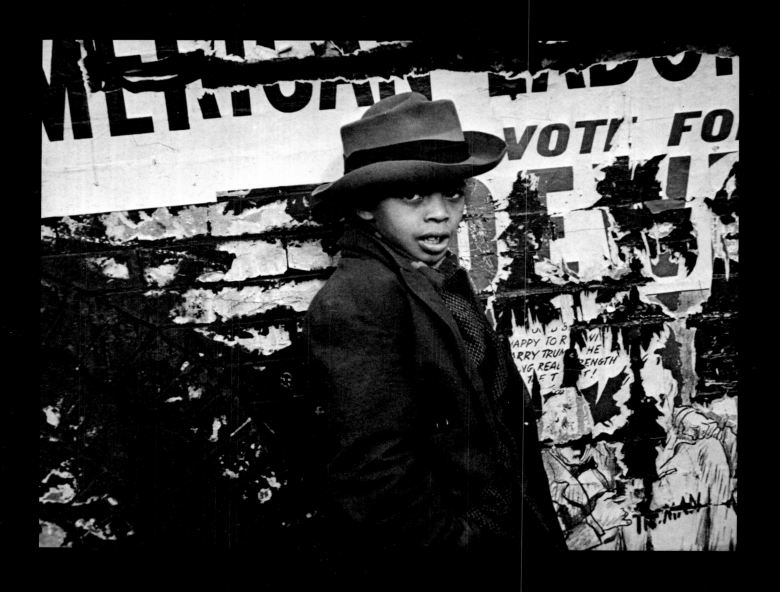

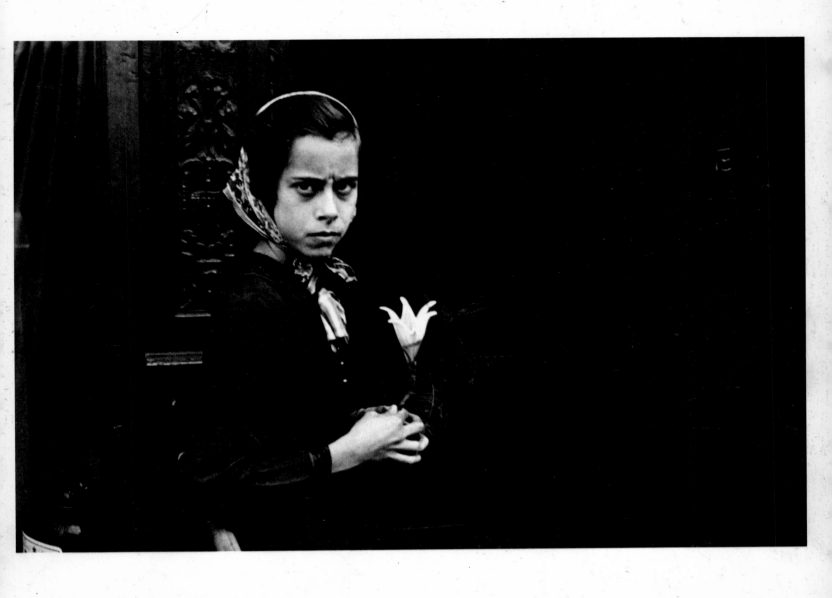

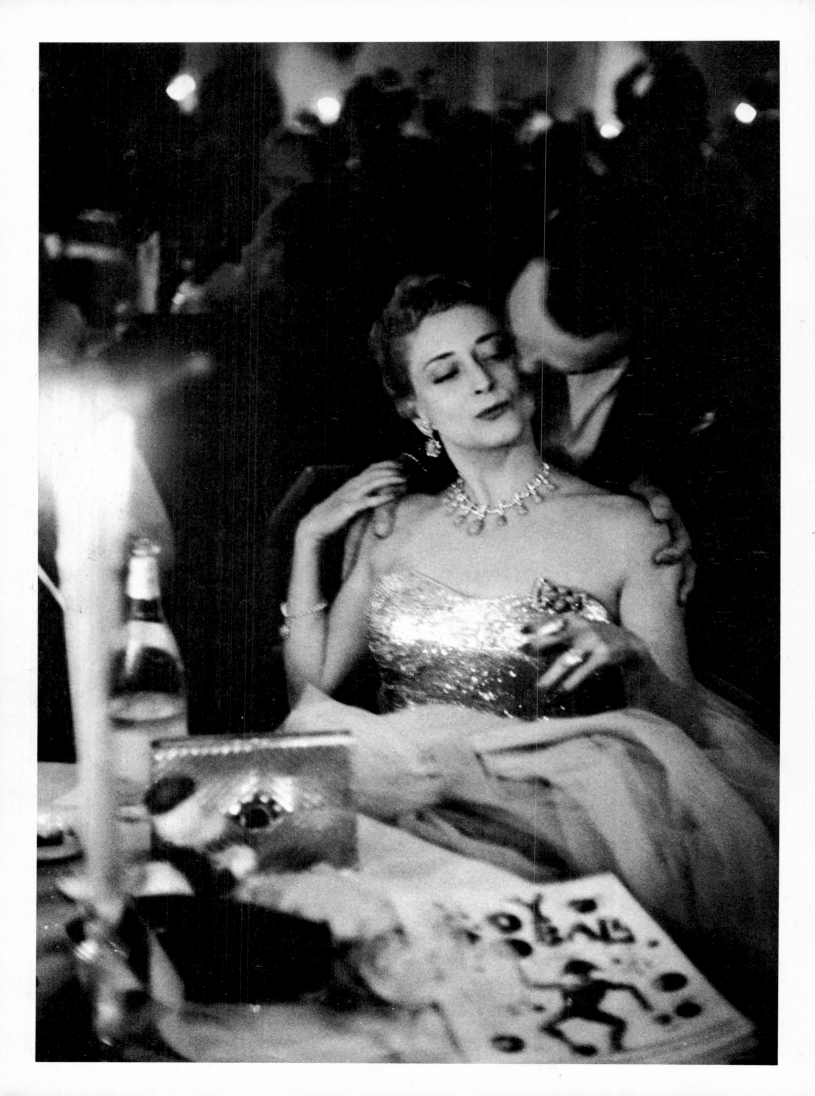

Robert Frank
Charity Ball, New York City, 1959

Frankian mind. I've been in the same Beaufort, and in the same year, but the only oddity noticed by my American eye was the new jail, which had five beautifully whitewashed and equal but separate cells for White Male, White Female, Colored Male, Colored Female, and U. S. Marines.

Again, the poet often outwits the acid-rock Surrealist. This is evident first in Frank's exhilarating sense of space; he treats the photograph not as a flat surface, a tradition borrowed from early-twentieth-century graphics, but as a truly three-dimensional medium, with parallel lines meeting at the horizon. And Frank the humanist is secretly present, too!—as in his intimate portraits of Mary Frank, pregnant; and even in the photograph, intended to be cruel, of a man leaning over to kiss a charity ball matron, her body encrusted with jewels and a glittering dress. I feel, perversely maybe, a stubborn celebration of private love in Robert Frank's words: *I have been frequently accused of deliberately twisting subject matter to my point of view. Above all, I know that life for a photographer cannot be a matter of indifference. Opinion often consists of a kind of criticism. But criticism can come out of love. It is important to see what is invisible to others—perhaps the look of hope or the look of sadness. Also, it is always the instantaneous reaction to oneself that produces a photograph.*

My photographs are not planned or composed in advance and I do not anticipate that the on-looker will share my viewpoint. However, I feel that if my photograph leaves an image on his mind—something has been accomplished. . . .

The work of two contemporary photographers, Bill Brandt of England and the American, Walker Evans, have influenced me. When I first looked at Walker Evans' photographs, I thought of something Malraux wrote: "To transform destiny into awareness." One is embarrassed to want too much for oneself. But, how else are you going to justify your failure and your effort?

Harry Callahan's street portraits suggest the opposite: that it may be more productive, at times, not to ask too much of one's self. Reviewing the history of his work, it seems clear that he followed two different roads, which are not opposite in direction but simply distinct. One idea he valued, particularly in his street work, was to move further and deeper into simplification. There are single faces more often than groups and complexities; here he takes a different direction than an artist like Helen Levitt, who senses a street drama with all its actors in movement at once.

Even in his single faces, he doesn't map the courses and the ridges of that particular person. The portraits

511

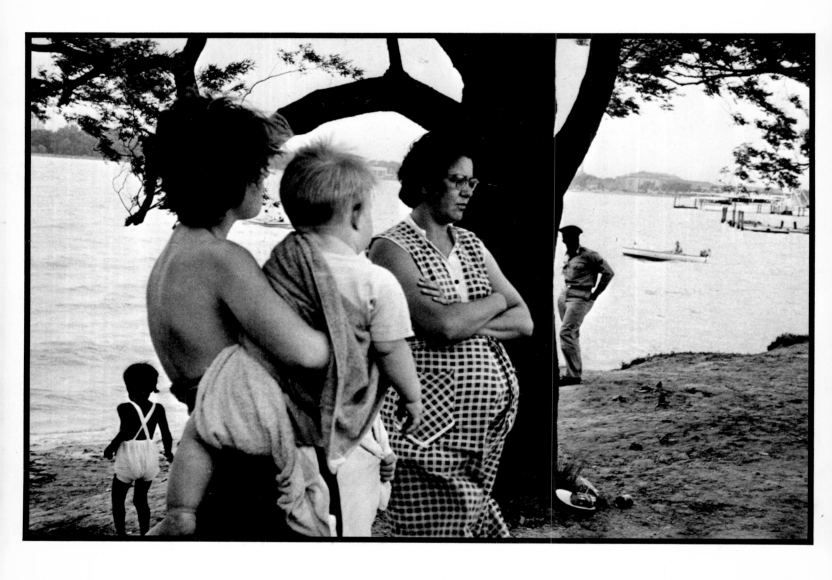

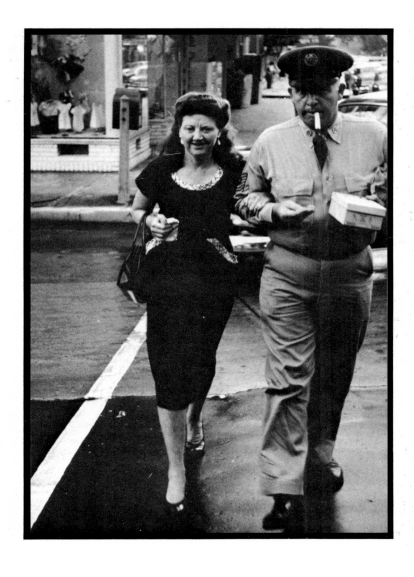

tend to be darkly shaded, simply scaled; they become, in this way, closer to the symbol of all such faces, rather than the inexplicable network of a singular character. In this sense, he is closer to the emblematic tradition of certain early Walker Evans photographs, like the woman in the cloche hat, already a mythic symbol of the twenties, waiting so fiercely for some enigmatic encounter.

On the other hand, Callahan is repeatedly drawn to the use of multiple images; again, these are structural ideas, and not particular persons. He's even tried complex collages of a couple of hundred faces, hoping to generate the idea out of the clash of cut-outs. One is tempted to say that he tries for utter simplicities, finds them somehow insufficient, and superimposes them to make another, and more complicated photograph, but this for graphic, not human reasons. These multiples work; they are inevitable rather than surprising in their logic. It's not an easy method; lesser talents have tried it, making narrowly surrealist compositions by the use of multiple negatives. The results are quite often dull, because dreams and fantasies are generally dull—other people's, that is.

Callahan himself has a multiple vision. He took his first photograph in 1938, but his serious work, since 1945, has at least five modes. There are the intimacies of wife and child, Eleanor and Barbara; there are the linear studies, graphs of the geometry of everyday architecture, mysterious like all repetitions; and there are the pedestrians, often isolated as if in the eyepiece of a fine gun, set against the baking light and sepulchral dark of Chicago; there are the strangers seen (one feels) dangerously close; and there are the ideograms of grass, tree trunk, twig, ivy, snow, water, and corroded paper signs. And in all these methods, one feels Callahan's central concern, expressed as a marked contrast between black and white, with the drama of hidden and morbid forces.

The next generation of street photographers (some of them middle-aged) are really too fresh in their careers to characterize in any way that has not, as one writes or reads, changed utterly by now. Garry Winogrand was a painter trained in photography by the relentless Alexey Brodovitch, the tyrant of fashion photography. Winogrand is still exploring the world of absurd collocations; animals are frequent faces in his street work; his 1969 exhibition was called *The Animals,* but these photographs have none of the hairy sentimentality of, say, Ylla. His people and his animals are like lost children in one another's sensual world.

Lee Friedlander, who was born in Aberdeen, Washington, and studied photography in Los Angeles, is

Harry Callahan
Chicago, 1961

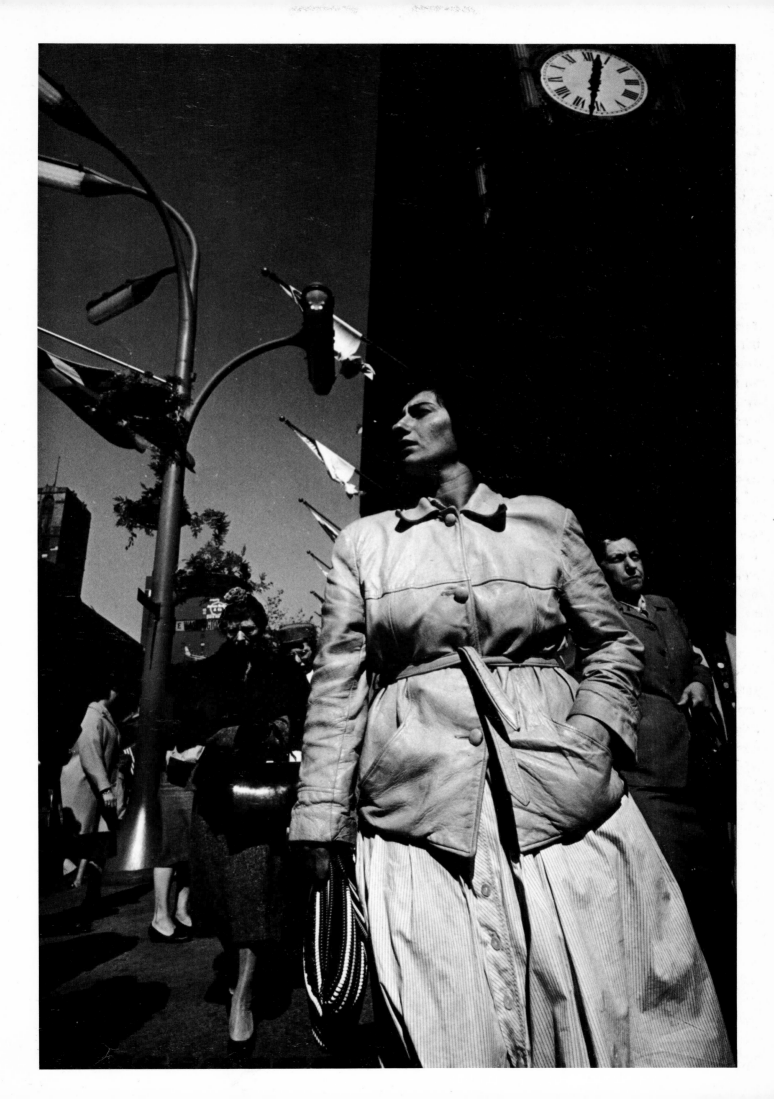

the son of a particularly American sub-culture: the Far West. We used to associate the Sierras, the Mojave Desert, the splendidly baroque Pacific coast, with a photographic sensibility that would deal with such landscapes: with voyages into space, with a consciousness that took the horizon as its natural limit. Brett Weston, Wynn Bullock, Edward Weston, and Ansel Adams especially (and beyond, I suspect, what he would have wished for himself) composed their landscapes with the focus, philosophic as well as physical, set on infinity.

But there was another Western tradition, too: Dorothea Lange and Imogen Cunningham and the socially sensitive Max Yavno, who were oriented toward people in the open air, the perspectives, growing more and more polluted, of those new, flat American cities. In a way, they were town photographers rather than city photographers. Friedlander, who exhibited at George Eastman House and was one of John Szarkowski's fresh and open enthusiasms, has kept a suburban eye. He is bright, wary, cheerful, gossipy in the best sense. His exhibit: GATHERINGS, at the Museum of Modern Art in 1972, gave us the insider's half-mocking, half-kindly, view of weddings, parties, barbeques, of jostling faces, not creased into the permanent worry of metropolitan pedestrians, but sweating cheerfully together in the slightly potted sociability that comes frothing out of pull-tab aluminum beer cans.

So Friedlander is more typical of a new, caustic, almost extraterrestrial attitude toward the city and its inhabitants, shrewd or stunned. The camera is miniature, but the range is amplified by using a flash. And by no means always, but still rather too often for my taste, these photographers produce "empty" photographs: a street (I'm inventing this) with a single garbage can, but otherwise quite empty; or even with a couple of persons, but too far away even to be graphic accidents. Yet street portraits produced by the use of flash are remarkably successful; in general, the younger photographers rely less on the inner structure of the face than they do on the face as a focal point of energy; consequently, sudden and quick though they are, the composition is quite often bold and solid and the product of a cultivated instinct.

Joel Meyerowitz is a rather more complex personality, and his mixture of joy, surprise, affection ("I love New York women!"), and sudden melancholy has colored all his prints. He will confess to a childish passion for water: not real water, but photographed water. And the silly brush of a palm tree in Los Angeles, which is surely the most banal invention of the botanic world, will elevate him into a heaven of

repeated exposures. Growing weary, this season, of people qua people, he will go on a photographic orgy of the architecture behind them and around them. He's begun to work brilliantly in color; and here his earlier standards retain their delicacy in an art full of chromatic pitfalls.

His energy is abundant; he is street-wise and he will say so. And this tough wisdom and this tireless use of that small glass poet, the 35mm. camera—these New York qualities are in all his best work: clever, of course but, the second time around, more somber than merely brilliant.

One is tempted to think that the smart, quick, restless quality of his mind and his street photographs are, perhaps, a reaction to the way he makes a living: the intricate, highly specialized practice of staging photographs for a page of advertising. Here he must cast his protagonists, and direct them, not only where to stand or sit, but how to behave; "Don't enjoy the cigarette," I heard one such photographer say, "enjoy the woman!" But on the streets Meyerowitz is not an arranger, but a keen traveler, elated beyond mere happiness into a high exhilaration, a kind of identity, as he works, with the living city, flashing against him in every sense of the word, including the vulgar.

Of the same generation is Mark Cohen, whose career followed that nineteenth century and perhaps useful tradition of coming from another field into photography. He was trained as an engineer and mathematician and the first photographs that excited him were Cartier-Bresson's. Cohen comes from an area of the United States that's little known—the industrial complex of Pennsylvania. Anthracite and iron have been mined here since the colonial centuries, and the towns are equally obsessed with mining and hunting. The majority of Cohen's photographs were taken in his native city, Wilkes-Barre: not a large place, but as various and busy as any part of Philadelphia. Cohen is, by choice, a street photographer, and an aggressive one. Some urban photographers are spies, secret hunters, surreptitious listeners and snappers. They wear inconspicuous clothes, impassive faces, and small cameras. They are the ideal tool for such work; they can be hidden under the elbow, lifted quickly, and as quickly moved to another angle, so they appear to have an interest only in the buildings beyond, not the troubled face in the foreground. They are easily adapted to the angle viewfinder or to the bright decoy lens mounted at a right angle to the real and deadly barrel. These subterfuges were long known and early practiced; but there were, and increasingly are, photographers who will boldly pursue their subject, sometimes for several blocks, and directly, openly

Joel Meyerowitz
New York City, 1972

Mark Cohen
Wilkes-Barre, Pennsylvania, 1974
Page 528
Mark Cohen
Wilkes-Barre, Pennsylvania, 1974

526

photograph them in movement. Cartier-Bresson has certainly done this, particularly in the earliest decade of his work; his subject will turn and curse the photographer, and Cartier-Bresson will photograph this gesture of refusal; and perhaps that was what he was after, anyway.

Cohen is just such a bold, open photographer. He swings with the subject, as close as his lens will allow; staying, as he says, "with the pivotal part of the image." The drama of the hunt is somehow rendered concrete in the print itself. There is a certain wildness at the emotional center of his photographs. They leap out at the viewer, as close, or closer, than one's own experience.

The still younger photographers have taken on another responsibility. Contemptuous of the dramatic and the arranged, they profess to love the banal. Truth is their first criterion, and so they photograph what they dislike: the new suburban look of flat streets, flat lawns, flat people. So they continue to work with small, light, fast cameras, but they no longer hunt; they prefer simply to be, to let things happen through and around them, and to let—or so goes the theory anyway—whim decide the "decisive moment." One wonders if the current interest in chance is not the result of anxiety about chance: the uncertainty of power—the impulse to embrace what you fear.

Chance, in any case, has begun to play a larger and larger part in photography, and in portraits as well; and this idea is in consonance with similar ideas in painting and cinema and music. It's a movement that wishes to expand to include the accidental, with all its boredom rendered intact. John Cage relates how he put on a recording he had done years before; he thought his composition was awful, and went to open the windows of his study. He heard the sound of traffic and birds and distant voices mingle with his music; that's much better, he told himself, and shut off the recorder; "That's best of all," he decided.

It's a neat story, but does it really help? Because the random is never truly random. It is more like a multiplication of choices, and often these are strongly governed by the unconscious. The famous dialogue of that unconscious—where the two persons are the creator and the viewer—is a somewhat uneasy tool. In aleatory art the distinction between these two people is not so clear as formerly; the boundary is purposely vague. One photographer has put on an exhibit of the dinner table, after eating, on thirty consecutive nights; another has done the same with the morning ideograms of his toilet bowl; I'm not sure, between these two, that there is any real distinction.

Still, it is a fact that every art has some gritty degree of chance; conversely, most chance is partly planned —even if the judgment is sudden, or hidden, or even denied. Here again, the double nature of photography —truth in bed with control—is just as true of the photographic portrait. And those who wander in the street in a fever of picture-taking require the discipline of an artistic prejudice. We can imagine a Zen or a Sufi photographer; indeed, there are such artists, and very fine ones, though they seem not interested in portraiture. So it must be recognized that convictions, either moral or metaphysical, are a human necessity; which doesn't make them sacred, absolute, or eternal. That conviction can be as simple as a passion for the details of human character. It doesn't matter whether such love—or hate—is rationally justifiable. It's sufficient that a fine portrait, by a photographer or a painter or a sculptor, is impossible without it. I particularly like what Robert Frank said about this question, fifteen years ago: *Black and white are the colors of photography. To me they symbolize the alternatives of hope and despair to which mankind is forever subjected. Most of my photographs are of people; they are seen simply, as through the eyes of the man in the street. There is one thing the photograph must contain, the humanity of the moment. This kind of photography is realism. But realism is not enough—there has to be vision, and the two together can make a good photograph. It is difficult to describe this thin line where matter ends and mind begins.*

Acknowledgments

For their cooperation in the preparation of this book, the author and publishers would like to thank the following: Berenice Abbott, Abbot, Maine; Ansel Adams, Carmel, California; Doon Arbus, New York City; Richard Avedon, New York City; Sir Cecil Beaton, Wiltshire, England; Brassaï, Paris; Esther Brumberg, photo librarian, Museum of the City of New York; John M. Cahoon, History Division archivist, Los Angeles County Museum of Natural History; Peter Castle, research assistant in charge, Library Photograph Collection, Victoria and Albert Museum, London; Mark Cohen, Wilkes-Barre, Pennsylvania; Van Deren Coke, Director, University Art Museum, The University of New Mexico, Albuquerque, New Mexico; John Coltharp, curator, and Mae Ellen MacNamara, research assistant, photography collection, Gernsheim Collection, The Humanities Research Center, The University of Texas at Austin; Doris Bry, New York City; Edna J. Bullock, Monterey, California; Harry Callahan, Providence, Rhode Island; Imogen Cunningham, San Francisco, California; Judy Dater, San Anselmo, California; Bernard de Montgolfier, premier conservateur-adjoint, Musée Carnavalet, Paris; Diana E. Edkins, research supervisor of the Department of Photography, The Museum of Modern Art, New York City; Morris Engel, New York City; David Featherstone, curator of photography, University of Oregon, Eugene, Oregon; Robert Frank, Nova Scotia; Lee Friedlander, New City, New York; g-inin-cadars, curator, Service Photographique, Caisse Nationale de Monuments Historique et des Sites, Paris; Suzanne Goldstein, Rapho/Photo Researchers, New York City; Emmet Gowin, Newtown, Pennsylvania; Alicia Grant, Richard Avedon Studios, New York City; Christine Hawrylak, Print Service, International Museum of Photography at George Eastman House, Rochester, New York; Therese Heyman, curator of photography, Oakland Museum, Oakland, California; Michael E. Hoffman, publisher of *Aperture,* Millerton, New York; Bill Jay, Royal Photographic Society, London; André Kertész, New York City; Roberta Kimmel-Cohn, Kimmel/Cohn Photography Arts, New York City; Helen Levitt, New York City; Jerome Liebling, Amherst, Massachusetts; Jerald C. Maddox, head, processing and curatorial section and curator for photography, prints and photographs division, Library of Congress, Washington, D.C.; Man Ray, Paris; Elaine Mayes, Amherst, Massachusetts; Joel Meyerowitz, New York City; Larry Miller, The Light Gallery, New York City; Lisette Model, New York City; Marjorie A. Morey, curator of photographic collections, Amon Carter Museum of Western Art, Fort Worth, Texas; Weston J. Naef, assistant curator, Department of Prints and

Photographs, The Metropolitan Museum of Art, New York City; Arnold Newman, New York City; Irving Penn, New York City; Philip Perkis, Warwick, New York; David R. Phillips, Chicago, Illinois; C. A. Ryskamp, director, The Pierpont Morgan Library, New York City; E. M. Sanchez-Saavedra, curator, Valentine Museum, Richmond, Virginia; Bill Eglon Shaw, photographer, The Sutcliffe Gallery, Whitby, England; W. Eugene Smith, New York City; Joanna T. Steichen, New York City; John Szarkowski, director, Department of Photography, The Museum of Modern Art, New York City; W. A. Taylor, city librarian, Birmingham Reference Libraries, Birmingham, England; David Travis, curator, photography collection, The Art Institute of Chicago; Roman Vishniac, New York City; Alexander D. Wainwright, curator, Morris L. Parrish Collection of Victorian Novelists, Princeton University Library, Princeton, New Jersey; J. P. Ward, research assistant, Science Museum, London; Jack Welpott, San Anselmo, California; Cole Weston, Carmel, California; Geoff Winningham, Houston, Texas; Garry Winogrand, Austin, Texas; Caroline Wistar, Philadelphia Museum of Art; Lee Witkin, The Witkin Gallery, New York City.

We gratefully acknowledge permission from the following sources to reprint the material indicated below.

Aperture, Inc.: from *Edward Weston: Fifty Years* by Ben Maddow, copyright 1973 by Aperture, Inc.; from *Aperture,* volume 9, No. 1, 1961, copyright 1961 by Aperture, Inc. The estate of Diane Arbus: from *Diane Arbus: an Aperture Monograph,* copyright 1972 by Doon Arbus and the Estate of Diane Arbus. Cornell University Press: from *Paris Under Siege, 1870–1871,* edited and translated by George J. Becker, copyright 1969 by Cornell University; from *Paris and the Arts, 1851–1896,* edited and translated by George J. Becker and Edith Philips, copyright 1971 by Cornell University. Crown Publishers, Inc.: from *Matthew Brady: Historian with a Camera* by James D. Horan, 1955. David R. Godine Publisher: from *Frank Sutcliffe* by Michael Hiley, 1974. Doubleday & Company, Inc.: from *Steichen: A Life in Photography* by Edward Steichen. Harcourt Brace Jovanovich, Inc.: from *Good Country People* from the volume *A Good Man Is Hard to Find and Other Stories* by Flannery O'Connor. Harper's Magazine Co.: from interview of Henri Cartier-Bresson with Yvonne Baby, reprinted from the November 1961 issue by special permission, copyright 1961 by Harper's Magazine. Harry N. Abrams, Inc.: from *The Picture History of Photography* by Peter Pollack. Little, Brown and Company, Publishers: from *The Magic Image* by Cecil Beaton and Gail Buckland, 1975. Norton Simon Museum of Art at Pasadena: from *The Photograph as Poetry* by Wynn Bullock, 1960; from a letter from Edward Weston to Manuel Alvarez Bravo, April 29, 1929. Prentice-Hall, Inc.: *Photographers on Photography,* edited by Nathan Lyons, copyright 1966, Prentice-Hall, Inc. Schocken Books Inc.: from *The Diaries of Franz Kafka, 1914–1923,* edited by Max Brod, copyright 1949 by Schocken Books Inc. Simon & Schuster, Inc.: from *Observations* by Truman Capote; from *The Europeans* by Henri Cartier-Bresson, 1955. William Heinemann Ltd. Publishers and Yale University: from *Boswell in Holland.*

Selected Bibliography

General Reference

Aperture, vol. 5, no. 2 (1957).

BEATON, CECIL, and BUCKLAND, GAIL. *The Magic Image: The Genius of Photography from 1839 to the Present Day.* Little, Brown & Co., 1975.

BORCOMAN, JAMES. "Purism versus Pictorialism: The 135 Years War." *Arts Canada,* December, 1974.

BRAIVE, MICHEL F. *The Photograph: A Social History.* McGraw-Hill Book Co., 1966.

COKE, VAN DEREN, ed. *One Hundred Years of Photographic History.* University of New Mexico Press, 1975.

GERNSHEIM, HELMUT. *Creative Photography: Aesthetic Trends 1839 to Modern Times.* Bonanza Books, 1962.

GERNSHEIM, HELMUT and ALISON. *Creative Photography 1826 to the Present.* Wayne State University Press, 1963.

Great Photographers. Life Library of Photography. Time-Life Books, 1971.

GRUBER, L. FRITZ, ed. *Famous Portraits.* Ziff-Davis Publishing Co., 1960.

LUCIE-SMITH, EDWARD. *The Invented Eye: Masterpieces of Photography, 1839–1914.* Paddington Press, 1975.

NEWHALL, BEAUMONT. *The History of Photography.* New York: Museum of Modern Art, 1964.

NEWHALL, BEAUMONT and NANCY. *Masters of Photography.* A & W Visual Library, 1958.

POLLACK, PETER. *The Picture History of Photography from the Earliest Beginnings to the Present Day.* Harry N. Abrams, 1958.

STEICHEN, EDWARD. *The Family of Man.* New York: Museum of Modern Art, Maco Magazine Corp., 1955.

The Studio. Life Library of Photography. Time-Life Books, 1971.

SZARKOWSKI, JOHN. *The Photographer's Eye.* New York: Museum of Modern Art, 1966.

Early Photography: Daguerreotypes and Talbotypes

"American Portrait Daguerreotypes." *Image,* April, 1957.

"Blanquart Evrard." *Image,* March, 1952.

BRUCE, DAVID. *Sun Pictures.* New York Graphic Society, 1974.

"Calotype Positives." *Image,* June 1958.

CARD, JAMES. "The Chorentoscope." *Image,* December, 1956.

"Chicago Historical Society Exhibition." *Image,* December, 1954.

CULVER, D. JAY. "The Camera Opens Its Eye on America." *American Heritage,* December, 1956.

"A Description of the Daguerreotype Process by Daguerre's Agent in America." Reprint. *Image,* March, 1960.

"Footlights and Skylights: Theatrical Photographs 1860–1900." *Image,* October, 1955.

"Forgotten Pioneers." *Image,* April, 1952.

GERNSHEIM, HELMUT and ALISON. *L. J. M. Daguerre.* London: Secker & Warburg, 1956.

———. "Rediscovery of the World's First Photograph." *Image,* September, 1952.

HOLMES, OLIVER WENDELL. "The American Stereoscope." *Image,* March, 1952.

"Index to George Eastman House Resources." *Image,* January, 1958.

KINGSLAKE, RUDOLF. "Petzval's Lens and Camera." *Image,* December, 1953.

"Light Sensitivity of Early Photographic Materials." *Image,* April, 1955.

MADDOX, JERALD C. "Essay on a Tintype." *Album,* no. 5 (1970).

MATHEWS, G. E., and CRABTREE, J. I. "The First Use of Hypo." *Image,* May, 1953.

MEREDITH, ROY. *Mr. Lincoln's Camera Man: Mathew B. Brady.* Charles Scribner's 1946.

MILLER, ALAN CLARK. "Lorenzo Lorain: Pioneer Photographer of the Northwest." *The American West,* March, 1972.

NEWHALL, BEAUMONT. "Ambrotype: A Short and Unsuccessful Career." *Image,* October, 1958.

———. "Ambulatory Galleries." *Image,* November, 1956.

————. "Daguerreian Gallery." *Art in America,* no. 4 (1961).

————. "Five Daguerreotypes by Daguerre." *Image,* March, 1955.

————. "Monsieur Daguerre." *Modern Photography,* December, 1951.

————. "Photographic Words." *Image,* December, 1956.

————. "The Broadway Daguerreian Galleries." *Image,* February, 1956.

————. *The Daguerreotype in America.* Duell, Sloan and Pearce, 1961. Revised edition. New York Graphic Society, 1968.

"Photography Comes to America." *Image,* January 1952.

"Pictures from the Eastman House Collection: Albert Southworth, Josiah Hawes." *Image,* January, 1956.

"Plastic Daguerreotype Cases." *Image,* December, 1955.

RINHART, FLOYD and MARION. *American Daguerreian Art.* Clarkson N. Potter, 1967.

"Sarony's Cameraman." *Image,* September, 1952.

"Southworth and Hawes Collection." *Image,* May, 1957.

TALBOT, M. FOX. "The Pencil of Nature." 1844. Reprint. *Image,* June, 1956.

THOMAS, D. B. *The First Negatives.* London: A Science Museum Monograph, 1964.

WEINSTEIN, ROBERT A. *The Calotype: A "Beautiful Image."* Issued for Friends of the U.C.L.A. Library, 1974.

"William Notman, 1826–91." *Image,* November, 1955.

English Photography

ALMANSI, GUIDO, ed. *Le Bambine di Carroll.* Parma, Italy: Franco Maria Ricci, 1974.

APPLEMAN, PHILIP. "The Dread Factor: Eliot, Tennyson, and the Shaping of Science." *The Columbia Forum,* vol. 2, no. 4 (1974).

ARONSON, THEO. "Empress Victoria." *Horizon,* Summer, 1974.

BEST, GEOFFREY. *Mid-Victorian Britain: 1851–1875.* Schocken Books, 1972.

BLACKWOOD, CAROLINE. "A Big House in Ireland." *The Listener,* 12 December, 1974.

BLUME, MARY. "The Prints Charming of Julia Cameron." Los Angeles *Times Calendar,* 9 February 1975.

CAMERON, JULIA MARGARET. *Victorian Photographs of Famous Men and Fair Women.* David R. Godine, 1973.

"Charles Harbutt: The Concerned Photographer." *Album,* October, 1970.

DAVIDSON, BRUCE. "A Portfolio of Welsh Photographs." *Horizon,* Winter, 1969.

DORÉ, GUSTAVE, and JERROLD, BLANCHARD. *London: A Pilgrimage.* 1872. Reprint. Dover Publications, 1970.

DOTY, ROBERT. "John Thomson: Street Life in London." *Album,* October, 1970.

————. "Street Life in London." *Image,* December, 1957.

FARWELL, BYRON. "Dr. Livingstone Presumes." *Horizon,* Summer, 1969.

GERNSHEIM, HELMUT. *Julia Margaret Cameron: Her Life and Photographic Work.* Aperture, 1975.

————. *Julia Margaret Cameron: Pioneer of Photography.* Fountain Press, 1948.

GERNSHEIM, HELMUT and ALISON. *Roger Fenton: Photographer of the Crimean War.* Secker & Warburg, 1954.

JAY, BILL. *Customs and Faces: Photographs by Sir Benjamin Stone.* Academy Editions, London/St. Martin's Press, 1972.

"Julia Margaret Cameron." *Aperture.* vol. 14, no. 2 (1969).

KERMODE, FRANK. "A Period of Civility." *The Listener,* December, 1974.

MARCUS, STEVEN. *The Other Victorians.* Basic Books, 1966.

MICHAELSON, KATHERINE. *David Octavius Hill.* Hill and Adamson catalogue. Scottish Arts Council, 1970.

NEWHALL, BEAUMONT. "Frederick H. Evans." *Aperture,* vol. 18, no. 1 (1973).

NEWHALL, NANCY. *P. H. Emerson: The Fight for Photography as a Fine Art.* Aperture, 1975.

OVENDEN, GRAHAM, ed. *Clementina Lady Howarden.* St. Martin's Press, 1974.

————. *Pre-Raphaelite Photography.* St. Martin's Press, 1972.

OVENDEN, GRAHAM, and MELVILLE, ROBERT. *Victorian Children.* St. Martin's Press, 1972.

Photo-Classics I. Victorian photography from the Gernsheim Collection. University of Texas. London: Photo Graphic Editions, 1970.

PIKE, E. ROYSTON. *Golden Times.* Schocken Books, 1972.

PLUMB, J. H. "The Victorians Unbuttoned." *Horizon,* Autumn, 1969.

"Poses of Poverty." *The Listener,* 29 August 1974.

ROUAULT, GEORGES. "Pictorial Conceits." *Verve Quarterly,* January/March, 1939.

SANSOM, WILLIAM. "Scenes from Victorian Life: The Work of Ford Maddox Brown." *Réalités,* December, 1973.

SMITH, ADOLPHE (text), and THOMPSON, JOHN (photographs). *Street Life in London.* Reprint. Benjamin Blom, Inc., 1969.

TURNER, PETER, and WOOD, RICHARD. *P. H. Emerson: Photographer of Norfolk.* David R. Godine, 1974.

WINTER, GORDON. *A Cockney Camera.* Penguin Books, 1975.

YEO, EILEEN, and THOMPSON, E. P. *The Unknown Mayhew.* Schocken Books, 1972.

American Photography: Nineteenth Century

ALLEN, GAY WILSON. *Melville and His World.* Viking Press, 1971.

ANDREWS, RALPH W. *Photographers of the American West: Their Lives and Their Works.* Superior Publishing Co., 1965.

COBB, JOSEPHINE. "Alexander Gardner." *Image,* June, 1958.

COLEMAN, A. D. "Visions of a Vanishing Race: The Photographs of Edward S. Curtis." Natural History Museum Alliance of Los Angeles County, *Terra,* Fall, 1975.

DEARSTYNE, HOWARD. "Photography: Youngest of the Arts." *Image,* January, 1958.

"Frontier Photographer." *American Heritage,* October, 1964.

HAAS, ROBERT BARTLETT. *Muybridge: Man in Motion.* University of California Press, 1976.

The Hampton Album. New York: Museum of Modern Art, Doubleday & Co., 1966.

HORAN, JAMES D. *Mathew Brady: Historian with a Camera.* Bonanza Books, 1965.

KUNHARDT, DOROTHY MERSERVE and PHILIP B., JR. "Assassination." *American Heritage,* April, 1965.

LAVENDER, DAVID. "The Hudson's Bay Company." *American Heritage,* April, 1970.

NEWHALL, BEAUMONT. "How George Eastman Invented the Kodak Camera." *Image,* March, 1958.

————. *The History of Photography from 1839 to the Present Day.* New York: Museum of Modern Art, Simon and Schuster, 1949.

NEWHALL, BEAUMONT, and EDKINS, DIANA E. *William H. Jackson.* Amon Carter Museum of Western Art, Morgan & Morgan, 1974.

RIIS, JACOB A. *How the Other Half Lives.* Dover Publications, 1971.

SMITH, SUZANNE. "An American Panorama." *American Heritage,* April, 1975.

WEISBERGER, BERNARD A. "You Press the Button, We Do the Rest." *American Heritage,* October, 1972.

WHITE, JOHN I. "That Zenith of Prairie Architecture—the Soddy." *American Heritage,* August, 1973.

WILEY, BELL IRVIN. *Embattled Confederates.* Bonanza Books, 1964.

American Photography: Photo-Secession

Alvin Langdon Coburn. George Eastman House, 1952.

DOTY, ROBERT. *Photo Secession: Photography as a Fine Art.* George Eastman House, 1970.

GREEN, JONATHAN, ed. *Camera Work: A Critical Anthology.* Aperture, 1973.

NEWHALL, NANCY. *Alvin Langdon Coburn.* George Eastman House, 1962.

NORMAN, DOROTHY. *Alfred Steiglitz.* Aperture, 1960.

———. *Alfred Stieglitz: An American Seer.* Random House, 1960, 1973.

STEICHEN, EDWARD. *Steichen: A Life in Photography.* Doubleday & Co., 1963.

———. "Rodin's Balzac." *Art in America,* September/October, 1969.

STIEGLITZ, ALFRED. "The Steerage" (picture from the George Eastman House Collection). *Image,* January, 1958.

———. *Stieglitz Memorial Portfolio 1864–1946.* Twice-a-Year Press, 1947.

STRAND, PAUL. "Stieglitz: An Appraisal." *Popular Photography,* July, 1947.

French Photography

ABBOTT, BERENICE. *Atget.* New York: Berenice Abbott, 1956.

———. *The World of Atget.* Horizon Press, 1964.

"An 1886 Photo Interview with Marie Eugene Chevreul." Reprint. *Image,* September, 1953.

BECKER, GEORGE J., ed. *Paris under Siege, 1870–1871.* Cornell University Press, 1969.

BECKER, GEORGE J., and PHILIPS, EDITH, eds. *Paris and the Arts, 1851–1896.* Cornell University Press, 1971.

BOUBAT, EDOUARD. *Woman.* George Braziller, 1973.

BOUDAILLE, GEORGE. *Courbet.* New York Graphic Society, 1969.

CAILLER, PIERRE, ed. *Corot.* Vesenaz-Geneve, 1946.

CARLYLE, THOMAS. *The French Revolution,* vol. 1. The Colonial Press, 1899.

CLARK, T. J. *The Absolute Bourgeois: Artists and Politics in France.* New York Graphic Society, 1973.

———. *Image of the People: Gustave Courbet and the Second French Republic, 1848–1851.* New York Graphic Society, 1973.

D'HARNONCOURT, ANNE, and MCSHINE, KYNASTON, eds. *Marcel Duchamp.* New York: Museum of Modern Art, 1973.

DOTY, ROBERT. "Daumier and Photography." *Image,* April, 1958.

"French Primitive Photography." *Aperture,* Spring, 1970.

HUGNET, GEORGES. "In the Light of Surrealism." New York: Museum of Modern Art *Bulletin,* November–December, 1936.

HUYSMANS, J. K. *Against the Grain* [A rebours]. Dover Publications, 1969.

JAY, BILL. *Robert Demachy, 1859–1936.* London: Academy Editions, 1974.

LEFÈBVRE, HENRI. *La Vieille Photographie.* Henri Jonquieres, 1935.

"Nadar, Twenty One Photographs." *Camera* (English edition), December, 1960.

OVENDEN, GRAHAM. *Alphonse Mucha: Photographs.* St. Martin's Press, 1974.

"The Photographs of Jacques Henri Lartique." New York: Museum of Modern Art *Bulletin,* vol. 30, no. 1 (1963).

PRINET, JEAN; DILASSER, ANTOINETTE; and VITALI, LAMBERTO. *Nadar.* Turin: Giulio Einaudi Editore, 1966.

RICHARDSON, JOANNA. "Nadar: A Portrait." *History Today,* October, 1974.

SLOANE, JOSEPH C. *French Painting: Artists, Critics, and Traditions, 1848–1870.* Princeton University Press, 1951.

German Photography

BARRACLOUGH, GEOFFREY. "Farewell to Hitler." *New York Review of Books.* 3 April 1975.

BAYER, HERBERT; GROPIUS, WALTER; GROPIUS, ISE, eds. *Bauhaus 1919–1928.* New York: Museum of Modern Art, 1938. Reprint. 1975.

GERNSHEIM, HELMUT and ALISON. "The First Photographs Taken in Germany." *Image,* March, 1960.

KAFKA, FRANZ. *Diaries 1914–1923 of Franz Kafka.* Edited by Max Brod. Schocken Books, 1974.

"Lost Berlin." *Horizon,* Autumn, 1974.

SANDER, AUGUST. *Men Without Masks: Faces of Germany 1910–1938.* New York Graphic Society, 1973.

"Timeless Teutons." *Horizon,* March, 1960.

American Photography: Early Twentieth Century

AGEE, JAMES, and EVANS, WALKER. *Let Us Now Praise Famous Men.* Houghton Mifflin, 1941. Reissue. 1960.

American Heritage History of the Twenties and Thirties. American Heritage Publishing Co., 1970.

BRANDON, TOM. "Pioneers, An Interview with Tom Brandon" (Fred Sweet, Eugene Roscoe, Allan Francovich). *Film and Photo Notes,* 1973.

CUNNINGHAM, IMOGEN. *Imogen!* (catalogue). Henry Art Gallery, University of Washington Press, 1974.

DOTY, ROBERT. "The Interpretative Photography of Lewis W. Hine." *Image,* May, 1975.

EVANS, WALKER. *American Photographs/Walker Evans.* New York: Museum of Modern Art, 1938.

———. *Messages from the Interior.* Eakins Press, 1966.

———. *Walker Evans.* New York: Museum of Modern Art, 1971.

———. *Walker Evans: Photographs for the Farm Security Administration 1935–1938.* Da Capo Press, 1973.

GUTMAN, JUDITH MARA. *Lewis W. Hine and the American Social Conscience.* Walker, 1967.

HINE, LEWIS W. *Child Labor 1909–1913.* George Eastman House.

"Imogen Cunningham." *Aperture,* vol. 11, no. 4, 1964.

KRAMER, ARTHUR. "Edward Weston: Tools and Techniques of the Greatest Craftsman." *U.S. Camera,* December, 1962.

LANGE, DOROTHEA. "The Assignment I'll Never Forget." *Popular Photography,* February, 1960.

———. *Dorothea Lange.* New York: Museum of Modern Art, Doubleday & Co., 1966.

———. *Dorothea Lange Looks at the American Country Woman.* Amon Carter Museum, Ward Ritchie Press, 1973.

"Lewis W. Hine: A Camera and a Social Conscience." *Album,* 1970.

MAURO, ELIO. *Tina Modotti: Garibaldina e Artista.* Udine, Italy: Circolo Culturale.

MORGAN, BARBARA. "Kinetic Design in Photography." *Aperture,* no. 4, 1953.

NEWHALL, BEAUMONT. "Paul Strand: Traveling Photographer." *Art in America,* no. 4, 1962.

———. "Reality/U.S.A." *Art in America,* no. 6, 1964.

PALFI, MARION. *Invisible in America: An Exhibition of Photographs by Marion Palfi.* Foreword by Lee Witkin. University of Kansas, Museum of Art, 1973.

Photo Eye of the Twenties. George Eastman House, 1971.

"The Shadow You Catch: The Voices of Two Photographers" (Frank Sutcliffe, Ian Berry). *The Listener,* July, 1975.

SHAHN, BEN. *Ben Shahn.* Edited by John D. Morse. Praeger, 1972.

———. *Ben Shahn, Photographer.* Edited by Margaret R. Weiss. Da Capo Press, 1973.

STEICHEN, EDWARD. *The Bitter Years: 1935–1941.* New York: Museum of Modern Art, Doubleday & Co., 1962.

STRAND, PAUL. *Paul Strand: A Retrospective Monograph, the Years 1915–1946.* Foreword by Leo Herwitz, afterword by Milton Brown. Aperture, 1972.

STRYKER, ROY EMERSON, and WOOD, NANCY. *In This Proud Land.* New York Graphic Society, 1973.

TERKEL, STUDS. "Hard Times Remembered." *American Heritage,* April, 1970.

TOMKINS, CALVIN. "Look to the Things Around You" (Profile: Paul Strand). *The New Yorker,* September 16, 1974.

"A Twenties Constellation" (James Abbe). *American Heritage,* December, 1972.

ULMANN, DORIS. *The Appalachian Photographs of Doris Ulmann.*

Preface by Jonathan Williams. Penland, North Carolina: The Jargon Society, 1971.

————. *The Darkness and the Light: Photographs by Doris Ulmann.* Preface by William Clift. Aperture, 1974.

WESTON, EDWARD. "Lobos 1944–1948." *Aperture,* no. 4, 1953.

Contemporary Photography

ADAMS, ANSEL. *Ansel Adams.* Edited by Liliane De Cock. Morgan & Morgan, 1972.

————. "Some Definitions." *Image,* March, 1959.

"American Artists Photographed by Arnold Newman." *Art in America,* June, 1965.

ARBUS, DIANE. *Diane Arbus.* Aperture, 1972.

AVEDON, RICHARD, and BALDWIN, JAMES. *Nothing Personal.* Dell Publishing Co., 1965.

AVEDON, RICHARD, and CAPOTE, TRUMAN. *Observations.* Simon and Schuster, 1959.

BABY, YVONNE. "Henri Cartier-Bresson on the Art of Photography." *Harper's,* November, 1961.

BEATON, CECIL. "The Debussy of the Camera." *Vogue,* April, 1976.

"Bill Brandt." *Album,* February and March, 1970.

"Bohemia Reborn." *Horizon,* Spring, 1974.

BOURDON, DAVID. "Art." *Village Voice,* 23 December 1974.

BULLOCK, BARBARA. *Wynn Bullock.* Scrimshaw Press, 1971.

BUNNELL, PETER C. "Photographs as Sculpture and Prints." *Art in America,* September/October, 1969.

Brassaï. New York: Museum of Modern Art, 1968.

CALLAHAN, HARRY. *Harry Callahan.* New York: Museum of Modern Art, 1967.

————. *The Multiple Image.* Chicago: Press of the Institute of Design, 1961.

————. *Photographs: Harry Callahan* (catalogue). Text by Hugo Weber. Santa Barbara, California: El Mochuelo Gallery, 1964.

CARTIER-BRESSON, HENRI. *The Europeans: Photographs by Henri Cartier-Bresson.* Simon and Schuster, 1955.

————. *Photographs by Cartier-Bresson.* Forewords by Lincoln Kirstein and Beaumont Newhall. 1947. Reprint. Grossman, 1963.

————. *The World of Henri Cartier-Bresson.* Viking Press, 1968.

COHEN, RONNY H. "Avedon's Portraits: The Big Picture." *Art in America,* November/December, 1975.

COLEMAN, A. D. "Latent Image." *Village Voice,* 25 January 1973.

"Cool Look at a Changing World." *New Scientist,* 11 March 1976.

DATER, JUDY, and WELLPOT, JACK. *Women and Other Visions.* Morgan & Morgan, 1975.

DAVIS, DOUGLAS. "Avedon Rising." *Newsweek,* 22 September 1975.

DURNIAK, JOHN. "Visual Mayhem." *Time,* 22 September 1975.

FRANK, ROBERT. *The Americans.* Grove Press, 1959.

HESS, THOMAS B. "Richard Avedon's Hidden Photographs." *Vogue,* September, 1975.

ISRAEL, MARVIN. "The Photography of Diane Arbus." *Infinity,* November, 1972.

KERTÉSZ, ANDRÉ. *André Kertész* (catalogue). New York: Museum of Modern Art, 1964.

————. *André Kertész: Sixty Years of Photography.* Edited by Nicolas Ducrot. Grossman, 1972.

————. *André Kertész/Washington Square.* Introduction by Brendon Gill. Grossman, 1975.

KIRSTEIN, LINCOLN. "Cartier-Bresson in the Orient." *Portfolio,* 1951.

KOUDELKA, JOSEF. *Gypsies.* Aperture, 1975.

KRAMER, HILTON. "Avedon's Portraits Radiate Glamor." *New York Times,* 11 September, 1975.

LAWSON, CAROL. "Richard Avedon: An Artist Despite His Success." *The New York Times,* 7 September, 1975.

LEIBOVITZ, ANNIE, ed. *Shooting Stars.* Straight Arrow Books, 1973.

MADDOW, BEN. "Surgeon, Poet, Provocateur." Photo League *Bulletin,* April, 1947.

NATALI, ENRICO. *New American People.* Introduction by Hugh Edwards. Morgan & Morgan, 1972.

NEWMAN, ARNOLD. *One Mind's Eye.* Introduction by Robert Sobieszek, foreword by Beaumont Newhall. David R. Godine, 1974.

PACIFICI, ANGELO. "Edward Weston: 164 Photographs." *Grain,* 1974.

PARKER, FRED R. *Manuel Alvarez-Bravo.* Pasadena Art Museum, 1971.

PENN, IRVING. *Worlds in a Small Room,* Grossman, 1974.

The Photograph as Poetry. Pasadena Art Museum, 1960.

"Portrait of the Portraitist." *Art News,* Summer, 1974.

RAY, MAN. *Man Ray.* Los Angeles County Museum of Art, 1966.

RESNICK, NATHAN. *"Intention and Reality: A Journey into Darkest Photography."* Infinity, May, 1968.

SMITH, W. EUGENE. *W. Eugene Smith.* Essay by Lincoln Kirstein. Aperture, 1969.

SOBY, JAMES THRALL. "Lee Friedlander." *Art in America,* no. 2, 1960.

STETTNER, IRVING. "A Visit to Brassai." Photo League *Photo Notes,* 1948.

STEVENS, NANCY. "The Child's Eye Opens Wider." *Village Voice,* 1 December 1975.

SZARKOWSKI, JOHN. *Looking at Photographs: 100 Pictures from the Collection of the Museum of Modern Art.* New York: Museum of Modern Art, 1973.

TUCKER, ANNE. *The Woman's Eye.* Alfred A. Knopf, 1973.

University of California at Los Angeles. *Catalogue of the U.C.L.A. Collection of Contemporary American Photographs.* 1976.

VISHNIAC, ROMAN. *Roman Vishniac.* I. P. C. Library of Photographers. Grossman, 1974.

WESTON, BRETT. *Brett Weston: Voyage of the Eye.* Essay by Beaumont Newhall. Aperture, 1975.

WOLFSON, GARY, ed. *Young American Photography,* Vol. 1. Lustrum Press, 1974.

Index

Page numbers in italic type face indicate pictures.